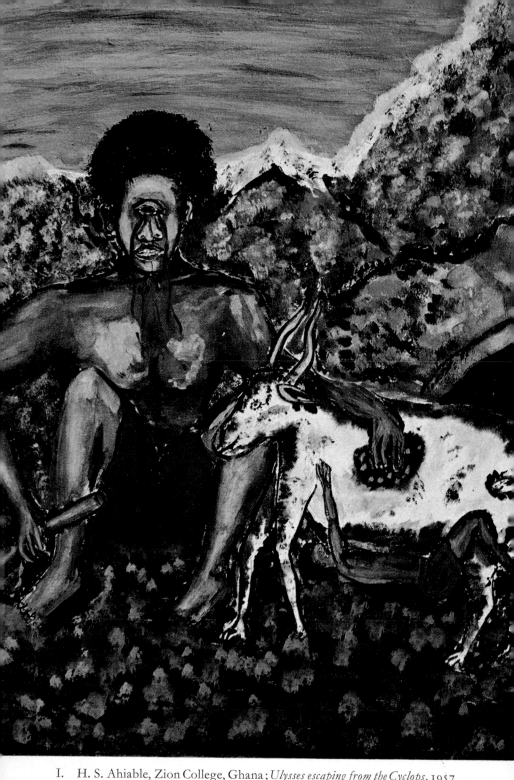

I. H. S. Ahiable, Zion College, Ghana; *Ulysses escaping from the Cyclops,* 1957

Draw They Must

A History of the Teaching and Examining of Art

by Richard Carline

Chief Examiner in Art for the Cambridge University
Local Examinations Syndicate

Edward Arnold (Publishers) Ltd

© Richard Carline 1968

First published 1968

SBN: 7131 1497 5

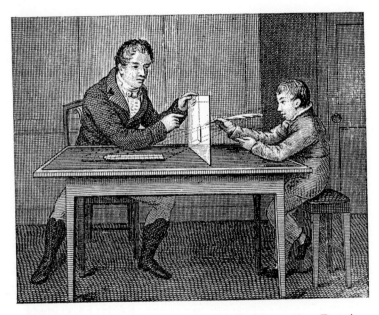

Lesson in Foreshortening, from Charles Hayter's Perspective, Drawing and Painting *etc., 3rd Ed. 1820*

Printed in Great Britain by
W & J Mackay & Co Ltd, Chatham

Preface

A book dealing with art teaching and examining was suggested to me by Mr J. A. T. Morgan of the firm of Edward Arnold now more than ten years ago. My friend and colleague, the late George Stevens, welcomed, as I did, this suggestion of recording what had taken place in the past and was happening in the present, while the information was still available.

We had often questioned, as had many other artists and teachers, whether progress in art teaching was sufficient, whether ground was being lost rather than gained despite efforts to win recognition of its value. Research tended to confirm our view that art had only acquired its place in education, modest as it is, as a result of the constant efforts of artists and teachers throughout its history. Are not such efforts still needed as much as ever? If so, an attempt to describe its history might well prove of value.

If is often and, I think, wrongly assumed that the place of art in society is secure and that the future of art teaching is therefore equally assured. It is easy to feel complacency when contemplating the advances that have been made in art teaching in schools and the attention it has received on radio and television in recent years. But despite these apparent advances, art performs a relatively minor role in the life of the community today and it means singularly little to the great majority of the world's population.

The general public's ability to appreciate art was inevitably reduced when machine-based industry replaced the old hand-craft culture, thus depriving people of the need to make or handle works of art in their daily life. Today, it is through school education only that people's aesthetic needs can be aroused and made fully known to them. The constant advance in science and technology must not replace but be counterbalanced by development in visual appreciation.

But why, particularly, should people be required to study art? This question provokes frequent disagreement and there is widespread uncertainty even as to whether it should be taught at all.

I was complaining to an English Language Examiner regarding the neglect of art teaching, at which he demurred: "First things must come first". But which are first? Are priorities immutably established? What is the aim of education? The average pupil is often the victim of misunderstanding between headmaster,

parents and art teacher. Their respective positions in relation to the study of art often conflict, and the pupil is left in a state of confusion.

Boys or girls who have never practised drawing or painting, even in childhood—there are, of course, few in this country but many overseas—are liable to prove deficient in the power to distinguish, memorize and describe, things seen. This may prove a handicap in subjects other than art, such as biology, chemistry, medicine, history, geography and literary composition. If the power to think visually is lacking the pupil will be wholly dependent on auditory means of study. The main goal of art teaching is not technical efficiency or skill, as usually assumed, but the development of the visual perceptions. Perhaps the art class might gain in status by a change in name, with "art" discarded in favour of "vision".

George Stevens, with his training in history—he had been a scholar of Queen's College, Oxford, after the First World War, in addition to studying at the Ruskin Drawing School and later at the Slade—together with his experience in teaching art at Achimota College on its foundation at Accra in 1924, was obviously equipped to write a book on the history and practice of art teaching. He had resigned in 1929, when the College refused his plea for better facilities, became art master at Eastbourne College, then director of a Crafts Centre, joined the Council of Social Service in 1944, was in charge of art at a Teachers' Training College, and finally became Principal of Battersea Men's Institute. Having had some twenty-five years of art examining for the Cambridge Syndicate, and being co-chief examiner for much of the time, he had exceptional experience in the subject, and it came as a shock when he told me in 1961 that circumstances compelled him to withdraw from our joint undertaking. He generously handed me all his notes. The much greater shock of his sudden death came in June 1963, and in addition to losing a very old friend, I could no longer enjoy the benefit of his knowledge and advice in the preparation of this book.

Stevens was a leading member of the Society for Education through Art, and I am glad of this opportunity to pay tribute to one who had devoted his life to the furtherance of their aims.

Some parts of this book were made possible only through the co-operation of the examining boards. The Cambridge Local Examinations Syndicate offered its support as far back as 1958, when Mr J. L. Brereton, then General Secretary, suggested, with Stevens' and my ready concurrence, that any discussion of examining should be undertaken objectively and impartially, and I have done my best to follow this advice. I must stress, moreover, that any opinions given, apart from quotations, are entirely my own and are not intended to convey the views of the Syndicate or of any other examining board.

I am most grateful to Mr T. S. Wyatt and Mr A. V. Hardy, the Syndicate's General Secretary and Deputy Secretary respectively. Mr Hardy's intimate knowledge of the Syndicate's art examinations from the administrative angle has been of great service in filling gaps in my own knowledge, and he has been so kind as to check relevant sections of the proofs. I also thank members of the Syndi-

cate's staff, especially Mr R. D. Moore and Mr A. G. Flack, with their long familiarity with examining problems.

The Syndicate has generously lent me and given me permission to reproduce certain examples of candidates' work, as well as photographs of craftwork, which had been submitted for G.C.E. examination, and for this I tender my thanks. I should emphasize that my use of them does not imply any superiority over other work submitted either to the Syndicate or any of the other examining boards. The selection has been mainly governed by convenience in using work which was known to me and readily accessible.

I greatly appreciated the interest taken by my good friend, the late Nalder Williams, the Syndicate's former General Secretary, and I deeply regret that his death prevented me from submitting to him sections of the proofs. I am equally indebted to Dr J. O. Roach, who was the Syndicate's Assistant Secretary for many years, and who has generously allowed me to use his special knowledge of examination history.

I am very grateful for the help given me by the Oxford Delegacy; Mr J. R. Cummings, Deputy Secretary, made their early Minute books and other records available for me as did the Oxford and Cambridge Schools Examination Board and the School Examinations Department of London University, where Mr E. B. Champkin gave me information and, with Mr A. H. Wesencraft, facilitated my researches in the University Library.

The other examining boards have also helped me with information, and I offer them my thanks, particularly Dr J. A. Petch, Secretary of the Joint Matriculation Board at Manchester, Mr P. A. Bryett and Mr R. Toncic of the Associated Examining Board, The University of Durham School Examination Board, the Southern Universities' Joint Board at Bristol, the Welsh Joint Education Committee, the Scottish Certificate of Education Examination Board, the Northern Ireland General Certificate of Education Committee, the Royal Society of Arts (Examinations Department) and other institutions.

I am very grateful to the Royal Drawing Society and Dr Viola, for information regarding the Society's examinations and for lending me examples of children's work. Dr Viola lent me photographs of the work of Dr Cizek's pupils and drew upon his unique recollections of the teaching. I am similarly grateful to Miss A. G. Holman for giving me the benefit of her recollections of T. R. Ablett, the Society's founder, and lending me its early publications.

I have every reason to thank the Royal Society of Arts and particularly its Curator-Librarian, Mr D. G. C. Allan, for letting me inspect drawings and other material and use some for reproduction. Mr Allan has, moreover, allowed me to draw freely from his intimate knowledge of the Society's early history.

For the early phases of art teaching I have encountered the difficulties usually experienced in historical research, in that school records have so seldom survived, and I am much indebted to those who have responded to my enquiries, even though in very few cases was information to be found. The Governors of Christ's Hospital, through their Clerk, generously permitted me to study their

Minute books, which survive, since the seventeenth century, at their offices in London, and allowed reproduction from certain manuscripts in the School Library at Horsham, and I regret that this book, in which their Librarian, the late A. C. W. Edwards, took a keen interest, was not completed in time for him to see. My thanks are also due to the Librarian of St Paul's School, London, the Clerk to the Merchant Taylors' Company, the Registrar of King's College, London, and the Librarian of Eton College. The Clerk to the Governors of Wymondham Grammar School Foundation, Mr W. B. Gledhill, the Warden of Wymondham College, the Chief Clerk of Trinity College, Cambridge, and the Director of the Groninger Museum, Holland, have all aided me with information concerning Henry Peacham.

For the work of Cotman, Crome, and members of their circle, I naturally turned to Norwich, and I record my thanks to the Director of the City of Norwich Museums for permitting me to reproduce drawings in their collection, and to Dr Rajnai, the Deputy Director, and Mr Alec M. Cotman, in particular, for placing their special knowledge of the Norwich School at my disposal. I also thank Dr N. L. Goldberg of St Petersburg, Florida, for his valuable information concerning John Crome, and, similarly, Mr Andrew Stephenson, the Headmaster of Norwich School

I have been able to make full use of the Libraries and Print rooms of the British Museum and the Victoria and Albert Museum, and I thank their Trustees for allowing me to reproduce drawings, prints and books in their care, also Mr Graham Reynolds, Mr Brian Reade and Mrs Shirley Bury, of the Victoria and Albert Museum, and Mr P. A. Troutman, Curator of the Courtauld Institute's Galleries. The Libraries of the Department of Education and Science, the Commonwealth Office, Friends' House and the Hong Kong Government Office have similarly given me facilities for research.

Through the kind offices of Mr Z. Pollen, I have had access to the Minute books and other records of the Society for Education through Art at Morley College, and I also thank the National Society for Art Education for the loan of literature, and Messrs Rowney for information on acryllic paint.

At a very early stage in the preparation of this book, a number of schools were asked for replies to specific questions on their art teaching. I offer my thanks to the following schools: Addey and Stanhope; Alvering; Bedales; Bryanston; Dartington Hall; D. G. Grammar; Eastbourne College; Eastbourne Grammar; Emmanuel; Kidbroke Comprehensive; Leeds Central High; Parliament Hill; Queen Ethelburga's; Roedean; Sedbergh; Thoresby High; Walthamstow County High; Wennington.

In pursuing my enquiries overseas, I was aided by my friend of many years, Mr A. E. T. Barrow, M.P., Secretary of the Council of the Indian School Certificate Examination in Delhi, and I have been in correspondence with various schools, many of which I had visited in past years in India, Ceylon, Malaysia and East Africa. I must thank, in particular, my friends, Mr B. Gunnery, late Principal, and Lady Temple, art mistress, of the Cathedral and John Connon School,

Bombay, together with their former colleague, Mr Nix-James, who sent me his recollections of the school in earlier days, also Mr G. S. Reutens and Mr Rathin Mitra, art masters of the Penang Free School, Malaysia, and the Doon School, Dehra Dun, India, the Principals of La Martinière College, Lucknow, the Lawrence Schools, Loveday and Sanawar, Loreto House, Calcutta, and Mr B. C. Gue, art master of Mayo College, Ajmer.

I am most grateful to Lord Hemingford for his information concerning Achimota College when he and Stevens were colleagues on its staff, Mr J. Ormerod Greenwood, for his notes on West Africa, and the Principal of Fourah Bay College, Sierra Leone.

While some of the illustrations are from paintings or books in my possession, the majority are derived from work lent me for reproduction, and I offer my acknowledgements to the owners who are listed elsewhere. Among these are many good friends, and I may mention Mrs Rossetti Angeli and her daughter, Mrs Dennis, who allowed me to search through their Rossetti and other pre-Raphaelite drawings, Miss Kathleen and Mr Donald Richardson, who permitted me to choose work by pupils of their sister, Marion, and helped me with information. I am equally grateful to my old friend, K. C. Murray, Inspector of Antiquities, Lagos, who generously took the risk of entrusting me with a selection of his former pupils' work on my return from Nigeria.

In reproducing the work of candidates for the G.C.E., I have been glad in most cases to receive their consent or that of the school where the work was done, together with much useful information concerning it, and in this connexion I must record my thanks to my friend, Mr R. E. Ndefo, art master of Dennis Memorial Grammar School, Onitsha in Eastern Nigeria, and to the Headmaster of Plumtree School, Rhodesia, and its art master, Mr H. A. Baker, whose information has been of great use.

Among schools which have generously sent me information concerning the work selected for illustration are the following: St Mary's, Kisubi, Uganda; Namilyango College, Kampala; Eko Boys' High School, Mushin, Nigeria; Our Lady's High and Washington Memorial Schools, both in Onitsha; Goethal's Memorial School, Kurseong, India and Dow Hill School, West Bengal; Adisadel College, Cape Coast; Government Secondary School, Tamale; Zion College, Keta; the three last named being in Ghana.

I submit my thanks, also, for information given me by the following schools in England: Cambridgeshire Girls' High School; Copthall, Mill Hill, and its principal Art Mistress, Mrs Nomi Durell; Dudley High School; Elliott School, London, with Mr Arnold Martin, Head of its Art Department; Girls' Grammar School, Hatfield; Hertford Grammar School; Kent College, Pembury; King Alfred's, Hampstead, with its art mistress, Mrs Hunt; Ounsdale Comprehensive, Wombourn; Sidcot School, Winscombe; West Buckland School, Devon.

I record my thanks to Mr and Mrs Paul Mellon, for permitting me to reproduce the painting by George Dance in their collection in Washington, their Curator, Mr Dennis Farr, and the Directors of the Sabin Galleries, London, also

the Director of the Birmingham City Art Gallery and the Marquess of Bath who have allowed me to reproduce their Peacham drawings.

I read recently that the Directors of an Art Festival intended to build a bonfire on which members of the public were to cast whatever they considered ugly. This was, doubtless, an excellent project for publicity, but very rash, because many people thoroughly dislike some of the greatest masterpieces and would be most unlikely to burn what the artist or critic would gladly see destroyed. In my opinion, artists have the social duty to help the general public to recognise what is good or bad in art, and such a task involves a great deal of co-operation.

In preparing this book I have not lacked the co-operation of fellow artists, teachers and examiners in art. Such friends are too numerous for me to mention more than a few—Miss Monica Young, a pioneer in the art teaching at Langford Grove and Badminton, Mrs Nomi Durell, whose work as an art teacher is well known, and similarly Miss Gladys Alden, Art Mistress of Clifton High School, Mrs K. P. Kurzke, art teacher and examiner, Miss Diana Madgett and Miss Phoebe Somers, with their experience in teaching art in the Far East and in Africa, Mr Alan Witney, Head of the Art Department at Merchant Taylors' School, Mr Morley Bury of Hornsey College of Art, Mr Morris Romans, Art Master of Eastbourne Grammar School, Miss Elizabeth Vellacourt, in charge of the Syndicate's Craft examinations and her colleague, the late Betty Rea, Miss Nan Youngman, Chairman of the Syndicate's Art Committee, and—an artist friend of many years—Mr Fred Uhlman.

I owe special thanks to my wife, Nancy, whose knowledge and aesthetic experience has been available when choosing and arranging the illustrations, and I frankly acknowledge that I have usually abandoned any proposals of my own in favour of hers.

In Japan, recently, where my knowledge of the language was wholly inadequate, I indicated my wish for tea in my bedroom, and the maid brought me a packet, but with no teapot in which to make it. Confused by my protests, she took away the tea and brought me an empty teapot. With mounting confusion, she then took away the teapot and returned with a bottle of whisky. In writing this book, I sincerely hope that it will not be thought that I have merely added to the present state of confusion, but have helped to clarify some of the problems which surround art teaching today.

Although my first lessons in art came from my father, I owe my interest in its teaching to my brother, Sydney, and my colleague, George Stevens, was always prompt to acknowledge his own debt to him as his first teacher at Oxford. I feel, therefore, that Stevens would have concurred with my wish to dedicate this book to the memory of Sydney Carline, who died in 1929, while at the threshold of his career.

Hampstead RICHARD CARLINE
May, 1967

Contents

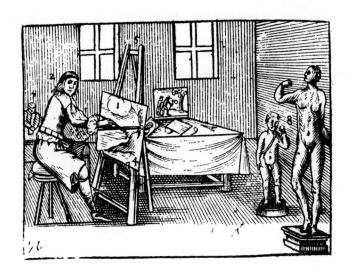

The Picture.

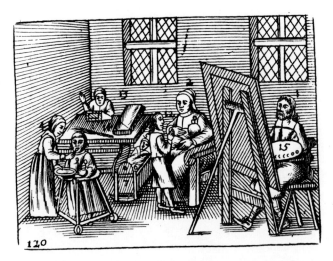

The Society betwixt Parents and Children.

From Orbis Pictus *by Comenius, 1659*

Introduction

With so much written on the teaching of art to children, yet so little mention of its history, one might conclude that it had no history to record. This is not quite the case, though information is meagre. Children have been taught to draw, and even paint, for some centuries, but the method of teaching them was indistinguishable from that used in training the artist or the craftsman, and what effect it had on the children and their artistic reactions to it have remained unrecorded.

It is only during the present century that children's art has been recognized as something quite distinct in character from that of the sophisticated adult and a different method of teaching devised in the elementary and secondary schools as opposed to the art or technical schools. To the art teachers of past centuries, our contemporary appreciation of children's work would have been completely incomprehensible.

If art teaching for the young was less in evidence three or four centuries ago than it is today, it was not through indifference but because it was beset with difficulties—scarcity of materials, absence of facilities in communication and travelling, lack of suitable conditions for practising art in schools, and chiefly because qualified artists were not trained in how to teach—something which was not contemplated at a period when all teaching in school was confined to the professional schoolmaster.

Under the Tudors, Stuarts and Georges, when art played a much more vital role in the life of the community than it does in our contemporary society, when the level of achievement in art was so high relative to the size of the population and when there was constant contact with works of art or of fine craftsmanship, people were inevitably more familiar with artistic expression and design. Thus education in art was scarcely so imperative as in our modern mechanized world, where art is confined to a relatively small proportion of the population and where works of art can be seen by the general public only by making a special effort.

Nevertheless, the importance of spreading an understanding and appreciation of art, particularly among those who might become its patrons, was often stressed in the sixteenth and, especially, the seventeenth centuries. There were writers and lovers of art, such as Elyot, Hoby, Peacham, Petty and Evelyn, who could not contemplate an education without art and brought to the subject a

degree of serious attention, which was manifestly lacking in more recent times. Alas, there was seldom much prospect of their aims being fulfilled.

The character of art teaching in the past, governed as it was by strict regimentation combined with complete deference to prevailing conventions and rules, has naturally been deplored in these days of freedom of expression. But allowance must be made for art having been regarded, until about two centuries ago, as a craft with its main emphasis on the teaching of technique—how to use pencil, brush or tools for limning, carving or engraving. Moreover, an undue reverence for accuracy and precision in drawing was, perhaps, to be expected at a time when the visual imagination was constantly exercised, needing no encouragement, and when the powers of invention and creation were thoroughly familiar to all in the making of every variety of useful object by hand.

This emphasis on technique, rather than on the imaginative and creative aspects of art, inevitably led to the schools producing specialists—competent artists or craftsmen—as the main objective of art teaching instead of contributing to general education. If social conditions made this objective necessary in earlier centuries, there is no justification for it today.

A dreary uniformity seems to have enveloped the typical drawing classes of the seventeenth and eighteenth centuries, but they must have been less monotonous than other classes, since the art teachers never lacked pupils. Out of this gloom, pioneers emerge, such as Alexander Cozens and John Crome, who demanded much more of their pupils than mere accuracy in representing objects on paper. Many of their doctrines took root among later generations of art teachers, but conventional methods were to remain entrenched in the schools for a long time to come.

The schools regarded art as a useful skill rather than a measure of refinement. This placed it in a manual rather than an intellectual category, a position of inferiority in which it has languished until well into this century. It is only quite recently that the art class has ceased to be a place of penance with the art teaching a drudgery. Barely forty years have elapsed since the notice board at a public school carried, without apparently any protest, the following announcement:

> All boys who appear at school in soft collars without permission must offer
> a satisfactory excuse to a prefect before morning prayer or they will be sent to
> Art School.[1]

Practical utility is still the main criterion by which art teaching is justified at a school. This circumscribed concept is strongly entrenched in schools overseas even today. At a school in southern Nigeria, at which I found that art was given exceptional encouragement, I was asked to talk to the senior pupils on the value of art in daily life. The Headmaster called for questions. I was promptly asked: "Will art be of use to me in plastic surgery?" It seemed that my talk had not penetrated the audience very deeply. The next boy to put up his hand asked whether he could earn a good living if he took up art on leaving school.

[1] *The Record*, published by the Art Teachers' Guild, July, 1923.

Attempts to give art teaching a broader educational objective beyond imme-diate utility seem thwarted by the modern tendency towards specialization. We seem so often to be fighting a losing battle. I recall the Headmaster of a famous school speaking of a pupil who was habitually late. It was severe weather with the hill covered with snow and ice and the boy had an apt excuse: "It was so slippery, Sir: with every step forward, I found myself taking two steps back-wards." "How then did you arrive?" was the obvious question. The reply needed careful thought: "I took the precaution, Sir, to turn round and approach school backwards."

This is the habitual fate of art teaching. Steps forward are usually followed by several steps backward, and we might make better progress if we turned round and faced the other way. When Rousseau and Cozens demanded more use of the imagination, the system of copying which deadened the imagination was gaining ground and was soon more firmly entrenched than ever. When Ruskin and Prout demanded that art teaching be founded upon the direct study of nature, the university examining boards, which had recently been set up, took the opposite course and concentrated upon geometric drawing. It would be impos-sible to recover all the ground lost in art education. There are many who think that until quite recently it was doing much more harm than good. From the point of view of developing aesthetic sensibility, the old methods were certainly quite valueless.

It might be hard to find a school in the British Isles today that makes no provision for art teaching. Many schools are lavishly equipped with studios presided over by fully qualified art teachers. But the latter will often complain that the art department is regarded mainly as a show place and the instruction treated as a useful hobby to fill up the pupils' spare time. Art is still disregarded far too often in modern education.

Sir Herbert Read put the case more than twenty years ago for revising our attitude towards general education. "We demand", he wrote, "a method of education that is formally and fundamentally aesthetic."[1] Although facilities for teaching art have grown so enormously since then, schools and colleges are still very far from adopting this creed. How often, we may ask, is the boy or girl who has chosen to study the classics and reads Greek and Roman literature given any equivalent insight into the Greek and Roman visual arts? Does the history class give adequate consideration to the course of development in painting, sculpture or architecture? Does the biology class, to suggest another example, seek the co-operation of the art department when studying natural form and structure? To take even such modest steps towards incorporating art studies in general education would still be far short of using the creative faculties as the means of education, as Read has urged. The training of the visual perceptions is available to very few in general education today.

I have heard mathematicians say that the boy or girl whose imagination has been enlarged in the art class often goes furthest in mathematics or science.

[1] Sir Herbert Read, *Education through Art*, 1945.

Nevertheless, they are constantly withdrawn from their art studies because they have revealed an equal promise in some other branch of study. This usually occurs when entrance to a university is under way. I made enquiries on this point of a number of schools, both independant and state-aided. More than half agreed that the pressure of academic subjects tended to deflect their pupils from art "to a very considerable extent". All the remaining schools gave the opinion that this pressure occurred "to some extent". Thus it is evident that pupils are not expected to remain in the art class unless they have already decided on a career in art or are backward in other subjects.[1]

Headmasters will often justify the art class being small on the grounds that so few of their pupils have shown any special talent for art or any particular inclination for it. This is quite the wrong attitude. It is not the boys or girls of artistic talent who most need teaching. They can be left to their own devices easily enough. It is those whose aesthetic faculties are weak, whose visual impressions and powers of observation are dim, and for whom art is like a closed book, who chiefly need the attention of the art teacher.

Englishmen, apart from a small minority, usually respond to the wrong types of art, if they respond at all. Many confuse art with sex-appeal. The fault lies in education. Most adults today have had no contact with art when at school and they feel thoroughly uncomfortable when placed before a work of art in later life. The educated Englishman's attitude to art is well conveyed in Jane Austen's *Sense and Sensibility*. Edward Ferrars is criticized for his uncritical admiration of Elinor, the merit of whose drawings he did not really understand. Elinor, taken aback, offers the defence that he is not, nevertheless, lacking in natural taste.

Many boys and girls leave school completely indifferent to art. An artist friend who was explaining to me how to bring up children advised surrounding the baby's cot with Botticelli reproductions in the hope that having little else to see the baby would become thoroughly familiar with the curious look which belongs to a work of art, and retain this familiarity into later life.

Creditable efforts are being made to attract young people nowadays to the Museums and Art Galleries. Books on art are plentiful and art is granted increasing space and time in press and radio, not to speak of correspondence courses of doubtful value. Art education should be making progress, but is it advancing or merely marking time? If art is obtaining a growing audience, so are less estimable forms of entertainment at a far more rapid rate—bingo, betting, strip cartoons, and even crime. While there must be several hundred art schools or technical institutes with evening classes in art available, at least one in every sizeable town, betting establishments, according to reports in the Press, already number more than sixteen thousand.

Art education is advancing much too slowly and its place in the life of the community is far behind many other activities which are less essential to human

[1] Neglect of art teaching is still more apparent overseas. It is doubtful whether art is being taught at as many as two hundred secondary schools in the whole of Africa, excluding the South.

well-being. It is generally admitted that children are naturally susceptible to visual stimulus, but the pictures they chiefly see are not by the hand of an artist, nor inspired by cultural motives, and are more likely to corrupt than edify. It was recently reported that a boy of twelve was found hanging from a tree. He had dressed himself to resemble a hero he had seen and admired on television.

The first report issued by the National Advisory Council on Art Education, mentioned the hope that

> "some secondary schools will so develop their teaching of art as to enable them to give introductory courses approximating in quality to those given in an art school."[1]

To raise the level of secondary school art courses is manifestly desirable. But how is it to be achieved? The Council would welcome

> "experiments in co-operation between secondary schools and art schools in which pupils in sixth forms would attend art schools for their art education."

This suggestion, by which the secondary school art class for the sixth form would be replaced by the art school is thoroughly mistaken and if widely adopted would lead us in quite the wrong direction. It places the emphasis entirely on the preparation of the artist, ignoring the true function of art education in the life of a school. The school art class should not only develop visual sensitivity but provide a background of taste, perception and appreciation which can be helpful throughout the school in studying a variety of subjects as well as art. It is not solely the future artist with whom it should be concerned but future members of the general public on whom the well-being of art must depend.

The Council's Report rightly urges that art schools "should be regarded as focal points for all those in the neighbourhood who are interested in the visual arts" and that by an extension of the system of providing part-time courses they could "try to increase public interest in" the visual arts. But this should not be interpreted to mean any lessening of the responsibility of the secondary school. On the contrary, too much dependance on the art school with its specialized concern is liable to lead us yet further along the road which ends in a divided society, with those who think, see and behave as artists—the minority—on the one side and those who are quite unconcerned with art—the great majority on the other side, both sides eyeing one another with suspicion. To enlarge the community of artists while ignoring the general public's ability to appreciate their work, which is how we tend to proceed at present can only end disastrously for art. It is the function of the secondary school to prevent this occurring.

It is widely assumed that pupils who do extremely well in art while at school should necessarily proceed to an art school. This assumption is mistaken. They

[1] The Council was set up in 1959 under the chairmanship of Professor Sir William Coldstream, to advise the Minister on art training in establishments of further education. The first of its three reports appeared in 1960.

may achieve equal success in some other career. Moreover, the reverse sometimes occurs, with pupils who have revealed only a modest talent as children making a success in art professionally.

Picking out seven pupils from various schools, who had produced work of exceptional merit, each having meanwhile left school, I made enquiries as to their subsequent fate. I learnt that only three—two girls and one boy—had sought and obtained places in an art school. Of the remaining four, one became an architectural draughtsman, one a farmer and two took up business careers. One of the three who went to an art school had been disappointed in G.C.E. results in art, success in one branch of work being accompanied by failure in another.

G.C.E. results in art are seldom taken into account either by the universities or the art schools when granting admission, although there is some slight evidence of this wasteful policy being revised. The main value of these results lies at present in their use by local authorities who have grants to confer or by parents or teachers in assessing vocational prospects. There should be closer contacts between the secondary school's art department, the art panel of the examining board and the staff of the local art school, without reducing the secondary school's responsibility. No such co-ordination has existed hitherto.

The conduct of art teaching in the schools and of art examining for the G.C.E. was not within the terms of reference of the National Advisory Council on Art Education. There is scope for such an enquiry at the secondary school level, in order to co-ordinate the work of the various examining bodies and define the function of art teaching in schools.

At present the various bodies concerned with art education function quite separately. The schools have the means for offering criticism of examination results, but contact is often frustrated by rules and precedents which have been originally devised for academic subjects and seem to have little validity in art. The art panels of the examining boards have as yet no contact with one another or the means for mutual discussion.

Such contacts are particularly desirable for schools which cater for handicapped children, such as those who are deaf, dumb or lack the use of a limb. The visual sensibilities of such children are often enhanced by the nature of their handicap, their work gaining in sensitivity where it lacks strength or firmness, and their art studies can be of inestimable value to them.

Fortunately for art education, we are no longer living in a man's world. Until this century, art teaching was exclusively conducted by men, usually with deplorable results. Many of the leading pioneers in art teaching in recent years have been women, and there are many active today.

We are now coming to recognize that girls at school do better in art than boys on the whole. G.C.E. results indicate that the proportion of girls who pass in art at Ordinary level is between 6 and 10 per cent higher than among boys, though the difference is less evident at Advanced level.[1] This has led to more

[1] This is not true of countries of the Commonwealth in Asia and Africa, where the boys usually obtain much better results in art than the girls.

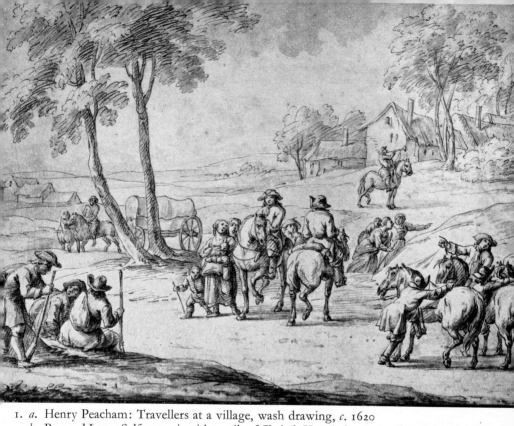

1. *a.* Henry Peacham: Travellers at a village, wash drawing, *c.* 1620
 b. Bernard Lens: Self-portrait with pupils of Christ's Hospital, copper-plate engraving,
 c. 1720

M.ᵉ Lens Miniature Painter and Drawing Master to Christ Hospital.

Invitation *Invitatio*

I.

The Master and the Boy. *Magister & Puer.*

M. Come Boy, learn to be wise.

P. What doth this mean, to be wise?

M. To understand rightly, to do rightly, and to speak out rightly, all that are necessary.

P. Who will teach me this?

M. I by Gods help.

M. *Veni, Puer! disce sapere.*

P. *Quid hoc est, sapere?*

M. *Omnia, quæ necessaria, rectè intelligere, rectè agere, rectè eloqui.*

P. *Quis me hoc docebit?*

M. *Ego cum Deo.*

2. Engravings from Comenius' *Orbis Pictus*, 1659

XXXVIII.

The outward parts, *Membra Hominis* of a Man *Externa.*

girls than boys seeking a career in art. Perhaps we are nearing the completion of a cycle, reverting to an earlier but primitive stage when the artists who made superb pottery and textiles were probably the women. We cannot judge what masterpieces the world might now possess had women been allowed to practise art alongside Fra Angelico or Donatello or work with Raphael in the Vatican.

In teaching art, we now no longer impose the handicaps that confronted female students in the eighteenth century and earlier when they were not allowed to draw from the nude nor work in classes with fellow students. Girls' schools today often provide better facilities in art than do the boys' schools. Enquiries addressed to a selection of schools of varied type reveal that 60 per cent, and sometimes even as much as 80 per cent, of pupils at girls' schools receive some art teaching, whereas at boys' schools the number seldom exceeds 50 per cent and is often much less. The time allowed for art both at the boys' as well as the girls' schools is usually one hour a week, but may be increased to two hours a week under exceptional circumstances such as preparation for taking art at Advanced level in the G.C.E.

So much advice has been published on how to teach children to draw and paint and practise sculpture and the crafts that there is no need to add to it. It is the art of the very young child that has been given the most attention. The adolescents' needs in art have been often overlooked, and it is with them that I have been mainly concerned in the preparation of this book, seeking such light as the pattern of ideas over the centuries may have shed.

While art teaching is fortunately freeing itself from mistaken concepts of the past, its history does reveal aspects which we may emulate and pioneers whose work must evoke our admiration. We may respect the direct methods of early teachers with their simple, straightforward objectives, their desire to develop art appreciation, the love of nature inspired by the romantic movement, the search for principles in design, the encouragement derived from the competitions and examinations, the struggles for university recognition, and, finally, the modern acceptance of experiment, research and the discoveries of science.

Obstacles impeding art teaching in schools have been and are being overcome, making it available to an increasing number of boys and girls, since draw they must, whether told to do so by parents or teachers or from some inner compulsion. There may yet be an opportunity before it is too late for achieving an education through art.

Wynkyn de Worde, woodcut from John Holt's Lac Puerorum, *1508*

I

the Early Background

THE concept of "Fine Art", confined to painting and sculpture and elevated above the crafts of everyday life, did not fully emerge in Great Britain until well into the eighteenth century, and it was only then that art teaching in a systematic form began to take root. This does not mean that drawing was completely ignored in the education of medieval England. As early as the fourteenth century, judging by Chaucer, drawing was respected as a genteel accomplishment, for the Prologue to the *Canterbury Tales* tells us that the young English squire, who was only "twenty yeer of age", could "wel purtreye and write". Thus a facility in drawing was appreciated and some method of teaching it must have been available.

That Chaucer should specifically mention an ability to portray, or draw, clearly denotes that it was regarded as evidence of distinction. During the fourteenth and fifteenth centuries drawing was chiefly used in transcribing and decorating books, which, prior to the discovery of printing, had to be reproduced by hand. Chaucer makes it clear, however, that this skill was not confined to the monasteries, but was also valued among the gentry.

The type of study pursued by the young squire in learning to "purtreye" would have consisted in drawing and applying colour to the initial letters of a manuscript and perhaps copying the decorative borders devised by a skilled hand. He is unlikely to have attempted any original design or illustration of his own imagining.

Drawing and writing were closely linked in the production of the illuminated manuscript, and were the only branches of visual art that a layman could hope to practise, since wall-painting and sculpture involved considerable physical effort with tools and materials beyond the average person's reach.

Opportunities of learning to draw must have been very limited, since even the manuscripts, which alone contained examples of good drawing on a suitable scale for the layman or the child to study and copy, were not available to many persons, and very few children could have had access to them. How, then, did people in general acquire the familiarity with drawing which was to become apparent under the Tudors?

It is often claimed that drawing is instinctive, since children, even before they can talk, will seize chalk or pencil, although the result may be no more than a

scribble. In order to draw the child must have the materials and the incentive. In the modern world the incentive may spring from seeing older children drawing, with the consequent desire to emulate them. But children today are able to derive further stimulus from their picture books. The modern child feels the urge to embellish or improve the pictures, as he traces the contours with his fingers, and thus forms the immediate wish to fill in the blank spaces with his chalk. Familiarity with the process of drawing naturally follows.

In this manner the average child of today acquires the habit from infancy of comparing objects represented in the picture books with the real ones. In course of time certain linear arrangements and combinations of colour become accepted as the symbols of a man, a tree, a boat, a house, etc. But how did the children of earlier periods, long before juvenile picture books had appeared, acquire this incentive to draw?

It may be answered that pictures have always existed since Palaeolithic man made his drawings on the cave walls or on pieces of bone and horn, and it is often argued that since these primitive hunters could draw it must be a faculty inherent in the human race. But this is by no means conclusive. There are many races scattered about the world who do not practise drawing and have never done so. It has sometimes been noted by travellers who came in contact with primitive peoples before the advent of European civilization that a picture would often prove incomprehensible to them. They would turn it round and upside down in a vain effort to understand its meaning. Two-dimensional representation seemed to baffle them.

Most artists who have worked outside the confines of civilization will have experienced this absence of familiarity with drawing. I recall an experience of my own which suggests that drawing is not naturally understood. When painting in the Atlas Mountains a shepherd boy constantly came to watch me, from which I concluded that he must have some special interest in drawing. Handing him pencil and paper, I urged him to draw one of the animals in his flock, thinking that his familiarity with them would make the task easier. I was surprised to discover his complete bewilderment at my request. After some persuasion, he drew a circle. As this bore no resemblance to his animals, which were lean and famished, it occurred to me that the round shape was meant to convey his wish to see them fatter.

I had occasion to observe in East Africa that boys and girls, who had been brought up in remote villages and were attending secondary school for the first time, had no previous understanding of what is meant by drawing. The use of pencil and paper for representing forms in nature seemed a mystery, but once these highly intelligent boys and girls had been shown drawings and had grasped the idea that a line can be made to denote the edge of a form three-dimensionally, they soon acquired remarkable ability in its use. Thus, the possibility of drawing had to be discovered before its technique could be passed on from one to another.

In Saxon and Norman England the use of drawing for expressing form by

means of a contour, whether on stone or parchment, must have been rarely seen until the Normans brought over the pictorial arts of Europe. Besides their illuminated manuscripts, they imported tapestries—a branch of art which did not take firm root in England until much later—and their wall-paintings, with their clear use of line, could be seen in churches, halls or refectories as early as the twelfth century.

The technique of wall-painting in fresco, with its status of a craft, was handed down from the master to the apprentice, who watched and helped in the grinding and mixing of colours, the preparing of grounds, and the handling of charcoal and brush with which the curved contours were drawn upon the wall. Children may have watched the artisans at work and thus acquired the wish to make similar experiments on their own. Once the children had appreciated that an object could be represented by means of lines the discovery of suitable materials must have inevitably followed.

In Chaucer's time a child, or for that matter the layman, would have been faced with many difficulties to hinder his practice of drawing. Parchment was too precious for general use, while the use of paper, which was not fully established in Europe until the fourteenth century, depended on importation and was accordingly scarce. Even when paper came to be manufactured in England in the sixteenth century it was relatively expensive at fourpence a quire and could not be squandered on children unnecessarily. It was, in fact, the early scarcity of paper that caused oral teaching to be continued until well into the Reformation. Thus until Tudor times children must have made their experiments in drawing when out of school and by other means than paper or pencil.

Once inspired with the wish to draw, the child would soon discover that any smooth surface of wood, stone or plaster could be used with the aid of a piece of charcoal from the embers of a fire. We know that slate was used for writing in Chaucer's time, for he advises the reader, in his *Treatise on the Astrolabe*, in 1391, to "take all the signes . . . and write him in by slate". Tablets of slate set in wooden frames, with a pencil made of softer slate, were used for geometry in the schools of the sixteenth century,[1] and it is reasonable to suppose that they provided children with an occasional opportunity for drawing pictures, if only when the teacher's back was turned.[2]

Most of us have, at some time or other, drawn animals or caricatures of our friends with a walking-stick or other pointed piece of wood on the wet sand of the sea-shore or river-bank. This pastime has been familiar since the dawn of human existence. In fact, it is more than likely that this was the first means of drawing to be discovered. In the cave of Niaux in the French Pyrenees, there is a bison and some trout drawn in outline with a pointed stick by a Magdalenian artist on the soft floor of clay, their preservation over thousands of years being due to the protection of a deposit of stalagmite. If it could thus occur to these

[1] Leonard Digges, *Pantometica*, 1571.
[2] The use of slates specifically for drawing is mentioned by Abraham Tucker, the Philosopher, in *Light of Nature pursued*, 1756.

Palaeolithic hunters to make drawings in this manner, it is reasonable to assume that the same simple discovery was not beyond the children of medieval England.

We have, in fact, the evidence of Hezekiah Woodward, a grammar-school master, that this pastime was practised in Charles I's reign, and he implies that it was no novelty in his day. He begs us to "follow the child's nature" and "observe him with his little stick puddering in the ashes, drawing lines there, or upon the dirt, where he can make an impression."[1]

From drawing lines with a stick on the ground it is an easy step to covering any vacant surface with lines or colours. The medley of lines with which the child in infancy tries to transform a blank space may suggest a resemblance to some familiar object, and he will try to repeat this success, thus making the first step towards the creation of a picture.

Boys, and possibly girls also, probably drew when and where they could with any ready-made materials that they could find. Such resourcefulness is recorded by John Aubrey with reference to his friend Francis Potter, a country parson.[2] He recounts that when Potter was a child towards the end of Queen Elizabeth's reign he showed a strong propensity for drawing, and "on the buttery dore in his parlour he drew his father's picture at length with his booke and on the spectacles in his hand is the reflection of the gothic south windowe". In an age when modern forms of entertainment, including the camera, were unknown, drawing must have provided one of the main forms of entertainment for many children, and bare walls would have proved very convenient for the purpose.[3]

Children in medieval and Tudor England would have learnt the rudiments of drawing merely by watching and imitating one another. They were certainly not encouraged to draw at school. Subjects were taught only because they were useful.[4] Thus it was by indirect means, such as the use of illustrations in the school textbooks, that art first obtained any foothold in the classroom.

The earliest illustrated school book known to us is the *Lac Puerorum or Mylke for Children*, by John Holt, usher at Magdalen College School, Oxford, in 1495, soon after the printing press was introduced into England. The frontispiece of this Latin grammar—a woodcut depicting the master seated in a high gothic chair, his birch across his knees, with his three scholars on a bench in front—is the only actual picture. The remaining three illustrations are purely

[1] H. Woodward, *Of the Child's Portion*, 1641.
[2] *Aubrey's Brief Lives*, written between 1669 and 1696, edited by O. L. Dick, 1950.
[3] In George Morland's self-portrait (Nottingham Art Gallery) the whitewashed walls of the studio appear covered with his humorous sketches, indicating that this was a common pastime in the eighteenth century and presumably much earlier. I remember that when the wall paper was stripped from attic walls in my grandfather's house (Lincoln) they were found to be covered with caricatures and portraits drawn on the plaster by boys of earlier times.
[4] Music only obtained its place in schools of the fifteenth century or earlier because the child's voice was useful for the church choir. When the Reformation withdrew this objective the teaching of singing declined and in many schools ceased altogether.

diagrammatic, representing the human palm.[1] However little these illustrations may have appealed to the average boy, they must have provided welcome relaxation from the tedium of Latin grammar, and were probably traced or copied by numerous boys, who had little opportunity of seeing other pictures.

The chance contact with pictures was not necessarily confined to school. More than a century later Sir William Petty, the surveyor, informed John Aubrey that he had acquired a love of art when he was eight, early in Charles I's reign, by studying the illuminated manuscripts which he found in his father's library.

> I cared not for play [he explains], but on play-dayes, gave myself to drawing and painting, beginning first with plaine outlines. Then at nine to colours, having no body to instruct me; copied pictures in the parlour in a table booke. I was pleased with the elegancy of the writing and the coloured initiall letters.

Such opportunities could not have been general, for even in Petty's childhood, illustrated books, whether printed or produced in manuscript, were still comparatively scarce, and children must have been prompted to draw by other chance occurrences. Aubrey cites the case of Robert Hooke, the philosopher, who was inspired to draw as a result of watching the artist, John Hoskins, at work in his father's house.[2] Hoskins was employed to "draw pictures", we are told. The boy was entranced.

> Thought he, why cannot I do so too [Aubrey tells us]. So he gitts him chalke and ruddle and coal and grinds them, and puts them on a trencher, gott a pencill, and to work he went and made a picture.

The child's delight in drawing may have been promoted, to some extent, by the very fact that it was discouraged at school. Not only was it absent from the curriculum in Tudor times and earlier, for practical as much as theoretical reasons, but when we do find it mentioned in connection with education it is usually because it was treated as an offence. Henry Peacham, the schoolmaster, who subsequently took to art and writing and of whom we will have much to say later, claimed that his love of drawing, when a child during Queen Elizabeth's reign, survived many obstacles put in his way at school:

> Ever naturally from a child [he writes] I have been addicted to the practice hereof; Yet [he adds significantly] could they never beat it out of me.[3]

[1] This is in the edition by Wynkyn de Worde (Caxton's successor) of 1508, the earliest known to us. (plate 3a). Richarde Pynson, his chief rival, reprinted it in 1520 replacing the frontispiece with a different woodcut of a monk reading in his library. Copies of the book may have been circulated only among schoolmasters, but their pupils must have had access to them.

[2] "Old Hoskins", as he was known, was a notable painter of portraits in miniature during Charles I's reign. He taught the great miniaturist, Samuel Cooper, his nephew, and died in 1664.

[3] H. Peacham, *The Compleat Gentleman*, 1622.

The school was in Hertfordshire and Peacham recalled an incident, about 1585, which typifies the average schoolmaster's concern with drawing:

> I remember one master I had (and yet living not farre from Saint Albanes) took me one time drawing out with my penne that peare tree and boys throwing at it, at the end of the latine grammar; which hee perceiving in a rage strooke me with the great end of the rodde and rent my paper, swearing it was the onely way to teach me to robbe orchards; beside that I was placed with him to be made a scholler and not a painter.[1]

Robbing orchards is, of course, the classic boys' offence, but Peacham's main crime, apparently, was his drawing a picture of such a scene.

That the practise of drawing was not considered a proper occupation for a schoolboy in Elizabethan times, or indeed earlier, is indicated by the punishments that Peacham endured for its sake:

> I have [he proceeds] been cruelly beaten by ill and ignorant schoole-masters, when I have beene taking, in white and blacke, the countenance of someone or other (which I could doe at thirteene and fourteene yeeres of age).[1]

Sir William Petty made a similar complaint to Aubrey that in exercising his zeal for drawing, when he was eight or nine years old, about 1631, he was "crossed herein by father and schoolmaster".[2]

Drawing materials even in the Elizabethan period were still far from plentiful, and we may note that Peacham used any blank space he could find in his school books.[3] Using "chalk, coal or blacke lead", he advises us as follows:

> You shall sharpen them upon one of your fingers, as also your blacke lead; be not without the crummes of fine white bread, to rub out your lead or coale, when you have done amisse.[4]

This wise precaution may have been doubly necessary in case the master might be watching.

Boys were recommended to make their own brushes, for "applying shadow", cut from a "broome stalke about the bigness of a spoon handle", and to "chew it between your teeth till it be fine and grow heary at the end like a pensill"[4]. The brush was needed for applying washes of ink, weakened when necessary with water. This was a century before the use of water-colour took root in England.[5] Pens for drawing were usually made from ravens' quills, but Peacham found that "goose quils serve for the bigger or ruder lines."[4]

[1] H. Peachman, *The Compleat Gentleman*, 1622. [2] *Aubrey's Brief Lives* (op. cit.).

[3] Paper was in use for writing in schools by the end of the sixteenth century, and presumably also for drawing when allowed, as Brinsley tells us (J. Brinsley, *Ludus Literarius or the Grammar Schoole, 1612*.)

[4] H. Peacham, *The Art of Drawing*, 1606.

[5] Wenceslas Hollar, followed by Francis Place, began using water-colours in England for tinting pen-and-ink drawings of landscape at the end of the seventeenth century.

With paper available, children's efforts would have been confined mainly to drawing with pencil, chalk or pen and ink. Painting with colours, considering the technical difficulties involved, must have been beyond their reach. Nevertheless, Peacham gives a number of recipes for obtaining black paint from walnut-shell or from soot, pinks and yellows from saffron, green from verdigris, and for various ochres. They were ground in gum arabic and stored in mussel-shells.

Thus there were many practical difficulties to prevent the spread of art teaching in medieval England. But a hindrance even greater than the shortage of materials for children's use in drawing was the lack of persons competent to teach the subject. At a period when the various branches of art were still confined mainly to craftsmen, it was necessarily very rare to find a man of education, still less a schoolmaster, who would venture to teach drawing. And when the schoolmaster did venture to do so it may be confidently assumed that from the artistic point of view he would have caused his pupils more harm than good.

As in later times the children of medieval England would have learnt to draw by teaching themselves, or imitating one another, through a process of trial and error. Presumably the teacher's ignorance of their proceedings, and perhaps even parental blindness, was something the children may well have prayed for when trying to draw.

Henry Peacham, Scene from Shakespeare's Titus Andronicus, *1595*

New Influences in the Sixteenth Century

THE influence of the Renaissance was slow in reaching England, but when it did so in the sixteenth century it brought a new respect for the visual arts. England's cultural isolation was brought to an end.

With the revival of interest in Greek and Roman art and the unearthing of its treasures Englishmen were chiefly attracted to Italy, where they came in contact with the work of contemporary Italian painters and sculptors. The travellers could not have failed to note the gulf that separated the primitive art of England from the great masterpieces of fresco-painting, portraiture and sculpture then being produced in Florence, Rome and Milan. Henceforward art was to be discussed from the cultural and educational standpoint.

Artists in Italy, since the beginning of the sixteenth century, had no longer been bound by the restrictions of the medieval guilds. Raphael, according to Vasari's celebrated statement, "did not live the life of a painter, but that of a prince". The artist was thus no longer a mere craftsman; he occupied a highly respected position in the social scale. The Medici had already set up an academy for the study of antique sculpture in Florence, and the whole problem of art appreciation was attracting the attention of cultivated people. News of these developments found their way to England and were to lead to the emergence of plans for art education.

Notable among English travellers to Italy in the sixteenth century was Sir Thomas Hoby. During his prolonged stay he became acquainted with the work of Baldassare Castiglione, the friend of Raphael and Michelangelo. Castiglione had written his book, *Il Cortegiano*, at Rome in 1508, but it was not published until twenty years later.[1] Hoby was inspired with the wish to produce an English translation, but by the time this was ready to appear in 1561, more than half a century after the original work was written, it had been preceded by a somewhat

[1] Castiglione paid a brief visit to London in 1506, and wrote his book shortly afterwards, while sitting for the two portraits that Raphael painted of him in Rome. He brought to England Raphael's "St. George and the Dragon" (now in Washington's National Gallery) as a present to Henry VII.

analagous treatise by Sir Thomas Elyot, whose *Boke named the Gouernour*, appearing in 1531, bore evidence of the same source of influence.

These two books brought art education to the forefront. Hitherto education had led only to the practice of law or the priesthood. These books introduced to England the novel concept of the gentry and members of the Court as lovers of the arts. Moreover, Castiglione expressly recommends teaching "gentilmen's children in the schooles to apply peincting as a matter both honest and necessary". He adds, alas, that it was "not to be taught to servauntes and bondmen".

Castiglione's *The Courtier*, to give it its English title, deserves to be considered first, though its translation into English came later.[1] It is based on an imaginary discussion between leading figures at the Duke of Urbino's Court as to the right behaviour and education of the knight or man of action. The work of Leonardo da Vinci, Mantegna, Raphael and other masters is freely discussed, and, as Hoby renders it, the newly discovered "auncient images of marble and metall, which at this day are to be seene". The reader is urged to make himself acquainted with these masterpieces of art.

> See then [he tells us] how the knowledge in painting is cause of verie great pleasure.

Here was the first suggestion that the reader should study the history and practice of art.

Castiglione causes his various characters to discuss the technique of art, as a subject which should be understood by all those who aspired to culture. He explains the use of perspective, then a new discovery in art, for representing objects in space or foreshortening of limbs. He calls it "the plainesse and farnesse", to be achieved by "force of measured lines, coulours, lightes and shadowes". Thus the English reader was learning for the first time about the representation of landscape or interiors.

The enjoyment of colour, which recurs in Castiglione's work, must have struck a fresh note in England, where colour was still used in a literal and descriptive manner rather than for the expression of emotion. In a splendid paragraph he urges that it is no "triflynge matter to counterfeyt naturall colours", assuring us that colour must convey the feelings or, as he explains,

> expresse the grace of the sight that is in the black eyes, or in azure with the shining of those amorous beames.

Nature, he explains, can only be truly visualized as a result of training, without which one

[1] *The Book of the Courtyer by Count Baldassare Castiglione* very necessary and profitable for yonge gentilmen and gentilwomen abiding in court, palaice or place, done into English by Thomas Hoby, imprinted at London by Wyllyam Seres at the signe of the hedghogge, 1561.

cannot show the colour of yelow haire, nor the glistring of armor, nor a darke
night, nor a sea tempest, nor those twinckelinges and sparkeles, nor the burning
of a citie, nor the rising of the morning in the colour of roses with those
beames of purple and golde.

The romantic type of landscape or seascape is here described in terms of colour,
foreshadowing the work of Claude Lorraine, Poussin and Rubens of a century
later.

An unexpected feature of *The Courtier*, considering the period when it was
written, is its plea that girls should enjoy the same educational opportunities as
boys. The author causes one of his characters, Lord Gaspar Pallavicin, who
proves to be somewhat of a misogynist, to open the discussion:

> Nature [he asserts] because she is alwaies set and bent to make things perfect,
> if she coulde, woulde continuallye bring forth men, and when a woman is borne,
> it is a slacknesse or default of nature, and contrary to that she woulde do. As
> it is also seene in one borne blinde, lame or with some other impediment, and
> in trees many fruites that never ripen.

These fantasies were, of course, put forward only for the purpose of demolishing
them. The author causes Julian de Medici, son of Lorenzo the Magnificent and
one of the author's closest friends, then living in exile, to voice the obvious
reply:

> I answere you that this is full and wholy to be denyed. . . . Whatever thinges
> men can understand, the self same can women understand also: and what it
> pearceth the capacite of the one, it may likewise pearce the other's. . . .
> Women being the tenderer of flesh, are also apter of minde.

Despite this unusual testimony, girls continued to suffer unequal opportunities
compared with boys in the study and practise of art for at least two centuries to
come.

Whether or not Sir Thomas Elyot, whose work was published some years
before Hoby had completed his translation of *The Courtier*, knew Castiglione's
work in the original Italian, he was certainly fully aware of the new attitude
towards the arts that was emanating from Italy. *The Boke named the Gouernour* was
the first treatise in English to advocate the teaching of art, though the subject is
discussed only briefly, and the author's recommendations must have aroused
some surprise, if not opposition, in a land barely emerging from the intellectual
Dark Ages.

The book contains the startling proposition that a gentleman should learn to
"paynte and karve, if nature thereto doth induce him". Painting and sculpture
in Tudor England still remained the exclusive occupation of craftsmen who
undertook the decoration of churches and banqueting halls; portraiture had
barely begun. It was only to be expected therefore that the author would voice
his fear "that someone will scorne me, sayenge that I hadde well hyed me to make
of a nobleman a mason or peynter". Painting, as distinct from drawing, and the
carving of stone or wood involved manual labour, which was not normally

expected from the gentry, and the author realizes the need to apologize for suggesting that any gentleman "shall present himselfe openly stained or embrued with sondry colours or powdered with the duste of stones that he cutteth".

This is not the full extent of Elyot's foresight. He was the first in England to assert that children may have artistic interests, for which they should not be made to suffer:

> If the childe [he writes] be of nature inclined (as many have been) to paint with a penne or to fourme images in stone or tree, he shulde not be therefrom withdrawen or nature be rebuked.

Here we have the first open recognition that art, including sculpture, may perform a valuable role in the education of the child.

There is, unfortunately, little evidence of Elyot's recommendations having been taken to heart in educational circles. Peacham, as we have seen, experienced half a century later, nothing but rebuke when his "nature inclined" him to draw. But Elyot proposed more than drawing. He suggested the much more ambitious programme of painting and carving. Nor was he thinking merely in terms of copying the work of others. He was the first to recognize the value of a child's imagination and his need to employ visual self-expression of his own free will, as when he

> taketh his penne or pensill and with a grave and substantiall studie, gatherying to him all the parts of imagination, endeavoureth himself to expresse lively. . . . Myne intente and meanyinge [our author continues] is onely that a noble chylde, by his owne naturall disposition and not by coercion, may be induced to recieve perfect instruction in these sciences.

These are views which educational circles have tended to ignore almost until the present century, nor did they make any appreciable impact on contemporary writers on education. Roger Ascham, noted as a calligrapher and instructor to the future Queen Elizabeth, makes scarcely any reference to the teaching of art in his book *The Scholemaster*, published in 1570 after his death, though we may infer from certain statements that he held the view that if drawing was to be studied at school it should be done willingly and not under compulsion.

It was in Court circles rather than educational ones that Elyot and Hoby made their impact, though this was slow to emerge. More than forty years elapsed after Elyot's work had appeared, before Sir Humphrey Gilbert launched his Academy for the Education of the Sons of Noblemen in 1572. The scheme provided for drawing, although limited to the new study of perspective and drawing of maps. Prompted by the growing urge for geographical discovery, such maps gave the artist scope for much fanciful pictorial embellishment. Gilbert's academy was, unfortunately, short-lived; nevertheless, it provided the first public announcement of drawing being included in a school curriculum.[1]

[1] A similar project to include the teaching of drawing was advocated in 1607 by J. Cleland in *The Institution of a young Nobleman*, but was never actually realized.

Any consideration of art teaching in Elizabethan England involved calligraphy, for it was through this branch of art that drawing gained a foothold in the schools.[1] Drawing, or limning as it was called, had been linked with writing from early times through the production of the illuminated manuscripts. Throughout Elizabeth's reign writing schools were being established, usually in combination with a grammar school, as in the case of Christ's Hospital in 1577, and they prescribed exercises that were equally required in drawing, such as control of the hand by the eye in using the pen or pencil, and for this purpose paper was required. The writing schools were in effect the precursors of the art class, dependent on teachers with the requisite technical skill.

The curriculum in any school was normally confined to subjects that the master and his usher, or assistant, could teach. When, for example, Christ's Hospital sought to appoint a new writing master in 1675 the Governors were concerned whether the candidate, William James, would be equally competent to teach arithmetic, to which James retorted that "if he was deficient in arithmetic, he would make it his business to inform himself better in it", a reply which perfectly satisfied them as to his fitness for the post.[2]

In the teaching of writing the schools often had recourse to the hiring of a journeyman scrivener, who might offer his services for a short period, usually in the summer. Thus calligraphy, and such drawing as accompanied it, seldom formed part of the regular school curriculum. At St. Bees, we are told, writing was limited to two hours a week and this took place only on Saturdays and half holidays.[3] At Heighington it was taken "upon Festival days or other convenient times", while at Houghton it was taught by the usher "on playing days and after supper".[3] John Brinsley, the grammar-school master, condemned this use of scriveners, "which go about the country, at least which go under the name of scriveners and take upon them to teach to write".[4] Thus writing, like drawing at a later date, was treated as an extra, often the subject of special fees.

The earliest and by far the most informative account of the teaching of writing combined with drawing has been given us by Richard Mulcaster, a schoolmaster whose experience, spread over half a century, was unique. His methods are outlined in his two books, *Positions*, published in 1581, and *Elementarie*, appearing a year later, when he had completed twenty years as the first headmaster of Merchant Taylors' School. Mulcaster is the first schoolmaster to

[1] Peter Bales, who wrote the *Writing Schoolmaster* in 1590, probably the earliest book of its kind in England, with engravings for the student to copy, is often described as the pioneer of calligraphy in England. Bales's work was much admired by Jodocus Hondius, the engraver of maps, who came from Flanders in 1583 to meet Bales. Holinshed's *Chronicles* records that Bales was accompanied by his pupils when he defeated his rival, Daniel Johnson, in public contest. Such was the romantic interest in calligraphy. Bales wrote the ten commandments, the Creed and some prayers in Latin and enclosed them in a gold ring as a present to the Queen.

[2] Minutes of the Governors' Meetings at Christ's Hospital.

[3] Prof. Foster Watson, *The English Grammar Schools to 1660*, 1908.

[4] J. Brinsley, *Ludus Literarius or the Grammar Schoole*, 1612.

have explained his views on the teaching of drawing, though we have no information as to how he actually handled his class.

In these two books the close links between drawing and writing are constantly emphasized. The author describes them as "cousins" and "bedfellows" and affirms from his own experience that pupils who "have any naturall towardnesse to write well, have a knacke of drawing too". It was his practice to teach both subjects together on the grounds that "penne and penknife, incke and paper, compasse and ruler, a deske and a dustboxe will set them both up, and in these young yeares while the finger is flexible and the hand fit for frame, it will be fashioned easily".[1]

Mulcaster believed in the teaching of drawing in order to promote good writing, rather than for its own sake. Nowhere in his writings do we find any reference to the visual image, such as Elyot had in mind. Like the typical pedagogue, Mulcaster concentrated on the immediate practical results which he sought from his pupils, such as a fluency and accuracy of line. As he tells us:

> It is out of all controversye that if drawing be thought needful, as it shall be proved to be, it is now to be dealt with, while the finger is tender and the writing yet in hand, that both the pen and pencil, both the rule and the compasse may go forward together.[2]

Glad though we may be that the teaching of drawing was considered necessary and, presumably, actually taught at Merchant Taylors' School, we may well quail at the thought of teaching it only with rule and compass.[3]

At Merchant Taylors', and subsequently at St. Paul's, where Mulcaster became high master in 1596, we can envisage the drawing class. The boys would have been busy practising the drawing of circles, ovals and spirals, constantly rubbing out the lines as their master indicated inaccuracies here or there. They would have practised varying the quality of their lines, sometimes thick or heavy, thin or light, the one grading into the other. Perfect symmetry would have been sought, as in rendering the two opposing sides of a vase, and different methods of shading would have been attempted.[4]

We can well imagine these boys of Elizabethan times, much as they might seem today, their arms spread over the desks, while they slowly and awkwardly

[1] *Positions*, 1581, edited by the Rev. R. H. Quick, 1888.

[2] *Elementarie*, 1582, edited by E. T. Campagnac, 1925.

[3] Mulcaster resigned from Merchant Taylors' in 1586, after some disagreement with the Governors, and was appointed high master of St. Paul's in 1596, relinquishing the post after twelve years, when he was nearing eighty. He had thus taught for half a century. Unfortunately, no records of his actual teaching have been preserved in the archives of either school, though it is recorded by Hayne that the boys returned to school in the evenings for the writing class.

[4] The first recorded drawing master at Merchant Taylors' School, according to the school archives, was James Fahey, who was appointed in 1856 and did not retire until 1884, when he was over eighty years old. I am indebted to the Merchant Taylors' Company for this information.

press hard with the pencil as if carving their lines rather than drawing them, and having frequent recourse to the breadcrumbs. A lighter touch would be constantly urged, and the teacher would demand that they sit upright, so as to hold their pencil at a distance.

The need to draw "leisurely" and "lightly" was equally urged by John Brinsley, who, like Mulcaster, was teaching towards the close of Elizabeth's reign. Brinsley was a strong advocate of drawing as a help towards the attainment of good writing. He urged his pupils to use the pen or pencil as "the painter doth", allowing it to "glide or swimme upon the paper".[1]

Brinsley was even more concerned than Mulcaster with the flexibility of his pupils' fingers. They were to be exercised like those of a pianist, practising at least once a day, preferably at "about one of the clock, for then commonly their hands are warmest and nimblest".[1]

Art teaching during the Tudor period and even under the Stuarts was inevitably handicapped by the absence of artists competent to teach. The professional schoolmaster, moreover, seldom revealed more than a very limited understanding of art. John Mellis, a Southwark schoolmaster, offered to teach writing, arithmetic and drawing at St. Olave's, where he set up his school soon after leaving Cambridge in 1564. He took pride in having had no training in drawing which, he explains,

> was naturally given mee from my youth without instruction of any man more than the love thereof, delectation, desire and practise.[2]

Mellis had been "training up of youth to write and draw", he informs us, for the previous twenty-eight years, which makes him, therefore, the earliest teacher of drawing known to us in England.

It was the limitations of the teacher rather than the pupils which impeded art education. The whole range and outlook in art was limited. Painting or the use of colour was seldom taught, if at all, purely because few schoolmasters had the requisite knowledge. As Mulcaster frankly admits in his *Elementarie*:

> Whatsoever shall belong to colouring, to shadowing, and such more workmanly points, because they are nearer to the painter than to the drawing learner, I will reserve them to the after habit and to the student's choice, when he is to divert and to betake himself to some one trade in life.

Painting was to be taught, therefore, only at the professional level.

From small beginnings the teaching of drawing was emerging in the schools of sixteenth-century England, though it had little to do with art and did nothing

[1] J. Brinsley, op. cit.
[2] John Mellis, Dedication to Robert Recorde's *The Ground of Arts Teaching*, 1607. Mellis addressed himself to all those who may "be minded to have their children or servants instructed", with the reminder that they will "find the author (according to his small talents) ready to accomplish the same for a reasonable reward".

b. William Faithorne the elder: The Writing Master at Christ's Hospital, engraving, c. 1680

IOHN SMITH
WRITINGMASTER
IN LONDON.

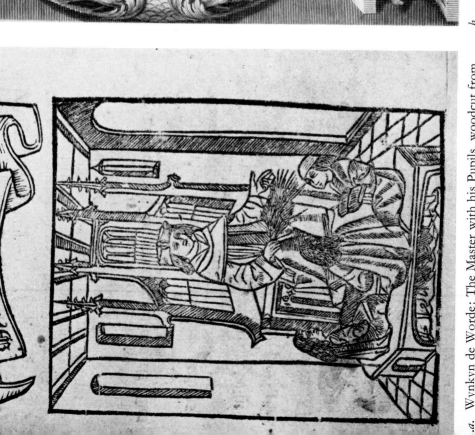

a. Wynkyn de Worde: The Master with his Pupils, woodcut from John Holt's *Lac Puerorum*, 1508

4. Alexander Cozens: *a*. River bank in Italy, pencil redrawn in ink, *c*. 1746
b. Italian landscape, pen and ink, 1746

to stimulate the imagination, in the way that writers like Elyot and Castiglione had urged. Several centuries would have to elapse before the child's real needs in art would be recognised, and before it would be realized that these needs lie in the broader field of art rather than in the mere acquisition of skill with pen or pencil or in accuracy of hand and eye.

Joseph Terry, a tailpiece from his log book, 1680

3

the Seventeenth Century

WHILE art education had been subject to discussion under the Tudors, it was not until the seventeenth century that the study of art began to assume a more practical form. If this was due to any one single factor, it was the introduction of copper-plate engraving. This recently invented process not only facilitated the teaching of drawing and, for that matter, writing, through the improvement in methods of reproduction, it also enabled a knowledge of art to be disseminated among a much wider public than had been possible hitherto.

The copper plate had been widely used on the Continent, especially the Netherlands, during the sixteenth century, but was scarcely known in England until James I's reign.[1] The use of this new method of engraving in the illustration of books and for making copies of fashionable portraits or other works by the masters was now acquiring a wide appreciation. Engravers were soon busily employed by publishers like Sudbury and Humble or William Peake.

This diffusion of prints led to a steady demand for books on how to draw or etch. Increasing numbers of people now felt an urge to experiment with drawing, and these books provided them with elementary instruction. One of the first to meet this demand was Peacham, whose *Art of Drawing* appeared in 1606.[2]

Henry Peacham, who has already made an appearance in these pages, is an unusual figure in the annals of art teaching, the more so as he had combined the professions of artist and schoolmaster. He was undoubtedly the first artist in England to write on the technique of drawing from sound, personal experience

[1] In *The Compleat Gentleman*, which first appeared in 1622, Peacham states that the new process had been "practised but of late years". He was clearly referring only to England, since A. M. Hind, in his *Short History of Engraving & Etching*, 1908, has shown that intaglio engraving was practised in Germany as early as 1446, and that Martin Schongauer and some of the Italian masters were using the medium well before the end of the fifteenth century.

[2] The full title reads: "The Art of Drawing with the pen and Limning in Water Colours . . . for the behoofe of all young gentlemen, or any else that are desirous for to become practitioners in this excellent and most ingenious art". It was reissued in 1612 as *Graphice* and again in 1622 as second part of *The Compleat Gentleman* and entitled *The Gentleman's Exercise or an exquisite practise, as well for drawing all manner of beasts in their true portraitures, as also the making of all kinds of colours etc.*

and perhaps the first to make any serious effort to teach it in school. His preface to *The Art of Drawing* begins:

> You have heer a few principles of mine art, which as franckly I impart unto you, as the heavens freely bestowed them upon myself: I call it mine, because it was borne with me, nor ever used I the benefit of any instructor save mine owne practice and experience.

Peacham, who was born in 1576, the son of a clergyman in Hertfordshire, turned to teaching early in his career. This was at the Free School, Wymondham, in Norfolk,[1] before the close of the century, but he seems to have disliked his profession and decided to retire from teaching shortly after writing *The Art of Drawing*. This work has, therefore, the added interest, from our point of view, that it presents the mode of teaching art that he had practised in Elizabeth's reign and thought suitable for schoolboys. It provides, in fact, our main source of information regarding this early period. That the author had his young pupils specially in mind is made clear in his Preface, which he wrote for the 1612 edition (entitled *Graphice*) beginning:

> It is now three years since I published this short discourse of the Art of Drawing, for the benefit of many young gentlemen, who were my Schollers. . . .

The Preface explains further that

> Concerning these directions I have given, they are such as I thought, in respect of their brevity and plainnesse, fit for the capacity of the young learner, for whom they were first and principally intended.

Peacham's work as an artist never gained him great renown. Horace Walpole mentions him merely as the engraver of Holbein's portrait of Sir Thomas Cromwell.[2] But he was clearly an able draughtsman, judging by his pen-and-ink sketch of country people, with its free rendering of movement.[3] His teaching was obviously based on the rule, so mistaken from our point of view, that the technique of drawing must be acquired first, before the pupil can consider the ideas he might wish to express. Although he himself must have had imagination and artistic feeling, these were not qualities that he sought to impart to his pupils. He contented himself with providing a rigid set of rules for drawing and instructing them by numbers, as it were, as on the barracks square. As a textbook on drawing and painting, Peacham's work deserved success, but, like other comparable books[4] that followed, it reveals little understanding of the qualities

[1] One of Edward VI's monastic foundations, it ceased functioning as a school early in the present century.

[2] Horace Walpole, *Anecdotes of Painting in England*, 1762.

[3] In the Birmingham City Art Gallery (plate 1a and notes on pages 293 and 304).

[4] Among seventeenth-century books on drawing may be mentioned *Graphice: the use of the pen and pencil or the most excellent art of Painting* in 1658 by Sir William Sanderson, who "marvailed at the negligence of parents in the education of their youth" as regards drawing, which was "so proper for any course of life whatsoever". There followed John Evelyn's *Sculptura*, 1662, and Dr. William Salmon's *Polygraphice*, 1672, which ran into several editions. The son of Crispin de Pass, the Dutch engraver, Peacham's "my

that make up a work of art. Even when artistic merit is recognized, there is a complete absence of any critical or analytical discussion of it. Are we not justified in assuming that the faculty to offer sound criticism in art has acquired its present significance only within the past century?

The seventeenth-century artist was mainly concerned with representing the human figure in accordance with the ideals of classical antiquity, and art instruction was designed to instil in the student's mind this classical concept of a human being rather than impressions of actual people in daily life.

For the composition of a picture great use was made of allegory, on which the artist relied for conveying his theme. But he also used it to indicate the mood and action of the figures. This descriptive aspect of drawing and painting found particularly fertile soil in England, where the appreciation of literature was so deeply embedded. Thus the pupil was expected to learn the various symbols used in drawing. Peacham indicates its importance by devoting to it an entire chapter.[1] He tells us, for example, that "May must be drawne with a sweete and amiable countenance", while "March is drawn in tawny with a fierce aspect, a helmet upon his head". Piety is to be drawn "like a lady of solemn cheare and a sober countenance", while matrimony—much the most complicated problem—requires "a young man standing, upon his shoulder a double yoake, his legs fast in a paire of stocks, in his hand a quince" etc.

Such rules could only have hampered the pupil who sought to rely on his imagination, but originality was not expected from the artist and was certainly not encouraged in the child. From this omission art teaching has suffered right down to the present century.

Portraiture was the branch of art mainly practised in the seventeenth century in England, as distinct from still life or landscape, and Peacham's pupils concentrated therefore on depicting the human head. His method was founded on the assumption—one which still finds its adherents today—that all objects in nature conform basically to simple geometric shapes. Thus his pupils were to begin their course of study by practising

> for the space of a weeke or thereabouts to draw circles, squares of all sorts,
> a cilinder, the ovall form with other such-like solid and plaine geometricall
> figures with a swift hand.

Justification for this rigorous exercise in the rendering of essential forms is given by our author as follows:

> As symmetry or proportion is the very soule of a picture, it is impossible that you
> should be ready in the bodies before you can draw their abstract and general forms.

honest loving friend" was also the author of a book on drawing, published in Amsterdam in 1643.

[1] Chapter 1 of the second "Booke of Drawing and Limning", which forms part of Henry Peacham's *The Art of Drawing*, is given the following heading:
"Teaching how, according to truth, to pourtract and expresse Eternitie, Hope, Victory, Pietie, Providence, Vertue, Time, Peace, Concord, Fame, Common safetye, Clemencie, Fate, etc, as they have been by Antiquitie described. . . ."

A certain facility in such drawing was required before the pupil might begin drawing from real life. Peacham explains his procedure as follows:

> Your circle will teach you to draw all sphericall bodies, as the sun, moon, starres, etc, the most flowers as the rose, marigold, helitropium, daisie, etc. . . .
> Your ovall forme will helpe you in drawing the face, a shield, or such like. . . .

Man's countenance, according to Peacham, has

> such pleasing varietie . . . that among ten thousand you shall not see one like another.

Nevertheless the rendering of the face was reduced to rule of thumb, the bisection of the oval providing the position of the facial features (page 34).

While the possession of individual characteristics was duly recognized, the representation of an individual was presumed to be beyond the capacity of the pupil. Mood, expression or gesture were to be conveyed only by superficial means. Thus we are told as follows:

> For an angrie or sterne countenance, let your brow bend so that it may almost seeme to touch the ball of the eye; what time you must also give the forehead a fine wrinkle or two.

For conveying an impression of love,

> you give the forehead a majestic grace and height, a full eye . . . a small proportionable nose, the nosethrills not too wide, a cleere cheek . . .

Although Peacham's methods of teaching were thus restricted by the conventions of his time, he was far in advance of his contemporaries in the realm of visual ideas. For example, he advised his pupils to sketch people in action. This was a generation before Rembrandt was making his rapid studies direct from nature.

"Take it when the partie minds you not, and to say the truth it is the best time of taking a picture", is Peacham's advice to his pupils. In support of this recommendation, the author quotes from his own experience:

> I have never drawne any more truly than when they have been busie in talking, at dinner, viewing something or other, and in this manner I have often taken his Majestie, sitting at dinner, or talking with some of his followers. . . . I have drawne him often with my pen and inke only upon a faire piece of paper in an houre, more truly and like, than the best pieces in oyle about the towne.

Peacham was exploring fresh ground when discussing the treatment of landscape, which was very much in its infancy outside the borders of Italy and scarcely known at all in England. His contemporary, Rubens, had not as yet painted landscapes, and those of Claude Lorraine, Poussin, Ruysdael, Hobbema or Francis Barlow were yet to appear. Our author must have been prompted by Castiglione's *The Courtier*, from which he had clearly borrowed certain passages. He may also have had Dürer's landscapes in mind when explaining how colours

get colder as they recede. He tells his pupils that if they use a dark green in the foreground

> the farther you goe, the more you must lighten it with a thin and aierie blue,
> to make it seem farre off.

Here we have the rudiments of aerial perspective.

Peacham might certainly be teaching today when he urges his pupils that they must not fail to observe "the time and season of the yeere" or "the bending of trees in winds and tempests". Although imagination is not actually mentioned, he comes somewhat near when recommending "invention", and the subjects he suggests as appropriate for "winter" could scarcely be bettered if his pupil's imagination was to be fired, as, for example—

> Felling of wood, sliding upon the yce, batfowling by night, hunting the beares
> or foxe in the snow, making your trees everywhere bare or laden with snow,
> the earth without flowers and cattell, the ayre thicke with clouds, rivers and lakes
> frozen, which you may shew by carts passing over.

In studying how to draw plants, Peacham wisely urged his pupils, as we would today, to study and handle them in the countryside "when you walke abroad into the fields to gather and keep them".

The composing of a picture by means of light and shade or "chiaroscuro", as it was known to the Italian and Dutch masters, was, as yet, unknown in England. In this branch of art Peacham was able to give only the conventional rule that shading must be used to indicate the form or roundness of an object, revealed by the light cast upon it, shadow being merely "a diminution of the light". The idea of conveying an effect of luminosity through tone values, as in the work of later masters like Gainsborough or Richard Wilson, had not yet been considered. In Peacham's time light and dark tones had very little meaning, except for throwing the figures into relief.

However much Peacham's precepts were limited by the artistic conventions of his period, he was a pioneer, certainly in England, in presenting drawing as an occupation to be enjoyed for its own sake, not merely as a practical means to an end. He was at pains to explain to his readers that the study of art entails more than the acquisition of skill, since "it doth speedily instruct the minde and strongly confirme the memory"—a precept consistently neglected even today. The book contains, furthermore, the first serious instruction in painting as well as drawing.[1]

It was difficult for the general public to acquire much real understanding of art, owing to the lack of opportunity for seeing the works of the masters. Few had access to the Holbeins or other masterpieces in England and foreign travel was within the reach of very few. No great collections had been formed in this

[1] Peacham's work may have prompted Sir Francis Kynaston to include the study of painting in the curriculum of his Musaeum Minervae, an Academy for Young Noblemen, in 1635, this being the first mention of painting together with sculpture as subjects to be taught regularly in a school. The academy existed, however, only a few years.

country when Peacham was writing his *Art of Drawing*, nearly a quarter of a century before Rubens visited our Court. There was, therefore, considerable novelty in the author offering his readers brief notes on the Italian painters, although the information seems to have been wholly derived from Vasari, whose *Lives of the Italian Painters* had appeared in Italy half a century earlier.

Several years later, Peacham was introduced to the Earl of Arundel and became tutor to his sons. In 1613 Peacham and his pupils spent a year on the Continent, visiting the great treasure houses of art. The Earl then began assembling his collection of statuary and paintings—the first of its kind in England— and doubtless he owed much to Peacham's taste and knowledge. Their friendship led to Peacham providing a more ambitious survey of the work of the Italian, German and Flemish masters in *The Compleat Gentleman* in 1622. In this book the author frankly recommends the reader to study Vasari, adding that he himself had been unable to see a copy of Vasari's work, but was indebted to his good friends, Dr. Mountford, Inigo Jones and Calvin Mander, for the greater part of his information.

Peacham's notes on the history of art do not contribute greatly, either historically or critically, to our knowledge of the subject. Readers of Vasari would have found nothing new. Nevertheless, this endeavour to promote a wider appreciation of art—the first attempt to do so in the English language—gives a special significance to Peacham's work. Within a few years interest in classical art and the work of the masters had grown apace, and Charles I, emulating the Earl of Arundel and doubtless stimulated by Rubens' visit, began forming his collection. Peacham must have contributed considerably to the broader interest in art, raised to a higher intellectual plane, that was now replacing the older concept of art as a craft.

Sir William Petty was another protagonist of art teaching in this enlightened age—he had studied painting in France before becoming a surveyor in Ireland. In 1648 Petty submitted his project for a college, which, although never to be realized, contained some revolutionary proposals. He intended to include art teaching as one of the mainsprings of education.[1]

> We wish [he writes] that a society of men might be instituted as careful to advance arts as the Jesuits are to propogate their religion.

His college was to combine a programme of teaching with the formation of a museum to contain, as he explains, "the rarest paintings and statues". Had this museum materialized, it would have preceded Elias Ashmole's collection (the nucleus of the Ashmolean Museum at Oxford) by more than thirty years.[2] Our author's aim, however, was to provide education rather than to indulge in collecting.

Petty's academy would have differed fundamentally from the earlier academies

[1] Sir William Petty wrote his pamphlet *The Advice of W.P. to Mr. Samuel Hartlib* in 1648 in response to a request from Hartlib, the indefatigable social reformer.
[2] Edmund Bolton had previously advocated a similar museum of art in *The Cabanet Royal*, and epistle to the King, 1627.

of James Cleland and Sir Francis Kynaston, which were intended only for the gentry. He proposed education on a wider, more democratic, basis, catering for girls as well as boys. The teaching was not to omit drawing because, in Petty's view, it develops the power to observe and, as he puts it, by "expressing the conceptions of the mind", it "performeth what by words is impossible".

No such proposal to educate through art had ever been made previously and not very often subsequently. Hitherto art teaching had been regarded solely as a means of providing men of leisure with an additional source of interest and accomplishment. Petty's project, alas, embodying so many progressive ideas, was doomed. It was launched, by mischance, just as King and Parliament were about to become embroiled in conflict, and the political environment was not favourable to its resuscitation later.

Throughout the seventeenth century the practical realization of any schemes for art teaching in schools was doomed, as in the previous century, by the lack of artists able to teach. In the absence of any organized system of education art could only be taught at institutions where the master was himself qualified in the subject, like Sir Balthazar Gerbier[1] or Henry Peacham. It was equally obstructed by the lack of time available in a curriculum monopolized by Latin as the medium for instruction. Roger Ascham had raised this issue in the sixteenth century. George Snell now came forward in favour of substituting English for Latin, and he expressly included drawing among the subjects which should be taught, if by this means time could be gained for them.[2]

Under the circumstances prevailing in the seventeenth century drawing was only catered for in schools as a spare-time subject in conjunction with writing, as had been advocated by the earlier schoolmasters. But writing, or calligraphy as we should describe it, was regarded rightly as an art in itself, perhaps never more so than at this period. It was especially in this subject that copperplate engraving created such a revolution.[3] Copy-books with engraved plates showing the correct formation of letters had been published in Italy during the previous century. They now found their way to England, their popularity being greatly extended by the renown of Edward Cocker, the most prolific and admired exponent of writing that the century produced. Though death came to him at the early age of forty-four in 1675, he had already published no less than ten books on calligraphy, many of them containing the fanciful extemporization of tails and flourishes, often pictorial in their effect, which he did so much to make fashionable.

[1] Sir Balthazar Gerbier included drawing, but not painting, in the prospectus of his academy in Bethnal Green in 1648, short-lived though it was. There is no record to show whether Gerbier, who achieved some renown as a portrait painter and architect, besides being a soldier of fortune and an adventurer, gave the actual tuition in drawing himself. Drawing, engraving and perspective were among the subjects on which he offered to lecture, and he invited not only the fathers, "but also the mothers".

[2] George Snell, *The Right Teaching of Useful Knowledge*, 1649.

[3] Richard Gething set up his writing school in Fetters Lane, London, about 1616 and published *The Art of Faire Writing* in 1619.

The teaching of writing under the influence of Cocker certainly incorporated elements of art teaching, and a writing school, such as his, with the pupils enrolled as boarders, was the nearest approach then made to the private art school. The development of the imagination, on which Cocker's own work so much depended, was stressed, and the pupils were urged, in his own words, "to pourtray to the life the idea in your head".[1]

Whether or not the cause of art teaching might have flourished if the Parliamentary forces had not triumphed is now hard to determine. Certain it is that the Commonwealth did little to promote it. Accuracy, neatness and moral restraint were the characteristic demands in the education of the period. John Dury, an idealist in education and a devout low churchman, has given us a vivid glimpse of this Puritan attitude to teaching.[2]

Dury was exceptional at this time in believing in the value of art education. He proclaimed that "a child's imagination and memory is thoroughly to be cultivated and exercised", but this was to apply mainly to the primary stage, when young children should be trained to "observe by the eye, eare and hand the differences of things, their proportions", etc, somewhat as Rousseau advocated for different reasons a century later. But Dury assumed, unlike Rousseau, that the imaginative vision implanted in childhood could be held in abeyance at the later stages of the child's development.

Anxiety lest the practice of any form of art would lead to depravity in morals dominated the thinking of the Puritan writers. Dury's solution was to keep the pupils constantly occupied, so that "no time of the day is to be lost without some teaching exercise",[3] but he feared that drawing lessons might provide insufficient security against the lapse in morals.

Dury was a pioneer in advocating higher education for girls and even co-education to some extent—a revolutionary proposal in Puritan England. But this merely entailed more rigid discipline for both sexes who might meet at prayers but have no "free communication", and it ensured less opportunity for drawing, especially by the girls. Any expression of taste or personal feeling was to be severely discouraged. The dismal background with which art teaching had to contend in the mid seventeenth century is well conveyed by Dury.

> The ordinary vanity and curiosity of their dressing of hair and putting on of apparell [he writes]; the customes and principles of wantonness and bold

[1] The School Library at Christ's Hospital has preserved evidence of Cocker's influence in the work of a pupil at the school, Joseph Terry, who was sent as an apprentice on board ship to the West Indies in 1680. His log-book is embellished with decorations of ships and birds, such as a boy would enjoy doing, and many are drawn with the continuous, flowing stroke of the pen for which Cocker was renowned (*see* pp. 23, 36).

[2] John Dury, *The Reformed School,* circa 1645.

[3] This maxim was to pursue the pupils even to the dormitory, where the usher was to "read unto them some part of the Holy Scripture while they uncloathe themselves", and repeat this reading again in the morning for half an hour at five o'clock in winter and four o'clock in summer. John Dury, *The Reformed School.*

behaviour and whatsoever else doth tend onely to foment pride and satisfy
curiosity and imaginery delights shall be changed.

We can well imagine the severe rigour with which these recommendations were
put into effect.

Some lone voices, however, were raised on behalf of teaching girls to draw.
Mrs. Bathsua Makin, who claimed that "women are not such silly, giddy
creatures, as many prowd, ignorant men would make them", included drawing
in her plea for better female education.[1]

With the co-ordination of writing and drawing in a growing number of
schools of the seventeenth century the whole emphasis lay in the use of pen or
pencil in the making of firm lines, with delicate or sweeping curves, and in
acquiring a sense of good proportions and spacing, but the use of colour, with
its practical problems in the creation of a painting, was ignored. Of chief
significance was the absence of encouragement to observe nature in its own
environment and apply such observation to the production of a picture.

This concept of a picture, as opposed to mere graphic exercises, obtained its
only foothold in general education, apart from the efforts of pioneers such as
Peacham, through the increasing publication of illustrated books. One of the
earliest and most popular of such books in the seventeenth century was Francis
Quarle's *Divine Emblemes*, with its many delightful copper-plate engravings by
William Marshall, Peacham's contemporary, which first appeared in 1635.

Much the most important among illustrated books, from the educational
point of view, was the *Orbis Pictus* by Comenius, in which the engravings
were intended as an aid in teaching Latin and other subjects in school. This
book, originally published in Nuremberg in 1657, introduced pictures into the
classroom on a much more extensive scale than John Holt's more modest Latin
grammar. Moreover, its one hundred and fifty-three engravings were intended
to be used and studied for their pictorial content. The *Orbis Pictus* constitutes
one of the landmarks in art education (plate 2 and pages x and 312).

John Amos Komensky, better known as Comenius, the Moravian scholar,
prepared this book while in exile in Poland as an abridgment of his earlier *Janua
Linguarum Reserata*, a children's encyclopedia.[2] The following year, 1658, Charles
Hoole, a grammar-school master in Lothbury, translated it into English,
describing it as:

> A nomenclature and pictures of all the chief things that are in the world and
> of men's employments therein.

Its aim was to teach the Latin and English names of familiar objects by associat-
ing name and picture. Each of the small engravings depicted a distinct subject,

[1] *An Essay to revive the antient Education of Gentlewomen with answers to the objectors*, 1673.
[2] Comenius had visited London in 1641, at the age of forty-nine, on Samuel
Hartlib's invitation, but his visit proved disappointing, and he departed next year.
William Hogarth acquired his youthful zeal for engraving, according to John Ireland,
his friend and biographer, as a result of studying the illustrations in his Latin grammar
when he was a boy.

such as "The Barber's Shop", "The Stable", "Birds that haunt the fields and woods", "The Sea-fight", etc.

Although the primary purpose was to teach language, the author also intended the engravings to be copied by the pupils so as to impress the form of objects on the memory. In fact, he believed that art was essential to education on the grounds that

> Children (even from their infancy almost) are delighted with pictures and willingly please their eyes with these sights.
> Let them be suffered also to imitate the pictures by hand [he contends], first, thus to quicken the attention also towards the things; and to observe the proportion of the parts one towards another; and lastly, to practise the nimblenesse of the hand, which is good for many things.[1]

Comenius's work was, therefore, the first attempt to encourage visual observation in centres of education generally and to provide the means for schoolboys and girls to practise drawing. Moreover, he did not confine it to mere accuracy, as was generally demanded, since "it matters not whether the objects be correctly drawn or otherwise provided that they afford delight to the mind". Comenius was perhaps the first to acknowledge the merits of a child's sensitivity.[2]

The artist or artists who made the original drawings for these engravings, so unequal in merit, but undeniable in charm, are not recorded; they were probably employed by Comenius to work under his directions. John Evelyn, a lover of art, regarding this work as "an instrument of education . . . above all other whatsoever", strongly condemned them as "wretchedly engraven".[3] Doubtless he was referring to the English edition, for which the original German woodcuts were indifferently copied on to copper plates. The book ran into several fresh editions between 1659 and 1705, with the result that the plates were re-etched with sad deterioration in their quality. In the eighteenth century the plates were entirely redrawn, presenting the figures in the costumes of the period and there was again a marked decline in merit.

Even so, for more than a century this collection of engravings, often clumsily drawn and printed badly, provided great numbers of children with their only familiarity with pictorial composition, perspective and proportions. It was however, equally a step in the wrong direction with its encouragement to children to copy illustrations, instead of producing their own original work—a system which has dogged art teaching ever since. Moreover, it encouraged the

[1] The *Orbis Pictus* was undoubtedly inspired by Eilhardus Lubinus, Professor of Theology at Rostock, who had proposed in the Preface to his *New Testament*, in 1614, reissued as *The True way to learne the Latin tongue* (translated by Samuel Hartlib, 1654), that children should be taught by means of pictures. Comenius was the first, however, to put this into practice.

[2] *Schola materni gremii*, translated by Daniel Benham as *The School of Infancy*, 1858 quoted by Rev. R. H. Quick in *Educational Reformers*, 1894.

[3] John Evelyn suggested that if improved "what a treasury of excellent things might be conveyed and impressed into the imaginations of children". *Sculptura*, 1662.

wrong use of medium, since lines made with the graver on a copper plate were
to be copied with pen or pencil. While there are many grounds for criticism,
the book deserves much credit, nevertheless, for making the public increasingly
aware of the value in learning to draw.

Henry Peacham, from The Art of Drawing, *1606*

the Drawing Class
at Christ's Hospital 1690–1750

CHRIST'S HOSPITAL has fortunately preserved what appear to be the earliest records of the formation of a school drawing class before the end of the seventeenth century. Hitherto tuition in art had depended on the initiative of an individual teacher.

The Governors of Christ's Hospital were not concerned with promoting an appreciation of art for purely cultural reasons, as had impelled Peacham. Their plans had more in common with Sir William Petty's project, though the practical advantages to be gained from art teaching provided the principal motive in forming this class. The developments in urban life which followed the rebuilding of London after the Great Fire, combined with the expansion of trade and industry, caused a demand for competent technicians capable of drawing up architectural plans, sketching perspective views or preparing working designs. A lack of native draughtsmen and designers was attracting a constant invasion of foreign artisans from France and the Low Countries, and it was hoped that a drawing class in one of the principal schools in England would help to stem this invasion.

There were two particularly eminent members of the Court of Governors— Sir Christopher Wren, then engaged on the construction of the new St. Paul's Cathedral, and Samuel Pepys, who was Secretary at the Admiralty. Both were advocates of art teaching, though with reservations as to its value in a grammar school. Pepys seems to have been somewhat negligent in attending the meetings of the Court, but he conveyed his views at great length in writing.

The initiative had been taken by the writing master, Mr. John Smith, in trying out some freehand drawing with a few of his pupils, and he had been paid an additional fee of £10 on this account. Mr. Nathaniel Hawes, the school treasurer, thereupon decided to invite the architect and the diarist to his house in November 1692, in order to have their opinion of the drawings. They appear to have judged the work not for its artistic merit but only as evidence of technical ability, command of proportions, knowledge of perspective and neatness in execution. In the main, they were concerned with proof that boys might, with

Joseph Terry, pupil of Christ's Hospital School, from a page in his log book, 1680

tuition, make competent working drawings, while keeping their personal taste as much as possible in the background.

Following upon this visit, Sir Christopher Wren wrote to Mr. Hawes, making the following comments:

> Dear Sir, I perceive your extraordinary diligence and that the improvement of your charge is always in your thoughts by your importuning me to recollect what passed in discourse sometime since at your house. . . . It was observed by somebody then present that our English artists are dull enough at invention, but when once a foreign pattern is sett, they imitate too well, that they commonly exceed the originall. . . . I cannot imagine that next to good writing, anything could be more usefully taught your children, especially such as will naturally take to it. . . . It will prepare them for many trades, and they will be more usefull and profitable to their masters. . . . It is not painters, sculptors, gravers only that will find advantage in such boys, but many other artificers. . . . I was surprised to see what Mr. Smith hath shown me performed by some of the boyes already by which you may perceive how soon they will emulate and teach one another.[1]

[1] Minutes of the Committee of the Schooles in Christ's Hospital, 30 November 1692.

Pepys' letter contains the following passages:

> I doo with all my heart concurr with the proposition, from my generall inclination to the advancement of arts and the propogating of them positively among these children. . . . If it be rightly directed in its execution, it seems as an undertaking so little likely to unfit the children for those honest and plainer callings . . . and will render them the better qualified for those very trades. . . . Your most affectionate and most faithful humble servant S. Pepys.[1]

These letters make it clear that real artistic expression was not expected from children who belonged to the humbler walks of life. They were not to create works of art but to carry out with perfection the requirements of their employers.

The School Committee decided in November 1692, after protracted discussion, to appoint a drawing master, who was to serve under Smith in the Writing School. This would enable a number of the boys to learn drawing. William Faithorne was appointed, but no indication is given in the records as to his identity or his qualifications. There can, however, be little doubt that this was the son of the famous engraver of the same name, whose print shop was often visited by Samuel Pepys, as recorded in his Diary.[2]

William Faithorne, senior, specialized in portraiture, the main occupation of artists at this time, although he also engraved other subjects. Smith, the writing master, was among Faithorne's sitters, and the son, William, did a mezzotint portrait of Mrs. Smith.[3] The son had already gained some distinction in this new medium. Thus old friendships would obviously have favoured the appointment of Faithorne, junior, who was thirty-seven years old, as the drawing master.[4]

The father died in 1691, and family circumstances might well have impelled the son to accept this employment, although the salary originally fixed at £10 a year appears far from tempting. Young Faithorne seems to have been of very different character to his father, if we are to believe Walpole's assertion that he was "negligent and fell into distresses which afflicted his father". This reputation is borne out by the records of Christ's Hospital and may have contributed to the unfortunate termination of the experiment in holding drawing classes at the school. On the other hand, the work was exploratory, and we may well sympathize if he found the tedium of teaching on the lines laid down for him wellnigh overwhelming. Altogether, we are given a unique glimpse of the conditions governing a drawing master's employment in a seventeenth-century school.

The writing master and his new assistant soon fell foul of the Governors and

[1] Minutes of the Committee of the Schooles in Christ's Hospital, 30 November 1692.

[2] 7 November, 1666.

[3] Faithorne's portrait of Smith was engraved by Peter van der Banck. Both portraits are recorded by George Vertue in Horace Walpole's *Anecdotes*, adding that there was some dispute over the payment (plate 3b).

[4] A wash drawing of Defoe attributed to Faithorne, junior, in the Witt Collection of the Courtauld Institute, probably dates from this period, and well reveals the artist's sensitive rendering of form and character.

their School Committee, who wanted a larger class in drawing than the ten or twelve boys to whom Smith and Faithorne wished it confined. One would have expected the teachers to seek more pupils rather than less. Asked for their reasons, they claimed a lack of space: "Every boy that draws takes up as much room as two other boys", they declared. As a result, the boys "that write are forced to be crowded in the windowes and other inconvenient places". It is hard to appreciate the teachers' argument. One would assume that places near the windows would be coveted rather than rejected. Presumably extra space had to be found for tables, instead of desks, on which were placed the objects, such as cones or cylinders, to be drawn.[1]

The two teachers wanted a separate room for the drawing class, but this solution did not appeal to the School Committee. "The said boys", they declared, "should be constantly under the eye and inspection of Mr. Smith, although taught by another person." Apparently the Committee had no confidence in Faithorne's ability to maintain discipline, while preoccupied with the work of each individual.

Discipline was the Governors' main concern. They agreed, however, to accept no more than twelve boys for drawing at one time, as long as the number was increased when the new Writing School was built. Meanwhile drawing was to be taught on Monday, Wednesday and Friday afternoons from 1 to 5 p.m., and Faithorne was to receive £20 a year in salary. He was to attend on the appointed three days, or any other day if unable to do so, and he was to fill any vacancy that might occur among the pupils.

Smith had complained that the drawing class constituted an extra drain on his time. He claimed entire responsibility for the teaching, ignoring Faithorne. On each boy's drawing, Smith affirmed, he had to "correct all the errors therein and make them perfect before they can proceed any further". Apparently the emphasis was entirely on accuracy, and the work was developed in stages, proportions of the objects and perspective having to be correctly drawn in outline before shading could begin. This procedure of working first in outline before tackling the mass continued until well into this century. The use of paper may have been confined to the experienced pupils, able to draw with a pen, since a fragment of black-primed canvas and a sponge have been preserved at the school with a label which states that they were in use for drawing until 1852. White or red chalk could be easily washed off the canvas, which could then be re-used by a beginner until he was sufficiently advanced to be allowed the use of paper.

In view of the obvious tedium of these drawing lessons, the period of four hours must seem excessive. Nevertheless, such was the eagerness of the boys to

[1] An aquatint of the Writing School in Ackermann's *History of Christ's Hospital*, 1816, shows the boys seated at sloping desks placed in long rows, facing the middle of the hall, with the windows behind them. The introduction of tables for drawing, which would presumably be necessary, would tend to disrupt the symmetry of such an arrangement.

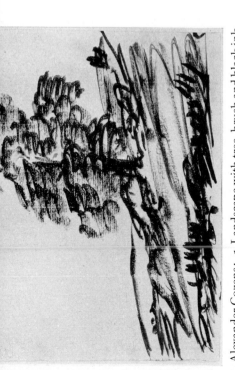

5. Alexander Cozens: *a.* Landscape with tree, brush and black ink
c. Blot or imaginary composition, brush and black ink

b. The same subject finished with pen and sepia
d. Blot or imaginary landscape, brush and black ink

Rob! Marsh 16 May 17

6. Pupils of Christ's Hospital: work submitted for Trinity House Examinations, 1765 and 1755

James Illg. Nov 5 1755

study that there was never any lack of applicants. When three vacancies occurred there were six applicants, and the Committee decided that in order "that the other three may not be under any discouragement, they should have the precedency at the next election of boys to draw". A year later Faithorne agreed to increase the total number to fourteen "without any expectation of a further reward".

It must have been difficult for the drawing master to retain the respect of his pupils after February 1695, since both master and pupils were summoned together before the School Committee for an inspection of drawings. The Committee apparently formed a poor opinion of the work, though how qualified they were to judge, we cannot tell. The minutes of the meeting inform us that "the Committee were of opinion that Mr. Faithorne does not acquit himself worthily and therefore gave him a severe reprimand and advised him to be more diligent for the future: Otherwise they will dismiss him". Such censure in the presence of the pupils can scarcely have helped the teacher to carry on his task with success.

Worse was to follow. A year later—so we read in the minutes of 13th March 1696—"Some of the Governors . . . going up into the Drawing School found the Master absent, and that he is frequently so, and hath but five children under his care." This time it was the Court of Governors before which he was summoned, accused of great neglect. The minutes record: "He had nothing materiall to say in his own vindication, but promised to use more dilligence."

It was now decided to place the drawing class in the Mathematical School, so that Newton, its master, "may see that he is present". Meanwhile Faithorne was to be paid no salary while the trial was made. Newton, however, wanted the drawing confined to his mathematical pupils, since it would be "of great advantage to them". The School Committee reported that Faithorne's teaching had "been of no advantage", and it was decided to dismiss him and "save £20"!

Thus the experiment in forming a drawing class at Christ's Hospital was brought to a sudden end. Faithorne may not have been solely to blame. He was clearly a sensitive artist rather than a stern schoolmaster able to keep under control the rough types that then attended grammar schools. Moreover, the drudgery of correcting drawings of cones and cylinders must have been irksome to one of artistic imagination, though the pupils are equally entitled to our sympathy. Ill health may have contributed to Faithorne's failure, for he died five years later, in 1701, at the early age of forty-five.

Smith, the writing master, was also in bad odour. He had requested the honour of reading the oration at the opening of the new Writing School. He submitted it to the Committee, with such disastrous effect that nothing was heard further of his oration, and we are told that a certain Mr. Flamstead was asked to compose and read one with the proviso that it must be brief. Shortly afterwards, Smith encountered further trouble. His assistant usher, Ives, was found to have persuaded one of his pupils, a boy named Dabb, to steal. Smith tendered his resignation.

Several years elapsed before the School Committee again considered the desirability of having drawing taught at the school. In 1705 they noted that Newton, the mathematical master, had neglected the instruction to teach his boys drawing, and it was decided to try the experiment once again of appointing a special drawing master. But this time the pupils were to be sought from the Mathematical School instead of the Writing School.

School policy was involved in changes that were barely perceptible at the time. With the competition for oversea markets and with goods constantly imported from the Orient and the New World, there was a growing demand for men skilled in navigation and in military and mechanical sciences. An ability to sketch harbours, fortifications or coastline, draw maps or design mechanical appliances was invaluable. Boys intended for such careers were enrolled in the Mathematical School.

There were two applicants for the new post of drawing master, George Holmes and Bernard Lens, and it is instructive to read how the Committee made its choice. No list of qualifications, credentials or references were perused, nor even submitted. It was an unusual post to fill. The Committee decided upon a practical test in order to prove which applicant, in their opinion, could draw the best, though we are not told how qualified they were to judge. The members of the Committee, so the minutes inform us, "went with the candidates upon the platform over the Mathematicall School and there set each of them to draw immediately with their pencill a view of Christchurch steeple and the prospect of the steeples as far as the Guildhall".

After the candidates had submitted to this ordeal, the Committee made their decision that "Mr. Lens draws the quickest and the best, and having been a teacher of that art severall years, he is much the better qualified". His salary was fixed at £30 a year.

Then aged twenty-three, Bernard Lens was a miniature and water-colour painter, as well as an engraver, descended from a line of artists, all of whom acquired reputations. Teaching was in the family tradition, for his father, who drew topographical views and worked in mezzotint, had established a private drawing school in conjunction with his fellow engraver, John Sturt, near St. Paul's Churchyard in 1697. Father and son were thus unique among artists at this period in having considerable experience in teaching art.

Bernard Lens' appointment as drawing master was as much a success as Faithorne's had proved a failure. Beginning with twenty pupils from among "the uppermost boys of the Mathematical School", he was soon asked to accept ten more boys from the Writing School. The drawing class was conducted in the Great Hall of the school. Pencils were provided, and at first the boys were permitted to take their drawing books home with them, but the following year, December 1706, the minutes record the decision that "Mr. Lens shall have the draughts made by the boys always in his keeping and custody".

Lens' method of teaching obviously relied, perhaps more than Faithorne's, on copying. This was revealed when he requested an increase in his salary, which

Bernard Lens, Near Leicester, etching for his pupils to copy, c. 1720; from his Drawing Book

was raised to £50 a year. By way of justification he pointed out that in order "to introduce a gracefull manner of drawing", he "had to spend much time at home preparing coppyes for them to delineate after", thus implying that his predecessor had not done so. These drawings were subsequently published as a copybook; they included line drawings of the human head, eyes, ear etc and of the foreshortened figure seen from various positions, showing a steady progression from simple contour to the complete form conveyed with shading in line by pencil or pen; there were also views of castles, harbours, forts, ruins and bridges.[1] Such topographical drawing was only just beginning. Lens' copybook was first in a long line of such books, which continued to be used for teaching art until well into the nineteenth century (page 41).

It is very easy for the pupil to produce what appears, viewed superficially, to be a very commendable drawing when merely copied, while the same pupil might be entirely unable to create an original work of any merit. This may account for Lens' success and Faithorne's failure. The uninformed Committee may well have been mistakenly impressed by the copies made by Lens' pupils, whereas Faithorne's pupils may have learnt much more by working direct from objects—if this was indeed their procedure—although their results might have seemed less impressive.

In 1707 Lens made an announcement—most significant from our point of view—which the Committee has recorded in its minutes as follows:

> There are several neat and handsome draughts done by the boyes in the Drawing School, which are fit to be exposed to public view.

The Committee decided to have them placed in frames and hung on the walls of the School Hall. This is, apparently, the first recorded exhibition of children's drawings in England. Alas, the exhibits do not appear to have survived the lapse of time.

Bernard Lens retired in 1725, the year in which his father died. He earned the gratitude of the School Committee for his "extraordinary pains", and was rewarded with a belated remuneration of £10 in addition to his salary. He had the satisfaction of seeing his son, Edward, a miniature painter like himself, appointed in his place. Lens had established the drawing class at Christ's Hospital on a secure basis, since for a quarter of a century thereafter no serious problems relating to it were brought before the School Committee.

Bernard Lens did not completely retire from teaching drawing. He held the office of Limner to the Crown (George I), and in that capacity taught drawing to members of the royal family. Horace Walpole was his pupil and, as proof of his honesty and virtue, narrates the following incident:

[1] A copy-book entitled *For the curious Young Gentlemen and Ladies that study the Noble and Commendable Art of Drawing*, containing over sixty etchings by Lens, was published in 1751, after his death. It is described as "very necessary and useful for all drawing schools, boarding schools etc" (plate 1b). Copies made by subsequent pupils at Christ's Hospital are still preserved in the School library.

Once when he was drawing a lady's picture in the dress of the Queen of Scots, she said to him, "But, Mr. Lens, you have not made me like the Queen." "No, Madam; if God Almighty had made your ladyship like her, I would."[1]

Christ's Hospital has proved unique in art education, not only by its founding a drawing class comparatively early and maintaining it over a long period, but also on account of the many notable artists who filled its office of drawing master. In 1749 we find Alexander Cozens, whose work Constable copied and admired, appointed, when Edward Lens died, from among four other candidates for the post.

Cozens was then about thirty-two years old, having arrived in England only a few years previously, Born in Russia, the son of a shipbuilder in the Czar's employment, Cozens had spent some while working and studying in Rome. Unknown in England, as he was, his appointment, with its salary now fixed at £50 a year, must have seemed fortunate. Doubtless, his family connection with the sea may have proved a strong recommendation, since the school trained so many boys for a sea-faring life.

Cozens like his son was essentially a landscape draughtsman, and his appointment suggests that drawing tuition at Christ's Hospital had now drifted away altogether from portraiture and figure composition and was primarily topographical, with the study of perspective in landscape and buildings as the main requirement. Such topographical drawing was now essential for those taking up a career in navigation, military engineering or architecture.[2] Cozens was one of the first artists to concentrate on teaching landscape, preceding Paul Sandby, who became drawing master at the Royal Military Academy at Woolwich in 1768.

That Cozens had the urge to teach is revealed by his elaboration of various systems for drawing or painting landscapes, and he was far from keeping these systems to himself for his own exclusive use. He does not appear to have consolidated these ideas during the period of his teaching at Christ's Hospital, from which he was obliged to resign in 1754, and a decade later, we find him employed as "extra Drawing Master" at Eton.

Cozens' style had meanwhile undergone a complete transformation. In Italy he had made pencil studies direct from nature, afterwards redrawing over the pencil lines with pen and ink. In this he differed from his contemporaries who used sketches mainly as a guide for work which was composed in the studio. Cozens had always been absorbed with problems of composition and his Italian work reveals this in the distribution of light and shade, achieved by drawing close parallel lines in ink for the darker areas with finer lines for the distant or light areas. The technique resembled etching (plate 4).

[1] H. Walpole, *Anecdotes of Painting in England*, 1762.
[2] James Nelson, an apothecary, in *An Essay on the Government of Children*, 1756, advocated drawing—"an important though much neglected branch of knowledge"— for all classes of society, since schools taught drawing "neither so often nor so completely as they ought".

In his early work, Cozens seldom had recourse to the brush and when he did apply a faint wash of tone, it did not have the depth so characteristic of his subsequent work.[1]

That Cozens taught at Christ's Hospital in this conventional style is indicated by such drawings as survive by his pupils, which are confined to landscape or seascape and reveal the same use of a fine precise line. Although it is known that Cozens was strongly opposed to copying, his pupils at Christ's Hospital could have had few opportunities for drawing landscape from nature. Specimens still preserved at the school reveal that, under Cozens, they continued to copy Lens' etchings of harbours, views or classical ruins.

Cozens' resignation from Christ's Hospital may well have been prompted by his wish to escape from the established routine of copying and explore new possibilities in teaching. At Eton, he could take his pupils on sketching expeditions, enjoying facilities for working direct from nature which were lacking in the midst of a city. In Cozens' day, nature meant trees in landscape not busy street scenes. Henceforward, Cozens' work acquired an exceptional freedom in brushwork and a richness in tone which was totally absent from his early work.

In expanding his ideas on teaching, Cozens constantly stressed the need for developing the imagination or "invention", as he preferred to describe it, and a publication entitled *An Essay to facilitate the Invention of Landskips* appeared anonymously in 1759; although it has generally been attributed to Cozens, there is no clear proof as to its authorship.[2] The first publication known to be his, *The Shape, Skeleton and Foliage of thirty two Species of Trees for the use of Painting and Drawing*, did not appear until 1771, the period of his work at Eton. It consists only of etchings, each one devoted to a different tree seen in isolation, and presents the characteristic appearance of boughs and foliage as in an anatomical chart, but as the artist sees them rather than the botanist. The very title with its emphasis on the observation of nature and on its use in painting denotes the change in objective from that required at Christ's Hospital. Although the book has the appearance of the old copy-books, it is unlikely that Cozens intended his etchings to be copied. He wished, rather, to help the student observe the salient characteristics of trees in nature, by means of examples, though he did not indicate their typical surroundings.[3]

Cozens must have found the post at Eton much more congenial than his previous one; the objectives were probably not so severely utilitarian as they had been at Christ's Hospital. Drawing at Eton was optional and was not treated by the school authorities as a serious subject; the boys came for study

[1] Cozens has recorded that he dropped the Italian drawings from his saddlebag while returning through Germany in 1746, but they were miraculously found by his son in Florence thirty years later.

[2] This is fully discussed by A. P. Oppé, in *Alexander and John Robert Cozens*, 1952, who states that no copy is now traceable.

[3] Cozens intended to publish a second series of studies of skies, but these were eventually added to his later *New Method* (referred to below).

only during leisure hours.[1] Presumably, therefore, the pupils, such as there were, had a real inclination to learn drawing or painting.[2] Under Cozens, boys were hearing for the first time about the problems involved in creating a work of art instead of acquiring mere accuracy in drawing.

Cozens had published his *Principles of Beauty relative to the Human Head* with plates by Bartolozzi in 1778; its fanciful theories were of little value but were widely studied. Shortly afterwards he was employed as drawing master to the young princes at Windsor. It was, however, not until his last years that his main surviving contribution to art teaching was launched. This was *A new method of assisting the invention in Drawing Original Compositions of Landscape*, which appears to have been written not later than 1784, though the date of its publication is uncertain. This is undoubtedly the most important and original treatise on the subject, for use in education, that had as yet been produced. It was a subject close to Cozens' heart, and the reader's attention is directed to the real problems in composing a landscape, depending, as it does, on the balance of dark and light tone.

Here, for the first time, the pupil is told how to develop a composition from the standpoint of imagination. The author expounds the value of "invention" in order to "promote original composition in painting". These are phrases which we have not heard used hitherto. At the outset he makes a frontal attack on the system of teaching boys to copy, which, he rightly states, "tends to weaken the powers of invention".

The main practical purpose of Cozens' treatise is to explain his particular method, which, as he states, "is in the power of most capacities" and for which "genius is not indispensably necessary". This is his famous "blot" system, for which he earned the nickname, "Blot-master to the Town". He explains the origin of his idea as follows:

> Reflecting one day in company with a pupil of great natural capacity, on original composition of landscape, in contradistinction to copying, I lamented the want of a mechanical method sufficiently expeditious and extensive to draw forth the ideas of an ingenious mind. . . .
> Happening to have a piece of soiled paper under my hand . . . I sketched something like a landscape on it. . . . The stains, though extremely faint, appeared upon revisal to have influenced me.[3]

He proceeds to explain how he mixed a tint with ink and water and made some rough shapes on another piece of paper and laid it "before the pupil, who instantly improved the blot, as it may be called, into an intelligible sketch, and from that time made such progress in composition, as fully answered my most sanguine expectations".[3] Cozens adds that he had learnt only afterwards

[1] When Dr. James became headmaster of Rugby in 1778 he allowed drawing to be taught only on Saturday afternoons.

[2] Cozens was assisted at Eton by Richard Cooper who subsequently succeeded him.

[3] A. Cozens, *A New Method* etc., reprinted by A. P. Oppé in *Alexander and John Robert Cozens*, 1952.

that he was not the actual originator of the idea and that Leonardo da Vinci had recommended the student to "look upon an old wall covered with dirt, or the odd appearance of some streaked stones . . . Out of this confused mass of objects, the mind will be furnished with abundance of designs and subjects perfectly new".[1]

But Cozens claimed that the main justification for his method lay in his "blots" being intentional rather than purely accidental. He seems to have had second thoughts. While describing a "blot" initially as "an assemblage of accidental shapes", he goes on, later, to insist that in making a "blot", it must reflect an idea, which is "the general subject in your mind". Perhaps the popular derision which his system aroused, being so far in advance of contemporary thought, may have prompted him, on reflection, to modify his original intention, which was clearly to let imagination exploit the effects produced by chance (plate 5).

Cozens was the first teacher known to us in England to decry the mere representation of nature, which he explains as "a habit in the draughtsman of imitating what he sees before him, which anyone may learn through practice". He believed that "a want of facility or quickness in execution" was often a source of difficulty for the student, because the composition "grows faint and dies away before the hand of the artist can fix it upon the paper".[2] These ideas bring art teaching much closer to the concepts of the present time. With Cozens art teaching had entered a new phase.

[1] Cozens' quotation from Da Vinci's *Treatise on Painting*.
[2] A. Cozens, *A New Method* etc., reprinted by A. P. Oppé in *Alexander and John Robert Cozens*, 1952.

Pupil of Christ's Hospital School, submitted for the
Trinity House Examinations (c. 1780)

the Society of Arts and the Royal Academy—Art Examinations in the Eighteenth Century

A SIGNIFICANT step in art education is recorded by a brief entry in the minute books of Christ's Hospital for the year 1753. This refers to an external examination in drawing, forming part of the examinations for pupils of the Mathematical School who sought to become pilots. It is apparently the first attempt to examine in art. These examinations had been instituted by Trinity House since 1696. Samuel Pepys was at that time a Brother of Trinity House as well as a Governor of Christ's Hospital, and we may well impute to him the initiative in organizing them.[1]

There is no information in the school minute books at Christ's Hospital to show when it was decided to include drawing as one of the subjects for this examination. It was, however, in this same year, 1696, when the Trinity House examinations began, that the School Committee proposed to establish the teaching of drawing for selected pupils of the Mathematical School, and although there was a delay of several years before this step was proceeded with we may well assume that it was proposed with the examinations in view.

While the first mention of drawing in connection with this examination occurs in the minute books in 1753, it implies that drawing had been examined in previous years, since the reason for mentioning the subject is solely an unexpected failure in the standard of the candidates' work. The letter from the Warden of Trinity House had reported unfavourably of the drawings submitted by the five pupils at Christ's Hospital: "Their drawings are worse than heretofore" is the ominous comment. It is possible, therefore, that examinations in drawing began when Lens was appointed in 1705.

Who were the judges and on what grounds they criticized Cozens' teaching is not recorded. Cozens was immediately summoned before the School Committee. The minutes inform us that the artist,

[1] There had been tests for admission to Trinity House since 1674; from 1696 they were held twice yearly until 1858.

being acquainted with the said complaint said in excuse that three of the said children were very dull and the other two but indifferent and promised to take particular care that there should be no cause of complaint for the future.

Unhappily, the results were considered no better the following year, and Cozens promptly resigned.

The examination work consisted of pen-and-ink drawings submitted in books, which included written exercises in navigation, mathematics and geography. Among the few examples preserved,[1] is one by James Elly, who submitted his work containing eighteen drawings in 1755, so that he must have been one of Cozens' pupils. His work includes views of Roman ruins, fortresses, lighthouses, harbours—several being copies of Lens' etchings—and an unusual composition of male bathers draped like classical gods and preparing to swim in a shady English mill-pool. Drawn in ink with a fine, delicate line and even cross-hatching for the shading, very reminiscent of Cozens' early precise style, they show a formal, somewhat rigid, type of composition, and are, curiously enough, singularly faulty in perspective. They completely ignore the lighting and cloud effects which so obsessed Cozens in his later years.

Whether or not Cozens was asked to resign or did so in protest, the incident indicates how small a value was placed on the specialized judgment of the artist. We have previously noted how the Governors resorted to an impromptu competition when choosing a new drawing master, making no attempt to seek an artist's aid in judging the merit of each candidate's work. Professional opinion seems to have been equally ignored in the case of Cozens.

At this period, and for some years still to come, the artist was regarded as a man of skill rather than of intellect, and his status was equivalent to that of an artisan. This was the legacy of the old guilds. There was no organized society for artists which could offer advice in matters of art or recommend candidates for teaching posts. Nor was there, as yet, any machinery for exhibiting artists' work collectively. Drawing masters had no means of obtaining evidence of their qualifications for teaching. Even the means for acquiring a professional training in art were very limited, and methods of teaching were largely subject to the conventions favoured by the individual drawing master.

Academies of art existed on the Continent, notably the Academie Royale in Paris, which had flourished since the middle of the seventeenth century. Nothing of the kind existed in England. According to Walpole, Sir James Thornhill had proposed the formation of a national academy, but failed to secure official support. In 1711, however, an academy was established under the control of a group of artists, including Bernard Lens, in Great Queen Street. Sir Godfrey Kneller was elected Governor with Thornhill one of the Directors. On Kneller resigning in 1716, Thornhill succeeded him.

When Kneller died in 1723 Thornhill decided to set up his own school the following year, using his house in Covent Garden for the purpose, but despite

[1] The School Library of Christ's Hospital, Horsham (plate 6); (see notes to the illustrations).

free admission it was not a success. Meanwhile other private art schools were springing up. Louis Charron and Vanderbank, both artists of French Huguenot extraction, had re-established Kneller's academy in St. Martin's Lane in 1720, with Kent, Highmore and Hogarth among its members. Life drawing was taught on four days a week during the winter months. Male models were usually provided, but the proprietors took the unusual step of using female models on occasion.[1]

Hogarth was somewhat contemptuous of these various attempts to establish schools of art in London, and attributed their failure to "the leading members assuming a superiority which their fellow students could not brook". Nevertheless, having married Thornhill's daughter, Hogarth decided to reopen the school in the workshop by sculptor Roubiliac in St. Martin's Lane in 1735.[2] He recorded the circumstances as follows:

> Sir James dying, I became possessed of his neglected apparatus; and thinking that an academy conducted on proper and moderate principles had some use, proposed that a number of artists should enter into a subscription for the hire of a place large enough to admit thirty or forty people to draw after a naked figure. . . . I proposed that every member should contribute an equal sum to the establishment, and have an equal right to vote in every question relative to the society.[3]

Hogarth refused to have the election of any "presidents, directors, professors etc", as being "a ridiculous imitation of the foolish parade of the French Academy". By the middle of the century the St. Martin's Lane Academy had become the chief, if not the only, centre where artists could meet, with drawing from life as its principal objective.

The artist's status in England was now beginning to rise. Preference was no longer given invariably to foreign artists or craftsmen. Special emphasis was placed on the problems of design, to enable British craftsmen to compete with continental products. The work of Thomas Chippendale, whose factory for cabinet-making was in St. Martin's Lane, and Josiah Wedgwood's fine porcelain were helping to raise the prestige of British art and craft.

The need for good design in industry and commerce provided the main incentive in teaching art in the early part of the eighteenth century, and it certainly contributed towards the founding of the Society for the Encouragement of Arts, Manufactures and Commerce in 1754, subsequently to become the Royal Society of Arts. The Society was the first public body to concern itself with art education, although its interests were, perhaps, directed more towards

[1] The main source of information is W. T. Whitley, *Artists and their friends in England 1700–1799*, 1928. Nicholas Pevsner, *Academies of Art, past and present*, 1940, states that female models were not used in art schools on the Continent until well into the nineteenth century.

[2] John Ireland, *Hogarth*, 1792.

[3] Quoted by John Ireland from papers found in Hogarth's possession at the time of his death, op. cit.

the discovery of artistic talent than towards the promotion of education in itself.

William Shipley, who had been teaching drawing in Northampton for several years, was the source of inspiration and active force in the Society's formation and he became its first secretary when that office was created the following year. His primary objective was to raise funds for the award of prizes in science and the industrial arts, but drawing was to be included in the competitions open to boys and girls.

An inaugural meeting was held in March 1754 at Rawthmell's Coffee House in Covent Garden, when certain competitions were decided upon, including those for drawing, which were publicly announced as follows:

> It being the opinion of all present that ye art of drawing is absolutely necessary in many employments, trades and manufactures and that the encouragement thereof may prove of great utility to the public, it was resolved to bestow premiums on a certain number of boys and girls under the age of sixteen, who shall produce the best pieces of drawing and show themselves most capable when properly examined.

This decision was to be published in the *Daily Advertiser*—the first public announcement of an examination in art.[1]

The drawing competition was to be held at the end of the year with the winners to be announced in January 1755. At a further meeting it was decided to hold the competitions in two sections, one for children under fourteen years of age and the other for those over fourteen and under seventeen. The winning competitors were to receive £15 each—though in practise the sum was nearly always divided—and were also to receive parchment certificates, the prototype of the Local Examination Certificates of a century later. In subsequent years the competitions covered a wider range of work and the age limit was gradually raised so that the senior ones were open to students of the St. Martin's Lane Academy, who were thus able to submit life drawings.

One of the remarkable features of the Society of Arts was its democratic character, with all members entitled to participate and vote. As a result any member might be present and take part in judging the competitions, irrespective of any capacity to judge. This procedure was subsequently the subject of strong criticism by an anonymous member,[2] but there is no evidence that the rule was

[1] From the minute books in the possession of the Royal Society of Arts. The information is recorded by Sir Henry Trueman Wood, formerly secretary of the Society, in *The History of the Royal Society of Arts*, 1913, and by Derek Hudson and Kenneth W. Luckhurst, *The Royal Society of Arts, 1754–1954*, 1954, also by Thos. Mortimer, *The Rise, Progress and Present State of the Society of Arts*, 1763.

[2] Signed 'a member' and dated 1761, the letter includes the following: "I could wish some method were fallen upon to ascertain the real merit of the pictures. . . ." The letter comments on chance constituting a committee to decide the prizes, since "the majority may be so ignorant of that noble art as to prefer a coloured twopenny print from the Sign of the White Horse at Newgate to Rembrandt". The letter, which is in the possession of the Royal Society of Arts, ends with the sound comment: "All men are not alike capable of discerning the beauties of a fine picture."

withdrawn. However, at the meeting in December 1754, when the final arrange-
ments for the first drawing competition were discussed, it was agreed, probably
for the first time in England, that the judgment of an artist in selecting prize-
winners was at least desirable. The minutes record the resolution

> that five of the most eminent masters of drawing be desired to assist in deter-
> mining ye merit of the drawings.

It will be noted, nevertheless, that they were only to "assist", and presumably
final decisions remained with the members of the Society.

It is of interest to learn who were considered "eminent masters of drawing"
at this period. Fortunately the Society's minutes record their names—

> Messrs. Dalton, Cheere, Strange, Bonneau, Vivarez and if any of these decline
> to assist, Mr. Shipley be asked to find some others in their stead.

Although no longer among the most familiar names in art, they were very
respectable names in the art circles of the time. Cheere and Dalton were among
early members of the Society of Arts and both Strange and Vivarez were mem-
bers later. There was a preponderance of engravers, revealing the respect that
this comparatively new branch of art engendered. They included Richard
Dalton, who became Keeper of the Royal Drawings and Medals and eventually
Surveyor of the Royal Pictures,[1] Robert Strange, who was subsequently knighted,
and was noted for his engravings after Vandyk and Titian,[2] and Vivarez, also an
engraver.[3] Jacob Bonneau, the water-colour painter, was the only one of the
group known to have practised as a drawing master. He had that very year
applied for the post at Christ's Hospital vacated by Cozens, but was unsuccess-
ful, although he had the support of Cozens and other leading artists. Henry
Cheere, subsequently a baronet, was the only sculptor, chiefly known for his
figures cast in lead and popular as garden ornaments. Vivarez was not actually
present at the judging.

For the competition organized a year later seven artists were named. This
time two particularly famous names appear—William Hogarth and Francis
Hayman. The jury also included the name "Mr. Pond". This was presumably
Arthur Pond, the portrait painter and engraver, who died two years later.

In the following year, December 1756, the Society invited Reynolds and
Highmore to serve in addition to Hogarth, Hayman and some of the others
previously mentioned. This was surely the most distinguished panel of artists to
have pronounced on the merit of children's work. This time they were not
asked merely to assist but were "appointed judges to determine the premiums".

[1] Dalton became a close friend of the sculptor Nollekens in Rome (J. T. Smith,
Nollekens and his Times, 1828.)
[2] Sir Robert Strange was author of the *Inquiry into the Rise and Establishment of the
Royal Academy of Arts at London*, a statement of his grievances.
[3] Vivarez's son, Thomas, who, like his sister, was a prize-winner in 1761, subse-
quently taught drawing.

A separate panel was chosen to judge the work submitted in design for ornament, weaving, cabinet or coach-making or other manufactures.

Some years later, Hogarth voiced some harsh criticism of the members of the Society distributing prizes for drawing and painting, these being "subjects of which they are totally ignorant, and in which they can do no possible service to the community," implying that lay members of the Society continued to participate in the judging, perhaps overruling the judgment of the artists. Hogarth poured contempt on their efforts to encourage drawing among the general public, which he described as "a smattering in the arts".

> How absurd would it be [he claimed] to see periwig-makers and shoemakers' boys learning the art of drawing, that they might give grace to a peruke or a slipper.

This is, of course, not in the least absurd; the art of drawing is precisely what they should have learnt, and it is strange to find Hogarth's professional jealousy placing him among the philistines.

There were forty-five candidates in the first competition and this was considered encouraging. In the junior group for those under fourteen the first and second prizes went to boys who were to become eminent in miniature painting. The winner, Richard Cosway, the future R.A., as notorious for his social ambitions as he was admired for his painting, was brought to London specially, at the Society's expense, when he was only twelve. The award was given for his chalk drawing of a "head of one of the virtues expressing compassion".[1] It is hard to conceive a boy of twelve choosing such a subject—the study of an old man's head. John Smart, who received the second prize, submitted a pencil drawing of a reclining nude figure of a man with incisive contour and astonishing command of foreshortening. Looking at these highly sophisticated drawings by such young children, one cannot help doubting whether they were drawn from nature, especially since the younger competitors were expected to copy.

These competitions provided the first recognition that female talent might be found in art. From the very beginning the Society took the unusual step of allowing girls to enter on an equal footing with the boys. The rule was adopted that when the candidates submitted works of their own choice they had to execute sketches of a similar character in the presence of the examiners. Both sexes worked in the same room together. Female competitors were few at the outset—there were only nine in 1754. Nevertheless, despite the unequal competition, the girls carried off considerable honours. Miss Elizabeth Keith gained the second prize of four guineas in the senior group, while Miss Marsden was awarded fourth prize of two guineas in the junior section with a small, precise drawing of a cottage among trees. She followed this up by gaining another prize the following year, subsequently marrying Jeremiah Meyer, the miniaturist and foundation member of the Royal Academy.

[1] The drawing was assumed to be lost, until it was found that a drawing exactly fitting its description had been labelled with the name "Richard Earlom". That this was a mistake is shown by the date 1754. Earlom did not compete until three years later.

In view of the girls' success, it seems the more unfortunate that this venture in co-education should have been threatened by themselves rather than by male prejudice. In January 1756 the minutes contain the following:

> A petition of several young ladies and girls (who have offered themselves as candidates for the drawing premiums) was read, setting forth the great disadvantages they are under in drawing in the same class with the boys.

Asking that they be given their tests separately, the petition adds that if this be agreed "numbers would offer themselves as candidates, who are now intimidated".

Thus the continuance of this progressive experiment was threatened because nine or so young ladies had been rendered nervous by the proximity of the boys. It was decided to set up a special committee, which included Hogarth, to consider the problem, but there is no information as to whether they acceded to the girls' wishes.

One of the most successful of the girl competitors was Mary Moser, winner of the senior prize in 1758, when she was only fourteen, and again the following year, when she submitted a flower piece in the Dutch style for which she was subsequently so noted, becoming one of the youngest of the foundation members of the Royal Academy. She had the advantage in having as father the distinguished miniature painter, George Moser, R.A., who ran a drawing school and Cosway had a romantic affair with her in later years.[1]

Great care had to be taken to ensure that the competitions were conducted fairly. Sometimes an element of deceit emerged. Miss Elizabeth Brown, who was awarded fourth prize in the senior group, tried again the following year, although over the age-limit of seventeen by one week. She was awarded the first prize, but this was promptly withdrawn when the truth regarding her age was revealed. It must have been difficult for competitors when the age-limits were often changed from year to year. In 1759, there were grounds for doubt as to whether Nollekens, the future sculptor member of the Royal Academy, deserved the prize of fifteen guineas provisionally awarded him. To provide further evidence and ensure that he received no help, he was locked in a room by himself for six hours, while he drew Lot and his two daughters.

The competitions were originally confined to young persons who "intended hereafter to become artists", and were open to rich or poor irrespective of class distinction. This democratic concept was subject to constant challenge. Within two years we find the distinction made between young ladies and girls. The livelihood of the drawing masters was beginning to depend on the well-to-do amateur, and voices were raised at the Society's meetings in 1758 in favour of a separate competition for amateurs. As monetary awards were thought to be inappropriate, gold and silver medals were introduced for the first time for "young gentlemen or ladies". The scheme was not a success, however, and was only tried twice. It was not easy, as the former secretary of the Society and its

[1] J. T. Smith, *Nollekens and his times*, 1828.

Royal Society of Arts Competition, 1759: *a*. William Pars
b. Michael Rooker

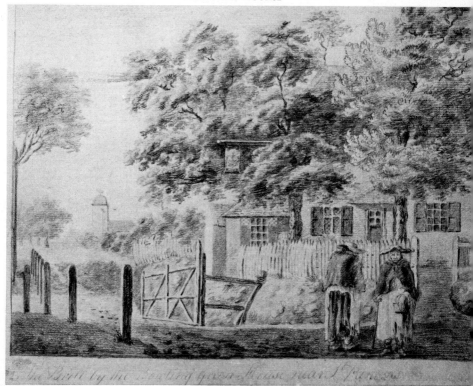

The Royal Society of Arts Competitions:
a. Richard Cosway: Fighting Gladiator, pencil, 1758 *b*. John Smart: Dancing Fawn, chall
c. Denis Dighton: Julius Caesar in Britain, pen and sepia, 1807

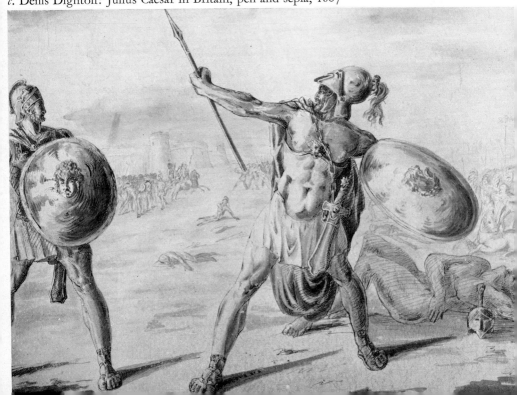

historian, Sir H. Trueman Wood, has pointed out, to check who was qualified to enter.[1] Some years later a special section of the competition was provided for the sons and daughters of peers, subsequently defined as "those who may hereafter become patrons or patronesses of the arts".

Within a decade the competitions had become well established, contributing greatly to the promotion of art education. As many as fifty distinct types of work or media in the different grades were catered for. In some sections youths up to the age of twenty-two or more were allowed to enter, particularly in drawing from the living model or from "models, casts in plaster or bas-reliefs",[2] but those under fourteen were allowed—mistakenly as we would consider today—to copy from a print. Moreover, the juniors were allowed to submit "drawings of any kind", although it is precisely the younger children, rather than the older ones, who require a specific lead.

There was a prize for "the best drawings or compositions after nature, of beasts, birds, fruits or flowers", available to those under twenty-one and also for those under seventeen, thus emphasizing the need for direct study from nature. There were tests requiring an "original design fit for weavers, embroiderers, callico-printers or any art or manufactory", recognizing that good design must be related to its practical use. It is in this branch of work that some of the most exquisite entries were made. The collection preserved in the Society's library includes floral designs, which are astonishingly competent in their knowledge of the craft and perfect in their execution to a degree that few could rival today.

It was mainly during the early years that the prize-winning drawings were retained by the Society and these provide a unique opportunity for assessing eighteenth-century art teaching. If one was not told the ages of the candidates, one could not possibly guess them from the character of the work. It reveals most forcibly that the *naïveté* of childhood was not in the least admired. Children's work was respected only to the extent that it emulated that of adults. The drawings by Smart, Cosway and others, when under fourteen, are of nudes, classical statues or of old age, subjects which would not be the normal choice of a child. Their work is highly sophisticated and their endeavour to conceal all evidence of childhood was obviously approved (plate 8).[3]

Drawing from the male human figure with pencil, chalk or charcoal, constituted the main sphere of study, and boys invariably entered for this branch of work: girls had no opportunities for making studies from the human figure and they usually confined their work to imaginary scenes or flower studies.

[1] *The History of the Royal Society of Arts*, 1913.
[2] Nollekens was one of these, gaining third prize for a sensitive drawing of the fawn with a kid.
[3] An oil-painting of this period by George Dance, R.A. (in the Paul Mellon Collection), shows a small boy (with a drawing of a head), standing by a table covered with a green cloth on which the master is either correcting with his pen another drawing by the pupil or producing a drawing for him to copy. The scene does not suggest that there was any scope for the pupil's own individual expression (plate 9).

The drawings from the life, both head and figure, or from classical statues were of a very high standard in their accurate expression of form, in the handling of chalk or pencil and their painstaking research in light and shade. A sense of life and movement was not sought, except in compositions which were almost invariably of classical or biblical themes and confined to the grouping of figures (plates 7, 8 and 10).

Although prizes were given in landscape, plant life or animals drawn direct from nature, the standard of technical competence was low compared with that achieved in the human figure, thus reflecting the very slow emergence of landscape and the study of nature in eighteenth century art. In comparison with the vigorous paintings by children in this type of work today, the prize-winning drawings of landscape, were for the most part mere conventional descriptions of cottages and trees, pathetically neat and rigid, revealing no reaction to conditions of lighting or weather. There are some, however, that reveal an undeniable charm. Flower painting was treated in a purely decorative manner, mainly by the girls.

The success of these competitions was proved by so many of the competitors having achieved subsequent renown in the world of art. There is John Flaxman, who won a prize for clay modelling when he was only eleven. Thomas Lawrence, the future president of the Royal Academy, submitted a copy of Raphael's "Transfiguration" when he was fourteen, but was debarred from the prize for having exceeded the time allowed. Cotman won a prize for a drawing of a mill and Mulready was successful at the age of fifteen. Landseer was only eleven when he received a medal for drawing animals from life—the foundation of his subsequent career. But perhaps the outstanding example of youthful precocity was Millais, who gained the prize for his "Battle of Bannockburn" when he was only nine.[1] There were, however, many others of equal promise, like Denis Dighton and Hugh Barron, the pupil of Reynolds, whose subsequent careers as artists proved disappointing.[2]

The holding of the art competitions led to a further significant step. It was decided to mount and frame the work of the successful competitors to be shown to the general public in the Society's new headquarters in the Strand in 1760. When, later on in the same year, the professional artists also displayed their work in the "great room" they revealed their dissatisfaction at having their work intermixed with, and sometimes mistaken for, the children's exhibits. The latter became, nevertheless, an annual event, and paved the way for showing the artists' work, which in turn led to the formation of the Royal Academy.

The Society of Arts was deeply involved in the controversies that now arose regarding how the artists were to display their work collectively and establish

[1] Two other prize-winning drawings by Millais, when aged eleven and twelve, representing groups of cavaliers, probably copied, are in the possession of the Royal Academy of Arts.

[2] Dighton won several prizes for his precocious drawings of Roman and other historical scenes, subjects which he favoured later in his career (plate 8c).

an art school under their own control. Some fifteen years earlier a group of artists—Hogarth, Gainsborough, Wilson, Hayman and others—had contributed pictures for the art collection at the Foundling Hospital, where they had been placed on display in 1745. This evidence of considerable public interest led to regular meetings of the group and a growing sense of responsibility for the problems of the artist's profession.

In 1759, when the group met, as they often did, at the Turk's Head in Soho, it was resolved to seek the Society of Arts' co-operation in an exhibition to include all the leading artists. Difficulties arose when the Society refused to allow the artists to charge a shilling for public admission. A compromise was reached with sixpence charged for each catalogue. This relatively high figure proved no impediment, since more than six and a half thousand were sold—an incredible number considered in the light of catalogue sales at exhibitions today.[1]

It is of interest to note that undesirable persons, who were to be excluded from the exhibition, were defined as "livery servants, foot soldiers, porters, and women with children"—classes of society that would be as welcome as any other at exhibitions of the present time. "Smoking and drinking" were forbidden, but some visitors were, nevertheless, so boisterous or stimulated by the exhibits, that damage was caused and windows smashed. It was estimated, however, that as many as twenty thousand persons visited the exhibition. No modern exhibition, allowing for the much larger population and greater facilities for travel, could boast a parallel degree of public interest.

The success of this exhibition, in which about seventy artists participated, prompted further overtures to the Society, but the artists demanded a greater degree of control. The Society insisted on retaining a voice in selecting and hanging the work and thus occurred the cleavage which deprived it of the leadership in the arts which its pioneer work had justified. The majority of the artists, including Reynolds, Hogarth, Gainsborough, Stubbs, Wilson and Roubiliac, to mention the most familiar names, decided to hold their exhibition in Spring Gardens as the Incorporated Society of Artists, which was later to be absorbed by the Royal Academy of Arts, when it was founded in 1768. The minority, including Nollekens, Cosway and Devis, remained loyal to the Society of Arts. Known as the Free Society of Artists, the group's independent existence did not last long, and most of the members subsequently joined the Academy.

One of the Academy's main functions was to teach. In this respect it was to differ from the Society of Arts. The latter had allowed its secretary, William Shipley, to conduct his art school in the Society's premises in the Strand, but it made no attempt to sponsor art teaching.[2] Whereas it had always sought to

[1] A full account is given by W. T. Whitley, *Artists and their friends in England 1700–1799*.
[2] Shipley resigned from the post of secretary in 1757 and a new office named Register was created for him, but in 1760 he decided to resign in order to devote himself more fully to teaching. Very shortly afterwards, however, he handed over his school in the Strand to Henry Pars, who had taught at the St. Martin's Lane Academy, his brother William having been Shipley's pupil. Later, the school was taken over by Ackermann, for his famous Repository of Arts.

encourage youthful talent, it took no responsibility for any subsequent development.

The young Royal Academy, like its predecessors, made the training of the artist its objective. This aspect aroused the hostility of Hogarth, who refused to co-operate. He was scornful of any endeavours which might place a few individuals in a position of authority leading to a scramble for such positions with a rapid growth in the number of teachers.

However confusing Hogarth's standpoint may have seemed, his fears proved to be not entirely without foundation, for the newly formed Royal Academy tended to adopt a narrow view of its responsibilities. Its Council made no move to encourage the teaching or appreciation of art among the general public. Any boy who was thought to have exceptional talent in art was advised to leave school and take up professional training in the Academy Schools. A specialized academic training was begun by boys who had barely entered their teens and who should have been developing their imagination and interest in the world around them.[1] This severely academic study bore little relation to everyday life.[2]

Joshua Reynolds—not in his role of vigorous colourist but as man of business and social climber—became the effective mouthpiece of the artists' profession, and it was his views more than those of anyone else, that set the character of art teaching in the eighteenth century. Far from seeking opportunities for educating the general public in matters of art, his efforts were bent towards keeping the mysteries of art beyond their reach. He is reported to have made his pupils work in a separate room lest they learnt the tricks of craftsmanship which he kept strictly to himself.[3]

Reynolds held the view that art was beyond the capacity of all but the few who enjoyed exceptional talent. His annual *Discourse to the Students* in 1784 contains the comment that

> It is of no use to prescribe to those who have no talents; and those who have talents will find methods for themselves. . .

The *Discourses* are full of references to "the common people, ignorant of the principles of art" or, again, "with the vulgar and ignorant". The student is decried who does what "every man could be taught to do". The art student was to be treated like the novitiate in a monastery:

[1] Turner was barely fourteen; Landseer was even younger, and was exhibiting almost immediately; Millais was only nine when he began professional training.

[2] On enrolment the student was given a handbook which defined his course of studies as follows:
"The schools are intended to provide the means of studying the human form, with respect both to anatomical knowledge and taste of design. They consist of two departments, the one appropriated to the study of the best remains of ancient sculpture and the other to the study of the living models.

[3] Haldane Macfall, *A History of Painting: The British Genius*, 1911.

The first part of the life of a student [Reynolds proclaimed], like that of other school-boys, must necessarily be a life of restraint. The grammar, the rudiments, however unpalatable, must at all events be mastered. . . . [1]

Hogarth was very critical of this academic training which tends "to seduce us from studying nature."[2] Reynolds was equally contemptuous of the "low and confined subjects" chosen by Hogarth, who had "very imprudently, or rather presumptuously, attempted the great historical style, for which his previous habits had by no means prepared him".[3] "History painting" was placed first among subjects at the Royal Academy. Hogarth's imprudence consisted in tackling his subjects in terms of real life.

Reynolds was the prime advocate of "the grand style" which characterized the work of the academic artists of the latter part of the eighteenth century, as opposed to the "realists" like Hogarth and Morland. Reynolds' *Third Discourse* of 1770 defined its "great leading principles" as "style, genius and taste". This doctrine contributed to the creation of a thoroughly artificial concept of art, far removed from the world of normal men and women, and steered art teaching, in so far as it was attempted at all in general education, along the pedantic course from which Ruskin tried to rescue it a century later.

In pursuit of the "grand style", students sought to model their work on the great masters of the past and absorb the ideals of beauty enshrined in classical antiquity. They concentrated on the study of art history to a degree never contemplated previously. Many of the leading artists turned their knowledge to good account and provided themselves with an additional income from buying and selling old masters, and Nollekens is said to have made a fortune out of classical sculpture brought back from Rome.

Hitherto Vasari's *Lives*, dealing with the Florentine artists, had provided almost the sole source of information on Italian art; other "schools" remained largely unrecorded. By the middle of the century, however, the first detailed account of the British school had been prepared by George Vertue, the antiquarian and engraver, and his voluminous notes were edited and made public by Horace Walpole in 1761 as *Anecdotes of Painting in England.*

Historical studies in art were completely reorientated, however, and given a more analytical approach by the work of Johann Winckelmann, the German art historian who was Superintendent of Antiquities in Rome. His *History of Ancient Art*, to give it its English title, which appeared in 1764, was accepted as the voice of authority in the interpretation of classical art. Criticism and appreciation in art now became serious branches of study.

By the end of the century, we find the professors at the Royal Academy— Barry and Fuseli, who taught painting, and Flaxman, who was Professor of

[1] Sir Joshua Reynolds, *Twelfth Discourse to the Students of the Royal Academy on the Distribution of the Prizes*, 1784.
[2] John Ireland, *Hogarth*, 1792.
[3] Sir Joshua Reynolds, *Fourteenth Discourse.*

the Sculpture School—concentrating their lectures almost exclusively on the work of the old masters and of classical antiquity, as the only models for the student to follow. Attention was directed away from the observation of real life in total absorption in the art of the past.

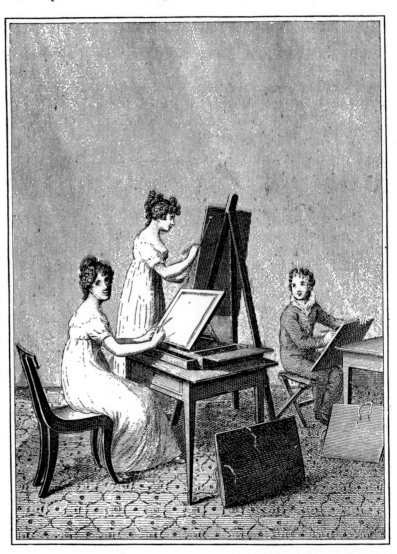

"An easy, graceful position while engaged in study," from Charles Hayter's Perspective, Drawing and Painting etc., 3rd Ed.: *1820*

Back to Nature—
the Drawing Masters from 1760 to 1835

FROM Jean Jacques Rousseau's *Émile*, which first appeared in 1762, stems the teaching of art as a means of educating children rather than producing the incipient artist. Hitherto, it had been taken for granted that art was taught, if at all, purely for vocational reasons, perhaps discovering hidden talent in the process. Its value as a branch of education had been strongly urged by earlier writers, as we have noted, but was never considered seriously until stressed by Rousseau in the education of his imaginary pupil, Émile.

Émile made an immense impression on society almost overnight—it was translated and published in England within a year—but its influence on art teaching was indirect. Art itself is mentioned only briefly and we are soon made aware that Rousseau had no actual experience in teaching or practising art and it is doubtful, even, whether he had any real understanding of the subject. Nevertheless, few writers have exercised so strong an influence on the development of art teaching.[1] These ideas took root in England only gradually and, to some extent, had to await the impetus provided by Ruskin. The sheer enjoyment of drawing and painting, on which the drawing masters were to thrive, with its sense of spiritual experience, originated with Rousseau, replacing the laborious exercises of the past. The romantic approach to nature was thus discovered.

Rousseau introduced his readers to a concept—entirely new to them—that the exercise of the child's senses is just as important for his education as acquiring information from books. His purpose, however, was to develop the intellect:

[1] Among the great educational reformers, J. H. Pestalozzi, in particular, recorded his indebtedness to *Émile*, but his writings, unlike those of Rousseau, made little impact in England at the time they were written. *How Gertrude teaches her children*, 1801, based on his experiences with children in Switzerland and including his views on the teaching of drawing, was not translated into English until 1894 (L. E. Holland and F. C. Turner with introduction by Ebenezer Cooke). Pestalozzi regarded drawing merely as a means of imitating forms in nature, to be taught by exercises, such as measuring how lines deviated from the vertical or the horizontal within a square, exercises of little value.

If instead of making a child stick to his books [he writes] I employ him in
a workshop, his hands work to the advantage of his intellect; he becomes a
philosopher, while he thinks he is becoming simply an artisan.[1]

But this plea for self-expression in art made very little headway in England at
the time.

Rousseau was at pains to make clear that exercising the senses through
drawing and painting meant exercising the sight and the memory. It was for
this reason that he wished to have Émile taught drawing "not so much for art's
sake", as he put it, "as to give him exactness of eye and flexibility of hand".[1]
Rousseau was thus reversing the vocational function of art teaching in favour
of practising it as a means to an end.

None of Rousseau's theories aroused more surprise in art circles than his
demand that teaching should be adapted to the child's needs and abilities, rather
than based on a series of fixed rules applied to all pupils alike. He went even
further in claiming that the child passes through distinct stages of development,
which must be recognized by the teacher. If these precepts had been applied
at the time, or within the next century, the history of art teaching would have
been transformed.

Rousseau was turning over entirely fresh soil when proclaiming the child's
need for colour as an outlet for his self-expression:

> We shall get brushes and paints, we shall try to copy the colours of things [he
> writes] and their whole appearance, not merely their shape; we shall paint;
> we shall daub; but in all our daubing we shall be searching out the secrets of
> nature.[1]

With what anxiety must eighteenth-century parents and schoolmasters have read
this open encouragement to daub! Never before had paint or brushes been
considered essential to a child. Nor was this bold use of colour allowed until
nearly two centuries had elapsed. It is only today that we can see Rousseau's
precept in full evidence on the walls of the art room in a modern school. More-
over, in the mid-eighteenth century, there were few who would venture to
teach the use of colour for its own sake. It was treated with restraint, using flat
washes in water-colour to convey light and shade.

If many of Rousseau's recommendations were thus ignored in art teaching
circles, this was not the fate of his recommendation that children should draw
and paint directly from nature. This was precisely what children hitherto had
never been encouraged to do.[2] It was the one aspect of Rousseau's system, con-
cerning art, that bore immediate fruit:

[1] Everyman Edition, translation by Barbara Foxley, 1911.
[2] Artists had sketched out of doors since earlier in the century, but this practice had
not been adopted in teaching. An artist seated on a rock while sketching is often
depicted in landscapes of the mid-eighteenth century, notably in the work of Richard
Wilson.

Nature should be his only teacher [he proclaimed]; he should have the real thing before his eyes, not its copy on paper.[1]

In recommending this direct contact with nature Rousseau had plant life, in mind; he was, of course, challenging the use of the copy-book. "Let him draw a house from a house, a tree from a tree", he urged.[2] Although sketching direct from nature was now to gain a foothold in art teaching, under Rousseau's inspiration, dependance on copying was not to be eradicated so easily. In effect the two methods were to coexist. It was mainly through teaching girls that direct contact with nature by means of flower painting acquired its popularity.

The intellectual activity of women was one of the most significant of eighteenth-century developments. Hitherto, they had been given little opportunity for studying drawing, still less for painting, and sculpture never. Art was a purely masculine vocation. The Society of Arts, as we have seen, had thrown its art competitions open to girls, but these had barely preceded the publication of *Émile*. Under the influence of Rousseau, the teaching of drawing among girls was to prove a lucrative vocation, and the career of a drawing master was to keep many artists busy for years to come.

In advocating equal facilities in education for both girls and boys, Rousseau was not thinking of the girl's career, but merely of her suitability as a companion for her future husband. He was concerned with the benefits arising from mutual and equal education. In a typical passage in *Émile* he states:

> Woman observes, man reasons: Together they provide the clearest light and the profoundest knowledge.[1]

In a further passage he explains how Sophy is to acquire her knowledge of drawing:

> The house is picturesquely situated and he (Émile) makes several sketches of it, in some of which Sophy does her share, and she hangs them in her father's study. . . . When she sees Émile drawing, she draws too, and improves her own drawing.[1]

It is clear that poor Sophy was not expected to produce work of much individual distinction. Nevertheless, Émile, and Sophy to some extent, were to practise drawing, if not out of doors, at least from direct observation, but not much more than an imitation of his work was expected from her. Rousseau was not prepared, moreover, to recommend girls tackling the more ambitious

[1] Everyman Edition, translated by Barbara Foxley, 1911.
[2] Alexander Cozens was among the first to follow Rousseau's precept in his *A New Method* (op. cit.), c. 1784, in which he states: "Too much time is spent in copying the works of others." Sir Joshua Reynolds gave similar counsel in his *Second Discourse to the Academy Students* in 1769: "How incapable those are of producing anything of their own, who have spent much of their time in making finished copies."

tasks, as in "landscape and still less figure drawing". He preferred them to concentrate on drawing "leaves, fruit, flowers, draperies", which could be done at home. It was the prevailing belief that girls should beware of subjecting themselves to the hazards of wind, sun or rain.

Nevertheless, young women, even more than young men, responded to Rousseau's romantic vision. There was a sudden taste for the simple life:

> How many young wives have I seen [our author writes] whose good-natured husbands have taken them to Paris where they might live if they pleased; but they have shrunk from it and returned home more willingly than they went, saying tenderly, "Ah! Let us go back to our cottage; life is happier there than in these palaces."[1]

This reminder of the beauty to be found in the humble thatched cottage, the windmill or the country lane—indeed in scenes which could be shared by all alike—had an immediate relevance to England, since it did not possess the classical ruins without which no scenery had hitherto been considered acceptable. The English, rather than the Roman, landscape could now be used for painting.

The vision of the "picturesque" was implanted in the minds of Rousseau's many readers, who were soon clamouring for lessons in the drawing of waterfalls, ruined abbeys and woodland glades. "Back to Nature" was the summons heard and willingly obeyed throughout Europe during the last quarter of the century. Its impact on the British public was such that landscape, despite Rousseau's reservations, obtained its lasting hold on the popular taste, thus changing the course of art teaching. The pursuit of art, both for the practising artist and the amateur, came to mean, more and more, an escape into this romantic world opened up by Rousseau, divorced from the practical work of the drawing school.

The official opposition to landscape was voiced by Sir Joshua Reynolds in his annual discourses to the students of the Royal Academy. Reynolds was not moved by Rousseau's ideas. Landscape had the lowest place among subjects for painting, unless it formed the background for a "history-painting". Claude Lorraine was admirable, in Reynolds' view, precisely because he did not paint direct from nature, but constructed his compositions from sketches. Richard Wilson, who had spent his early years in Rome, as was then the custom, was condemned. "His landscapes were in reality too near common nature", was Reynolds' scathing comment.

It was precisely this "common nature" which was to provide the material for the artist henceforward. Wilson, in his later years, painted the homely English or Welsh scenery, but this was not the right receptacle for that "nobleness, grandeur and the poetick character" which Reynolds demanded in a landscape.[2] Rousseau's influence came too late for Wilson's lake and mountain scenes to

[1] Everyman Edition, translated by Barbara Foxley, 1911.
[2] Sir Joshua Reynolds, *Fourteenth Discourse to the Students of the Royal Academy*, 1788.

achieve popularity during his lifetime, nor to persuade Gainsborough's patrons to buy his woodland scenes or herdsmen with their cattle.[1]

The cult of the "picturesque" came at the right time for George Morland, whose thatched cottages, stables and pigsties began to sell readily, and the wayside inns and creaking country wagons, in which Wheatley and Gainsborough had delighted in their later years, became equally popular together with the work of Rowlandson, Ward and their contemporaries. When James Barry became Professor of Painting at the Royal Academy during the last two decades of the century Rousseau's "nature" appears fully triumphant. In his second lecture Barry asks the students:

> Who is not delighted with the lowing herds, smooth lakes and cool extended shades; the snug, warm cot, sufficient and independent, the distant hamlet; and the free, unconfined association between all the parts of nature.[2]

This eulogy of the picturesque, repudiating Reynolds' doctrine, emerges as a final vindication of the new attitude to nature which stemmed from Rousseau.

To be a drawing master was now a distinct branch of the artist's profession, and many struggling artists found therein a source of livelihood. While some doubtless had difficulty in making ends meet, others, like John Varley, friend of Blake, gained renown as a teacher and was much in demand. He is reported to have charged a guinea a lesson in addition to a premium before the course began, accumulating the fantastic income, for those days, of £3,000 a year. Such sums were not to be obtained from the pockets of aspiring artists. It was the wealthy amateurs who sought out the most eminent art teachers and paid so handsomely. An ability to make sketches of scenery or studies of one's friends was an accomplishment essential for any young lady or gentleman, and well-to-do travellers would carry their sketch-book, water-colour box with its cakes of paint, palette and pencil, made to fit the pocket, in the same way as tourists take their cameras today (page 60).[3]

The novels of the Regency period seldom failed to introduce the romantic figure of the drawing master and a sketching incident. Jane Austen has conveyed with such admirable cynicism this amateur dabbling in drawing that it is worth reminding ourselves of the passage where Emma is invited to make a portrait of Harriet:

[1] The subject is discussed by R. H. Wilenski in *English Painting*, 1933.
[2] James Barry, R.A., *Lectures to the Students*, 1811.
[3] There were conflicting views expressed by schoolmasters of the period. Dr. Vicessimus Knox, headmaster of Tonbridge from 1778 to 1812, deplored this growing popularity of drawing lessons, "a sedentary amusement", and to meet the danger of leisure he proposed a reduction in school holidays: *A Liberal Education*, 6th ed., 1784. James Burgh, a schoolmaster, writing somewhat earlier, found drawing "sedentary" and consequently "prejudicial to the health" but justified because "it does not lead to any vice that I know of . . . and may often prove useful". *The Dignity of Human Nature*, 1754.

Emma wished to go to work directly, and therefore produced the portfolio
containing her various attempts at portraits, for not one of them had ever
been finished, that they might decide together on the best size for Harriet. Her
many beginnings were displayed. Miniatures, half-lengths, whole-lengths, pencil,
crayon and water-colours had all been tried in turn. . . . There was merit in
every drawing—in the least finished, perhaps the most. Her style was spirited. . . .

Lady Catherine de Bourgh, in *Pride and Prejudice*, was dismayed to learn that
Elizabeth Bennett did not draw: "Your mother should have taken you to town
every spring for the benefit of masters", she urged. Wilkie Collins, having an
artist father, was able to draw upon his familiarity with the career of an art
teacher in his novel, *The Woman in White*, but in this case the drawing master is
the long-suffering hero, patiently trying to teach the young ladies to sketch from
the shelter of the summer house.

At the turn of the century two names stand out among artists who practised
as drawing masters—John Crome and John Sell Cotman—and their careers are
illustrative of the profession at this period. Crome, distinctly the elder, was the
pioneer in their native Norwich, but both, with their sons succeeding them,
became rivals.[1] Their methods were utterly different. Crome gave his lessons out
of doors, weather permitting, whereas Cotman mainly relied on making drawings
for his pupils to copy.

Outdoor sketching parties formed characteristic events in the social scene,
but were restricted by the shortness of the season. Dawson Turner, Crome's
friend and biographer, has described such a sketching expedition with the
master surrounded by his pupils in a muddy country lane. A fellow artist,
passing by, expressed surprise at finding him in such uncomfortable circum-
stances instead of in his studio. For reply, Crome pointed to the view they were
busy sketching: "Do you think you or I could do better than that?"[2] Crome was
essentially a lover of landscape and trees and he sought to communicate this
to his pupils.[3]

Water-colour owed much of its popularity in the eighteenth century to its
suitability for use out of doors, replacing pen and ink or pastel. Oil-colour was
seldom used by the amateur, though it was not more difficult as a medium. In
fact, oils, turpentine and varnishes were thought injurious to the health, and

[1] S. D. Kitson in *The Life of John Sell Cotman*, 1937, has recorded that Cotman's
son, Miles Edmund, was seeking a post at a local girls' school with some confidence.
"I had", he writes to his father, "reckoned without my host. . . . She (the headmistress)
has one pupil who will not learn of a Cotman, either father or son; one who is a staunch
admirer of Crome's style and cannot endure ours."
It was eventually settled that Cotman was to teach some, while John Berney Crome
would teach those who showed a preference for him.

[2] John Wodderspoon, *John Crome and his Works*, 1858.

[3] The seven Gurney sisters were among Crome's most ardent and constant pupils.
He taught them at their home at Earlham and often accompanied them on holidays (as
recorded by Percy Lubbock in *Earlham*, 1922).
The pencil studies of trees by Richenda and Louisa showed sensitive handling and
a search for the structure of trunk, boughs or the masses of foliage (plate 11).

ladies with their delicate constitutions and temptation to faint were never expected to use them. Although Crome based his work on the direct study from nature, he relied on pencil sketches and preferred not to use oil-colour outside his studio. Landscape, nevertheless, acquired its full range through the work of Crome.

In the work of the earlier painters landscape had been treated as if it was static and any expression of movement confined to people or animals. Paul Sandby's water-colours, for example, present trees and sky as if immobile and permanently lit by the midday sun.[1] A concern with the unity and interplay of sky and land did not begin to emerge until the middle of the century, coming to fruition in the water-colours of John Robert Cozens, Alexander's son, with their rhythmic shafts of sunlight, rain or shadow traversing trees and ground. The young Turner and Girtin were ardent students of the younger Cozens' studies from nature and Constable considered him "the greatest genius that ever touched landscape."

Crome had fully absorbed this concern with the unity of nature—the interplay of masses in tree and cloud (plate 12b). He reverts to this in a lengthy criticism of a painting by his favourite pupil, James Stark, from which the following are salient extracts:[2]

> I should have liked it better if you had made it more of a whole, that is, the trees stronger, the sky running from them in shadow up to the opposite corner. . . .

Again he reverts to the same point:

> I cannot let your sky go off without some observation. I think the character of your clouds too affected. . . . Breadth must be attended to, if you paint. . . . making parts broad and of a good shape, that they may come in with your composition, forming one grand plan of light and shade. Trifles in nature must be overlooked that we may have our feelings raised by seeing the whole picture at a glance, not knowing how or why we are so charmed.

Then come some splendid and characteristic comments in a postscript:

> Do not distress us with accidental trifles in nature, but keep the masses large and in good and beautiful lines, and give the sky, which plays so important a part in all landscape . . . the prominence it deserves.

Crome could never afford to dispense with teaching, in which he probably had more genuine interest than Cotman. Having been offered the post of drawing master at Norwich Grammar School at the beginning of the century, when

[1] Henry Peachman, a pioneer in this field, had given his pupils the following rule: "You shall always in your landtskip shew a faire horizon, and expresse the heaven more or lesse either over-cast by clouds, or with a cleere skie: . . . you shall seldome, except upon necessitie, shew the moone or starres, because we imagine all things to be seene by day". (*The Art of Drawing*, 1606.)

[2] Letter from John Crome to James Stark, January 1816, quoted in full in the catalogue of the sixth exhibition of the Norwich Art Circle containing a memoir on the work of James Stark, June 1887.

he was thirty-three, he was thankful to retain it for the remainder of his life.[1] When the Norwich Society of Artists was formed in 1803, with Crome a foundation member, we find Dr. Forster, master of the grammar school, named vice-president—evidence of Crome's gratitude.

Cotman was a pupil at the grammar school before Crome began teaching there, and at that time no drawing lessons were provided. There is the story that the boys incited Cotman to draw a caricature which was placed in the master's desk when he was not looking. Dr. Forster, however, took one glance at the caricature and then at Cotman, announcing that there was no need for the only boy who could have drawn it to own up, since he knew his name already.[2] Neither Crome nor Cotman appear to have received any art instruction in their youth and their work does not seem to have suffered thereby.

Cotman's livelihood seems to have depended entirely on teaching, and for most of his life he had to rely on private pupils. Competition was severe from fellow members of the Norwich Art Circle.[3] As early as 1802, we find him advertising in the Norwich *Mercury*, addressing himself to

> those ladies and gentlemen who may think his sketching from nature or style of colouring beneficial to their improvement.[4]

His charges were to be half a guinea for an hour's lesson. Twenty years later, now aided by his two sons, he was still in search of pupils, and was planning a school for drawing and water-colour painting—a plan he had outlined to Dawson Turner in 1806—which would, according to the announcement in the *Mercury*, "embrace every instruction necessary to form the professional and the amateur artist". His terms were now more modest—one and a half guineas for the quarter. Substantial as these sums may seem, pupils were scarce, and his plans seldom materialized. Cotman had occasion to write of his friend, John Berney Crome:

> But a short time back he travelled with his horse and gig and manservant seventy miles for but three pupils, and now he fears it will be less.[4]

[1] The school was conducted in the old chapel of St. John, in the Cathedral Close, with its gallery at one end. Having no room to spare for the drawing class, it is probable that Crome taught selected pupils out of doors or from natural objects in his studio. The usual drawing from geometrical objects or by copying seems quite inconsistent with Crome's outlook. His terms of employment and salary would have been the master's responsibility.

[2] James Reeve, *Memoir of the Artist* (in the catalogue of the exhibition of Cotman drawings, Norwich, 1888).

[3] The words "Drawing Master" were often added after the artist's name in the exhibition catalogues. Cotman gave each of his drawings a number before circulating them among his pupils. The latter had to return them with their copies (plate 15). Some of the latter show broad brush strokes in sepia applied over the pencil drawing, suggesting that it was Cotman's method, or perhaps of his son, John Joseph, to demonstrate how the composition might be intensified or life and movement given to sea or sky (plate 14a).

[4] S. D. Kitson, *The Life of John Sell Cotman*, 1937.

Nevertheless, he was determined to maintain his scale of charges, and advised his son, John Joseph, to charge not less than half a guinea a lesson, more if possible. "You gain no credit by working under price", was his comment.[1]

Cotman's financial worries seemed to be laid at rest when, in 1834, he was fortunate in obtaining the appointment of drawing master at King's College School, London. His letters home reveal his eager anticipation of obtaining this high honour at the college, as he presumed it to be.[2] He soon found, however, after taking up the post, that he required the help of his son and daughter in preparing for the lessons. Thus the whole family had to work for a salary which did not keep them clear of debt. For the entire first year Cotman did no painting himself. It seems indeed pathetic that an artist of Cotman's genius should have been compelled to waste so much of his time and energy throughout his life for such doubtful benefits.

While Crome allowed his mood to dictate the character of his work, Cotman was pre-occupied with composition, carefully disposing of form and colour. A note by Cotman referring to a seascape, reveals his concern:

> This dark clowd ultra grey. The light warmish to the left. The sky at top, to the right, ultramarine blue, but not dark. Sea darker grey with much of the sky tint. The dark point about black—the boat passing the pier redish oker, black and warm brown. The ship in the offing pearly white. I think that a beautiful simple subject and likely to suit old Toddles.
> I am not sure but what a figure in red on a very flat shore might improve the subject at bottom to the right. But it is perfect without—therefore its introduction very doubtful. It would smack of composition and artifice.[3]

In these unruly times the schoolmaster's constant concern was with the maintenance of discipline, and Cotman's letters to his friend Dawson Turner often indicate his unjustified sense of inferiority, heightened by the difficulties of keeping order. There were as many as fifty boys in each class, and Cotman was writing, soon after taking up his new appointment, with obviously disguised anxiety:

[1] The account books of father and sons (preserved in the Castle Museum, Norwich) show that extra charges for materials were carefully itemized, such as "color box six shillings, sketch book eight shillings, paper," etc.

[2] The post was not actually at the college, as Cotman described it, but at the school attached to it. The college records make no mention of Cotman's appointment, nor does Fearnshaw's *History of King's College*. Moreover, the college statutes did not provide for a professorship of art, which Cotman mistakenly claimed in his letters.

His successful application appears to be due to his pupil, Lady Palgrave, Dawson Turner's daughter, but she seems to have been in two minds whether it would not have been better to recommend the son, Edmund, rather than the father, owing to the latter's "very uncertain state of mind and spirits" (in a letter to her father, quoted by S. D. Kitson in op. cit.).

[3] Written in red chalk on a scrap of paper and unpublished hitherto, this note was found within the leaves of *The Sketcher's Manual* by Frank Howard, which Cotman gave his son, John Joseph, August 21, 1839, adding: "The campaign at King's College, London, commenced this day". (In the possession of the Castle Museum, Norwich.)

I am quite up to the work [he assures his friend], and I am really astonished at myself, when the noise like the rushing of mighty water is hushed by a sentence: "Gentlemen, I cannot go on thus! You must be silent or I must leave the room." The effect is electrifying. My mode of teaching shall be, if possible, to gain the love and respect of my pupils.

Reading this overconfident passage, we may well imagine the actual state of confusion.

S. D. Kitson, the biographer of Cotman and editor of his letters, informs us that one drawing was placed before each pupil with the brief instruction: "Copy this." Many of the drawings show pin holes pricked through the salient features such as the summits or angles of towers, masts, prows of boats etc. The pupils then inserted the sharp point of the pencil in these holes, so as to mark on their drawing paper the main positions and proportions, and by drawing the lines between were able to concentrate on expressing the form within (plate 14b).[1]

The brothers, Dante Gabriel and William Rossetti, were among Cotman's later pupils, and the latter has given us an intimate glimpse of the drawing lessons:

> The Drawing Master was the most interesting personage of all [he writes], somewhat worn and worried. He seemed sparing of speech, but high-strung in whatever he said. . . . The course of instruction did not extend far beyond giving us pencil sketches, often of his own, to copy.[2]

It is clear that the best artists do not always make the best teachers, and it would have been far better if Cotman could have been spared from teaching and enabled to give his entire time to his art. Through the misguided system of copying—and few teachers, apart from Crome and Cozens, seem to have discovered any other basis for their teaching—Cotman found it necessary to spend his entire spare time in making the drawings to be copied, a task in which his son and daughter had to help, often late into the night. Kitson has estimated that Cotman had made more than two thousand before going to London, and this was doubled before his death.

The "copies", as they were called, ranged over every possible variety of subject. Rossetti mentions, at random, fisherfolk, troopers, peasants, boating,

[1] Kitson's assumption that these holes were made by the pupils is questionable. The points were carefully decided and the blackened edges of each hole show how the pencil was inserted by successive pupils. That this was a device for the boys rather than Cotman's adult pupils is indicated by these holes being found chiefly on copies stamped "Cotman King's College London"—presumably a precaution against theft. The Castle Museum, Norwich, posseses a large collection of Cotman's copies.

[2] W. R. Rossetti, *Memoirs of Dante Gabriel Rossetti*, 1895. Dante Gabriel constantly drew during childhood, favouring illustration, as was to be expected from one with his literary leanings, and his many illustrations of poems and studies of historical figures in costume have been preserved by his niece, Mrs. Rossetti Angeli (plate 13 and page 74).

9. George Dance, R.A.: The Drawing Lesson, oil, (Collection of Mr and Mrs Paul Mellon, Washington, U.S.A.)

10. The Royal Society of Arts a. Venus and Cupid, watercolour, 1807
 Competitions: Miss S. C. Day b. Augustus entering Cleopatra's apartment, pencil, 1806

etc.[1] To provide occasional relief, the pupils, according to Kitson, sometimes tried to "improve" the drawings by adding jokes of their own in a spirit of caricature. Many of the "copies" show evidence of the Cotman family having had recourse to an indiarubber in order to erase unedifying embellishments. After the master's death in 1843, his son, Miles Edmund, continued the teaching but had to relinquish it when he found his health would not support the extra hours of work he was asked to undertake.

The system of copying became the more entrenched in teaching as a result of the invention of lithography at the beginning of the century.[2] Senefelder's discovery made it possible to reproduce an artist's drawing on the stone, while preserving the quality of the pencil. Ackermann, through his Repository of Arts in the Strand, was responsible for publishing numerous copy-books containing picturesque scenes, sometimes hand-coloured, with hints for the beginner.[3]

Many artists saw a means of livelihood in the production of copy-books, and of these Samuel Prout was the most gifted and perhaps the most prolific. His *Rudiments of landscape with progressive studies*, of 1813, was followed by *Bits for Beginners* and *Hints on light and shadow, Composition etc.* They contained a number of plates produced by lithography from sketches made during Prout's travels in England and on the Continent, together with much sound advice, and it is, perhaps, disparaging of their merit to liken them to the modern correspondence courses in drawing.[4]

There were few teachers, during the Regency, of the standing of Prout or of David Cox, his contemporary: the latter taught at the Military College, Farnham, in 1813, until he found that his enforced residence there hindered his own practice of water-colour painting, and prompted him to resign the following year in favour of a girls' school in Hereford.

Prout's work was particularly admired by Ruskin, when a young man, and and he has recorded that Prout's water-colour of a wayside cottage formed the foundation of his father's collection. His cousin, Mary, often copied it, and it was directly responsible for his own studies in drawing when he was twelve. Ruskin was anxious at the time to acquire a copy of Prout's *Sketches in Flanders and Germany*, published in 1833, and records accompanying his father to the shop and seeing the specimen print—"the turreted window over the

[1] Those at Norwich Museum are mainly of ships, churches, castle ruins or bridges. There are very few of animals, trees or the human figure, subjects which were presumably considered too difficult for all but the better pupils.

[2] Benjamin West, Stothard, Barry and Fuseli were among the artists contributing to the *Specimens of Polyautography*, published in 1803.

[3] The circulation of copy-books was promoted by the Art Union of London (modelled on similar unions in Germany), which sought to encourage a taste for the fine arts. In return for a subscription of one guinea a year the subscriber would receive at intervals a copy-book containing reproductions in outline of famous pictures, suitable for copying in pencil or pen and ink. Each issue would contain some prints for framing. The society also offered monetary prizes.

[4] Prout's pupil, James Harding, also specialized in the production of copy-books.

Moselle".[1] Of this drawing the young Ruskin subsequently made a copy.

This extraordinary popular esteem for Prout's work must seem to us somewhat inflated. Prout was an admirable topographical draughtsman and watercolourist, but scarcely to be admired above Constable, Turner, Cotman and many others of his contemporaries. His success was due to his work so admirably reflecting the tastes of the prosperous middle class. His studies of picturesque streets, churches and bridges evoked dreams of foreign travel among the well-to-do merchants and professional men in Dulwich or Blackheath, and his unpretentious water-colours were thoroughly suited to their suburban dwellings. Prout's work was not for the baronial hall either in scale or subject-matter, but for the modest breakfast parlour. It was these middle-class patrons who supported art teaching in the early years of the nineteenth century.

Prout's publications had one manifest superiority over the earlier copy-books, in directing the attention towards contemporary scenes instead of idealizations of the past. Prout used his pencil, with his highly individual technique, to render living nature, its crowded streets and busy markets. Instead of wearisome theories of perspective, Prout would discourse on light and shade, explaining how composition depends on a balance between light and dark areas, with an intense light equalling in strength a large expanse of moderate shadow or vice versa. He would show by example how a building might be transformed as a result of the effect of light and shade, thus allowing the pupil "to sink what is unseemly into obscurity and to raise features requiring prominence". "Breadth of effect is the first quality to be secured", ran his advice to students; "The eye should not be drawn towards one feature only". In order to achieve this, "light and dark should, as it were, travel about the picture". When several "masses of light and shadow are introduced, they must not be of equal quantities."[2]

Although Prout made his living largely through the production of copy-books, he made a point of emphasizing that students should copy his drawings only inasmuch as it led them subsequently, to work direct from nature. "If it (copying) becomes the end instead of the means", he warned his readers, the student would find himself "incapable of producing works of any originality".[2] This was remarkably candid advice from one who depended for his livelihood on the maintenance of copying.

Many prominent artists of the early nineteenth century, W. P. Frith among them, strongly opposed the system of teaching by copying.[3] But no concerted effort was made to direct this influence in the right direction. They assumed that the qualities desirable in a picture were beyond the capacity of a child, and they

[1] John Ruskin, *Praetorita*, 1885 (plate 12a).

[2] S. Prout, *Hints on light and shadow, composition etc as applicable to landscape painting*, published by R. Ackermann, 1838.

[3] Frith received lessons from a French drawing master at St. Margaret's School, Dover, of which he has recorded: "I could have done something in the shape of original work instead of wasting valuable, irrecoverable time in profitless copying." W. P. Frith, R.A., *My Autobiography and Reminiscences*, 1887.

were unable to recognize the artistic merit peculiar to childhood. It was natural, therefore, that artists failed to supply any positive alternative to copying as a method of teaching.

It is to Ruskin's discredit that he never brought himself to repudiate the system of copying, though he often complained of its effects. In his reminiscences written half a century after the events described, Ruskin has given us an admirable glimpse of the typical drawing lessons of the Regency period. Of his cousin, who was attending day school at Herne Bay, he writes:

> Mary could have drawn, if she had been well taught and kindly encouraged. But her power of patient copying did not serve her in drawing from nature, and when that Summer (1829), we went to stay at Matlock, all that she proved able to accomplish was an outline of Caxton's New Bath Hotel, in which our efforts in the direction of art, for that year, ended.[1]

The Ruskin parents were, however, tolerably impressed and asked her teacher to give their son a lesson of one hour each week. The reluctant victim has recorded them as follows:

> I suppose a drawing master's business can only become established by his assertion of himself to the public as the possessor of a style, and teaching in that only. Nevertheless, Mr. Runciman's memory sustains disgrace in my mind in that he gave no impulse nor even indulgence to the extraordinary gift I had for drawing delicately with the pen point. . . . Mr. Runciman gave me nothing but his own mannered and inefficient drawings to copy, and greatly broke the force both of my mind and hand. Yet he taught me much, and suggested more. He taught me perspective, at once accurately and simply . . . and the habit of looking for the essential points in the things drawn, so as to abstract them decisively, and he explained to me the meaning and importance of composition, though he himself could not compose.[1]

Perspective was taught theoretically rather than visually. Thus the pupil learnt to draw what he knew to be there rather than what he saw; he was not taught to observe how proportions diminish with distance. Ruskin's belief in the study of perspective underwent some modification in later years. Having written a handbook on perspective, as we shall note later, he subsequently dismissed the subject:

> Prout [he wrote] drew every lovely street in Europe without troubling himself to learn a single rule of perspective.[2]

With the early nineteenth-century advances in water-colour technique, this medium became the main objective of the drawing lesson rather than pencil or pen and ink. Copley Fielding had succeeded Varley as the most fashionable of drawing masters, largely due to the popularity of his water-colours. Ruskin,

[1] J. Ruskin, *Praetorita*, 1885.
[2] *Notes by Mr. Ruskin*, 1880, published by the Fine Art Society's Galleries, for the exhibition of drawings by Samuel Prout.

senior, paid forty-seven guineas for a Copley Fielding. "A tremendous sum for us," his son comments, "and the day it came home was a fiesta, and many a day after, in looking at it, and fancying the hills and rain were real."[1] Ruskin was sixteen when he secured Fielding's promise of six lessons at a guinea an hour. Actually he had eight or nine lessons, during which he learnt

> to wash colour smoothly in successive tints, to shade cobalt through pink madder into yellow ochre for skies, to use a broken scraggy touch for the tops of mountains, to represent calm lakes by broad strips of shade with lines of light between them. . . . Fielding taught me to produce dark clouds and rain with twelve or twenty successive washes, and to crumble dark umber with a dry brush for foliage and foreground.[1]

With Queen Victoria's reign beginning, the "Back to Nature" movement in art teaching had become as stereotyped as the "classical" influence had been in the previous century. Changes were now to emerge; the Government would act; even the universities would participate. An altogether new approach would stem from Ruskin.

[1] J. Ruskin, *Praetorita*, 1885.

D. G. Rossetti, La Tomba, *pen and ink illustration to his poem* Lisa ed Elvis, *age 14, c. 1843*

the National School of Design

SCHEMES for art education on a national scale had been proposed at various times, but it was not until the 1830s that they received serious consideration. The attitude towards art was undergoing change. Artists were now concerned with a wider range of activities and subjects than in the past. Besides landscape and portraiture, there were historical or contemporary themes for murals or mosaics, and there were the new problems of industrial design. There was the growing recognition that art education was a social issue implying broader considerations than the drawing masters of the past had assumed. The time was ripe for developing a system of art teaching instead of merely showing the pupil a number of technical tricks for representing distance, foreground, skies or reflections.

It was in the field of design that action was chiefly demanded. Foreign artisans had long been competing with British craftsmen and it was for this reason that the Society of Arts had been formed. The expansion of industry and manufacture now made the training of designers in Great Britain more than ever necessary. Goods formerly made by hand were being turned out by machine. Metalwork, cast-iron, china, textiles, carpets, decorated tiles and wall-papers were among the materials and products to be considered. It was no longer the lone craftsman but the manufacturer with his numerous employees who needed good designing.

We are often inclined to regard the nineteenth century as a period of artistic philistinism. Yet people in authority, including manufacturers, often showed themselves well aware of the importance of good design and recognized the need for safeguarding art from the domination of the machine. Official reports or discussion in the press emphasized to a surprising degree that art must not be sacrificed merely in the interest of profit and there was widespread fear lest artistic quality might suffer from monotonous planning or mass production. A national assessment of the problems of art education was long overdue.

Public concern over the lack of good art teaching, especially among those engaged in industry, was brought to a head by the appointment of a Select Committee of the House of Commons in 1835, under Lord Melbourne's administration—perhaps the most notable step taken for the promotion of art in this country. The Select Committee's net was cast wide: it was to

enquire into the best means of extending a knowledge of the arts and the principles of design among the people (especially the manufacturing population) of the country; also to enquire into the constitution, management and effects of the Institutions with the Arts.

The Committee was thus required to focus attention on two distinct problems—art education for the general public and the Royal Academy's duty to the community and valuable results were anticipated.

Witnesses were drawn from manufacturing as well as artistic circles, both in London and in the provinces. In addition, several distinguished personalities were invited from abroad, to disclose conditions in countries such as France and Prussia. The superiority of French design was repeatedly emphasized. The Committee was told that "in France, the workman is himself the artist". The evidence showed that in Germany drawing formed "an element in the system of national education".

In contrast, the absence of any system of art teaching for the working classes in this country was continually stressed. "The arts are not taught in any public or charity school in Coventry", was the blunt assertion of the Mayor of that city. Another witness, a sculptor, pointed to the absence of any national schools in this country where students could obtain instruction in ornamental drawing. There were the drawing classes sponsored by the Mechanics' Institutes, but these were in their infancy and made no attempt to teach art in the true meaning of the term; drawing only was taught. It was made abundantly clear that art teaching was completely lacking as regards the general public, apart from a few private schools which were available only to people of means.

The inadequacy of art teaching in Great Britain was duly noted by the Committee in its final report, which stated:

> The arts have received little encouragement in this country [although] there exists among the enterprising and laborious classes of our country an earnest desire for information in the arts.

The Committee considered that the Government should aim "at the development and extension of art"; it should not control "nor force its cultivation". Schools where design is taught should be located near the factories so that manufacturers would be in a position to "encourage a knowledge and a love of art among their workmen". To this end, "the principles of design should form a portion of any permanent system of national education". Unfortunately technique was mistaken for "art", and few of these recommendations were ever realized in practice. The wrong system was adopted.

The Select Committee proceeded to call witnesses who could testify regarding the role performed by the Royal Academy. Eminent critics of the Academy, such as Benjamin Robert Haydon and John Martin, were heard. There were complaints of unfair treatment of the work submitted by artists who were not members. The Academy Council was charged with a "disregard of the interests of other artists", of "a spirit of exclusion", and even of "a selfish administration

of the funds". The teaching was severely criticized. The Committee neither approved nor condemned, but the Academy was reminded in the report that "if it really represents the artists of Great Britain, it should be responsible to them".

It must be a matter of surprise that no representatives of the English universities, then confined to Oxford and Cambridge, or the public schools attended these sessions of the Select Committee. Presumably they were not summoned because it was not considered that they bore any responsibility for "extending a knowledge of the arts". Nevertheless, they came in for some well-deserved criticism in the report, which states:

> It is with regret that your Committee notice the neglect of any general instruction, even in the history of art, at our Universities and Public Schools.

Neither the universities nor the public schools appear to have taken note of this criticism, nor was any action taken in this quarter where action was so vitally needed. Nearly a quarter of a century was to pass before the two universities would recognize drawing, but not art, in education by including the subject in their local examinations, and they never allowed it to contribute towards a degree.

There was one encouraging note in the Select Committee's report. It was able to comment favourably on the educational value of the new "steam printing machine" which "permits the circulation of cheap publications on art" and can thus "convey instruction to the very dwellings of the people". The Committee had put its finger on a significant advance in art education. Hitherto, the poorer classes, who enjoyed no means of studying art, could only cultivate their artistic instincts by the practice of a craft. Works of art apart from prints had been accessible to them only in the monuments and windows of the Church. With the new means of reproduction pictures—although often enough bad ones—became universally available and were soon adorning the walls of every parlour.

When the Select Committee on the Fine Arts was set up in 1835 the House of Commons voted £1,500 for the foundation of a School of Design in London. Two years later, the school was duly opened in Somerset House, which the Royal Academy had just vacated. This was the first step taken by the State to sponsor art education in a practical way. The school had a number of very distinguished names on its Council, such as Chantrey, the sculptor, David Wilkie and Etty, the painters, names which only tend to emphasize its disappointing results.

A new figure now emerges, to dominate art teaching throughout this formative period. This was William Dyce, a young Scottish painter, then aged thirty, who had studied under Lawrence at the Academy Schools. He had recently returned from Rome, where he had fallen under the spell of Overbeck, inspired by the medievalism which subsequently led to the formation of the Pre-Raphaelite Movement, although Dyce himself never chose to enrol in the Brotherhood.

On his return to Scotland, Dyce together with Charles H. Wilson were appointed early in 1837 by the Board of Trustees for the Encouragement of Arts and Manufactures in Scotland to conduct a class in design at Edinburgh. Dyce had intellectual power—he was a graduate of Aberdeen University—combined with deep religious conviction. His post gave him the opportunity to elaborate a thorough system of teaching, which he outlined in a letter addressed to Lord Meadowbank, chairman of the Board.

While advocating a carefully prepared syllabus to which students should work—a proposition that was new in art teaching—Dyce also held the view that the teacher should work together with his students in the manner of the Italian masters with their apprentices. His school was to consist of two main departments, one for form and the other for colour. Gradations of colour and their relationship were to be demonstrated by means of a series of diagrams, which Dyce intended to prepare. It has to be remembered that colour theory was, at this period, occupying the attention of many artists, and Dyce's entire system was largely theoretical, the very antithesis of the older methods of the Italian guilds, which were severely practical and adapted to the needs of the individual.

The Board was sufficiently impressed with Dyce's proposals to forward them to London, which led to his being commissioned to visit the Continent and study methods of art teaching in Germany and France. His report on this tour, addressed to the President of the Board of Trade, led to his appointment in 1840 as director of the new School of Design.

Dyce lost no time in putting his syllabus into effect. The course began with elementary drawing, first in outline, both geometric and freehand, then in the round, meaning cubes or cones to be drawn with shading, and finally from natural objects. This mechanical progression in technique was characteristic of the academic teaching prevalent throughout the century. The next stage was described as "modelling from the antique and from nature". This presumably included drawing from the figure. Then came the course in colour—first copying coloured drawings and then working direct from nature. Finally, the student proceeded to his ultimate objective, design, which appears to have been confined to "the history, principles and practice of ornamental art", using examples from the antique, medieval and contemporary styles.[1]

Dyce was seeking to give art teaching a more scholarly and scientific basis than it had enjoyed hitherto. It was based on his own analysis of form and colour, but whether this purely theoretical approach was ever likely to bring out the artistic potentialities of his students is very doubtful. The student was expected to represent on paper what he knew rather than what he might perceive in the structure of the object or the human figure, and for this purpose hand and eye were trained to ignore ephemeral effects or individual characteristics. There was nothing particularly unusual in Dyce's system, but it demanded a more exacting artistic discipline than prevailed in the easy-going art schools of the time. It was

[1] Report of the Council of the School of Design, 1842-3.

in revolt against such a school as that of Henry Sass, where many students studied before proceeding to the Royal Academy.

W. P. Frith, who was a student at Sass's Academy in the 1830s, complained in after years that artists only turned to teaching when they were unsuccessful in selling their work. Art teaching was thus completely uninspired. Pupils were merely put through the usual conventional drill which was called "art teaching".[1] But the established painters made little effort to improve matters, and it was the young artists, like William Dyce, on the threshold of their careers, who tried to introduce some order and system into the chaos of art teaching in early Victorian times.

The School of Design provided daily instruction together with evening classes, and the number of students rapidly rose from only twelve, when the school was opened in June 1837, to 123 in December three years later. Students paid four shillings a week for the day sessions and one shilling a week for the evenings only, but it was found necessary to reduce the fees by half, and the Government's initial subsidy of £1,500 had to be increased to over £11,000.

We must be grateful to Dyce for establishing, in the face of opposition, the first art school for women in 1841. This was a branch of the School of Design, and was housed on the ground floor of Somerset House. The Council's report of 1842 explains that accommodation had to be found for the girl students "sufficiently distinct from the other part of the school", occupied by the male students. There was also the problem of the staff. The report reveals that "a competent instructress" had to be procured, "whose character might afford a sufficient guarantee for the moral welfare of the pupils". Apparently male assistants could not be entrusted with the school for women. The difficulty was obviated by the appointment of Mrs. McIan. While other teachers came and went during the next decade, Mrs. McIan stuck to her post, and even outlived the formidable Committee of Enquiry that was set up in 1847. At one stage in the life of the school Mr. McIan came to assist her.

Dyce's letter to Lord Meadowbank had recommended the holding of an annual exhibition of students' work together with the offering of prizes. With the formation of branch schools, which submitted examples of work to Somerset House, it was possible to carry out this proposal. There was, however, growing

[1] W. P. Frith, R.A., recorded his recollections of his student days in *My Autobiography and Reminiscences*, 1887. He and his fellow students were fond of their master, Henry Sass, with his queer, untidy ways, but feared his sudden outbursts of temper. Sass had prepared outline drawings of hands, feet, etc., taken from the antique, which the students copied. This was known as "drawing from the flat". The course of study proceeded as follows: "The young student, beginning with 'Juno's eye', was compelled to copy outlines that seemed numberless."
For the next stage of "light and shade" the student was set to draw "a huge white plaster ball standing on a pedestal. I spent", he tells us, "six weeks on that awful ball. Then came a gigantic bunch of plaster grapes, intended to teach differences of tone. . . . I felt weary and indifferent. I could feel no interest in what I was about. Perspective bewildered me and to this day I know little or nothing about that dreadful science."

criticism. It seems that Dyce was overbearing in his manner, and his system much too rigid; his assistants complained that he retained too much of the teaching in his own hands. In 1842, after only two years as director, Dyce decided to resign, but agreed to accept a new post of Inspector of Provincial Schools, of which a number had recently been opened. Dyce's old associate, C. H. Wilson, of Edinburgh, was appointed director in his place.

The maintenance of discipline among the students appears to have been a problem, and this is scarcely surprising, considering the wearisome character of the syllabus. Tightening of the rules was the new director's first task. There was to be "no talking or unnecessary moving about". There must have been complaints, since it was now laid down that the course of study must not be so prolonged "as to incur any danger of becoming too mechanical", though this was an evil "little to be apprehended". On the other hand, the new rules prescribed that the student might not move on from the elementary class "until he can draw with correctness". This inflexibility was the main fault, and was not to be the subject of reform.

By 1844 there were as many as 275 students on the roll. The original purpose of the school, to train designers for industry, was reaffirmed, and students were required to declare that they had no intention of becoming painters or sculptors. This separation of art from design was thoroughly mistaken, constituting one of the main reasons for the failure of art education.

Despite these administrative reforms, fresh critics emerged. Alfred Stevens and J. C. Horsley, the illustrator and future R.A., were now on the staff as assistants. Shortly afterwards they were joined by Richard Redgrave, the painter, subsequently a Royal Academician. All three voiced criticisms, and Dyce resolved to sever his connection with the school entirely.[1] It was complained that few students ever advanced beyond the course in drawing and that their main objective, to study design, was seldom reached. Clearly, the new director, Wilson, had not improved matters, since his rules made it more than ever difficult to progress beyond the elementary course in drawing. Probably the critics were not themselves fully aware of the real reasons for their dissatisfaction. The future would reveal that Dyce's retirement was a loss rather than a gain.

In 1847 criticism reached a point at which the House of Commons felt compelled to take action, and a Select Committee was set up to consider the future of the School of Design. Doubtless much mud was stirred by Henry Cole, a Civil Servant in the Records Office, through his activity in many governmental backwaters. Cole was possessed with an enthusiasm for art and a passion for administering artistic ventures, and was acquainted with many who could exert authority. He had already written to Earl Granville, then Vice-President of the Board of Trade, drawing attention to the need for a more practical objective and less emphasis on theory. But were his criticisms pointed in the right direction?

[1] Dyce's resignation may have been prompted by dissatisfaction, but also by the offer of the post of Professor of the Theory of Fine Arts at King's College the same year. One lecture was given, but little more was heard of this post.

Horsley, who was head of the figure class, was foremost in his criticism. We may judge the value of his views in general by his having objected to the male students drawing from nude female models. Moreover, he did not approve of women taking up art. Some years later he shocked an audience of teachers by declaring that "for women to attempt the highest walks of art is an utter mistake" and he would like to see an Act of Parliament prohibiting it.[1]

Henry Cole and Richard Redgrave were to the fore among witnesses heard by the Select Committee, and they did not attempt to soften their criticism. It was scarcely to be doubted that the future reorganization of the school would be placed in their hands, since they alone seemed sure of the course to be taken. But reorganization could not, by itself, provide the solution, which lay in reforming the character of the teaching.

Some delay was caused by the plans for the Great Exhibition at the Crystal Palace, to be held in 1851, absorbing the energies of many public figures from the Prince Consort downwards, including Henry Cole. The exhibition was to focus attention on the wide use of art in industry and had the same objective as the School of Design. In 1852 Cole was sufficiently free of other duties to take over as superintendent, and Redgrave was appointed head of the teaching staff, new premises being obtained at Marlborough House.

From this distance in time, it would appear that the main change lay in the name, which became "School of Practical Art". Thus one point of criticism was met in name if not in deed. While the system of teaching was scarcely changed, the organization was greatly augmented. With enormous industry, Cole set machinery in motion for organizing branch schools in all the main provincial towns.[2] There were twenty branch schools when Cole took charge. These soon increased to thirty-six and had nearly trebled twelve years later.

The new policy of the school was outlined in a letter Cole wrote to the President of the Board of Trade, Lord Taunton, in 1852. There were to be three practical objectives—to train teachers of drawing at the elementary level, to train masters for provincial art schools, and to provide training in the technical arts for industry. In due time the provincial schools were to provide the elementary teachers. Here we have the real fault: the good teacher must be an artist in the first place and ability to teach must follow.

At the opening of an elementary school at Westminster in June 1852, Cole had an opportunity of outlining the new policy. After commenting upon the "low state of art education", he assured his audience that the Government intended to "recognize for the first time the want of elementary instruction in art for all classes, and to assist the public in obtaining it".[3] Thus a national system of art education in elementary schools was proclaimed publicly for the first time as the official policy. But was it "art" that was taught?

[1] Transactions of the National Association for the Advancement of Art and its Application to Industry, 1890.
[2] *Fifty Years of Public Work of Sir Henry Cole*, edited by A. S. and H. Cole, 1884.
[3] "Department of Practical Art": Pamphlet issued by the Board of Trade, 1853.

Cole's plan envisaged the parochial authorities taking the initiative by setting up local committees of management. They were to provide some suitable building for the class. As long as they could guarantee at least "twenty male or female scholars for not less than three months", each paying sixpence a week, the Government would guarantee the teacher's salary. It would also sell "drawing copies, models, coloured examples" and art materials at half the cost price.[1]

These local institutions for art education, or technical schools as, in fact, they were, would be linked, wherever possible, with local Mechanics' Institutes or any other educational body, while the School of Practical Art trained the teachers. By this system, they hoped, as Henry Cole explained, "to lead the public to feel the want of beauty and propriety, to be sensible of their presence and impatient at their absence . . . to demand good designs in manufactures, and be willing to pay for them". It was intended "to introduce drawing as a necessary part of instruction into every school in the kingdom".[1] These pronouncements sounded well, but they alone could not produce good artists. Meanwhile the school proceeded with its task of training a body of professional drawing masters.

The promotion of a public interest in art was greatly helped by the enthusiasm of the Prince Consort. Most of the important artistic ventures undertaken by the British Government were closely associated with him and largely ceased on his death. It is not so often, however, that we connect the queen with an interest in art. Richard Redgrave's diary records an occasion when she visited the school. This was in 1853, when the first annual exhibition of students' work was held at Gore House, the Queen and Prince Albert being invited to the opening.

In order to add to the interest, Mulready, then at the height of his fame, generously agreed to lend some nude studies, which were displayed in a room separate from the students' work. An official, Mr. Caldwell, deputed to receive the royal visitors, was anxious to save the Queen from the shock of seeing this display of nudity. Henry Cole did not share Caldwell's anxiety, and he contrived that the door of the Mulready room was left half open, thus causing the Queen to catch a glimpse of Mulready's drawings. "What fine works!" she exclaimed, doubtless weary with inspection of students' painstaking studies of cubes, cones and scrolls. The embarrassed Mr. Caldwell, unsuccessful in his effort to close the door, was compelled to follow her and the Prince in a prolonged inspection. Mulready was so gratified by the Queen's praise that he begged permission to present her with one of the drawings.[2]

If Dyce's methods of teaching at the old School of Design may have seemed over-rigid, this was not the aspect that Cole and Redgrave purposed to reform. The general character of the course remained unchanged. Redgrave immediately set about preparing the drawing exercises which were for use at the branch

[1] "Department of Practical Art": Pamphlet issued by the Board of Trade, 1853.
[2] Recorded in F. M. Redgrave, *Richard Redgrave, C.B., R.A., A Memoir completed from his diary*, 1891, also recorded in *Fifty Years of Public Work of Sir Henry Cole*, 1884.

schools. They were to be copied first in outline and then with shading as in the past. These were followed by examples of foliage, flowers and the human figure, with some "explanatory perspective". Drawing direct from nature, either flowers or the human figure, with study of anatomy, was reserved for the advanced course, which also included designing "ornamental arrangements to fill given spaces in colour". Thus the syllabus revealed no essential differences from that established by Dyce.

The scope of the teaching at the branch schools is well revealed by the list of objects available for purchase:

one disc and two wires, solid cube, one wire cube, sphere, cone, cylinder, hexagonal prism.[1]

Casts included the following:

Twelve casts of hands, arms, legs and feet from the antique and from nature; two horse's legs from nature; two greyhound's legs; one lion's head; one goat's head.[1]

Books and charts were also supplied, including the Superintendent's public addresses, Burchett's *Definitions in Plane Geometry*, and Redgrave's *Elementary Manual of Colour*. All this was the stock-in-trade of a type of teaching which poisoned the art schools throughout the nineteenth century.

The pupil was given careful instruction as to his posture when drawing. He "should sit square to the desk" etc, the pencil to be "held freely but firmly between the thumb and the first and second finger". "Students (especially the younger ones)", so the instruction runs, "are apt to twist themselves about in strange positions . . . placing their head on one side with corresponding movements of the tongue".[2]

Discipline was tightened under Cole's administration. It was announced that "the master must not deviate from the course laid down, and the local Committee must not interfere without communicating with the Department of Science and Art."[1]

To avoid any misconception the rule was repeated: "The master must teach only from the examples and copies recognized by the Department."[1] Even the decoration of the school was prescribed in the Department's pamphlet—the walls to be "an olive green of neutral tint, which may be relieved by narrow lines of some more positive colour in the cornice".[1]

It is difficult to reconcile these rigid rules and mechanical system of teaching with the declared motives that inspired the policy of the school. If one had been present when Redgrave and Cole made their public addresses, one would have

[1] *Instruction in Art: Directions for establishing and conducting Schools of Art and promoting general education:* Issued by the Department of Science and Art, October 1855.
[2] John Bell, sculptor, *Outline from outline or from the Flat*, issued by the Royal Society of Arts, 1852, and recommended for use by the School of Practical Art. It was intended as Manual No. 1 of a projected series entitled *Rudimentary Art*.

truly felt that the needs of art education were to be fulfilled. "Everywhere there is evidence of an awakened desire for art education", announces Redgrave in an address delivered at the school in 1853. Their aim was "to form an audience fitted to understand" and "to give to all a knowledge of form as a means of expressing their thoughts". Those concerned with art teaching must have felt reassured to hear that drawing "has a valuable bearing on general education, since it greatly stimulates and improves the general perceptive faculties".[1]

Cole was not far behind Redgrave in the expression of these ideals: Their work was to lead towards

> improving and beautifying the objects of everyday use . . . to greater symmetry of form, increased harmony of colour . . . more beautiful and therefore more useful.[1]

Did they anticipate that the school under their direction would fail to "improve and beautify", that "harmony of colour" would decrease and form become neither "useful" nor "beautiful". They certainly knew why art should be taught, but did they know how to teach it? Their mistake lay in creating a professional body of "art" teachers instead of producing artists.

Ruskin was almost alone in opposition to the official programme, which was, in his view, "to enable the pupil to design rapidly and cheaply for manufacturers".[2] Addressing their teaching "so definitely to the guidance of the artisan" was responsible for its being "so little acknowledged by the general public, especially by its upper classes".[3] If we take sides with Ruskin, we can only regard Dyce, Cole and Redgrave as hypocrites. Ruskin had in mind Redgrave's *Manual of Colour* when facetiously suggesting that art would be helped if a tax could be levied on all cakes of colour, except black, prussian blue, vandyck brown and white. "I believe", he concluded, "such a tax would do more to advance real art than a great many Schools of Design."

[1] "Department of Practical Art": Pamphlet issued by the Board of Trade, 1853.
[2] J. Ruskin, *The Elements of Drawing*, 1857.
[3] J. Ruskin, *Education in Art*, 1858.

Art in Local Examinations—
Acland, Dyce and Ruskin

A R T teaching was bound to acquire an improved status in general education as a result of the local examinations which the universities and other institutions were now being urged to adopt. As a subject for examination, art would obtain a respect seldom received from schools hitherto, although methods of teaching might show no improvement. By contributing, even in a small way, towards the gaining of a certificate or other evidence of education, its place, albeit a modest one, in the school curriculum was likely to be safeguarded thereafter.

These considerations underlay the discussions that preceded the local examinations. Strangely enough, more thought appears to have been given to the role that art and music might play in the scheme than to any other subject. The ultimate decision to try out the inclusion of art was of great significance from our point of view, since the effect of working for examination results—however much to be deplored in many ways—with the prospect of a certificate which might prove of inestimable value in after life, was bound to influence art teaching thenceforward.

The first school-leaving examination was organized by the College of Preceptors; this was in 1850 at Nottingham for a private school run by one of its members. The College had been founded four years previously, following a meeting of the masters of private secondary schools, but its local examinations with the grant of a diploma, were not fully launched until 1853; the attendance of a few hundred candidates was secured from among prospective teachers.[1]

These examinations were to promote improved education for the middle classes and establish recognized standards by which they could evaluate it. This was put very concisely by one of the pioneers of local examination:

> It is evident that in the absence of some public test, the parents, a body of
> men habitually engaged in manufacturing, buying and selling, are not, as a

[1] There is no evidence of art having been included among the subjects for the College's school-leaving examination for at least a decade, by which time other institutions had entered the field.

class, good judges of the merit or demerit of the education they pay for, till, too late, they judge by the result in after life. They require professional help.[1]

The whole concept of labels by which education was to secure its guarantee was the product of the Industrial Revolution and the Reform Bill of 1832. The new middle class was reared in the fierce atmosphere of individual and commercial competition. The members of this class in general, at the beginning of the century, may have had little knowledge of the possibilities of educational privileges or Church and Crown patronage in the field of art or letters, but they knew how a man might rise in wealth or status by his own unaided efforts. The ultimate value of verse-making in dead languages may have passed them by, but they believed with Jeremy Bentham in the importance of useful knowledge. They were becoming more than ever impatient with the inadequate, confused and entrenched system of secondary education which they saw around them— inadequate, because the population was swelling, with only nine established public schools but a great number of endowed schools, often paralysed in their curriculum by reason of these endowments, with only two established universities in England, largely devoted to the clergy.

The institution of local examinations was part of the general reform—the introduction of competition through examination for places in the Civil Service, together with the recommendations of the Royal Commissions of 1852 and subsequent Acts of Parliament which removed many long-established restrictions at Oxford and Cambridge. But chiefly there was the growing power of officialdom to be seen in the expanding functions of the Committee of the Privy Council, which exercised some degree of control over education through its grants and inspectorate. But education remained mainly dependent on institutions like the College of Preceptors and the Society of Arts, and it was these institutions that first introduced local examinations.

The Society of Arts had enjoyed a long experience in examining art-work, with competitions held, as we have seen, since the preceding century, though on an entirely different basis from those now to be envisaged. First steps were taken when the Society, at the suggestion of their member, Mr. H. Chester, decided to form a Union of Mechanics' Institutes, located in various parts of the country, with the aim of organizing an examination for their benefit. Tests were to be offered in eight main subjects, of which "the fine arts" were to constitute one. The first examination was announced for March 1854, but it was planned, apparently, in too much of a hurry, for only one candidate—a chimney sweep— offered himself, and it was postponed until the following year. The Society was, therefore, the pioneer in holding a public examination in art.[2]

[1] Sir T. D. Acland, *Some account of the Origin and Objects of the New Oxford Examinations for the title of Associate of Arts and for the Certificates,* 1858.

[2] The art examiners were John Bell and F. S. Carey. The latter was a successful art teacher, having taken over Henry Sass's Art School, when Sass retired in 1840. John Bell, a sculptor, had recently written *Outline from Outline* (referred to in the previous chapter), on behalf of the Society of Arts. As the first of a series for beginners in

11. *a.* Crome's pupil, Louisa Gurney, Charlecomb, *c.* 1803
 b. John Crome: The Pool

The use of the title "Fine Art" gave the examination a most promising start, but, alas, it was inexplicably abandoned in 1855 in favour of "Freehand Drawing". Thus Fine Art made its transitory appearance on the stage, never again to emerge as a title in any public examination until well into the present century. Henceforward, the title is "Drawing", with all the limitations in aim and scope that the word implies. This decision probably did more to hinder the advance of art teaching than any other.

The Society's inclusion of drawing in its examinations was, moreover, short-lived, for in 1860 it was dropped so as to leave the field clear for the Department of Science and Art, with its School of Practical Art, previously the School of Design, which had meanwhile organized a national examination in art through its provincial branches. Members of the Mechanics' Institutes who wished to obtain a certificate in art were able to sit for the Department's examination, but this was mainly technical in character rather than educational. The work had to be sent to London for examination, where it was available for inclusion in the annual exhibition held at South Kensington.

Thus art might well have faded out altogether as a subject for examination in general education and, in consequence, from the secondary-school curriculum, as distinct from the technical institutions, if it had not been for the untiring efforts of Ruskin's friend, Thomas Dyke Acland. As a member of a family which had long figured in the public affairs of the West Country, Acland held liberal and progressive views—he was a Liberal Member of Parliament during Sir Robert Peel's Ministry—and his wide range of interests fortunately included art.[1]

Acland set himself the task of organizing a Middle Class School Examination for the West of England, to be sponsored by the Bath and West of England Society for the Encouragement of Agriculture. The idea was based, as he admitted, on the Society of Arts' examination but, as he explained in the preliminary announcement of the examination in April 1857, he did not intend "to offer a system of education, but only examination in the results of instruction". The scheme was to be a trial which, if successful, might be extended. He proposed to "test the value which the middle ranks may be disposed to attach to certificates if awarded by competent examiners".[2]

The "middle ranks" certainly required to become accustomed to the idea, but once they had done so, they attached an ever-increasing importance to the

art, it was "to assist in placing the rudiments of drawing, as a part of general education, on somewhat the same footing as those of reading, writing and arithmetic".

[1] T. D. Acland subsequently succeeded to his father's baronetcy. His younger brother, Henry (subsequently Sir Henry, Regius Professor of Medicine at Oxford), was Ruskin's fellow undergraduate at Christ Church, Oxford, and his close friend for many years.

[2] Sir T. D. Acland, *Middle Class Education*; the scheme of the West of England Examination and prizes to be carried into effect with the assistance of the Rev. F. Temple and J. Bowstead, Esq., under instruction from H.M. Committee of Council on Education, etc., April, 1857.

gaining of certificates, until today these have become, unfortunately, the essential passport to a prosperous career.

In the discussions that preceded the launching of the scheme much emphasis was laid on acquiring an appreciation of art as opposed to mere technical skill. This concern with the educational aspect of art was symptomatic of the wide public interest in art that had been aroused by Parliamentary discussions during the 1830s and 1840s. Very few, however, among scholars or those engaged in public affairs have rivalled Acland in his anxiety to bring about "a closer alliance between general education and art". He wanted art recognized "as a branch of a liberal education by the side of literature and science".[1]

There was, however, as in the past, the deep conflict of view between theory and practice. The broad artistic aims aired so freely in discussion were allowed to evaporate when the examinations were actually launched. The examinations as framed did not correspond in the least with the professed aims in holding them. The art syllabus that was eventually drawn up merely reflected the conventional and uninspired methods prevalent in the worst type of teaching during the nineteenth century, methods which did nothing to promote the appreciation of art which Acland sought so vigorously.

It proved to be a cardinal mistake to adopt in respect of art, as the examining institutions did, the principle that the syllabus should follow the normal school curriculum rather than help to determine it. This rule resulted in the examining bodies introducing no improvement in the methods of art teaching. On the contrary, the very rigidity of the examining system, operating on a large scale, precluded any rapid change, even when deemed desirable. Thus the methods of teaching current in the 1850s became congealed and improvement was hindered rather than assisted when the examinations were in full swing.

The West of England Examination, confined to the three counties of Cornwall, Devon and Somerset, was held at Exeter in June 1857, during four days. One hundred and twenty candidates had entered their names and all except thirteen presented themselves at Exeter, some of them having walked thither from far-distant homes, taking several days to make the journey. Such was the general determination of candidates to avail themselves of the offer of a certificate.

Art was one of the subjects for examination, though not obligatory.[2] Its inclusion was entirely due to Acland's insistence, to a degree that must now seem astonishing, on art's educational value. The preliminary announcement of the examination had proclaimed the encouragement of art and music as one of the main objectives, and Acland devoted much of his subsequent report to his reasons for their inclusion.

In introducing the scheme Acland described art as "a special subject . . .

[1] *The New Oxford Examinations*, T. D. Acland, 1858.

[2] About one-quarter chose drawing as one of their subjects. A minimum standard had to be reached in either mathematics, language or history, and candidates had to pass in religious knowledge.

one of immense importance in a densely peopled, highly civilized country. In the proposed examination", he proceeds, "prizes are offered to encourage the study of art, both as a branch of mental education and as a means of material and economical advancement."[1] In this statement we see the basic conflict we have referred to, which had hampered art education hitherto. The purely cultural objective had to be combined with the possibility of profit by improvements in trade. These two different objectives could not be satisfactorily united. To teach boys or girls the appreciation and knowledge of art as the visual means of expressing ideas involves a procedure quite different from teaching them to make good working drawings or designs for trade or industry, and in practice the former always gives way to the latter. Men of culture, like Acland, in the mid-Victorian era, valued art for its own sake, but felt that they could not justify its inclusion in a school curriculum or in examinations unless it could be shown to be also economically profitable. This was the tragedy of Victorian art teaching.

A syllabus for the drawing examination at Exeter was announced in advance. It included a preliminary test, which was purely theoretical, requiring written answers; this was obligatory. There followed five other tests covering geometry, perspective, drawing from models and memory, together with some optional questions on design. Candidates were divided into two groups—Juniors under fifteen and Seniors over fifteen but under eighteen. The examination was the same for both, but a higher standard was expected from the seniors.

The influence of the old School of Design was evident in many of the questions set.[2] The emphasis was, alas, on technical knowledge essential for the artisan but not for the artist. This was apparent in the preliminary test, which might have catered for the aesthetic interests of the candidates. On the contrary, its questions, based on Redgrave's *Manual of Colour* and excellent in themselves, were obviously set for the would-be industrial designer. They could not test artistic talent.

1. What are primary colours? How are tints and shades produced?
2. What is meant by complementary colours?
3. In what proportions must yellow and purple combine to neutralize one another?
4. How do colours modify each other when put side by side?
5. What is the use of white or black edgings round ornamental forms on white or black backgrounds?

[1] This was written before the examination had taken place. This and subsequent quotations are from *Middle Class Education* reprinted in *The New Oxford Examinations*.
[2] The paper was set as follows:
 I. Freehand drawing in one hour: Copy in pencil the daffodil illustrated in outline, enlarging it without instruments to about one-third above the original size.
 II. From solids: (i) Group a few blocks of wood according to your taste and draw them. (ii) Draw an egg.
 III. From memory: Draw one of the following—table, cup and saucer, door, gate, cast, boat, anchor, tree, flower, horse, dog.
 IV. A test in geometry [a series of questions follows].
 V. Perspective: Draw a chess board, a flight of steps, a circle horizontally, an elevation of a cottage or colonade, and then draw it in perspective.'

Since painting was not tested in the examination, we may well question the value of written answers unaccompanied by any evidence of a sense of colour.
The mechanical approach to drawing, so prevalent at the time, was shown in the choice of subjects prescribed in the syllabus—triangles, oblongs, circles or "common objects such as a block of wood, a box, chair, table, leaf or plaster cast". Only the test in memory included any natural objects, such as a plant or an animal, but the human figure was nowhere mentioned. In memory alone was the candidate allowed any freedom. The syllabus stipulated:

> Candidates may select subjects themselves and draw in any way and with any material they may prefer.

Although choice was actually limited to eleven different subjects, this part of the syllabus showed a degree of liberty that was never equalled in any other examination for the remainder of the century.

Curiously enough the syllabus did not specify a test in drawing from the flat, which meant copying an outline reproduction. This was, however, the very corner-stone of Victorian art teaching, and its inclusion among the questions, however much to be deplored, was inevitable with the influence of the School of Practical Art in the background. The test was called "Freehand Drawing", because the copy had to be made without use of ruler or compass. In all other respects freedom did not enter into this test.

Candidates had the option of taking some additional questions on design, combining written answers with practical work:

> (i) Show by drawings the different styles of ornament suited to wood, stone, iron, gold. What is the real use of flowers or other natural objects in the ornamentation of flat fabrics, such as carpets? Is the hexagon or the square the best element of composition?
>
> (ii) Draw a pattern for a carpet or a paper using either geometrical forms or a flower. Which is the most retiring and which the most advancing colour?
>
> (iii) Draw a design for a railing or a balustrade in wood, iron or stone.

The questions failed to stipulate any working knowledge of these crafts and revealed the prevailing neglect of overall design in favour of ornamentation.[1] Victorian objects were overloaded with decoration which often merely served to conceal weak design. This failure to design in relation to function was encouraged at the beginning of a pupil's training.[2]

The fulfilment of Acland's artistic and educational aims was doomed from the outset by his reliance on the local representative of the School of Practical Art, Mr. Wigzell, master of Exeter School of Art, who was invited to examine the

[1] The purely decorative approach is indicated in the books to which candidates might refer: Owen Jones' *Propositions on Decorative Art,* and Lindley's *Symmetry of Vegetation.*

[2] Owen Jones' monumental work, *The Grammar of Ornament,* produced in 1856 with its elaborate plates in colour, sought to show, however, that ornament in past ages was beautiful only "because it was appropriate". It contributed considerably to the deeper understanding of design.

work. In addition, George Richmond, the friend and admirer of William Blake, and C. R. Cockerell, R.A., Professor of Architecture at the Royal Academy, who had both served on the Council of the School of Design, were asked to advise and report on the results of the examination.

We cannot now ascertain the methods employed in examining. We may presume that such qualities as precision and neatness in handling the pencil were looked for, together with mechanical accuracy rather than observation. As regards the questions on design and colour, presumably the answers were expected to conform with Redgrave and the other authors recommended. We are told in the report that candidates were placed in two categories—"fair" and "deficient". We learn that three-quarters of them were classified as "deficient". One candidate, George Bassett, was commended.

This West of England Examination was unimportant in itself, judging by its relatively small scale and short life. Its significance, on the other hand, was considerable in so far as it served as a trial experiment, with a view to persuading the universities to adopt a similar scheme. In fact, Acland announced it as "an experiment which is being tried in one corner of the Island under somewhat favourable circumstances". With his eye on Oxford and Cambridge, his announcement asked pointedly "whether our elder Universities are not in a position" to give "an impulse and a right direction to general education". He offers the hint that "the advantages which have hitherto been confined to the wealthy" might thus be extended.

Acland did not hesitate to expand this pressure into the realm of art:

> The Universities might render great assistance to the people at large in this matter of art [he proceeds]. . . . The study of the history and practice of art . . . is still a want of our time.

Acland amplified his point when thanking Richmond for looking over the drawings at Exeter; his letter pointed out "how much the nation would benefit, if men of liberal education, generally, knew enough of the objects and principles of art to have some safer guide . . . than their own uninstructed predilections".

To a man of Acland's high intelligence it was obvious that a knowledge and appreciation of art should contribute to the enjoyment of life generally, which was more important than the acquisition of technical skill. His letter proceeds:

> When we consider how the impressions of every child and schoolboy are now affected by the arts of design and music, it seems truly wonderful that anyone should think of passing over the subject of art in plans for education for the middle rank. Yet a strange indifference to the bearings of this question still prevails in some quarters.

It seems to have been generally assumed that only "the middle rank's" appreciation of art was thus neglected. In actual fact it was the "upper rank" that was too often a prey to "uninstructed predilections", as Acland had put it. It was disastrous to art teaching that so little attention was paid in the scholastic

sphere to Acland's "desire to draw closer the links between the arts and the other branches of education".

Acland was essentially the initiator rather than the specialist. He knew how to tap the right source of influence, but not necessarily the best advice. He was a victim of his own thesis that the artist and the scholar "have not learnt to speak a language common to both". Unhappily, art examining was launched in a form which had very little in common with either.

The Rev. F. Temple, Inspector of Schools and subsequently Archbishop of Canterbury, was nominated by the Privy Council to advise Acland in setting the papers and examining at Exeter. Temple had reservations about the value of teaching art, but gave Acland his full support. On the conclusion of the Exeter examination, in July 1857, considerable correspondence ensued between them and their advisers as to the character that future art examinations ought to assume. In a letter of the same date, addressed to George Richmond, which was also repeated to Dyce and Ruskin, Acland stated the problems on which their advice was required.

1. Should we trust exclusively . . . to literature and science; . . . or should art itself be the subject of special reward and encouragement?
2. Supposing it is decided that art is to be distinctly recognized as a subject of examination, should it only be allowed to enter as one among many elements of a good general education? Or should only those with so-called genius in art be rewarded?
3. Should examination be confined to what young men can do (i.e. draw) or show what they have learnt from books about art, its principles and history?

Such questions as these still trouble us, and it may be of considerable interest to us, today, to note the answers given by eminent figures in the art world of over a century ago. George Richmond, not given to lengthy exposition, obviously found the questions academic but replied that "the step now taken" had his full support. William Dyce, on the other hand, expressed the artist's point of view at considerable length in three letters. Emphatic that art should be treated as "one of the elements of a good general education", he was equally positive that it must be separated from literature and mathematics, with which it had been linked during previous centuries.

Dyce's main consideration was that the examiner's concern should be with "art" rather than merely "drawing". This point had never been sufficiently emphasized hitherto. "Instruction in art, as a matter of general education", he writes, as distinct from "a certain amount of teaching in drawing, is at present a blank in our system". He held the view, so seldom advocated, that "if you merely content yourselves with noticing approvingly the power of drawing . . . you will have done nothing whatever for art as art . . . only encouraged a useful accomplishment." Such views could not have been more hopeful for the future of art education, but they were never put into practice.

Why was this? In the Victorian concept, "art" lay in the message that a

picture might convey, often a literary one, rather than in its visual expression and execution, which was conventional.

Dyce's reliance on theory rather than practice is sufficiently revealed by his reply to Acland's third question:

> My own idea [he writes, is to have] less regard to mere skill in drawing than to general information about art.

Acland had suggested that any art criticism that candidates could offer would only be a second-hand retailing of other men's views. Dyce retorted promptly:

> Surely boys are not expected to provide original views. Examine not only what they can do but also what they know about the Arts.

Dyce's point of view is clearly shown in the examination scheme he now put forward. Drawing, together with some painting, should be confined to one of three tests, and therefore reduced in importance. The other two should comprise a practical test in design and a theoretical test in the history and principles of the arts. His concept of "instruction in art" as distinct from merely drawing was obviously incorporated in this latter test.

We turn now to John Ruskin, whose future eminence in the world of art was already foreshadowed by his publication of *The Stones of Venice*. Acland had declared that there were "at least three parties contending in England for mastery in the guidance of the Arts". There was firstly the Royal Academy, where "the traditions of the past and the tastes of the dilettanti find expression"; then there were the Schools of Design under the Department of Science and Art with its "doctrinaire adherence to abstract principles" (a reference, perhaps, to Dyce); and thirdly there was "Mr. Ruskin and his pre-Raphaelite allies—a considerable force of irregulars". Dyce, on the other hand, had ranged Ruskin with "the Oxford men", in opposition to the professional artists, such as Dyce himself, although it was he, rather than Ruskin or "the Oxford men", who demanded a reduction in drawing or painting in favour of theory and history.

Ruskin was brought into the discussion by Temple. There was every justification for consulting the former at this time, as he was actively engaged in the problem of relating art to education. Three years previously, in 1854, when Rev. F. D. Maurice had founded the Working Men's College in Bloomsbury, Ruskin had offered to take an evening class in drawing. Lowes Dickinson joined him, and when Ruskin's close friend Gabriel Rossetti offered to teach they divided the work, with Rossetti teaching figure drawing one evening, while Ruskin and Dickinson took the elementary drawing and landscape class on two evenings.[1] William Ward and Ebenezer Cooke, among their pupils, subse-

[1] R. H. Wilenski, in *John Ruskin*, 1933, asserts that he was "handicapped by his lack of official status. He was treated as an amateur and his comments were clearly regarded as unjustifiably pretentious." He records that when Ruskin was explaining his views to the Trustees of the National Gallery the chairman asked what was his position. Ruskin could only reply, "I am master of the elementary and landscape school of drawing at the Working Men's Institute." This was, in fact, the only post he had held at that time.

quently assisted in the teaching. The former recorded that Ruskin used to introduce natural objects, such as minerals and shells, and on one occasion "sent a tree to be fixed in a corner of the classroom for light and shade studies". On another occasion he "took for his subject a cap and, with pen and ink, showed how Rembrandt would have etched it".[1] These were revolutionary methods.

Ruskin had just completed his treatise—*The Elements of Drawing*[2]—which embodied his methods for beginners, and made it obvious that his advice regarding the new examinations would be unconventional. In reply to Acland's query whether boys should be asked to give answers based on the reading of books, Ruskin was in general agreement with Acland and opposed to Dyce. He offered the view that the retailing of received opinions is "useless if not harmful".[3] On the other hand, he agreed with Dyce that boys should not be expected to give their own opinions on art. "A sound criticism of art is impossible to young men", was Ruskin's reply. That was as far as agreement went.

Ruskin was an authoritarian. He believed there was only one correct opinion on the merit of a work of art. The student should not merely learn the opinion but understand the reason that produced it. He recommended that a student should be shown, for example, a Dürer engraving and be told as follows:

> That is good whether you like it or not, but be sure to determine whether you do or do not and why?[3]

Respect for authority was the core of Ruskin's concept of good art teaching. In his paper on *Education in Art*, read to the National Association for the Promotion of Social Science, the following year, he amplified this point of view.[4] The student must learn

> that good drawing is good, and bad drawing bad, whatever any number of persons may think or declare to the contrary—that there is a right or best way of laying colours to produce a given effect . . . and that Titian and Veronese are not merely accidentally admirable but eternally right.

In the mid-nineteenth century, with its industrial expansion and incipient social and labour conflicts, respect for authority and discipline was demanded. There was no liberty of self-expression in the factory or in the home. Ruskin saw in art the satisfaction that comes from such submission to mental discipline, though it may well be questioned whether he applied the principle to himself. Creative effort made discipline acceptable. The one could not be achieved without the other. Hence throughout Ruskin's writings we find continual moral exhortation. Such precepts as "wholesome study", the "reward of toil", the "need of labour" constantly recur. The child who "shows talent", we are told in *Elements*

[1] W. G. Collingwood, *The Life and Work of John Ruskin*, 1893, and recorded by William C. Ward in *John Ruskin's Letters to William Ward*, 1922.

[2] *The Elements of Drawing in three letters to Beginners, 1857.*

[3] Letter to the Rev. F. Temple, September 25th, 1857 (*The New Oxford Examinations*).

[4] Written in 1858, and published in *A Joy for Ever*.

of Drawing, must be praised "only for what costs it self-denial, namely attention and hard work".[1] Ruskin was prepared to combat the prevailing fear that artistic licence might gain the upper hand and thus weaken the bonds of discipline and promote vice, but he believed in restraint through discipline, and that caution in art is better than boldness.

Ruskin was thoroughly in harmony with Dyce in stressing "art" rather than the mere acquisition of skill in handling the pencil, a point of view which was persistently ignored by those in authority, even when advised by the two most distinguished art teachers of their time. While Ruskin was anxious that no incipient genius should remain undiscovered or, as he picturesquely phrased it, to "leave no Giotto among hill shepherds", he was mainly concerned to diffuse a knowledge of art "among those who are likely to become its patrons".[2] But thereafter agreement with Dyce ceased. The latter relied on the intellect, the study of the theory and principles of art; Ruskin demanded practice, constant practice.

Ruskin believed that the study of art was beneficial generally and should not be confined to those who intended it as their profession, but that it must be studied seriously or not at all. In his view, "the kind of drawing which is taught, or supposed to be taught, in our schools, in a term or two, perhaps at the rate of an hour's practice a week, is not drawing at all".[3]

Many are unaware of their own ignorance in art. Ruskin insisted on this in his paper, *Education in Art*:

> It is impossible to make every boy an artist or a connoisseur but quite possible to make him understand the meaning of art in its rudiments, and to make him modest enough to forbear expressing, in after life, judgments which he has not knowledge enough to render just.

This was Acland's view as we noted above. Again, in *The Elements of Drawing*, Ruskin emphasizes the value of art appreciation:

> It is a more important thing, for young people and un-professional students, to know how to appreciate the art of others, than to gain much power in art themselves.

He constantly recurred to this point, deploring the want of an "enlightened judgement of art in our upper and middle classes", for which education was to blame.[4]

Ruskin parted company from the art teachers of his time, including Dyce, over the type of drawing to be encouraged. It was not so much the method of drawing as the choice of subjects. He was prepared to see the time-honoured

[1] In *Art School Notes*, addressed to the Mansfield Art Night Class, in 1873, some fifteen years later than the period we are dealing with, Ruskin forcibly repeated this authoritarian viewpoint: The youth must discern not only "what to admire", but equally "whom to obey."

[2] Letter to Temple (op. cit.)

[3] *The Elements of Drawing*, 1857.

[4] J. Ruskin, *Inaugural Address at the opening of the Cambridge School of Art*, 1858.

cones, boxes, cubes, etc. omitted altogether from the examination syllabus, and thus from art teaching generally, though he failed to get his proposal adopted.

Ruskin's opposition to the drawing of cubes and cones had been conveyed in *The Elements of Drawing*:

> I believe, though I am not quite sure of this, that he (the student) never *ought* to be able to draw a straight line. I do not believe a perfectly trained hand ever can draw a line without some curvature in it or some variety of direction . . . A great draughtsman can, as far as I have observed, draw every line *but* a straight one.

Alas, we find those who were to frame the subsequent art syllabus of the universities proceeding on precisely the reverse assumption.

In the drawing of man-made objects the study of perspective is often involved. This provided an added reason for Ruskin's opposition. He held the view, widely accepted today, but very unfamiliar in his own day, that "no great painters ever trouble themselves about perspective, and very few of them know its laws; they draw everything by the eye". He added:

> Turner, though he was Professor of Perspective to the R.A., did not know what he professed and never, as far as I remember, drew a single building in true perspective in his life.[1]

Here again, we shall find the examining authorities adopting the contrary advice.

Almost alone among art teachers of the period, Ruskin placed his entire emphasis on the drawing of natural objects. This was not so much for improving the pupil's ability to draw as because it trained the powers of observation. The manufactured object, such as a box or a cone, could be drawn by calculation instead of using direct observation.

Ruskin believed that the pupil must love nature if he was to draw well.

> I would rather teach drawing [he wrote in *Elements of Drawing*] that my pupils may learn to love nature, than teach the looking at nature that they may learn to draw.

In *The Stones of Venice* he describes nature as "the mother of art" and adds that its "study is art's act of filial devotion". He wished the study of natural history to go hand in hand with art. In his paper on *Education in Art* he proposes a typical lesson, or series of lessons, for an elementary school, that would thus combine these two subjects:

> Draw such and such a flower in outline, with its bell towards you. Paint the spots upon it. Draw a duck's head—her foot. Now a robin's—a thrush's— now the spots upon the thrush's breast. . . .
> The student's aim should be absolutely restricted to the representation of visible fact.

[1] *The Elements of Drawing*, 1857. Nevertheless, Ruskin was inconsistent; two years later he wrote as an appendix *The Elements of Perspective*.

Such a course of study would train the boy to use his power to observe and store up his impressions in the memory:

> Look much at the morning and evening sky [he counsels the pupil], and much at simple flowers . . . as nature arranges them in the woods and the fields.[1]

The pupil is recommended to avoid the picturesque, which inevitably led to the expression of a false impression of nature. He is urged to go further:

> Choose rough, worn and clumsy looking things as much as possible. Everything that you think very ugly will be good for you to draw.[1]

Ruskin analysed the function of good drawing to an extent never attempted by previous teachers. Hitherto the latter had been content with accuracy in rendering the contour. Ruskin refused to halt there. The expression of form is the main objective, since "all drawing depends, primarily, on your power of representing roundness". Teachers of the period must have been horrified to read his advice that their pupils should try drawing an ordinary stone.

> Get the stone to look solid and round [he urged], not much minding what the exact contour is. . . . You will get it more right by thus feeling your way to it in shade, than if you tried to draw the outline at first. For you can see no outline.[1]

Such advice on how to express, rather than merely imitate, form could not be bettered, yet how seldom had it been followed in schools?

Then there is the insistence on relating the object to its background, an aim so often overlooked at schools. Ruskin's advice is delightfully explicit:

> Always draw whatever the background happens to be, exactly as you see it . . . ugly or not: else you will never know whether the light and shade are right.[1]

He might have explained farther that the form of the object cannot be conveyed without relating it to the background.

An eminent educationalist has described Ruskin as "in some ways the greatest indirect force in education".[2] On the other hand, an equally eminent art critic opens his chapter with the words: "Ruskin's art criticism, as it stands, is an appalling muddle."[3] It was perhaps as much due to the vigour and novelty of his views as to their general confusion from a practical point of view that they were so seldom adopted. His proposals for an examination syllabus contained ideas that were far in advance of anything proposed either before or for the remainder of the century, but it would have needed another genius to put them into a practical form.[4]

[1] *The Elements of Drawing.*
[2] R. L. Archer, *Secondary Education in the Nineteenth Century*, 1921.
[3] R. H. Wilenski, *John Ruskin*, 1933.
[4] In his letter to Temple, regarding a suitable art syllabus for the proposed examination, Ruskin suggested the following:
> 1. Sketch such and such an object (e.g. a bird, drapery, foliage) in light and shade, in half an hour.
> 2. Finish a portion perfectly, irrespective of time. *(continued overleaf)*

Let us consider the fate of some of these admirable suggestions. Ruskin would omit drawing from the flat and drawing of objects from memory. But both tests, as we shall see, were subsequently adopted by the universities, and were not dropped until recent years. He also proposed to omit tests in perspective and to substitute drawing of natural objects or drapery, but this advice was similarly ignored.[1]

As regards design, Ruskin insisted that ornament be treated in relation to a given place and purpose. This was very different to the meaningless "space-filling", so generally encouraged until recently. But chiefly important, Ruskin was the first and only advocate of a test in picture-making or imaginative composition, as we would describe it today, which was generally neglected.

A prominent place was given in his syllabus to the actual use of colour. No other teacher since Rousseau had advocated letting children employ colour freely. Hitherto the child was expected to go through a laborious drill in outline drawing before being allowed to handle paint, which was confined to a few neutral tints. Moreover, colour and form were relegated to quite separate compartments of study. This was not Ruskin's method. He rightly regarded colour and form as inseparable, pointing out that one cannot visualize a form-less colour, nor a colour-less form.

In *The Elements of Drawing* the author suggested that differences in colour are observed by children earlier than shape. For this reason he recommended that the child should be allowed to use paint and paper "almost as soon as it has sense enough to wish for them". He continues:

> As soon as it begins painting red coats on soldiers, striped flags to ships etc,
> it should have colours at command, and without restraining its choice of
> subject.

Nothing like this had ever been suggested, except by Rousseau, and it is regrettable that this advice was never adopted in the final framing of the syllabus.

Ruskin's examination syllabus contained one final proposal for testing the candidate's appreciation of art. Instead of demanding a discourse on the old masters derived from perusing books or listening to lectures, Ruskin wished him to discuss a contemporary picture of his choice. Needless to say, such a proposal did not appeal to the academic mind, and was never adopted.

Above all, Ruskin placed the artist on a pinnacle, as a figure of admiration

3. Sketch it in colour, in half an hour.
4. Design an ornament for a given place and purpose.
5. Sketch a picture of a given historical event in pen and ink.
6. Sketch it in colours.
7. Name the picture you are most interested in at the Royal Academy this year: State its merits, faults, with your reasons.

(T. D. Acland, *New Oxford Examinations*).

[1] He did not include figure drawing, basing this on the somewhat reactionary theory that figures cannot "be drawn to any good purpose by an amateur". (*The Elements of Drawing*.)

for the average man, but where we seldom find him today, and summarized his vision as follows:

> All work is done in the spirit of the artist, aims at the perfection of the artist, and announces the joy of the artist.

This joy of the artist! How little of it have we seen so far in schools and colleges. Did Ruskin's disciples still hope to find some joy surviving amidst the clutter of casts, cones and spheres, the T-squares and projections, which obstructed the course of any average Victorian boy or girl who sought to become an artist?

9

the "Locals" at Oxford and Cambridge from 1857

OXFORD was the first of the universities to institute local examinations in June 1857, catering for boys who did not have the prospect of a university education, but might benefit through examination on leaving school. It was to be conducted at local centres—nearly a dozen were to be formed at the outset—but was not to interfere with the system of instruction at schools. "The University", states the first examination report, "was only asked to test results, not to enquire into methods." Nevertheless, the methods of teaching were bound to be governed to a large extent by the examination results. It was some years before attendance at school was insisted upon and a system of inspection of schools established.

T. D. Acland and the Rev. Frederick Temple, the pioneers at Exeter, were among those appointed to the new Delegacy charged with administering the examination.[1] There were eight main subjects, to which drawing and music were "added on a somewhat different footing". The report explains:

> It was thought desirable to encourage them generally as useful elements in a liberal education, as well as to recognize any remarkable merit of this kind in individual candidates.[2]

This restrained encouragement was the highest contribution that the Delegacy could offer regarding the arts.

Unlike at Exeter, it was wisely decided to hold separate examinations for Juniors under fifteen and for Seniors under eighteen. Candidates had to provide their own drawing boards 23 in. × 16 in., eight drawing pins, T-square, set square and compasses, but not paper.

It is not recorded who prepared the syllabus in drawing for the first examination held in June 1858, but it certainly had merits that were lacking subsequently. Acland was a member of the committee which prepared the list of examiners, and presumably he suggested the artistic advisers he had consulted at

[1] Both retired from the Delegacy in 1878.
[2] *First Annual Report of the Delegacy to Convocation*, 21st December, 1858.

Exeter. At all events the same names appear on the roll of Oxford examiners, with the addition of S. Evans, art master at Eton. The Delegacy's minutes record that "Mr. Richmond and Mr. Ruskin were to superintend Drawing, Mr. Evans, Freehand Drawing, Mr. Dyce, Design, and Mr. Cockerell, Geometrical Drawing".[1]

The Senior syllabus was entitled "Drawing and Architecture", and divided into three sections as follows:

(1) Drawing from the Flat, from Models, from Memory and in Perspective.
(2) Design in pen and ink and in colour.
(3) The History and Principles of the Arts of Design: A fair degree of skill in freehand drawing will be required in order that a candidate may pass in this section.

Junior candidates were required to take only Section (1) of the syllabus.

This syllabus bears so little resemblance to the broad scheme proposed by Ruskin in his correspondence with Temple and Acland at Exeter that one can only suppose that he took very little part at first, though his influence is unmistakable later on. There is more evidence of Dyce's ideas, especially in the framing of Section (3) the Arts of Design, which, as it turned out, did not prove a success and had to be largely modified.

Dyce, in his letter to Acland the previous year, had appealed to the universities to "assign the arts a place of their own or else ignore them". In effect Oxford did neither. It did not ignore the subject, but allowed it only a minor position in the examination scheme and applied the term "Arts" to the design section alone. It soon appeared that the real emphasis lay on accuracy and neatness of drawing and this limiting approach subsisted for three-quarters of a century.

Section (1) of the syllabus, taken by the Juniors as well as the Seniors, required the setting of four separate question papers. For "Drawing from the Flat", a reproduction in outline was provided for each candidate to copy one quarter larger than the original. "Precise imitation and clearness of outline" was demanded. For "Drawing from Models", a cast of a human ear was supplied for each local centre, from which the candidates made two drawings, one in outline and the other with shading.[2] Here we have the first deviation from the Exeter examination. Such casts of parts of the human body, characteristic of art-school equipment, might have proved of some value for older students who had practised drawing the human figure, but for boys with no opportunity to do so it could be of little use. Their main need was to appreciate the unity and balance of the entire human figure. Such casts, however, continued to be provided for the next ten years.

[1] George Richmond, William Dyce, R.A., and C. R. Cockerell, R.A., Professor of Architecture at the Royal Academy.
[2] With the steady increase in local centres, it was decided in 1878 that "easily procurable objects" should be specified thence-forward.

For "Drawing from Memory", for which only one hour was allowed—less than half the time given for either of the other sections—as many as twelve alternatives were specified. The candidate was to "sketch" one or more of the following:

A box with lid raised; basin and ewer; table; cottage; house; dog; garden roller; boat; stem of tree; flower; ox; cart.

This was not a real test of memory, for the candidate could only have shown his knowledge of their appearance, not his actual recollection of how they appeared amidst natural surroundings or under particular lighting conditions. It is scarcely surprising that after inspecting the work the examiners reported:

For the most part, they appear to consist of recollections of prints, lithographs etc, rather than of the objects themselves, and show scarcely any trace of observation or thought.

It was the setting of the question that was at fault rather than the candidates. The memory question was dropped, and with it disappeared the candidates' only opportunity of exercising their visual imagination.[1] The final paper in Section (1) consisted of five exercises in the theory and practice of perspective, for which no time limit was imposed.

The Juniors were thus given no test in the use of colour, reflecting the prevailing belief, opposed by Ruskin, that colour was beyond the ability of younger boys. The Seniors, on the other hand, were offered additional alternatives, which enabled them to use the brush, although a full range of colour was not expected. These were either a shell to be drawn life-size with ink or sepia or a sketch of a rose in water-colour. Both were to be from nature. Here we have the first evidence of Ruskin's participation, for who else would have proposed the painting of natural objects, and the wording of the question is unmistakably his:

The light and shade of the form, as well as the variations of tint on the surface of the shell are to be rendered. The outline may be drawn with pencil or in any other way preferred, but the effect is to be given by the brush.

In Section (2), Design, which was for Seniors only, ten different crafts were specified for which the candidates were to make a design in pen and ink or in colour. Presumably they were to choose as many as they wished since the number was not limited, and they might introduce the human figure or animals into their designs. It is difficult enough to draw the human figure direct from nature, but boys who had never practised it would find it a formidable task to incorporate the

[1] The test in memory drawing at Oxford had a chequered career. It was reintroduced in 1880, but again dropped in 1893. It was again introduced in 1904, and again dropped, to be revived in 1912, for Junior and Senior candidates, of whom 435 chose it. The attitude of teachers and examiners seems to have been capricious. The examiners' report advised that it should not be "attempted without previous knowledge of the rules of Model Drawing", but this misses the whole purpose, which is to develop the memory of something seen rather than draw by rule of thumb something which has been constantly practised.

13. Dante Gabriel Rossetti, age 12: illustrations to Homer's *Iliad*, pen and ink, 1840

14. *a.* Cotman's pupil, Anne Martineau: Squall at Sea, pencil with Cotman's brush strokes in se

b. J. S. Cotman: Dun Otter Castle, with pin holes to aid his pupils in copying at King's College Sc

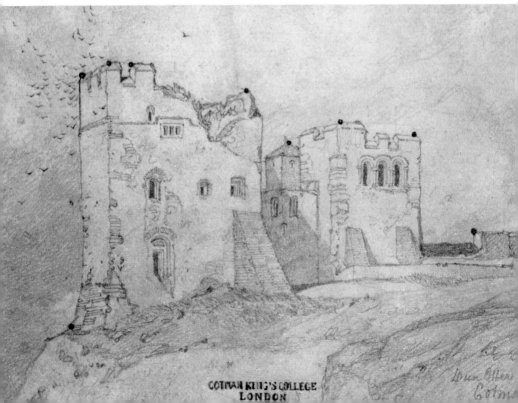

COTMAN KING'S COLLEGE
LONDON

human figure in a design, and it must have resulted in a mere repetition of conventional classical figures. No information was given as to the size, subject or other details which the designer needs to know, so that it was only to be expected that the examiners were disappointed with the results, and the paper, in this form was not set again.[1]

Section (3) of the syllabus, also for the Seniors, was perhaps the most valuable from the artistic point of view. "The History and Principles of the Arts of Design" constituted a written test, which we would describe as history and appreciation of art. The requirements were excessive, though the candidate was not expected to answer all of the twenty-four questions. However brief the answers might be, they covered a very wide range, requiring some familiarity with classical, renaissance and contemporary periods; the following may be cited as typical examples:

3. Mention the names of any ancient authors whose writings furnish us with information respecting Greek and Roman Art.

4. To what accident are we indebted for our knowledge of the great taste displayed by the Greeks and Romans, particularly by the latter, in articles of domestic use?

12. What modern nations, during the period lying between the 13th and 16th centuries, inclusive, have most successfully cultivated the arts of Design?

16. Who was the reputed inventor of oil painting? Give the supposed date of the invention.

Some of the questions were purely technical, such as "what is meant by warm or cold colour?" Finally, the candidate was to write on a contemporary theme, and it is instructive to note the type of aesthetic problem with which the mid-Victorian boy's mind was taxed:

Write a short essay on either:

23. Suppose it to be one purpose of painting and sculpture to produce successful imitations of external objects, to what higher ends ought this imitation

[1] The subjects set for Section (2) Design, were as follows:
1. An ornamental border for a title-page of a book to be engraved in wood.
2. A book-case with ornaments to be carved in wood.
3. The handle and blade of a bread-knife, the handle being carved in wood.
4. An embroidered cushion cover or table cover.
5. A porcelain flower vase.
6. A hearthrug, the border having a geometrical pattern, the centre with leaves and flowers.
7. A paper-hanging in three colours.
8. An iron gate or railing in wrought iron.
9. A candelabra in metal.
10. A glass water-jug or goblet.

to be subordinate? And what conclusion would you draw from your
answer, as to the artist's choice of a subject and his manner of treating it?
24. State any remarkable difference between Poetry and Painting, or between
Painting and Sculpture, with respect to the choice of subject?

This preoccupation with choice of subject was typical of the art of this period,
with its strong literary leanings, but it is essentially a problem which concerned
the trained artist. Could any schoolboy pretend to ideas of his own on such a
matter?

The examiners were surprised to discover that no more than fifteen, out of
rather more than one hundred Senior candidates in art, attempted this praise-
worthy but far too elaborate test in art appreciation. The character of these
questions points to Dyce as responsible for setting them. It was decided,
however, that a simpler paper, based on specific periods of art history, should
be set in future. Perhaps Dyce felt this to be a personal reflection, attaching such
importance, as he did, to the candidate's need for a wide understanding of all
the various aspects of art. At all events, he resigned and his name no longer
appeared in the list of examiners. With his departure, the examination lost much
of its higher, intellectual aspect.

Less than one-fifth of the Senior candidates in art for this first local examina-
tion at Oxford were judged worthy to pass, and only three gained Distinction.[1]
The examiners found in their work no "evidence of additional feeling and
progress" over that of the Juniors. They ascribed this to drawing "becoming
more generally included in the elementary course", whereas at advanced levels
"it is quite superseded by other exercises". But even the Juniors were unfavour-
ably reported upon, a large proportion falling "much below mediocrity".[2]

With nearly two hundred Junior candidates, which was approximately
double the number of Seniors, the art examination proved itself popular, since
this represented more than a quarter of all those who entered for the entire
examination. Moreover, it fulfilled its secondary objective—the recognition of
any remarkable merit—by reporting that the second-best candidate in both
sections was sixteen years old, a year younger than his rivals. The *First Report*
ends with the examiners' disappointing conclusions:

> Some attention to drawing is more or less spread over the whole country: But
> whether owing to misconception of the object to be aimed at, to a defective
> method of teaching, or to any other cause, the results except in a few places
> are unsatisfactory.[2]

One might have supposed that this severe criticism from men like Richmond,
Dyce, Cockerell and the art master of Eton would have made itself felt in educa-
tional circles. But the general methods remained unchanged, and those con-

[1] This low proportion of "passes" was much reduced subsequently, when it seldom
fell below 50 per cent. In 1887, as many as 85 per cent of the Seniors and 90 per cent
of the Juniors were allowed to pass, but this appears to have been exceptional, and
implies an absence of continuity in the standards of marking.

[2] Appendix to the *First Annual Report*, 1858; (previously cited).

cerned with examining made no further effort to improve art teaching for the remainder of the century.

While these four examiners were each paid a fee of five guineas, the minutes of the Delegacy's meetings do not record any fee paid to Ruskin, indicating that he had taken no active part in 1858, though he appears more prominently thereafter. For the ensuing year Cockerell dropped out as well as Dyce, so that the team was reduced to Ruskin, Richmond and Evans.[1]

No action on the examiners' findings could be put into effect until 1860, when Dyce's elaborate paper on the "History and Principles of the Arts of Design" was replaced by a simpler one in which the questions were founded on Wornum's *Epochs of Painting*, and the candidates were wisely notified of the periods to be examined. But these covered almost the entire history of art.[2] Even this modified paper lasted only four years, and the history of art was thenceforward excluded from the examination for the remainder of the century.

Of still greater importance in the art examination for 1860 was the replacement of the practical paper on design (Section (2)) by a much shorter paper offering three alternatives instead of ten. The syllabus was changed so as to read: "Design for an ornament or pattern or for a picture", one and a half hours being allowed. Questions were set as follows:

Picture: David with the head of Goliath.
Ornament: A chair
Pattern: An altar-cloth.

Here we have the first introduction in any public examination of a test in pictorial composition, with its recognition of the imagination in general education. This highly significant step in art teaching survived for the next twenty years, as we will note later, and, considering the attitude prevailing in educational circles at the time, we may well feel surprised that it lasted so long.[3]

In the questions set for 1862, we can recognize Ruskin's ideas and turn of phrase, to a greater extent, in the longer and more elaborate directions given to

[1] Richmond returned his fee of five guineas for 1859, no reason being given in the minutes, but in 1860 he replaced Ruskin, joining Dr. Liddell, Dean of Christ Church, as co-examiners in art. Both received a fee of five guineas. Ruskin, Richmond and Evans were together again in 1861, with Evans receiving a higher fee.

[2] R. N. Wornum, friend of Ruskin, was Keeper of the National Gallery, and lecturer at the School of Design.
 Questions included the following from Wornum's Book I.
 1. What remains are there of early Oriental art? What is their artistic value? Compare them with the best works of the Egyptians.
 2. Give an account of the three classes of Egyptian painting.
 4. What pictures are said to have been painted in Asia Minor before 500 B.C.? Does Homer mention any kind of pictorial representation?
 Questions were also set from Book III, covering the period from Cimabue to Perugino; Book IV, Leonardo to Titian; and Book V, the German and Flemish schools.

[3] A test in so-called memory drawing was substituted when this entire paper was dropped from the syllabus in 1880.

the candidate. Drawing from the cast or model was set for both Seniors and Juniors, with so much as three hours allowed, as follows:

> Sketch the accompanying cast of a head from Trajan's Column, of the size of the original, giving its general light and shade as completely as possible.
> In drawing from the cast, the student must attend to the relation of depth in shade and to justness of contour, more than to the execution of parts. A small portion of the drawing may be completed (and indicated by a cross) to shew the candidate's power of finishing. But little regard will be paid by the examiners to such power if the relations of shade are false or the contours inaccurate and unrefined. The drawing will, *caeteris paribus*, be considered the best, which depends for its effect least on the direction of lines and attains its results merely by differences of depth in shade. Exaggeration of darkness is particularly to be avoided.

Whether or not the candidates clearly understood these instructions, they were fortunate in receiving an admirable lesson in the value of light and shade instead of seeking a purely superficial effect of the work being finished.

The 1862 syllabus also included a paper entitled "Drawing in colour from a natural object" for the Seniors only, and here again we can discern Ruskin's ideas on colour in relation to background, the subject set being a grape for which the following instructions were added:

> In the exercise on colour, the examiners will look for truth and purity of colour only. No attention will be paid to smoothness of brush-work or precision in drawing, except in so far as these contribute to perfectness of line. The grape is to be drawn with its actual background as it happens to be seen. It must in every case be represented exactly as it appears. No conventional background may be introduced.

The quality of this advice, with its rejection of mere neatness and emphasis on seeing the object in relation to its background raises this drawing examination of 1862 to a level which it never attained again for at least three-quarters of a century.

Ruskin's enthusiastic support of the examinations was revealed in a curious way. He often pronounced against overmuch insistence on perspective and had questioned the value in teaching it.[1] Nevertheless in May 1862 the Delegates were informed, as reported in the minutes:

> Mr. Ruskin has offered to prepare at his own expense solutions of the questions in perspective with diagrams to be published in any way which the delegates may think best. It was resolved to publish this at the end of the Examination Papers, and to express thanks to Mr. Ruskin and to request that he will attach his own name to the solutions and prefix a short statement of the reasons for publishing them.

[1] *The Elements of Drawing.*

There is, unfortunately, no actual record of the solutions, nor of the offer having materialized.[1]

The Oxford Delegacy had kept the sister university informed of their proceedings from the beginning, and the Cambridge Syndics were thus able to announce their first local examinations within a few months of Oxford, but to take place in December instead of July.[2] "Drawing" was included as an optional subject, as at Oxford, and in framing the syllabus the Syndics seem to have been generally content to follow the same path.

With so many leading figures in art education already recruited by the Delegacy, the Syndicate was left with little choice, and they were fortunate in being able to enlist the help of the one eminent art teacher who springs to mind—Richard Redgrave.[3] We find his name listed by itself as "Drawing Examiner" for 1858. It is, perhaps, surprising that he was able to accept, since he had the previous year been appointed Inspector-General for Art and Surveyor of the Crown pictures.

In the first part of the Cambridge syllabus the questions differed from those set for Oxford only in minor respects. The candidate was allowed less time—only one hour for each paper—and in the memory test the choice was simpler, being confined to three different types of object, though no nearer true memorization than the Oxford test.[4] More emphasis was placed on perspective, with questions calling for the drawing of plans, elevations and sections.[5] This does not appear to have been popular with candidates or else they found it too difficult, since it attracted fewer entries than any other section of the drawing examination.

The Cambridge Syndicate diverged from Oxford mainly in the paper entitled "Design". This contained no questions on designing for the crafts, as set during the first year at Oxford, but was limited to a choice of three questions which

[1] From 1863 onwards Ruskin's name no longer appears in the list of examiners. For the next decade two art examiners are listed—Evans and Spencer Stanhope, a member of the Royal Institute of Painters in Water-colour, whose work was largely based on classical themes.

[2] Cambridge did not set examinations in July as well as in December until 1907.

[3] Richard Redgrave, R.A., head of the School of Practical Art.

[4] The question set at Cambridge in 1858 for memory drawing reads as follows:
"Make a careful drawing from memory of a small square table, supporting on its top a small fish globe. The eye of the draughtsman is supposed to be above the rim of the globe."
The candidate was offered two additional alternatives as follows:
"Either a wheelbarrow upside down, or a gantry supporting a beer cask."
Candidates were told that they might "add any amount of shadow necessary to the full expression of the subject". This is the opposite of the instruction given at Oxford that "overmuch darkness" was "to be avoided".

[5] Perspective was needed in model drawing, for which the subject was a square-framed chair on a table, the Seniors having to draw it in a more difficult upside-down position. An additional paper entitled "Linear Perspective" required a plan, elevation and section of a one-roomed park lodge, which we would describe as an orthographic projection.

curiously combined design with imaginative composition and use of memory. One and a half hours was the inadequate length of time allowed by the Syndicate for a sketch in pen and ink for one of the following:

(*a*) A figure (the body and legs nude) in the act of throwing a stone, about eight inches high.

(*b*) A group of two figures wrestling (the body and legs nude).

(*c*) An ornamental design of leaves and flowers to fill the spandril of a semi-circular arch of nine inches radius; it may be treated as a relief ornament or for completion in colour.

To cater thus for the imagination was certainly to be welcomed and the drawing of the human figure was not tested elsewhere in the examination. But here we have the same problem as we found at Oxford, where the use of the human figure in a design was purely optional. To set questions of this character for boys who can have had little opportunity for drawing the human figure from life, especially the nude, was to invite copying from pictures. The drawing of nude figures in action, as demanded at Cambridge, would have required the candidates taking a course of study—only to be obtained at an art school—if the work was to prove of any value.

The third question in the Cambridge design paper specified no practical function and launched the worthless test in "space-filling". Although this type of question was dropped the next year, it was unfortunately resuscitated and became so firmly established that it was not finally eliminated from the syllabus until near the middle of this century.

Cambridge followed Oxford's example in setting a paper for the Seniors entitled "Colouring". Candidates were allowed one hour for the following:

The object to be imitated is a card with a feather affixed, the card being so placed that the feather throws a shadow on it.

This emphasis on "imitation" led the following year to a change in title to "Imitative Colouring", which continued in use until 1902, carrying with it the mistaken approach to painting which the adjective implies. Nevertheless the setting of the question sometimes revealed such a degree of ingenuity and imagination on the part of the examiner that one can only hope that these same qualities were implanted in the candidates. For example, in 1864 the question reads as follows:

Let a sheet of blue foolscap paper be twisted so as to form a hollow cone, like a grocer's sugar paper. Lay this in such a position on the table that the light from a window may fall obliquely into its open end, then break a well-baked captain's biscuit into three or four large pieces, and place them in the mouth of the paper-cone, partly in light and partly in shade. Let the candidate make a full-size sketch of the broken biscuit and the opposing tints of the paper.

We cannot ascertain who may have produced this complex masterpiece among

question papers, but his sleight of hand certainly provided a valuable exercise in the balance of light and shade and of warm and cold colour. It is disappointing to learn, therefore, that no more than fourteen candidates out of 176 had the courage to tackle it.

The Cambridge Syndicate followed the Oxford Delegacy in setting a paper requiring written answers entitled "The Arts of Design", and here we find Redgrave's imprint as clearly as Dyce is reflected in its Oxford counterpart. The paper contained eighteen questions of which the candidate was to tackle as many as he could in the two hours at his disposal. It must have been assumed that the candidate had studied Redgrave's *Manual of Colour*, since the first four questions, which were compulsory, tested his knowledge of complementary colours and their terminology. Of the remaining questions, which were optional, six concerned the use of technical terms, such as "chiaroscuro", while the remaining eight were historical, ranging from the Parthenon to Michelangelo.

Such a paper would have served admirably if schools had sufficient time to provide adequate preparation in art. Obviously this was not the case, and candidates must have found this wide range of questions beyond them. At all events it was withdrawn in 1861, even sooner than the equivalent paper at Oxford, and Seniors were not again tested at Cambridge in the history or theory of art until 1925.[1]

After only two years of examining, Redgrave had to withdraw in 1860, doubtless due to the strain of his many other duties, for he did not retire from public life for another thirty years. Having established the main lines of the drawing examination at Cambridge, he passed the work of examining to H. A. Bowler, one of his inspectors at the School of Practical Art, then aged thirty-six and Redgrave's junior by twenty years. It is noteworthy that the examination, with its potentiality for improving art teaching in secondary schools, was to remain under the superintendence of Bowler for nearly half a century.[2]

A follower of the Pre-Raphaelite school, Bowler had already made some mark as a painter, having exhibited at the Royal Academy in 1847, when he was twenty-three, but he does not appear to have continued doing so.[3] Perhaps teaching and examining exhausted his creative energy, for he seems to have introduced no fresh ideas to benefit the examining. On the contrary, throughout his régime the Cambridge art syllabus constantly declined in artistic value and

[1] The subject was included by Cambridge in its Higher Examination, introduced in 1869 to meet the needs of the growing number of Girls' schools. Few candidates took it, and in 1877, when there were only three, it was decided to drop it in the following year.

[2] Until 1894 Bowler was single-handed. The following year, he was joined by W. H. Blythe, M.A., of Jesus College (artistic qualifications not indicated), and E. R. Taylor, head of Birmingham School of Art. This team, with the addition of Martin Buckmaster in 1900, continued until Bowler's retirement in 1907.

[3] The Tate Gallery, London, possesses an oil by Bowler—"The Doubt", a pre-Raphaelite "problem" picture, showing the young woman lingering at the grave of her lover. Bowler became assistant director in the Department of Science and Art.

never advanced, though to what extent the blame should be placed at the door of the examiner rather than the Syndics is now hard to tell.

During 1861 both memory drawing, with its modest scope for conveying imagination, and the history of art were omitted, and the resultant examination at Cambridge was now reduced to a choice of three out of five papers. Three of these were in geometrical drawing or perspective and the remaining two were in freehand (copying the line drawing provided), which was obligatory, and model drawing, which was confined to cubes, spheres, etc. The Seniors were given the same choice of papers with the one addition of 'Imitative Colouring', which attracted only ten candidates. With such a syllabus, limited largely to a mechanical type of drawing, it was scarcely to be expected that art teaching in schools could make much progress.

Thus within a few years of the commencement of the university-sponsored examinations—only three years at Cambridge and a little longer at Oxford—the encouraging objectives announced by Acland, Dyce, Ruskin and Redgrave, had all but disappeared, although some vestiges of value were still retained at Oxford.

The shortcomings of the drawing examinations in the 1860s are revealed not so much by the papers themselves as by what they omit. The use of colour, altogether excluded at the Junior level, was limited for the Seniors to the mere tinting of a drawing. Throughout the nineteenth century the examinations offered no test which would encourage drawing the human figure from a living model, which had always constituted the foundation of art training. Any indication that work should be based on one's own observations of nature ceased with the omission of memory drawing, however modest such indications had been. Nor was there any mention of composition in the Cambridge papers. The necessity for developing the powers of analysis or appreciation of works of art had also been withdrawn.

This emphasis on purely geometric treatment found its echo in the drawing examination introduced for the first time by the College of Preceptors in 1860. The paper consisted only in producing a perspective drawing of a cone. Two years later the College extended the syllabus to include three papers, but merely offered a wider choice of man-made objects.[1]

Oxford alone deserved credit for retaining some pictorial element through its design paper, in which one of the three alternatives, was designated "Picture", as we have already noted. In 1862 the subject set was "Reaping". This was the first of a series of rural subjects, enabling candidates, for the first time, to compose

[1] The three papers were: (1) Drawing from the flat, (2) Model drawing, (3) Perspective, of which the candidates had to choose two, three hours being allowed in all. For model drawing the following alternatives were set: Cone, cube, cylinder, sphere, hexagonal prism, square frame and cross. If these were not available, further alternatives were a cricket ball, egg, jam-pot upside down or a jug. Thus, all the objects were of regular or geometric shape. In 1865 a group was set instead of a single object, consisting of a chair on which was placed "a man's hat of the usual shape and a walking-stick resting upon the ground". Candidates were told: "No marks will be allowed for shading of the group, unless the drawing be correct."

a picture on some aspect of life which they might have seen, although no instruction to that effect was given. In 1865 "A Roadside Inn" was set, and the following year it was "Ploughing". Examiners were, however, highly critical of the results. Their report of 1873 states:

> None of the designs for the picture were of any value. They showed not only lack of invention, but extreme feebleness in the drawing as well.

This criticism seems a little unfair, since invention could scarcely be expected of candidates from schools where this faculty had never obtained any encouragement. Moreover, the examiners did not offer guidance as to how invention might be revealed in a picture.

Nevertheless, this welcome effort in offering a test in pictorial composition, modest though it was, was not yet doomed, for a reprieve came with next year's report, which stated that "the improvement is most marked". But in 1880 the paper was dropped and pictorial composition did not emerge again until well into the present century.

A significant step was taken in 1863, though drawing was not involved until later, when the Cambridge Syndicate accepted an application to form a local centre at Queen's Collegiate School, Trinidad. It was agreed that the examination papers be sent to the Governor, who would appoint an inspector to superintend the examination and return the scripts to Cambridge. Shortly afterwards the Oxford Delegacy received a similar application from Natal, then a British colony. The Syndicate's procedure was repeated. These were the beginnings of the School Certificate Overseas, which was ultimately to expand, especially as regards Cambridge, on a very large scale.

No further application from overseas was received at Oxford until ten years later, when Nassau was granted permission to set up a centre, but Albany, U.S.A., was refused on the grounds that it was not intended to operate the examination in foreign countries. Although some further oversea centres at Hong Kong and Sierra Leone were accepted by the Delegacy before the end of the century, the Oxford policy was to discourage their formation. The Cambridge Syndicate, however, welcomed centres from Colonial territories, though development was slow.[1] Drawing was not, however, among the subjects taken by any of the oversea centres until some years later.

Cambridge's initiative was responsible for another equally important step— the inclusion of girls in the local examinations. This had been tried as an experiment as early as 1863, with the result that the admission of girls was approved by the Senate with a very narrow majority two years later. It was decided that the girls might take the same papers as the boys, but were to be known only by numbers and not by name. A committee of ladies was to be formed in each local centre to superintend the examination, which was to be held in a room separate from that of the boys.

[1] Twenty years later Cambridge had accepted five oversea centres—Trinidad, Maritzburg (South Africa), Ceylon, Demarara, Jamaica. By the end of the century there were other centres in the West Indies, Hongkong, New Zealand and Mauritius.

During 1865, the first year in which the girls were examined, there were only nine female candidates in drawing at the Junior level whereas there were 328 boys, but there were sixty-six girls in the Senior examination, compared with 176 boys. Only two girls attempted the use of colour in the paper called "Imitative Colouring", and perspective was not popular. Within a few years, however, the number of girls taking drawing had exceeded the boys and by 1878 there were twice as many girls compared with boys.[1]

Oxford was duly apprised of the Syndicate's bold step, and in 1867 the Hebdomadal Council was informed that the admission of girls, having been tried thrice at Cambridge, "no injurious or inconvenient results appear to have followed".[2] Nevertheless, the Council hesitated to follow suit, and did not finally do so until 1870. One of the problems which prompted caution was the provision of separate examination-rooms. For example, at Truro, only one room being available, a screen had to be used, and the boys and girls entered by separate doors. Such were the gloomy conditions in which the examinations were conducted, with the candidates filing in to face the stern supervisor, and, when drawing was the subject, finding a dismal group set up before them consisting of white cones or boxes poised like a pack of cards.

In 1873 a considerable change was made in the policy of the two universities, when they agreed to set up, jointly, a third examining board, whose function would be to inspect and examine candidates from the public schools, as distinct from independent candidates. The certificates to be granted by the Oxford and Cambridge Schools Examination Board would gain exemption from various public and university entrance examinations.[3]

Art was not among the subjects which the new Board proposed to examine. Examination was to be confined to "subjects which have as yet acquired a recognized place in the curriculum of first-grade schools".[4] In the 1870s very few public schools included art in the curriculum. It was at most an extra to be taken by boys in their spare time. This decision by the Joint Board was largely responsible for the backward attitude taken by the public shools towards the teaching of art, an attitude which has only been modified to some extent in recent years. Art has obtained a firmer foothold in some of the grammar schools and particularly girls' schools, simply because they took the examinations of the Delegacy and the Syndicate, which included drawing, although the subject had little pretensions to be called art.

Art was considered more suitable for girls than for boys, and for this reason the Joint Board decided in 1878 to allow the girls' public schools to take drawing

[1] Durham University School Examination Board admitted girls in 1866, but it set no art papers.

[2] Minutes of the Delegacy 8th June, 1867.

[3] The Oxford and Cambridge Joint Board, to use its more familiar name, was one of the results of the first Headmasters' Conference in 1870, which met following the passing of the Public Schools Act and of the Endowed Schools Act the following year.

[4] Report of the Oxford and Cambridge Schools Examination Board, November 1873.

as an optional subject, but the syllabus was even more restrictive and mechanical in character than those of the other examining boards.[1] There were three papers —Freehand, Model and either Perspective or Geometrical Drawing—and for the next ten or twelve years very few candidates attempted it. In 1879 there were two entries, both of whom passed. Three years later there were again two candidates and this time both gained distinction. It was not until 1891 that the numbers suddenly grew to twenty-one, but, according to the report, their work was "generally wanting in freedom", and the next year they did not sufficiently value "neatness of drawing and accuracy of construction". The few girls who ventured to tackle art certainly received little encouragement from the Joint Board's Examiners.[2]

[1] The Regulations read as follows:
"Girls who offer themselves for examination shall be allowed the option of these additional subjects: (a) Italian; (b) Drawing shall be added to the list of subjects in Group II (Mathematics). But no candidate shall be allowed to offer both Drawing and Mathematics at the same examination; (c) Music."
[2] The examiners in 1891 for the Oxford and Cambridge Joint Board are named as Macdonald and Prior. In 1892 the latter was replaced by W. E. Dalby, B.Sc. Alexander Macdonald was master of the Oxford Art School and became Ruskin's assistant in charge of the Ruskin Drawing School at Oxford. He had been examiner with J. G. Jackson for the Oxford Delegacy since 1873; Evans and Stanhope, having retired, were drawn into consultation when required.

10 🌿🌿🌿🌿🌿🌿🌿🌿🌿🌿🌿🌿🌿🌿🌿🌿🌿🌿🌿🌿🌿🌿🌿🌿🌿🌿🌿🌿🌿

Art in British Education Overseas—
India and the Colonies

INDIGENOUS art did not have any place in the educational policies of British Colonial Governments throughout the eighteenth and nineteenth centuries. Its very existence was thus largely ignored in teaching until comparatively recently. Only within the last few decades, when all but too late, have efforts been made in some of these territories, both before and since their independence, to rectify this long-established neglect.

It has to be recognized that art teaching, if it is to prove of any value, must derive its main impetus from the type of art, its style and methods of creation, evolved and basically understood by the people. If we had sought to teach in British schools, alien methods of painting, such as those evolved in India or China, it would have been considered absurd, yet this was precisely the course adopted, in so far as any art teaching was provided at all, in the schools of India and the British Colonies.

In some territories, such as those of East Africa and the Malay and Pacific archipelagos, artistic traditions did not cover the wide field so evident in India, Ceylon or West Africa, with their fresco-painting or sculpture, but throughout the former colonial empire the crafts were practised, especially pottery, weaving and basketry, and these have been brought through the ages to a very high level of perfection. The crafts have flourished in the villages, as they still do to a considerable extent today, but until quite recently their study has been completely ignored in the schools. Even during a recent visit I was sometimes told by well-meaning administrators: "You will find, I fear, no art of any value in this territory and it is not worth trying to teach it." I have yet to discover any place in the world where boys and girls do not benefit by art teaching, nor have I found, or ever heard of, any people who are entirely without artistic traditions in some branch of art or craft, however elementary, which did not justify encouragement through the medium of the schools. And in this we have the full support of Ruskin, who asserts, in *The Elements of Drawing*, that he had "never met with a person who could not learn to draw at all".

The British educational system found its way to India and the Colonies in the

wake of British government, schools being founded steadily in the eighteenth and early nineteenth centuries. It was assumed, as a matter of course, that they should follow the pattern of schools in the home country. With art included so reluctantly in the average school curriculum at home, it was only to be expected that it would be largely ignored overseas. The need for art teaching among the professional classes or for training designers in industry—the motive that prompted art teaching in England of the eighteenth and nineteenth centuries—was not considered applicable in the Colonies, and this was true enough in the social and economic organization of the period. But the assumption that a knowledge or appreciation of art had no value among the people generally was particularly mistaken.

Any attempt to develop an understanding or knowledge of the indigenous arts was completely thwarted from the beginning by the absence of any authoritative study of them. Even in the nineteenth century such studies were confined to India and Ceylon. The arts of Africa remained completely unrecognized until the present century. It was scarcely surprising, therefore, if those responsible for education in the early days ignored the existence of the indigenous arts.

There were other factors, moreover, opposing the teaching of art in Asia and Africa. The arts were too closely intertwined with native religion and customs, which were thought to have no bearing on education. Indeed, it was often the endeavour of teachers and the educational authorities to suppress the practice or appreciation of art, because by its means the faith in native gods was maintained. To this somewhat narrow view of the teacher's responsibilities must be ascribed much of the blame for the steady decline in the practice of art in the Colonies, a decline which was deplored by Sir Thomas Munro, when Governor of Madras, as early as 1822,[1] and which now appears difficult to reverse.

During the early days of colonial administration school teachers could have justifiably indicated, if they had wished, that there were many practical obstacles to prevent the inclusion of art in a school curriculum. They could have pointed out that the necessity for teaching English as the medium of instruction imposed a heavy strain on the time available, that in many schools funds were barely sufficient for the most essential needs, leaving little to spare for practical subjects; thus art materials would have been completely lacking. Furthermore, schools usually depended on a permanent staff to teach all subjects, and such staff seldom included anyone with the specialized knowledge required for teaching art.

These were the typical arguments of the time. Had there been any real wish to teach art, native artists or craftsmen might have been asked to help and local materials used, as is often found necessary in schools today.

Education in the Colonies, especially during the eighteenth century, was mainly dependent on the Christian missions, which were particularly loath

[1] F. W. Thomas, *The History and Prospects of British Education in India,* 1891.

to encourage indigenous arts, so inevitably bound up with the religious beliefs they sought to oppose. Many of the early mission schools, such as those founded on the West Coast of Africa, were inspired by the English Charity School system, and every effort was made to lure the pupils from any respect they had for their native arts. The first to be founded in British West African settlements was the "Colonial School" on the Gold Coast in 1752, and for many years it was the only establishment of its kind.[1]

With the missionaries and the educational authorities thus combining to disapprove of the teaching of art, it must be a matter of surprise if we discover evidence of any such teaching in the colonial empire until radical changes in the entire system had emerged during this century. Nevertheless, art found its way into the schools here and there.

The Nonconformist missions, especially the Quakers, were foremost in their disapproval of art. In fact, pictures were not displayed in Quaker homes. Nevertheless, we learn from Hannah Kilham, a missionary who established village schools in Gambia and Sierra Leone between 1823 and her death in 1832, of her reliance on visual aids in teaching Africans—"addressing" oneself "to the eye as well as to the ear", as she described the system. She records having taken a collection of "pictures" with her to Sierra Leone to help her in teaching.[2]

The nearest approach to the teaching of crafts was in needlework, but this was for making frocks so that the girls might appear "more civilized", as Hannah explained. Girls at Quaker and Nonconformist schools were encouraged to embroider samplers, so popular at the time, and botanical drawing was permissible; boys might carry out some geometric drawing. Mixed schools had been established in Freetown, when Hannah Kilham was there in 1828, for she records with some surprise, perhaps shock, finding "the boys on one side and girls on the other" and that there was nothing to keep them apart beyond "a few slight posts".[2] Meanwhile Fourah Bay College had been established in Sierra Leone for the training of teachers in 1827, but the records make no reference to any teaching of drawing.

The establishment of mission schools in India had begun as early as 1715, with the founding of Saint George's School and Orphanage in Madras, followed five years later by the Barnes High School under the direction of the Bombay Education Society.[3] British schools, however, remained relatively few in India until the second quarter of the nineteenth century, which saw a great expansion in missionary enterprise in the wake of the growing volume of trade. They had first appeared in Calcutta with the founding of the Saint Thomas' Schools for boys and girls in 1789, but there was very little further development until Saint Paul's was founded in 1823, subsequently moving to its present home in Darjeeling. La Martinière School for boys and its sister school followed in 1836, and

[1] C. G. Wise, *A History of Education in British West Africa*, 1956.
[2] Hannah Kilham, *Report on a recent visit to the Colony of Sierra Leone*, 1828.
[3] It was the Bombay Education Society that also founded Christchurch High School in Bombay in 1815.

La Martinière College was established in Lucknow a few years later. Catholic missions soon followed with schools for girls in Madras as well as Calcutta, which also received Loreto House, the first of the Loreto foundations, in 1842, followed by its sister school in Darjeeling four years later.

These institutions tended to introduce some form of art teaching. At the Loreto schools, almost since their foundation, drawing of a kind had been taught by one of the sisters or even by the Mother Superior, using methods derived wholly from the Western world. Model drawing, plant drawing and designing for embroidery were favoured, though when precisely such subjects were first introduced into the curriculum has not been recorded.[1]

The records of La Martinière College at Lucknow make no references to the teaching of art until 1879, when mechanical drawing was taught to those in the senior classes seeking entrance to an engineering institution. Thus we find the utilitarian motive, so prevalent in England, equally dominating the teaching of drawing in India. Some freehand drawing and use of colour was gradually introduced in the college, such as the sketching of buildings or bridges, but it was not finally separated from mechanical drawing until the last years of the century.[2] Moreover, freehand drawing was not introduced in the girls' school until 1892.[3]

Among the earliest of the schools founded by British enterprise in the Far East was the Free School in Penang. A site for the school had been donated in 1816 and Mr. J. Cox was appointed the first headmaster. He resigned, however, five years later in order to manage the local printing press, and a British non-commissioned officer of the Indian Army was appointed to replace him. The school records indicate that Sergeant Smith was seldom "sober and steady".[4]

An attempt was made, a decade later, to raise the general standard of teaching in the Free School, by the appointment of a committee of seven Englishmen. They recommended that the school should be conducted "on the plan adopted by Dr. Bell at Madras". Thus, "the children of Malayan, Chulia and Hindustani parents" were instructed "in useful employments as carpenters, smiths, shoemakers, tailors, bookbinders etc", in addition to studying the ordinary elementary subjects. The actual teaching and maintenance of discipline was handled by selected senior pupils, described as monitors.[5]

Drawing was included among the subjects taught at the Penang Free School from its earliest days. It is recorded that drawings were copied on slabs of slate

[1] From information kindly sent me by the headmistress of Loreto House, Calcutta.
[2] There was no attempt to teach drawing in the primary and preparatory school until 1899.
[3] The principal of La Martinière College has kindly placed this information, derived from the college records and reports, at my disposal.
[4] Recorded in a letter, based on information given in the school records, from Mr. G. S. Reutens, art teacher at the Penang Free School.
[5] This same year, 1827, saw the foundation of the Raffles Institution in Singapore, subsequently becoming the main centre of education east of India and ultimately providing some art teaching.

with a slate pencil, or with chalk on a blackboard, or on the floor, indicating that paper was too costly a commodity to be spared readily. The drawing instruction was closely related to the practical training in crafts and trades, but these crafts were those practised in England, not the traditional ones of the Malay States, such as weaving, basketry, net-making or puppetry. A short-lived attempt to teach Malay handicrafts was made in 1853, but they were not finally incorporated into the curriculum until well into this century.[1]

The objectives that underlay the teaching of drawing in India and the Colonies were purely practical, and they were accepted by the local governments when they assumed control over education. With the adoption of a new system of administration, certain schools were granted a secondary-school status, carrying education to a higher level. But the change did not embrace art, except in so far as it gained some added consideration as a means of counterbalancing the purely academic aspect of the teaching.

The vagaries in educational policy revealed by governments overseas were crystallized in India perhaps to a greater extent than in other colonial territories. Uncertainty as to the course to be pursued emerged early in the history of British India. Warren Hastings had favoured an Oriental bias. Had this policy endured, the teaching of art might have taken a different course, more sympathetic to the traditions of art in India. But this was not to be. Controversy was brought to a head with Lord Macaulay's famous minute of 1835 recommending the reversal of Warren Hastings' Orientalism in favour of a purely Western approach to education.

It was Macaulay's view that education in India should help disseminate European culture, literature and science. To this end the funds spent on the printing of Oriental books were to be employed henceforward in promoting European studies. The resulting neglect of Indian traditions, with the inherent loss to art, was not a factor which was taken into account. This policy of Westernization was duly incorporated in the East India Company's Educational Despatch of 1854, and subsequently confirmed when the government of India passed to the British Crown.

There was no longer any likelihood of the traditional arts and crafts of India gaining any foothold in the schools under British control, and this only hastened that rapid decline of the arts which Sir Thomas Munro in an earlier and more sympathetic period had deplored. With the School of Practical Art controlling the type of teaching to be given to the sons and daughters of India's merchant and professional classes, there was no likelihood of any concessions to their artistic traditions. The Indian aptitude for line and colour revealed in the Moghul and Rajput painting, or the rich patterns and vivid colour that distinguished the

[1] G. S. Reutens, in the letter quoted above, writes: "Some improvements in art education began in 1901, when formal lessons in art were given to a few pupils during week-ends. Design and pattern drawing were also taught, but were entirely geometrical in character." An Art and Craft Club was started in 1929, but failed to maintain itself. It was subsequently revived with seven boys and "has been developing ever since".

15. *a*. Cotman's pupil, S. C. Edwards, 1835, copy of the master's work below
b. J. S. Cotman: North Gate, Yarmouth

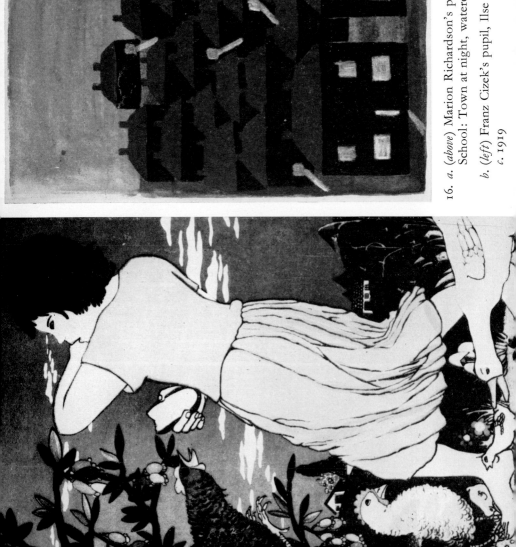

16. *a.* (*above*) Marion Richardson's pupil, N. Yates, age 12, Dudley High School: Town at night, watercolour, *c.* 1919

b. (*left*) Franz Cizek's pupil, Ilse Breit, age 14, Vienna: The Farmyard, *c.* 1919

folk-art of Bengal, so inherent in the outlook of the people, might fade com-
pletely from Indian life, as far as British education was concerned. Education
in India certainly contributed very little towards encouraging the arts or stem-
ming their decline.

It was unfortunate for India, and indeed the British Colonies in general, that
Ruskin never extended his wide interests to embrace the problems of art teaching
in these countries. It was not until a generation after Ruskin that India produced
in E. B. Havell its own prophet—Englishman though he was—to preach the
maintenance of Indian traditions in art. But it was by now almost too late.

Meanwhile, throughout the nineteenth century, art teaching in India, such
as it was, followed the British pattern at its lowest level. Whether or not there
was any value whatever in teaching Indian boys the type of drawing approved
in the schools of Victorian England may well be doubted. Our sympathy may
well lie with the local governments that hesitated to allow it, but we can scarcely
approve their motive. They did not oppose the type of drawing that was taught
but merely begrudged the expense.

The archives of Hooghly College give us a glimpse of the moves for and
against the teaching of drawing in government-sponsored education under the
East India Company. The college had been founded in 1836 at Chinsurah near
Calcutta, with Dr. Wise as its first principal, its objective being to encourage
the spread of Western science and the command of English. It was, nevertheless,
one of the few schools of the period in India to include drawing and perspective
in its curriculum as early as 1838.

Drawing was taught as an extra. There were two teachers—Mr. Vernieux
for the English department, mainly attended by Hindus, and Mobaruk Ali in
the Oriental department or Madrassah, where the pupils were mainly Muslim.
Some indication of the methods adopted—mainly based on the prevailing
system of copying—is given in the archives:

> At one time there was considerable enthusiasm, and some plates were ordered
> as models. But the Principal reported that some of these were unsuitable, either
> because they were not sufficiently draped or because the postures were
> "coquettish".[1]

Presumably the plates were for the pupils to copy, and it is surprising that the
drawing of human figures was permitted in the Muslim department.

The general results proved disappointing, since we read further:

> The Drawing Master (Mobaruk Ali) limited himself to human studies and stiff
> landscapes, and could give no instruction in any useful kind of drawing. A
> proposal to give him six months training was refused, and the drawing class
> gradually declined. By the end of 1860, there were no pupils and the Drawing
> Master was recommended for pension.[1]

It is hard to conceive where this six months' training was to be obtained, since

[1] K. Zachariah, *History of Hooghly College, 1836–1936.*

art schools had not by then been established in India. Doubtless, Mobaruk Ali was too instinctive an artist with his "human studies" to satisfy the authorities.

A professor of drawing and surveying, who would supervise the work of the two drawing masters, was proposed by the College Council in 1847. Mr. C. Grant, described as "an artist of known ability and great local reputation", was suggested for the post at the modest salary of three hundred rupees a month, but the Government would not sanction "so heavy an expense".[1] In 1861 Vernieux followed Mobaruk Ali into retirement, and the office of drawing master was suspended. The class was restarted a decade later, but the archives give no indication as to its character.

The mid-nineteenth century, when there was immense expansion in education in England, with many new public schools being founded, saw the extension of the public-school system to India. The Lawrence Schools were founded at Sanawar (Simla Hills) in 1848 and at Loveday (in the Nilgiris) in 1858, for the sons of soldiers in British regiments serving in India, though this function ceased with independence. There are no records to show, however, when drawing was first included in the curriculum. The Scindia School was founded in Gwalior, where art and craft teaching soon gained a foothold and has been excellently taught ever since.

It is to Mayo College near Ajmere, Rajputana, however, that we may look for a detailed account of art teaching in India during the later Victorian period. Founded by the Government of India in 1875, with donations from the Indian princes, it was to cater for the sons of noble Rajput families.[2] Its first headmaster, Mr. Herbert Sherring, has left a revealing account of some of the problems involved in teaching art in India. Moreover, he was unique among headmasters in having been himself responsible for conducting the art class.

The teaching of drawing must be seen at Mayo College against the curious and peculiarly Indian background of caste and privilege, prevailing in an institution that sought to graft the traditions of the British public school upon a country that inherited an entirely different social system. The report by the then Inspector of Education for North-West Bombay, Mr. E. Giles, directs special attention to the obstacles raised by these formidable class distinctions at such an institution as Mayo College:

> Not only have the boys no neccessity to learn, but the class of society from which they are drawn is one hitherto unaccustomed to literary effort, and home influences are usually entirely wanting or decidedly antagonistic to such effort. . . .
> The students are free from the stimulus of poverty and the necessity of employing education as a means of livelihood.[3]

[1] K. Zachariah, *History of Hooghly College, 1836–1936.*
[2] The college was named after the viceroy, the Earl of Mayo, who performed the opening ceremony.
[3] Herbert Sherring, *The Mayo College—"the Eton of India"; a record of twenty years, 1875–1895,* Calcutta, 1897.

Each pupil was attended by not less than one servant, together with a groom for his horses, while the more wealthy boys might have a retinue of two hundred servants to wait upon them at school. A pupil would seldom be unattended by his valet or his secretary, often a poor relation.

There had been no intention to include drawing in the curriculum when the school was founded, but Mr. Giles urged its inclusion as an extra subject, and the headmaster, an enthusiastic amateur, welcomed the opportunity to conduct the drawing lessons himself. Governmental consent was required, however, and this, as at Hooghly College, was not readily forthcoming. A year elapsed before this official opposition was overcome and Sherring could begin teaching a class of fourteen boys. But within two months the class was closed by government orders, and pressure to obtain permission for it to begin again in January 1894 had to be renewed. Even so this renewal was subject to a trial period of six months and the number of pupils was not to exceed ten. The grounds for this grudging attitude could only be that drawing was assumed in official circles to be a waste of time. What other reason could there be, since attendance was purely voluntary and subject to special fees? Moreover, no extra expense was imposed on the Government. Perhaps officialdom also feared that art teaching might inspire undesirable activities.

Small as the class was, it was divided into a senior and junior group, each of which met for one hour twice a week.[1] It was an experiment, as the headmaster was at pains to explain, since this was the first attempt to teach any form of art to the young Rajput princes, among whom, as he states, "no previous generation had drawn a line or painted a square inch; so that the faculty of art is entirely acquired and not in the least hereditary".[2]

The experiment was a success in Sherring's view and he was delighted with his pupils' artistic potentialities.

> The Rajput prince [he tells us] with a light hand and correct eye can draw and paint as well as any English boy, if he is properly taught. He is very fond of form and colour, especially the latter, and though not very original, yet he is a wonderful copyist . . . and there is no reason whatever why he should not develop into a true artist, provided he is given the chance.[2]

The headmaster was perhaps not entirely fair in charging his pupils with a lack of originality, since this was something that they had little opportunity to reveal. Enlightened as he obviously was, he could only be expected to adopt the methods by which he would have been taught in England. These methods gave very little scope for originality. From his own description, his teaching methods seem to have followed the usual procedure from the use of

[1] The time allowed was generous when compared with the allowance at many schools in England today.
[2] Herbert Sherring, *The Mayo College—"the Eton of India"; a record of twenty years, 1875–1895*, Calcutta, 1897.

straight lines to curves, then some shading. This continued, "little by little to advanced studies of landscapes and animals". Moreover, the senior class tackled water-colour, we are told, "beginning with monochromes and continuing with neutral tints". If we could be sure that the landscapes and animals were studied from nature and not from copy-books, we would feel that the Rajput princes had little to complain of in Sherring's classes, although he was not a professional in art.

We are greatly reassured when we read that our author urged his pupils "to look for inspiration to nature and not to copies", but then our hopes are dashed by reading that the temptation to copy was put in their way and that "copying was interspersed with drawing and painting from nature". Needless to say, the copying would not have been from fine Rajput drawings to be seen in the princely homes, but from Vere Foster's drawing books and the South Kensington cards. Is it not probable that the pupils' view of nature was becoming stereotyped by the hackneyed versions of it that they were constantly copying? "The boys will certainly have learnt to use their eyes", wrote Mr. Thompson, principal of Agra College, after an inspection of the work at Mayo College. But were they using their eyes for the right purpose?

However much the headmaster may have sought to steer his pupils away from copying, he could scarcely hope to succeed when it was precisely the copies that were singled out for praise by no less an authority than the head of the Bombay Art School. When this leading teacher, Mr. Manners Smith, attended the school's annual display, he awarded the first prize in advanced studies for a copy of a picture of Harlech Castle—a strange subject for anyone living in India.[1] For the prize-giving the following year there were five boys, so we are informed, who "had tried their hand at sketches from nature". But these were entirely overlooked and it was the copies that caught the eye of the head of the Bombay Art School, with a dog's head, copied in oils by Jai Singh, gaining the first prize. The description alone suffices to indicate the low artistic level of this painting, since no artist would wish to depict an animal's head detached from the body.

Such qualities as originality or freshness of vision received little encouragement from Manners Smith, who was concerned, we are told, with "correctness of hand and eye" in the drawing of straight lines and curves, and his report repeatedly singles out those whose "curves are a little faulty" or whose "lines are clean and clearly defined". Any hint of the ancient artistic genius of India had little hope of recognition from such an obvious protagonist of South Kensington teaching.

The character of art teaching in India showed little change for some years to come, according to Mr. Nix-James, who joined the staff of the Cathedral and John Connon Boys' School, Bombay, in 1920. Recalling his own early experiences in India, he writes:

[1] Each pupil was allowed to frame his best picture, the work being displayed on the billiard-table. (H. Sherring, op. cit.)

Geometrical designs, drawn with the help of instruments, and coloured with flat water-colour washes or crayons was the first approach; then came copying of drawings of simple toys, leaves and flowers from flat drawings on the blackboard. . . .[1]

Referring to the drawing of models (rectangular blocks, etc.), he adds:

In the earlier stages they were drawn only in outline with no attention to light and shade; next, shaded edges were represented in heavy lines, then pencil shading of surfaces, and ultimately cast shadows. Unsymmetrical objects such as shoes, tools, drapery or fruit were never studied by boys. They did no colour work in the classroom, nor figure drawing.

Painting was considered slightly effeminate by our boys, and while those who were interested would try pencil sketches of buildings or landscapes in their own time, very few would try to use colour. Painting was taken more seriously in girls' schools, though even here there was a leaning toward the pretty rather than the expressive.

Occasionally, an art teacher would take a class out of doors to draw steps or doors. I remember drawing an antique cannon—a large pre-Mutiny brass one mounted on an iron carriage—which stood outside our school.[1]

It has to be remembered that the Anglo-Indian schools in the nineteenth century catered mainly for British boys and girls resident in India or for those of mixed Anglo-Indian parentage. Such schools were quite distinct from those, like Mayo College and many other institutions, which catered only for pupils belonging to the various races and religions of India. But the various types of school seem to have shown no difference in their treatment of art.

The formalistic exercises described by Mr. Nix-James, like those of Mayo College, had as their objective a descriptive and representational facility in the use of the pencil. Such an objective was purely Western in origin and quite unrelated to the Indian traditions in art. It is pathetic to learn that colour, a quality so appealing to the people of India, was neglected in schools as effeminate. Such an attitude of mind could only have had, surely, an Anglo-Saxon origin.

While British educationalists must shoulder blame for ignoring the valuable contribution that native traditions could have offered towards the teaching of art, such considerations did not, of course, apply to the British settlements in Australia, New Zealand, Natal, Canada, etc. In these Colonies education, including the teaching of art, had every justification for adopting British methods, especially in the initial stages.

The colonial settlements in Australia were slow in evolving an educational system of their own. When the scheme for establishing a chain of national schools was evolved during the early years of the nineteenth century the extreme shortage of qualified teachers compelled the adoption of a monitorial system,

[1] In a letter from A. Nix-James, December 1964, to Mr. B. Gunnery, principal of the Cathedral and John Connon Boys' School, Bombay (since retired). The school was founded by the Anglo-Scottish Education Society.

like that of the Penang Free School, mentioned above, in which the teaching was largely dependent on the senior pupils, the system advocated in England by Joseph Lancaster. This lack of teachers was presumably responsible for the absence, certainly in the early years, of any instruction in drawing. In the report of the Board of National Education for New South Wales in 1855, which covered as many as 202 national schools, we find mention of drawing in the curriculum at only four of them.

It was not until 1867 that a training school for teachers was established in Sydney. Subjects for instruction included drawing, described as "Freehand", which covered perspective and involved making copies. The motive was purely utilitarian to help in equipping pupils in the various trades.

There were very few secondary schools in Australia until the 1850s. In New South Wales there was the King's School at Parramatta, founded in the 1830s, and the Sydney Grammar School; in Victoria were founded the Melbourne Grammar School, followed within a few years by the Scotch College and the Geelong Grammar School.[1] There is little evidence to suggest that drawing was taught at these secondary schools to any greater extent than in the national or elementary schools, or in any different manner.

For a specialized subject, such as drawing, schools in Australia had no alternative but to rely on visiting teachers. This was confirmed in the report issued by the Council of Education in 1867, which states:

Elementary singing and drawing being entirely new to a large proportion of the schools, the Council approved special teachers for these branches (of study).

The report indicates that these special teachers were to provide instruction at the training school and model school in Sydney, as well as visiting all other schools in New South Wales "as frequently as circumstances permit". They were to "assist the regular teachers by their advice and example". Drawing was to be allotted one hour each week.[2]

Not only was the time allowed insufficient, but the teaching, dependent as it was on this occasional visit by a specialist, must have proved of little value. Moreover, what sort of drawing was considered suitable at these national elementary schools? There was certainly a shortage of art materials, as was the case throughout the British colonies; slates had to be used rather than paper, and the work must have been completely mechanical.

The headmaster of the Glebe National School in New South Wales kept a journal of the day-to-day activities at his school during the decade from 1862 to 1872, indicating the hazardous nature of the teaching with its spasmodic inclusion of drawing. The following are a few typical entries:

[1] A. G. Austin, *Australian Education, 1788–1900*; S. H. Smith and G. T. Spaull, *History of Education in N.S.W., 1788–1925*; D. H. Rankin, *History of the Development of Education in Victoria, 1836–1936*.

[2] Report of the Council of Education upon the condition of the public schools, published by the Sydney Government, 1868.

20th October, 1862. Told Miss Russell that I could not allow her to box the infants' ears or smack their faces.

16th March, 1864. School closed at noon for the grand cricket match.

22nd May, 1868. Arithmetic—idleness and listlessness of some are the worst features of this department.

24th July, 1868. Reprimanded Mr. Alcock for severely punishing a boy by pulling his ears and boxing his jaws.

5th February, 1869. I find it impossible to get Miss Smith to keep order in the class.

12th November, 1869. Mr. Fowles gave his usual monthly lesson in drawing.

1870. Mr. Fowles visited and inspected the drawing classes throughout the school.[1]

Presumably, Miss Smith or Mr. Alcock or some other member of the staff gave periodic drawing lessons, perhaps one hour weekly, as prescribed by the Council of Education, while Mr. Fowles offered criticism and advice during his monthly visits. This was perhaps better than no teaching at all, but was scarcely adequate if art was to be used as a branch of education. There could have been no scope for developing any personal expression or use of the imagination, qualities that were missing in Australian education for many years ahead.

In New Zealand drawing was made a compulsory subject at all standards in the primary-school syllabus in 1885, following the report of the English Royal Commssion on Technical Instruction. Putting this decision into practice produced a chaotic situation.

In the primary schools [we are told] hundreds of teachers, who had never before attempted to make the crudest drawing, were suddenly required to teach the subject. . . . The necessity at once arose of instructing the teachers.[2]

New Zealand was, perhaps, more closely linked with the homeland than was Australia, and the former definitely looked for help in art teaching from South Kensington. A. D. Riley, a graduate of the School of Practical Art, was chosen to fill the void. Under his direction, the Wellington Technical School established courses in drawing with a series of graded examinations, and the students submitted work for the South Kensington Art Teachers' Certificates. The Wellington Technical School also became affiliated with the City and Guilds of London Institute, students being similarly prepared for the examinations conducted by that body.

Canadian education during the nineteenth century followed a quite different course. The schools being free from any system of external examination and providing their own internal examinations, the teaching of drawing was largely left to chance, dependent on the attitude of individual teachers. After 1870 there was some teaching of drawing in the elementary schools, while Quebec, in

[1] D. C. Griffiths, *Documents on the establishment of Education in N.S.W., 1789–1880*, published by the Australian Council for Educational Research, Melbourne, 1957.

[2] A. G. Butcher, *Education in New Zealand since 1878*, 1930.

1877, actually made the subject compulsory in elementary schools.[1] In the primary schools Froebelian influence made itself felt, bringing with it the use of colour and freeing art teaching from the rigidity that had governed it hitherto.

Secondary schools were established in the West Indies by the mid-nineteenth-century, maintaining a close contact with the mother country. In fact, as already stated, the Queen's Collegiate School in Trinidad was the first school overseas to enter for the Senior and Junior certificates in 1863 in the Cambridge Local Examinations. By the end of the century more than a dozen examination centres had been formed in colonial territories, but there is no evidence of drawing having been included among the subjects taken until 1895. Jamaica had the credit that year of being the first oversea centre to enter for drawing.[2] It is recorded that among 223 boys and girls in Jamaica taking the examination, only one girl was entered for drawing, and she was successful in gaining "distinction".[3]

The Jamaican girl's success in drawing brings us to the consideration that oversea candidates were at a very great disadvantage in art compared with candidates from the home country. This makes her success all the more remarkable. Not only did the oversea candidates have to work in the European style, which might be completely alien to them, but they were faced with the added difficulty that the subjects prescribed might be quite unfamiliar. While a coal scuttle or fire-irons might be suitable for object drawing in cold and wintry England, they would be quite out of character in tropical regions. Candidates used to the light clothing and sandals of the East could not have the same familiarity as English children have with boots, gloves or winter clothing which they might be required to draw.

Until recent years the examining boards made no attempt to set subjects likely to be within the experience of oversea candidates. The great majority of candidates being from home centres, the subjects were set solely with the English environment in mind. This is evident in the Cambridge papers for 1915, which gave the candidates in memory drawing a choice of either a railway milk-can, a pastry-board with roller, ivy leaves or a dog-kennel—a typical British range of subjects, but quite unfamiliar overseas. The old type of milk-can used on British railways was unknown outside the British Isles, and some oversea candidates might never have seen a railway. Pastry-making and dog-kennels, normal features of British life, were by no means familiar in the tropics, where rice and mealymeal are the staple farinaceous foods and dogs usually wandered in the

[1] C. E. Phillips, *The development of Education in Canada*, Toronto, 1957.

[2] The Penang Free School entered candidates for the first time in 1901; some candidates in art being given lessons in the subject at week-ends. (G. S. Reutens, op. cit.)

[3] Relatively few schools overseas took their pupils beyond the Junior School Certificate. While some centres, notably Ceylon, chose the London examination, the great majority, such as India, the Federated Malay States, Fiji, the West Indies, East and West Africa, Mauritius, Gibraltar, together with British schools in foreign states, such as the Argentine, Chile and Shanghai, took the Cambridge examinations.

streets. Ivy—a favourite subject with examiners—is unobtainable in many regions.

As an example of this problem, I recall the Oxford Board setting a frying-pan with two poached eggs and a soda-water syphon for the test in water-colour painting. These objects would be familiar enough in the European club, but not necessarily in a native home or a secondary school, and the examination supervisor in Hong Kong wrote somewhat as follows:

> Dear Examiner: We have not been able to obtain a soda-water syphon, but we have set our candidates to carve one in wood, colouring it to resemble glass. We trust this will prove acceptable as a substitute.[1]

Oversea candidates were equally at a disadvantage in imaginative work, when characteristic British subjects of forty or fifty years ago, such as "The Windmill", "The Wayside Inn", "The Arrival of the Coach" were set. Instead of encouraging oversea children to observe their own environment, the examinations tempted them to acquire their visual ideas from European pictures and fostered the impression, that drawing was a British hobby devoted to hot-water bottles, deck-chairs, wayside inns and dog-kennels.

[1] The letter, which I quote only from memory, had been addressed to the Oxford Local Examination Board's art examiner some time during the 1920s.

II

a New Approach to Art Teaching—Ruskin, Cooke and Ablett

THE new attitude towards art teaching which emerged during the latter part of the nineteenth century largely stemmed from Ruskin, with his insistence on the need for art in general education. Ruskin had never engaged in much actual teaching, but his ideas were the source of inspiration for others. At his evening classes in the Working Men's College in the 1850s he had gathered together, as already mentioned, a band of enthusiasts and some, like Ebenezer Cooke, who studied under him at first and then worked with him, helped to spread his views.

It was during his later years that Ruskin succeeded in bringing the practice of art into the university. His appointment as Slade Professor of Fine Art at Oxford in 1869 helped towards the realization of this project, and the Ruskin Drawing School was founded in 1871.[1] Ruskin himself provided its endowment, without which it is unlikely that the university would have accepted the proposal.[2]

Ruskin was not principally concerned with those who might take up a career in art, though his school might have led in that direction. He envisaged filling a gap in university education, and it is on these grounds that the school falls within the scope of our survey. In Ruskin's view those seeking higher education should have the means of gaining some practical knowledge of art, which the lectures of the Slade Professor were not meant to provide. His drawing school was at that time the first and only institution of the kind in a university. Convinced that art could be properly understood only as a result of practical study in drawing and painting, Ruskin had no respect for those who offered criticism

[1] The school was quite separate from the existing Oxford Art School, then under Alexander Macdonald, Ruskin's disciple, functioning in the Randolph Gallery (as recorded in the Rev. St. John Tyrwhitt's *Handbook of Pictorial Art*, 1868). Tyrwhitt became co-examiner with Macdonald for the Oxford Delegacy in 1880. Meanwhile, Ruskin asked Macdonald to take charge of the new drawing school as master.

[2] Sydney W. Carline, Macdonald's successor, expressed the fear that "a lesser man than Ruskin would have failed to persuade the University to establish a practical school of art, and indeed other schools had been started privately and abandoned through lack of encouragement": (a lectured delivered at Oxford in 1922).

without such experience, and he was equally convinced that some knowledge of art was essential for anyone pretending to education.

Selwyn Image, who was one of the first pupils to attend the drawing school —he subsequently became Slade Professor—recalled his impressions of Ruskin as a teacher; this was in conversation, many years later, with Sydney Carline, then recently appointed Ruskin Master of Drawing, who recorded it as follows: Selwyn Image recollected Ruskin, dressed most carefully in frock-coat with blue stock, seated with his back to the light.

> His conversation immediately put people at ease, and characteristic of his sympathetic spirit, after conversing some time, he rose from his place and exchanged seats, remarking: "I have had the advantage of the light upon your face until now; let us exchange places so that you may now enjoy the same advantage."[1]

Selwyn Image was set to draw a floral scroll. Having been taught at South Kensington to use a line of "steel-like hardness", he naturally looked for some approbation:

> When Ruskin saw what I had done, he took the pencil from me, remarking that I might be using a crow-bar, and showed such delicacy and variety in its handling, at the same time explaining his interpretation of the subject so vividly, that those qualities which I now prize the highest in my work, I date from this first lesson.[1]

Ruskin laid down rigid rules for the teaching, which he placed in the hands of his assistant, Alexander Macdonald.[2] The course was designed for "students of either sex entering our classes from the age of sixteen and upwards".[3] Pass certificates were to be issued, according to Ruskin's printed instructions, but students were expected to give "at least a couple of hours in each week out of their best and untired time, and supplementing the work done in residence by some consistent practice during vacations". The course took three years.

> In the first year [runs Ruskin's instructions] the student will be required to attain steadiness and accuracy in the outline of simple forms, and ease in the ordinary processes of pure water-colour painting.
> The second year will be given to the study of landscape, completing in connection with it that of architecture, so as to form the student's taste and judgment.[3]

[1] Sydney W. Carline, a lecture delivered at Oxford, 1922.

[2] Under Macdonald's tuition studies were made mainly from the original drawings and reproductions in the school and the casts in the Taylorian Galleries. Macdonald, who retained the mastership of the drawing school for over forty years, enjoyed some reputation as a water-colour painter of the Oxford neighbourhood, and contributed a chapter on water-colour and perspective in Tyrwhitt's *Handbook of Pictorial Art*, 1868. With his thick grey beard and frock coat, he was a familiar figure in Oxford art circles.

[3] *A Note by Professor Ruskin for the use of the students at the Ruskin Drawing School* (in the author's possession).

The third-year course appears somewhat ambiguous, combining copying in the galleries with work from nature. The student was "to draw from the beautiful forms of life, distinguishing (them) from those of awkwardness or deformity . . . and (to be) encouraged at the same time in the rapid sketching both of animals and figures from nature, so as to give him interest in familiar scenes and daily incidents".[1]

There was no love lost between Ruskin and the School of Practical Art, the centre of officialdom in art teaching, which was now located in South Kensington under the Department of Science and Art. The South Kensington methods were beginning to incur frequent criticism.

Ruskin's disciple, Ebenezer Cooke, who was to become one of the severest critics, had been a pupil of Pestalozzi in 1848–9, and was now teaching drawing at C. H. Lake's school in Caterham. Lake had founded the Society for the Development of the Science of Education in 1875, with Cooke as a member of its Council and an occasional contributor to the Society's *Journal*. Cooke had been foremost in opposing the South Kensington doctrines at the International Conference of Teachers in 1884, and he discussed this in a paper read at a meeting of the Society.[2]

The conference was attended by art teachers and by representatives of the Department of Science and Art. It was in all probability the first gathering on a large scale at which methods of art teaching were freely discussed, and problems such as the use of the imagination were voiced publicly for the first time. It gave the reformers a chance to confront the advocates of established methods, and the latter certainly had to listen to some forthright views.

The theme of the conference was "The teaching of drawing and colouring as a preparation for designing and decorative work". It was immediately challenged as too limiting to permit a full range of discussion of the issues that really mattered in art education. Was decoration, the critics asked, the sole objective in teaching drawing?

John C. L. Sparkes, principal of the National Art Training School, and one of the South Kensington representatives, ventured the discouraging conclusion that "a boy has but little chance at school of obtaining sound training in free-hand drawing". Cooke rounded on such references to "sound training", describing it as "the school view—the drill and discipline possible at the age of sixteen or seventeen, needed for technical work". What was their object in teaching art? Cooke demanded a discussion of its broader issues:

> The Educational value of art [he complained] was not to be referred to, nor its elementary stages, nor its use for any other purpose, but only this fraction of the

[1] *A Note by Professor Ruskin for the use of the students at the Ruskin Drawing School.*
[2] E. Cooke, *Our Art Teaching and Child Nature, a review of the discussion, Art Section, International Conference, Health Exhibition, 1884.*
 A paper read May 18th, 1885, and published in the Transactions of the Education Society, 1885/6.

established curriculum for technical training in decoration, to a few selected students, excluding, as far as possible, education.[1]

The use of colour came up. What was meant by the theme "colouring as a preparation for designing"? Sparkes had expressed the conventional view that "colour cannot be taught; the colourist is born, not made", to which Cooke responded:

> Is it fair to say colour cannot be taught? Little children were not likely to be injured by colours. The child wants colour, imagination, movement, life. We give dull flat copies—with no invention, dead!

During recent years Froebel's "Kindergartens" had been introduced into England and his methods applied to the teaching of art to very young children. Cooke was a strong supporter of these experiments. As he explained:

> Froebel's aim is education by natural development, working in alliance with nature, by methods learnt from observing the child.

The Science and Art Department had ignored these experiments in their training of teachers, and its representatives at the conference table had to endure Cooke's chastisement:

> The Kindergarten system and the Science and Art Department might have been mutually helpful long ago. The Kindergarten is still unrecognized, poor and struggling; but if, thirty years ago, Schools of Design could have understood its purpose, not art teaching alone but the whole education of the country would probably today be on a sounder basis.

Sparkes had rashly ventured the view, generally accepted in his day, that children are incapable of originality. Cooke's patience was nearing exhaustion:

> Imagination? [he asked] Some teachers consider it their enemy. Mr. Sparkes puts it aside. Froebel makes it the very centre of his system, for his aim is education, not instruction, still less decoration.

The Froebel Society had been founded in 1874 and the following year the London School Board had established the Teachers' Training College at Stockwell for those who wished to teach by Froebel's methods. These methods were derived from the proposition that the child is not merely an incipient man but a growing and developing organism passing through well-defined stages, and that education must be adapted to the child's real needs at each stage. If the purpose is development, then it follows that teaching must be grounded in observation of the child's progress. Thus the teacher was conceived as an observer rather than an instructor, and this, in turn, implied the psychological study of the child.

[1] E. Cooke, *Our Art Teaching and Child Nature, a review of the discussion, Art Section, International Conference, Health Exhibition, 1884.*
 A paper read May 18th, 1885, and published in the Transactions of the Education Society, 1885/6.

It was the Froebel view that development is brought about by activity such as art and that this must be spontaneous on the part of the child. The teacher's role should be passive and protective, not prescriptive or categorical. The child's use of drawing and colour has a meaning which corresponds with its particular stage of development, emanating from its first infantile scribbles.

Neither the Froebel, nor the subsequent Montessori, methods were primarily aesthetic in intention. Nevertheless, the practical apparatus of teaching involved the provision of lavish supplies of papers and cards, plain or coloured, chalks, paints, clay, paste, glue, etc., which converted the classroom into a workshop, with the children moving about freely or in groups as occasion required. Writing, drawing, pattern-making, painting and modelling all became parts of one exciting creative activity.

The child's creative abilities were thus attracting the attention of the psychologist. Some scholars such as Professor James Sully, a vice-president of the Education Society, sought to explain the child's artistic tendencies by equating them with those of "the savage". The paintings of bison which had recently been discovered on the ceiling of the cave at Altamira in Spain, had proved to an incredulous world that art of a high order was practised in the Old Stone Age. If art was present so near the dawn of life, should it not be found equally among children, was the question immediately posed.

In an analysis of the child as artist, written some ten years later, Sully noted three stages: First—vague, formless scribble; second—primitive design as in the diagrammatic lunar shape for the human face; third—a more sophisticated treatment of the human figure and animal forms. But Sully did not profess to see at any of these stages "any elements of artistic value", though often apparent to the artist.[1]

It was observed that the child never drew geometric forms of its own accord unless required to do so by the teacher. All natural tendencies on the part of the child, rather than any artificially acquired skill, ought to be developed in the classroom. Cooke elaborated this psychological approach in a further paper on "Neglected Elements in Art Teaching". One of these "neglected elements", in his opinion, was the elliptical curve, which children found more natural than the exact arc or circle. This was because the child sought rhythm rather than symmetry.

> Tired of cramped fingers [writes Cooke], he (the child) throws his whole hand and arm, his whole body, into the delightful and rapid motion.[2]

Cooke named this rhythmic action "free-arm drawing" and suggested that it should provide the basis for a sound method of teaching, since it combined physical and mental effort. Here he deviated from Ruskin with his emphasis on the mass as opposed to the outline. Cooke claimed that the child had an inherent need for outline, which the ellipse provided.

[1] James Sully, *Studies of Childhood*, 1895.
[2] E. Cooke, *Neglected Elements in Art Teaching*, a paper read before the Education Society, December 1887, and published in the Society's *Journal*.

Among those who had supported Cooke at the Conference of Teachers in 1884 was a young art teacher, T. R. Ablett, then Superintendent of Drawing for the London School Board, who was to make a considerable impact on art education. He had acquired his first teaching experience in 1862 at Beverley Grammar School, where Ridgeway, the headmaster, encouraged drawing, using Ruskin's *Elements of Drawing* as his guide. Thus Ablett was introduced to Ruskin's ideas. Ten years later, when still only twenty-four, Ablett joined the staff of Bradford Grammar School with its 450 boys.[1]

Having received no normal art school training, Ablett had to seek his teaching qualifications by submitting work to the Department of Science and Art for the usual certificate, and he accepted with alacrity the opportunity to visit art schools in London and on the Continent. Armed with this experience, he was able to persuade the Governors of the Bradford School to extend its facilities for studying art. With three studios and a lecture room included in the building programme, art could be taught on a scale quite unusual in any school.

Ablett's methods attracted the attention of the Girls' Public Day School Company, with the result that his classes at Bradford soon included girls as well as boys. Ablett's ideas were now beginning to take shape. He noted that children learnt letters by memorizing their form rather than the line, and concluded that the drawing of letters and of objects should be practised together. His motive, unlike that of Mulcaster and Brinsley nearly three centuries earlier, was to develop the child's artistic faculties rather than to promote good writing. He taught his pupils to memorize the complete shape of an object rather than the contour, and thus draw with a continuous line which would immediately establish the shape, instead of making a series of broken lines, recording a succession of detached observations.

Opportunities for communicating his ideas farther afield came Ablett's way in 1882, when the London School Board invited him to lecture before London teachers. The Royal Commission on Technical Instruction in 1881 had reported that three-quarters of the elementary schools provided no art teaching, and to meet this criticism Ablett was appointed Superintendent of Drawing for the London School Board. The Girls' Public Day School Company was anxious not to lose the services of this inspiring young teacher. Thus Ablett was invited to inspect the work done in London schools which were under the Company's control. In course of time he was conducting their annual examinations in drawing, painting and writing.

When other independent schools asked to be included in these examinations Ablett conceived the idea of forming a public institution for the sole purpose of conducting art examinations for children on a national scale. Thus the Drawing Society was formed in 1888, receiving its Royal Charter four years later—the first public body to hold school examinations exclusively in art.

The examinations began, modestly enough, with only fifteen independent schools, but by the end of the century the number had risen to 341 throughout

[1] Report on the Annual Exhibition of the Royal Drawing Society, London, 1899.

John McGill, a Student at High School, The Dancing Class: Prize winner, the Royal Drawing Society's Exhibition, 1901

the country in addition to the thirty-two schools of the Girls' Public Day School Company. Certificates of proficiency were issued in various age groups. Special courses for teachers were also provided, leading to a teachers' certificate. This was in two grades—a "blackboard certificate" at the ordinary level and a "teacher-artist's certificate" for those attaining a higher grade.[1]

Ablett was among those attending the first of Sir Martin Conway's Art Congresses, held at Liverpool in 1888, and the warm reception of his ideas encouraged him to take his next notable step—an exhibition of children's work which took place in London in 1890, with Princess Louise, the Society's first president, awarding the prizes. It was decided to make this an annual event, and the Princess's husband, the Duke of Argyll, coined the title "the Children's Royal Academy". Leading artists, such as Watts, Lord Leighton, Briton Riviere, the animal painter, and public figures like Lord Avebury, gave the new venture their support.[2]

It was Ablett's aim to make the value of art teaching known to the general public, who would, therefore, demand it for their children, and in this he had considerable success. For the first time the work of children appeared in the press, with criticisms of the exhibitions in *The Times*, the *Morning Post* and the *Daily Telegraph*. It was largely due to Ablett's efforts that the artistic merits in childrens' paintings were thus awarded serious discussion in the leading journals.

From the outset Ablett echoed Ruskin and Cooke in stressing the educational value in learning to draw.

> Drawing should be used as the foundation study of all education [he wrote some years later]. It makes the acquisition of all knowledge simpler and easier. It is because drawing facilitates the learning of the unchangeable facts of nature . . . that it is of supreme value in general education[3].

He was equally at one with them in rejecting the long-established respect for neatness and precision in outline as the main criteria of merit in children's work and to recognize, instead, its force and vitality. In concentrating on the mass rather than the outline, Ablett's pupils were urged to build up broad areas of light and shade, using sepia and charcoal.

The use of the brush in working direct from nature was strongly recommended by Ablett, its soft, flexible point responding to the child's sensitive perceptions more readily than the rigid pencil. Ebenezer Cooke had taught in

[1] The examination was, and is still, divided into groups: Group I, age up to seven; Group II, up to eleven (called Primary); Group III, up to sixteen (Full Drawing Certificate); Group IV, up to nineteen (Higher Drawing Certificate). Honours, as well as Pass, certificates were issued. Ablett's former student and, subsequently, senior examiner, Miss A. S. Holman, has informed me that in the early days he himself did all the examining.

[2] A drawing by Blanca L. Tennant, entitled "Babyland", was awarded the Princess' prize in 1892. It was for some years in Queen Victoria's possession and was subsequently returned to the Royal Drawing Society.

[3] Pamphlet published by the Royal Drawing Society, 1928.

this way at Caterham, with Ablett's fervent support. In his paper read at the
Conference of Teachers in 1884 Ablett had declared:

> The use of the brush stirs the intellect and calls out the inventive faculty at the
> outset of a student's career. Freedom? [he demanded] What freedom does a
> lead pencil give compared with its facile colleague, the brush?[1]

Ablett was well aware that children possess acute perception, spontaneity
and freshness of vision and that these qualities are not confined to the few
gifted with unusual talent. He deduced from this that art was not beyond the
reach of ordinary persons, especially if developed during childhood. He was not
particularly interested in the subtleties of fine art nor searching for artistic
genius. He was concerned with an ability in art on a more plebeian level.
Ablett was not a practising artist like many of the great teachers of the past. He
was, perhaps, scarcely an artist at all, except in his response to the work of
children, in which he was pre-eminent.

If artists have sometimes been alienated by the methods used by Ablett to
popularize drawing, somewhat resembling present-day correspondence courses
in drawing, it must be remembered that artists in the nineteenth century were
often very exclusive. Although sometimes descending to the lowest depths of
popular sentiment, Victorian painters nevertheless concealed the finer points of
their technique behind a veil of mystery, which they did not wish ordinary
people to penetrate. Ablett was determined to prove that this veil could easily
be pierced and the artist's secrets shared by many.

The publicity that art education was acquiring towards the end of the nine-
teenth century brought one aspect in particular to the fore. This was the training
of the visual memory. Ablett made this one of the main features of his system.
The growing belief in working from nature, especially those aspects that are
fleeting, imposed increasing reliance on the memory for recording impressions.
This was quite different from drawing a chair or a barrow out of one's head.

Belief in the value of developing the memory originated with the teaching of
Lecoq de Boisbaudron, who had published his essay on the subject as far back
as 1847, when Professor at the École Impériale de Dessin in Paris. It attracted
very little attention until thirty years later, when reissued with other essays.[2]
It was Alphonse Legros, subsequently head of the Slade School in London, and
R. Caterson Smith, of the Birmingham School of Art, who were chiefly respon-
sible for introducing Lecoq's ideas and methods into England; they were, Lecoq
claimed, essential for general education and not exculsively for the artist.[3]

[1] E. Cooke (op. cit.): *Transactions of the Education Society*, 1885/6.

[2] Lecoq de Boisbaudron, *L'Education de la Memoire Pittoresque*, 1879, first translated
into English as *Training the Memory in Art* by L. D. Luard in 1914.

[3] The following incident is recorded by L. D. Luard in *Training the Memory in Art*.
Intending to copy Holbein's "Erasmus" in the Louvre, Legros found he had left his easel
behind, and resolved to memorize the picture. "I calculated the exact distances between
the various points, fixed the characteristic traits firmly in my mind. . . . Thus I learnt

Lecoq required his pupils—so Caterson Smith informed his students at Birmingham—to memorize their subject in an upper story of the art school and then descend to the basement to carry out their drawings. This encouraged concentration, since they were loath to walk up several flights of stairs whenever memory failed them.[1]

In 1897 the School of Practical Art at South Kensington became the Royal College of Art and the following year it acquired an eminent figure in the world of art—Walter Crane—as its principal. During his short reign of two years the organization was transformed, but, more important from our point of view, a new syllabus was issued for the guidance of teachers in elementary schools. Hitherto, in order to qualify for grants, the schools had been required to teach according to a prescribed formula with "freehand" drawing of "lines, angles, parallels, etc." The Board of Education very properly criticized this as "a wearisome exercise". Crane sought to introduce some less wearisome features.

A circular was issued in 1901 by the new Board of Education, which had absorbed the Department of Science and Art. This was largely based on Walter Crane's notes and illustrations, and its preamble contained welcome evidence of the changed attitude in official circles:

> The Board regard instruction in drawing as an important means of cultivating in children a faculty of observing, comparing, recollecting and thinking about all sorts of objects with a view to representing them in an intelligent and careful manner and of developing a sense of beauty.[2]

Whether or not this was written by Crane, it was certainly the first time that elementary-school children had been urged in an official document to observe or recollect visual impressions.

Ablett's advocacy of the brush now became official policy, but of chief importance the more intelligent use of the memory was now to be encouraged. According to the Board of Education's new syllabus an object was first to be drawn from sight and then removed and the pupils told to draw it from memory "during the same lesson". Moreover, children should "be encouraged", so runs the excellent advice in the circular, "themselves to choose objects from which they are to draw in order to cultivate ability in selection".

Ablett took this new enthusiasm for training the memory a step farther by launching his "snap-shot drawing", a title suggested by the new Kodaks then much in vogue. Quick to discover its popular appeal, Ablett had the title entered at Stationers' Hall in 1902 as the copyright of the Society. He described

slowly to dissect and reconstruct this masterpiece. When I returned, Lecoq asked me for my drawing. 'I have not done it,' I replied, and then, seeing his perplexed look, I added quickly: 'But I am going to do it now.' "

[1] I am indebted for this information to Ruth Munro, a former student of the Edinburgh Art School.

[2] *Circular on Primary Drawing*, No. 191, H.M. Stationery Office, December, 1901.

it as "the art of rendering the thing seen with all the freshness of a first impression". Children were to practise it when very young, less than a minute being sufficient for observation.

There was, in fact, nothing new in "snap-shot drawing", barring the name. Rapid drawing based on quick observation had been recommended by Peacham three centuries earlier, but largely forgotten until the idea was thus revived. Ablett placed such confidence in the basic need for memory drawing that he made it compulsory in the Society's examinations.

Art teachers were now beginning to raise their voices collectively, and it was the obligation to take snap-shot drawing in the examinations that aroused general opposition, although it was often practised in the classroom. It was claimed that it encouraged superficiality instead of "disciplined knowledge combined with rapid observation".[1] Moreover, half a minute was considered too short a time in which to observe a complicated group. Ablett had staked so much in snap-shot drawing that he was not prepared to make concessions, and his unconciliatory attitude caused some schools to cease taking the Royal Drawing Society's examinations.

Hitherto, the woman's voice in art teaching had been seldom heard, but before Queen Victoria's reign had ended the number of art mistresses had grown. The increasing support for reforms in teaching largely derived from the art mistresses. This was rendered voluble by the vigorous corporate action of the Art Teachers' Guild, an organization of women concerned with teaching art, and the Guild could claim credit for many of the valuable changes in art education that now emerged.

During the 1890s Miss Hine, a London art teacher, had made tentative attempts to bring her fellow art teachers together, inviting them to meetings in her home in Hampstead to discuss problems over tea or coffee. The question how to train art teachers loomed large in their discussions: Was the art school the best place for training educators? Why did training colleges not cater for art students who wished to teach, and why did they not enlist the services of an artist?

When Miss Beatrice Collins came to London as art mistress at the Skinners Girls' School, Stamford Hill, in 1900, enthusiasm was renewed, and in March 1901 at a meeting in Berners Street the Art Teachers' Guild was duly founded with fifteen foundation members and a committee of six. Miss Lucy Varley was elected chairman and Miss Collins, an indefatigable organizer became secretary. The latter subsequently became a student of Tudor-Hart in Paris and her teaching thenceforward reflected his ideas.[2]

[1] Minutes of a meeting of the Art Teachers' Guild, 1909.
[2] Percival Tudor-Hart, an artist of highly original ideas, with his school in the Rue d'Assas in the Latin Quarter, believed that artists had more to learn from children than to teach them. The child, in his view, was born with perceptions which tended to be lost in later life. The adult could only hope to retain the natural reactions to visual stimulus, which he had possessed as a child, as a result of training. Failing this, the average student had to face an uphill battle to regain this lost sensitivity. Miss Collins, on her

The original aim of the new Society was a simple one—to promote "discussion and development of methods of teaching drawing in schools". They still spoke of "drawing" rather than "art". There was also the emphasis on "method". When the chairman, Miss Varley, addressed a general meeting of the Guild a few years later she made the comment, with a sly dig at the rival all-male Society of Art Masters:

> Some associations exist primarily to secure for the teachers better salaries and shorter hours, but it has been the main object of the Art Teachers' Guild to secure better methods of teaching.

The Guild's aims were further defined in 1902; namely to "band together those interested in the teaching of drawing in schools". This was to establish the Guild's claim to negotiate on behalf of art teachers collectively, in the same way as the Society of Art Masters was already doing.[1] Professional standards were to be maintained, and the Guild was to keep "a register of those duly qualified to be art teachers".

A Teachers' Registration Council had been recently set up by the Board of Education, which asked the Guild to formulate suitable qualifications. This was a momentous step—the first time that an official request had been made. Hitherto, anyone had been able to practise as an art teacher, without being expected to reveal qualifications.

The Guild undertook this task in the spirit of the Puritans. It drew up a set of requirements, reasonable today, but which at that time few could hope to comply with: The prospective art teacher was to be in possession of a Higher Certificate from one of the university examining boards, together with the Art Class Teacher's Certificate issued by the Board of Education or an equivalent certificate from either the Royal Academy Schools, the Slade, Bushey or the Paris Art Schools. In addition, he or she should have spent one year at a training college, ending with an examination in the theory and practice of education, and finally one year as a probationary teacher at a recognized school.

return from Paris, proposed Professor Tudor-Hart as an honorary member of the Guild, to which he was duly elected. In 1913 he moved his school to Hampstead.

[1] The Society of Art Masters had been founded in 1888 at a two-day meeting in the South Kensington Museum, its objects being to promote "the interests of art education, of Schools of Art and of Art Masters". It was, therefore, the first organized body to concern itself with art teaching, though concerned chiefly with the interests of teachers rather than methods of teaching. Women had not then entered the profession in any numbers, and the Society made no provision for extending membership to them. Art masters were almost invariably graduates of the Department of Science and Art, and the Society sought recognition of its right to represent the profession. Edward R. Taylor, head of the Birmingham School of Art, the Society's first chairman, stressed, in his opening address, the lack of contact between art masters and the Department of Science and Art, and this the Society hoped to achieve. Becoming the National Society of Art Masters in 1909, it again changed its name to the National Society for Art Education in 1944.

There was some doubt as to whether art teaching would have a representative on the Registration Council. The Guild insisted, but the Council refused. Ultimately, it was agreed that a representative might be nominated jointly by the Guild and the Society of Art Masters.

Those who believed strongly in the value of art education were much fortified at the beginning of the new century by the formation of an International Federation of Art Teachers, with its seat at Berne. The Federation held periodic congresses. One of these was planned for 1904 at Berne, and the Guild resolved to send Miss Spiller with a collection of drawings from various London schools. Her participation seems to have made a distinct impact on the art teachers from different parts of the world, since it was agreed to meet next in London in 1908.

Meanwhile, the influence of the Guild was steadily expanding. Within a few years its membership had advanced from about sixty to well over two hundred. It now laid its membership open to art masters, as well as mistresses, who might be interested in reform. Moreover, it took the ambitious step of publishing a bi-annual journal—*The Record*.

For the London Congress on Art Teaching, the Guild organized a number of preparatory conferences, and art teachers can never previously have had so many opportunities for exposing the difficulties and issues confronting them.

One of the main activities planned for the Congress was an exhibition representing work by children at different age levels. It was to be very different in aim from the exhibitions held by the Royal Drawing Society. Mathew Webb, art teacher at the Crystal Palace School, was chosen as secretary of the organizing committee.[1] The exhibition was to "demonstrate the value and importance of drawing to education" and "show what schemes are being followed in the several grades of schools", but would not in any sense create competition. Art teachers agreed with Martin Buckmaster, then art master at Tonbridge School as well as examiner, that their efforts should "lead to more encouragement being given to art teaching", and there was general support for the thesis:

> If ideas of art are ever to be disseminated and the standard of public taste raised, it must be done by the children.[2]

Such were the hopeful signs of new vitality in art education in the early years of the new century. But it needed more than signs to change official policies in respect of teaching and examining in art.

[1] Mathew Webb taught subsequently at Oxford. In his early years he had assisted Burne-Jones. I recall the dry humour with which he told how Burne-Jones valued his (Webb's) ability in painting briars and thorns, and for this reason instructed him to paint the tangled undergrowth surrounding the Sleeping Beauty, which formed part of Burne-Jones' series of paintings on "The Legend of the Briar Rose".

[2] *The Record*, March 1909.

the Art Examinations
under Criticism

WITH the commencement of the present century the art examinations in England had become the main target of criticism from dissatisfied art teachers, resenting policies which seemed short-sighted in their neglect of art. They held the view that the seats of power in university circles were too often occupied by those who were philistines in their approach to art and who lacked adequate understanding of the subject. At the International Congress on Art Teaching in Dresden in 1912 a British speaker was applauded for declaring:

> The university-trained people are the chief offenders, because they ought to know and do not, and especially the clergy.[1]

Art teachers felt, perhaps with some justification, that the visual arts were regarded with suspicion in the universities, thus fostering their neglect. Was there not a tendency among university men to regard artists as figures of fun—the target for misplaced humour? This attitude bred an element of distrust which was assimilated in turn by the local examinations.

The drawing examinations had now been held at Oxford and Cambridge for nearly half a century without any advance being made either in objective or character. Changes had been for the worse. The Oxford and Cambridge Schools Examination Board (the Joint Board), whose drawing examination was confined to the pupils of girls' schools until 1899, had made no appreciable changes in the syllabus since 1878.

Durham University had established its Secondary Schools Examining Board at the same time as Oxford in 1858, with art included in group (d), but no question papers in the subject had been set. The examination was discontinued in 1883, and although Durham revived its "Locals" in 1895, it excluded art until 1917. The Central Welsh Board came much later in 1897, and an examining centre for Victoria University, combining the northern colleges, came into being in

[1] A paper on *Art in the University*, by J. T. Ewen, H.M. Inspector for Scotland (*The Record*, November 1912).

1903 as the Joint Matriculation Board of the Northern Universities at Manchester, but in both these cases, art was not examined at the outset.[1]

London University established, in 1902, a board for the extension of university teaching and for the inspection and examination of specified schools, functions resembling those of the Oxford and Cambridge Joint Board. Here again, art was not at first among the subjects acceptable for examination, though it was to be included later.[2]

In Scotland the situation as regards art was only slightly better, in so far as drawing of a kind was catered for. Local examinations had been established by the Scottish universities, following the example of Oxford and Cambridge, as early as 1865 at Edinburgh and St. Andrews, in 1877 at Glasgow and in 1880 at Aberdeen.[3] These were in two grades, a Junior and Senior, but as with the English universities they were not intended to test fitness for university entrance. They appealed in consequence mainly to pupils of girls' schools. In fact, in 1879 Glasgow established a Higher Local Examination specially for female candidates.

Since art, or rather drawing, was generally considered to be much less a waste of time for girls than for boys and even obtained some degree of encouragement in girls' schools, the Scottish universities included the subject "Drawing" in their local examinations, both at the Junior and Senior grades. It was treated as one of the extra, or optional, subjects, which did not contribute towards the granting of the certificate, but in which success was acknowledged on it.[4]

These tests, it may be said at once, had no artistic value, and scarcely equalled

[1] The Welsh Board replaced inspection by examining in Drawing in 1899, with 45 schools entering candidates. The Northern Board, representing the University Colleges of Manchester, Liverpool, Leeds and Sheffield, began examining for School and Senior School certificates in 1909, but art was not examined until after the First World War. Birmingham University was added in 1916. The Board now caters for more candidates in England than any other board, with some 40 per cent entering for art (the figure given for 1950). The Board's history is recorded by its Secretary, Dr. J. A. Petch in *Fifty Years of Examining*, 1953, but no mention is made of art.

[2] The University Calendar for 1904/5 mentions for the first time "inspection of art work", schools being "required to submit a scheme of art teaching definitely divided into grades". The Inspector (W. Egerton Hine) was to "criticise where necessary the scheme of teaching apart from the results obtained in the different grades". Proficiency in the subject would be endorsed on the Certificate. Five schools are listed as having availed themselves of this concession in 1903.

[3] H. M. Knox, *Two hundred and fifty years of Scottish Education, 1696–1946*, 1947.

[4] When Scottish education became separately administered in 1885 the Parker Commission recommended the Scottish Education Department to introduce School Leaving Certificates for the benefit of secondary schools. These were available in 1888 at the junior and senior levels and were examinable by the School Inspectors. The basic curriculum that was catered for included drawing and at the Junior level "Nature knowledge and Drawing" were compulsory. In 1902, an Intermediate Certificate was introduced for boys and girls of fifteen who had passed the Leaving Examination in four or five subjects, but was withdrawn when reorganization was recommended in 1921 and the Day School Certificates, Higher and Lower, were substituted. (see also H. M. Knox, op. cit., and M. Mackintosh, *Education in Scotland, yesterday and today*, 1962).

those of Oxford and Cambridge; they could only have hindered art teaching in the schools. At Edinburgh, for example, even as late as 1901, the Junior examination was confined to a single test—copying in outline from an example provided (drawing from the flat). The seniors were allowed three alternatives in drawing, shading or painting from an object with a test in perspective. The Glasgow syllabus went a little farther by allowing the juniors to draw from solid forms in outline as well as from the flat. Its seniors were limited to drawing the human figure from casts and from copies. There were not many candidates who chose drawing. Glasgow gave, in 1892, only six passes in the subject, among 446 candidates in all subjects.[1]

In England the low-water mark was reached in 1893, when the Oxford Delegacy adopted a series of rules which made a complete mockery of the drawing examination. The rules adopted were as follows:

1. Pencil only might be used in the papers for freehand and model drawing.
2. In model drawing, only geometrical solids (meaning spheres, cones, boxes, etc.) would be specified rather than natural objects.
3. Juniors would not be required to shade but to confine their drawing to outline only.
4. Model drawing would in future be called "Drawing from the Solids".

Thus liberty of choice in materials was withdrawn and the range of work so restricted that it is not surprising that the Delegacy proposed to curtail the time allowed for each paper so as not to exceed one hour. No competent professional art adviser was present at this meeting,[2] and it may be merely a coincidence that the reports on examining for the next few years made no reference to drawing. The one test in the use of colour for still-life survived, but the emphasis lay on freehand and geometrical drawing. Those who obtained "honours" were granted the title, "Associate of Arts". Nevertheless, art was not counted among the minimum number of subjects required for the certificate.

There was very little left in the examination which could be labelled "art". In fact, the very name itself had disappeared when the history of art was dropped from the Oxford syllabus as far back as 1865. Martin Buckmaster, who had joined Macdonald as co-examiner, prepared a paper on the history of architecture in 1897, but it was decided that questions would be set only if requested and soon afterwards the option was withdrawn, though it was reintroduced subsequently. The making of a picture had been given no place in the syllabus following the omission of the design paper in 1880.

The Cambridge examination had similarly reached its lowest level from the artistic standpoint. By 1902, when the Syndicate withdrew its "Imitative Colouring", the use of colour was no longer required in the senior as well as the

[1] In 1892, the Joint Board of Examiners of the Scottish Universities was set up, but the Minutes do not record any examinations in art having been held, nor by its successor, the Scottish Universities Entrance Board, established in 1919.

[2] Present at the meeting were the Vice-Chancellor, the Senior Proctor, the Provosts of Queen's and Worcester and seven other members of the University.

junior syllabus. Henceforward, with the objects having to be drawn in outline only, the board or other surface on which they rested would appear in the drawing as if floating in space. The Syndicate reintroduced memory drawing in 1903 (a wardrobe or a church porch being the alternatives set), but candidates must have felt completely frustrated by the instruction:

> Drawings should not be small, nor in too much detail, nor shaded, and may be sketched in pencil and finished with pen and ink. Mark on your paper the supposed level of the eye.[1]

This final instruction was to ensure correct perspective.

With examinations now able to claim no artistic pretensions whatever, we may well feel that Cambridge was fully justified in its proposal to withdraw drawing, together with music and book-keeping, from the list of subjects qualifying for a Certificate in the Senior and Junior Examinations. This would have meant ceasing to examine in art. The plan was proposed to the Oxford Delegates in 1904 with the suggestion that they might follow suit, but this they declined to do. Presumably the Syndicate was disinclined to act alone, for no more was heard of the proposal.[2]

From the art teaching point of view, a further unsatisfactory feature in the art examinations was now emerging. This was the growing uniformity among the boards, both in syllabus and examining. The syllabus left schools with no variety of choice. When Oxford decided in 1893 to confine drawing to the outline only and to the representation of geometrical solids, we find that Glasgow had previously adopted the same rule. When in 1903 Cambridge reintroduced memory drawing and design (a plant form to fit within a circle), we find Oxford doing the same the following year. This was doubtless the general policy, but damaging to teaching, since it prevented schools from exerting any preference for one syllabus over another.

This uniformity became inevitable when the three English boards increasingly shared the same examiners. Alexander Macdonald and Martin Buckmaster, who

1 Freehand attracted the greatest number of candidates at Cambridge in 1905 with 5,876 (Junior level) and 1,680 (Senior level), followed by model drawing with 5,110 and 1,530, respectively, and geometrical drawing with 3,338 (Juniors only). The other papers, design, memory and perspective (Seniors only) were taken by only a few hundred candidates. The syllabus remained virtually unchanged until 1915, when Cambridge allowed "any medium", and 1925, when some slight element of composition was discernible in the Syndicate's instruction that:
"The objects must be combined in a group and not scattered separately about the paper".

2 Both universities adopted, at the beginning of the century, a third level of examination, the Preliminary, for candidates at the age of fourteen. Drawing was included, but comprised only two papers—freehand and geometrical drawing. Oxford added model drawing in 1906. The Oxford Delegacy's Minutes described the new examination as giving "a more practical turn to school education", a practical concern that was disastrous to art teaching. The Joint Board also introduced a Lower Certificate. The Junior examination continued to attract the great majority of candidates, especially at Cambridge, and there were many more taking the Preliminary than the Senior.

had been examining for the Oxford Delegacy, took over the examining for the Joint Board, for whom F. W. Woodhouse had examined. Shortly afterwards, in 1900, we find Buckmaster on the Syndicate's team, which subsequently included Woodhouse. This not only led to a close similarity in the setting of the papers, in so far as they allowed for much variety, but must have produced a uniform judgment of the candidates' work. If schools, or pupils for that matter, taking the Cambridge examination suspected any prejudice in favour of one type of work, they had no redress, because the same prejudice would equally have emerged at Oxford.[1]

Uniformity was in danger of becoming complete in 1906, when the suggestion was made that the two English universities should combine their examining boards. Fortunately the scheme did not materialize. Had it been adopted, the methods of art teaching would then have been almost entirely at the mercy of one team of examiners.

The number of boards examining in art was increased, though without adding any variety, when London University included drawing in its Junior Schools Examination in 1907 for pupils of approved schools at the age of fifteen. The syllabus scarcely differed from that of the other boards. Freehand drawing (copying a print supplied) or model drawing could be taken as supplementary subjects, contributing but not essential to the gaining of a certificate.

If the local examinations in England had little to offer of any value in art, the position in the Australian States was even worse. Their external examination system seems to have been largely modelled on that of the British universities, but, as regards art, borrowing only the worst features. The Public Instruction Act of 1880 in New South Wales enabled the State to exercise separate control in matters of education, and the other States took similar steps. The universities conducted their own school examinations, but these differed only in details.[2]

Under the revised regulations introduced in New South Wales in 1911, the boys and girls had their examination procedure firmly laid down. This largely echoed that of the Scottish Education Department. After taking a qualifying examination which enabled them to pass from primary to secondary school, they could take the Intermediate Examination after two years, at the age of fifteen or sixteen. They would sit for the School Leaving Certificate after a further two years, if they chose to stay at school that long. By the University Amendment Act this Certificate was recognized as the equivalent of matriculation into a university.[2] An Honours examination, which would be roughly comparable with the Higher School Certificate in England, could be attempted later.

A choice of subjects was offered, and the candidates had to pass in a minimum number varying from four to six. Drawing was among the subjects available in these examinations. It is of interest to note that in 1922 in the State of Victoria

[1] In 1922 Buckmaster was also examining for London.
[2] S. H. Smith and G. T. Spaull, *History of Education in New South Wales 1788–1925*, published 1925.

more than half the Intermediate candidates chose drawing, but barely a quarter
chose it for the Leaving Certificate.[1] This may have been due to the subject
having no place within the universities in Australia.

The Schools Board of the University of Melbourne prescribed a syllabus in
drawing which, according to its report for 1921, covered the following five
subjects:

1. Elementary practical geometry.
2. Elementary perspective.
3. Geometric models and common objects (described as "straight-lined or
 curved, of simple form in easy positions").
4. Memory drawing of the same objects.
5. Plant drawing from simple specimens of three or four leaves.

It may have been claimed that the title "Drawing" was not used to connote a
branch of art, since these tests were intended only to promote the use of design
in industry. But, surely, this would be an admission of defeat, rather as if in
examining French we were concerned over whether it would be serviceable on
the cross-channel steamers instead of expecting the candidate to reveal a real
knowledge of the language.

Those taking art in the Honours examination at Melbourne were allowed to
go farther, being offered either "drawing in light and shade from simple
models or objects, or from casts of plant forms or ornament", or as an alternative
"the application of simple plant and animal forms to decorative designs for
borders, panels and the like".[2] In 1927 a paper on the history of art was added
instead of geometric drawing.

An examination in drawing of a stereotyped and thoroughly mechanical type,
as these examinations were, was perhaps only to be expected in the early years
of this century, since art was valued in most schools purely from the utilitarian
point of view. The really astonishing feature is the continuance of this type of
syllabus in art, apparently unchallenged in Australia, almost until the present
time. We read of cylinders and cones being drawn from memory, the omission
of shading, space-filling and such shades of the past in the University of
Adelaide's examinations as recently as 1957.[3]

What had really happened to push the clock back in these art examinations?
Clearly, the intentions of Acland and his colleagues, Ruskin, Dyce, Redgrave

[1] J. A. Seitz, *Variability of Examination Results*, 1936.
[2] University of Melbourne: *Handbook of Public Examinations for December 1923 and February 1924.*
[3] University of Adelaide: *Public Examinations, 1956/57.* The syllabus consisted of (1)
Geometrical drawing, (2) Design and colour, (3) Plant, lettering and showcard writing,
(4) Dimensional sketching, (5) Object drawing, (6) History of art. For plant drawing
the instruction reads: "Motifs to be conventionally treated in line, and shading may
be added, but shading will not be required in the examination." The history of art
syllabus ranged far too extensively over the entire ancient world to the present time,
and candidates must have been thoroughly daunted by the requirement "to analyse in
line or in mass the composition of any picture supplied".

and the others, seeking to bring art into general education, had been disregarded. Perhaps the university men who controlled the local examinations were half-hearted when they accepted Acland's plea to include art in the examination scheme. During the half-century that had followed the inauguration of the "Locals" in 1858 they had taken a succession of steps to elliminate art and substitute the type of skill required by the industrial draughtsman.

But what about the examiners? Bowler, at Cambridge, Alexander Macdonald, Martin Buckmaster and others were pre-eminently artists.[1] Could they have willingly participated in the abandonment of art in the examinations? Perhaps they protested unheard. A growing body of art teachers, at all events were not willing to see art ignored in schools, because of examination policy, without protest.

Serious criticism was voiced when Miss Fuller, a London art teacher, read a paper to members of the Art Teachers' Guild in 1906. Such gatherings enabled issues to be raised which had rarely found expression heretofore. It was claimed that the examination merely sought evidence of instruction not education. Why, Miss Fuller demanded, could not the child be encouraged to "experiment in different media or to express what is in him"?[2] Miss Fuller threw down the challenge: "Must the child take these exams? Can we not educate better without them?"

There was wide support for such criticisms. Art teachers were no longer willing to accept dictation derived from the "Locals" unless they could approve their character. The examining boards in Oxford and Cambridge had lamely suggested that the difficulties in assessing art work should be taken into account. Miss Collins reacted sharply. Did this mean that the examiners had to set the type of questions "which could be most readily marked"? If this was the case, those who believed in education would not support it.[2] In point of fact, though, as every examiner knows, the problems of assessment must be taken into account when setting the papers. It was not really the papers that were at fault, but the entire syllabus.

The art teachers failed to appreciate that their pleas were being ignored mainly because at that time the universities in control of these examinations were frankly not interested in art as a means of education.

Whether or not criticism was making any headway, it does so happen that the Joint Board announced a revision of its syllabus in drawing the following year—the first it had made during its thirty years of existence. While some parts of the syllabus, such as freehand and model drawing, remained unchanged, perspective and geometrical drawing were withdrawn in favour of memory drawing. The main innovation was plant drawing in pencil or pen and ink from a natural specimen, which was also to be drawn from memory, revealing details of

[1] I recall Martin Buckmaster in retirement not more than a few years back—tall and active when well over ninety—a refined and distinguished man of taste and erudition, explaining lucidly the finer aesthetic points in Spanish ceramics.
[2] *The Record*, July 1906.

structure. This was a distinct advance, perhaps reflecting the growing influence of the girls.

Improved as it was by such introduction of natural forms, the syllabus still contained too many of the discredited "co-ordination of hand and eye" features to satisfy the members of the Art Teachers' Guild. *The Record* carried an editorial in November 1907 which roundly condemned the examinations:

> Good, sound, honest teaching of drawing need not be—should not be—the deadly dull thing which these tests imply.

School teachers were more than ever aware that lessons did not have to be dull in order to educate and that drawing could and should be made interesting to any child.

The drawing examinations were discussed at a joint meeting of the Art Teachers' Guild and the Society of Art Masters at Manchester in 1908, and a series of recommendations were submitted to the university examining boards. Greater latitude was demanded in the choice of materials; in design, larger, half imperial sheets of paper should be allowed and the subjects related to a specific purpose, such as a programme or notice; freehand drawing[1] should be withdrawn and a test in colour reintroduced. Miss Welch, of Clapham High School, went so far as to urge that colour be "brought in throughout the school course".[2]

It is astonishing to find such proposals being made nearly forty years before they were finally adopted by the examining boards. What prevented their adoption earlier? Who was at fault—the schools or the universities? The schools, especially those without qualified art teachers, were too complacent in accepting the type of syllabus offered, and the university boards were quite content to accept this complacency as justification for making no change.[3]

Highly sceptical of any prospects of progress, the Guild proposed a different system of examination, embodied in the following resolution adopted at their meeting in November 1908:

> It is desirable to substitute inspection of drawing for external examinations, and that some recognised authority shall be requested to organise such inspection and possibly to grant leaving certificates.

It was submitted to the two associations of heads of schools, and it was hoped that the London County Council might co-operate. London University was also

[1] This perennial was hard to uproot; twenty years later it was still being claimed that it had to be retained because it was chosen by the majority of candidates in the subject. The Art Teachers' Guild retorted: "It is not recognised that it has neither educational nor aesthetic value" (*The Record*, March 1924).

[2] Minutes of the Guild's Committee, March 1909.

[3] Marion Richardson wrote of her early efforts to adapt her art teaching at Dudley High School around 1912 so as to include the examination requirements. "In one way or another we managed more or less to make friends with the examination and got it on our side", she wrote in 1946. "From the children's point of view, the verdict of an external authority is reassuring", and success "gave the subject and their own abilities a standing in their sight". (*Art and the Child*, 1948.)

asked to give its support. This was the first open demand for an internal method of examining that has been pressed from time to time ever since, though resisted by the examining boards. The proposal might never have been made—for external assessments must carry more weight than internal ones—if the boards had shown any readiness to reflect the views of art teachers, who were qualified to judge.[1]

Criticisms and proposals alike fell on stony ground. The Cambridge Syndicate replied briefly that the regulations could not be altered, and the Oxford Delegacy, calling attention to improvements made recently, pointed to the administrative difficulties involved in any acceptance of the Guild's proposals.

It was insufficiently recognized that mere "improvements" could not solve the basic grounds of criticism, which sought an entirely different syllabus. There was a fundamental cleavage in point of view, between the teachers and the examining boards, regarding the objectives in teaching art. The critics were concerned with art as a means of expression, whereas the universities persisted in regarding it, for examination purposes, as a form of skill.

During the early years of the new century the role of art in society was in process of change. Facilities for study were gradually, but constantly, expanding with the increasing number of art schools. Artists were being absorbed in the running of art galleries and other institutions concerned with art. Societies and conferences were devoted to its problems. But the conflict in educational policy still persisted.

Should art be taught mainly because an ability to draw was useful, while unusual talent might occasionally be unearthed in the process? This was the conventional attitude. In the view of enlightened teachers and artists generally, it ought to be taught because a knowledge of art helps to create a more civilized human being, and provides him with a more interesting life. "Could the school curriculum afford time for such nebulous objectives?" This would be the orthodox view. The "progressives" would counter thus: "If schools are to continue neglecting the creative faculties, giving all their attention to the other faculties, education will remain lop-sided and ultimately the boat will capsize."

Was there a sufficient supply of trained art teachers? Schools which ventured to include art in the curriculum would often place the art class in the hands of some member of the staff who had no real training in art or some local amateur might be engaged in a visiting capacity. Although the position had greatly improved during the course of the century now expiring, comparatively few of those teaching art in secondary schools could claim to have received a full art-school training.

The Board of Education's Royal College of Art at South Kensington was the main springboard for the art teacher, just as the Slade at University College, the R.A. Schools, Heatherley's and Bushey (under Lucy Kemp-Welch, R.A.)

[1] In recent years similar proposals have been received much more sympathetically, but the boards have pointed to the practical difficulty involved, while coping with the ever-increasing number of candidates.

mainly catered for students who hoped to live by practising art or exhibiting their work. When the new Board of Education came into being in 1900, absorbing the functions of the old Department of Science and Art, some changes were made without substantially altering the system. The Board's examinations in drawing, painting, modelling and pictorial design continued as before with slight modifications.

These examinations led to the grant of the Art Class Teacher's Certificate or to the more advanced Art Master's Certificate, the sole avenue of qualification for those who wished to take up a career as an art teacher.[1] The rigid and mechanical character of these tests were beginning to alienate the serious art student. Those who planned to depend on art teaching as a career had, alas, no choice and even found themselves treated in the artists' world as if they belonged to another race.

These teaching certificates, essential to those who taught in the local art schools and technical schools throughout the country, were seldom demanded in secondary schools. This issue—the essential qualifications for a secondary-school art teacher—had been debated by the Art Teachers' Guild at one of their first meetings in October 1902. They pressed for the inclusion of artists on the staff of the training colleges for teachers; moreover, one of the Guild's main objects was to keep a register of those qualified to teach art.

It was becoming increasingly clear that the problems of art teaching must be envisaged as a whole and placed on a much firmer basis than the haphazard one that had served hitherto.[2] The battle to secure an adequate place for art in general education must be re-aimed to secure a more enlightened understanding of the problems in teaching it. The battle had to be fought on different lines. No real progress was being made by frontal attacks directed at the heads of schools or universities.

It was at this point that John Lea, who was both a member of the Art Teachers' Guild and Assistant Secretary of London University Extension Board, suggested that the Guild should undertake a full-scale enquiry into the present state of art teaching in secondary schools. Armed with such information, it might be easier to make some headway with the universities, the schools and the Board of Education. A questionnaire was submitted in 1909 to six hundred boys' and four hundred girls' secondary schools—the first endeavour of this kind.

[1] In 1911 they were replaced by the Art Teacher's Certificate or Diploma, which required a higher standard. Shortly afterwards the Oxford Delegacy introduced their "Secondary School Teacher's Drawing Certificate" for those who had taken the Higher School Certificate. It was severely condemned by the Art Teachers' Guild.

[2] The success of the International Congress on Art Teaching in London in 1908 prompted the London County Council to convene a conference on problems related to the teaching of drawing. Of the fifty-five persons present only five were artists and these were far from progressive (Sir George Frampton, R.A., William Strang, A.R.A.), except Ebenezer Cooke, who dissented from the majority opinion and sponsored a minority report. The Art Teachers' Guild compared the two reports to "a cookery book versus a treatise on human nature".

A year and a half elapsed before there were sufficient replies to permit John Lea to produce his report—a unique survey of art education at the time. As was to be expected, quite half the schools failed to respond, and presumably most of these did not teach drawing. Of those that replied—nearly five hundred—all taught drawing to some extent, though the Naval Colleges at Osborne and Dartmouth confined it to machine drawing. Many discontinued the subject after the fourth form, but made it compulsory up to that stage. Of those replying rather less than half the boys' schools and more than half the girls' schools included drawing throughout the school as a compulsory part of the curriculum. Many professed to encourage imaginative work—the girls' schools more than the boys'—but only 5 per cent claimed that the development of the creative faculties constituted their main objective. Very few provided any drawing from the human figure or from landscape, and those that did so were exclusively the girls' schools.

Drawing appeared to be more widely taught than might have been expected, but what sort of drawing? In more than half the schools—those in which drawing was an extra—the treatment of the subject gave a most dismal impression.

> They begin [states the Report] with outline drawing in the lower forms, frequently from freehand copies, geometric models and simple common objects. Not until the higher forms are reached are the pupils given any opportunity for drawing objects of a more interesting character, or of drawing them in a way which leaves any freedom for individual expression.[1]

The report summed up the position regarding the majority of schools as follows:

> Drawing occupies an unimportant place in the curriculum and is treated as a separate subject without consideration of its educational value in relation to the general school course.

Judging by the replies, few schools were prepared to repudiate the right of the examining boards to influence the course of art teaching, and most of them related their teaching to examination requirements. It was maintained that the "freehand" copy was retained in the schools for this reason, although the examining boards always claimed that the schools demanded this test. Thus the teaching of drawing seemed like a dog chasing its own tail: schools could not change their methods because of examination requirements, which could not be altered, so the boards claimed, if they were to reflect the teaching in the majority of schools.

The report made it abundantly clear that art teaching would remain on the fringe of education, as long as its main function was to comply with the syllabus and enable pupils to pass their examinations. These tests merely demanded an exact representation of the objects (geometric models) provided. This meant the training of hand and eye by a process of graded exercises, ranging from the

[1] *The Record*, May 1911.

simplest forms to more complex ones—a skill to be instilled into the child by stages. Here we have the child and there we have the body of adult knowledge or skill to be implanted in him. This was what was intended, though it may not have been stated, and education consisted merely in absorbing as much as possible of this skill, to enable the child to grow up as quickly as possible.

Whether it was coincidence or a direct result of John Lea's report, it was in 1911, shortly after its appearance, that London University decided to extend its local examinations in art, the first break-through to the universities. It is, perhaps, significant that John Lea was about to become Registrar of the University's Extension Board, which was responsible for the examinations. The art teachers certainly had a friend at court in John Lea, a man, as I recall him, of intense enthusiasm for art, small and far from robust, but abounding in energy.

The Extension Board announced that the syllabus for the School Leaving Certificate (Matriculation Standard) would include "Drawing (Art)"—the first time that this designation had appeared in examinations since the 1850s—but, alas, the qualification "Drawing" remained. The subject had been taken at Junior level since 1907, but was now to be included at Senior level.[1] Drawing papers were still not set, however, for London's Higher School Certificate.[2]

The Junior syllabus had been revised in 1909, with improvements to the memory test, the objects being shown to the candidates for ten minutes before removal. Now, in 1911, tests in design and water-colour painting were added, making a choice of five papers, and a similar range was offered in the Senior syllabus. Both examinations possessed features placing them far ahead of those offered by the other boards.[3]

It was not merely a change in titles—the old model drawing now became "Light and Shade"—but candidates were given a still-life group instead of geometrical solids, and could paint instead of using pencil only. There was drawing from a natural object, and for design an embroidered cushion cover was specified instead of the discredited "space-filling". The paper on "freehand" was regrettably retained, but received a curious connotation. A photograph of an Oriental dish was provided and in addition to copying it in pencil the candidate was asked to name the country to which the dish belonged and guess its colour scheme. Obviously, few could have given the correct answers except by accident, but the questions had the merit of demanding artistic judgment, which had not been called for in any of the university examinations for nearly half a century.

Schools were slow to respond; there were only 165 Senior candidates in the first year. Noel Rooke, a painter and teacher of engraving at the Central School of Arts and Crafts, was the examiner at the Senior level, and credit was, perhaps,

[1] It became "Senior School Examination" at the end of the year and "General School Examination" in 1918.

[2] Though approved in 1923, the earliest I have been able to discover were set in 1926.

[3] In 1915 London University added the history of architecture.

due to him for the further advance two years later, when London became the pioneer in providing a paper in life-drawing. The head or full-length figure were to be drawn in pencil or chalk, but colour was not to be used.[1] Thus within a few years London had transformed the examining position in art. But the whole system was now to be reviewed.

This review came about when the Board of Education decided in 1911 to launch an enquiry into examination procedure. Hitherto schools had to choose, as the subsequent report explained, from "a dense jungle of uncoordinated and un-standardized examining bodies". Art, however, had been examined by very few of these institutions. It was not until 1914 that the enquiry resulted in a new scheme. Thenceforward, the Board was to recognize only the two examinations, known as School Certificate and Higher School Certificate, the former for the fifth form with average age of sixteen and the latter for the sixth form two years later.

Whether art and music should be dropped from the examinations under the revised scheme was again seriously contemplated. There was the school of thought that questioned the wisdom of examining in culture, since this was "a part of education which cannot be tested by the ordinary written examination".[2] It might have been asked which was the part of education that did not constitute culture. Moreover, the Board was swayed by the argument that a subject that is not examined is likely to disappear speedily from our teaching curricula.

Drawing was thus allowed a place with music, technical subjects and house-craft in Group IV, a status of minor consequence:

These subjects [the Board's report states] will not count towards a certificate, but candidates may take them, so far as the time-table allows, and if they do sufficiently well in them, the subjects will be endorsed on their certificates.

Contempt for the arts as subjects for education could scarcely have been more apparent and the position regarding art teaching remained much as it was before.

The Board of Education's task was completed in 1918, when the Secondary Schools Examination Council was set up, to include representatives of the examining bodies, of which seven were to be recognized—the universities of Oxford, Cambridge, Durham, Bristol and London, together with the Oxford and Cambridge Schools Examination Board, and the Northern Joint Matriculation Board. The Central Welsh Board was added two years later. The new Council's first task was to co-ordinate the standards of examination.

Hitherto the examining boards had been completely free to adopt whatever syllabus they desired, but as regards art they tended to conform. They were still free to formulate their own syllabus and set their papers. Moreover, drawing papers might now be set by those of the boards which had hitherto omitted the

[1] There was a curious addition in 1916, requiring candidates to make "a small diagram of the head of the model to show the principal forms and planes". This recalls Harold Speed's system of drawing.

[2] Philip Hartog, *Examinations and their relation to culture and efficiency*, 1918.

subject altogether.[1] When examining for the new certificates began in 1918 the London syllabus, alone, met the criticisms of the Art Teachers' Guild, and its candidates were the only ones allowed freedom in choice of materials and in the use of colour.

The other boards now began to fall into line very gradually. Cambridge introduced its memory paper in 1917 in which candidates were set to draw some-one in action, such as a man digging, somewhat similar to that set by Oxford five years earlier, and some choice in medium was permitted.

These modest developments naturally aroused hopes of wider reforms in the whole field of art education. The minor role which art performed in education prompted the Art Teachers' Guild in 1916 to address an appeal to the Prime Minister, H. H. Asquith, a known supporter of the arts, requesting the appoint-ment of a Commission of Enquiry into the state of art teaching. There was no result, as Asquith's administration fell shortly afterwards, and the pressure of the World War made further steps impossible. With the war ended, however, the Art Teachers' Guild joined with the National Society of Art Masters in sending a deputation to the Board of Education, though without success. Proposals for a new examination syllabus were then submitted to the Board, taking as their starting-point the following principle:

> Drawing should be on an equality with other subjects so that boys and girls should not drop drawing lessons because they are taking an examination, but should choose it as one of their subjects.[2]

The art examinations should, in the Guild's view, comprise three main sections—memory, creative (design or an imaginative illustration) and imitative (drawing or painting from common objects, plant life or the human figure). The Higher School syllabus should be similar but more advanced, with the addition of the history of art, which should be obligatory. The Guild was informed that the Northern Universities' Joint Board intended to use this scheme as the basis for their syllabus, but other boards refused to make such drastic changes and this was as far as the Guild was able to proceed.

It seemed that nothing further would be achieved unless the teaching of art could obtain a higher status in education. What was now standing in the way? It was clear that the policies of the universities constituted the main obstacle.

[1] Durham set papers in art for the first time in 1917. All six papers had to be taken, for which only four hours were allowed. Main improvement lay in the inclusion of "Colour Study" (cabbage leaves were set). The work was to be little more than a miniature (six inches by four was specified), and candidates were to render "the exact apperance". Papers in art were not set by Durham for Higher School until 1932. The Welsh Board set art papers in 1916 for Senior, Junior (discountinued after 1921) and Higher School Certificate (with seldom as many as a dozen candidates). Three papers had to be taken (two in the Junior section) from either Drawing from the flat, models, plant, memory and space-filling. Following London's example, the syllabus included "Painting from common objects and natural forms", and the Higher Certificate allowed "Drawing from life" with "Study of anatomy".

[2] *The Record*, May 1919.

Since art did not contribute towards a university degree, it could not be considered in granting matriculation—thus ran the argument. Hence, it could not be allowed to take up time in the sixth form at school. Unless the universities could lift this obstacle at the summit, there was no hope of improvement at the bottom of the hill.

The recognition of art within the universities had been demanded as far back as 1908, when W. E. Hine, Art Inspector for London University and art master at Harrow, read his paper at the London Congress on Art Teaching. Art should be included in the university course "as an indispensible part of a liberal education" was the essence of his theme, which earned wide applause.[1] The subject was again on the Agenda of the Dresden Congress in 1912, with J. T. Ewen, Art Inspector for Scotland, reading his paper, referred to earlier, on "The need for the Inclusion of Art in the University Degree Course".[2]

This repeated airing of the subject aroused no perceptible response from the universities, and the editor of *The Record* felt compelled to make the pathetic lament:

> The universities are still far behind. Art remains outside, feebly knocking at the door, unheeded, uncared for. Have we yet to educate our masters?[3]

The subject was again revived after the First World War. The Art Teachers' Guild laid a formal statement before the conference of Heads and Assistant Masters in November 1921, and embodied it in a letter to *The Times Educational Supplement*:

> Under present conditions [the letter ran] candidates, though wishing to continue their art education, are usually under the necessity of dropping the subject while preparing for the qualifying examination, which takes no serious account of the educational value of art and its call for sustained effort.
> Until art is recognised as a qualifying subject to count towards a pass in matriculation, the candidate wishing to take it up as a career is induced to discontinue its study at the most impressionable age.[4]

But was it likely that the universities would accept art as one of the qualifying subjects for matriculation, when it did not lead to a degree course within the university?

This issue was taken up from the standpoint of the Ruskin Drawing School, which was the only institution for teaching art in either of the two older universities.[5] Why were its students—those who had matriculated into the Univer-

[1] *The Record*, March 1909.
[2] *The Record*, November 1912.
[3] *The Record*, January 1916.
[4] 25th February 1922. The letter was signed by Miss Spiller, President, and Miss Sharp, Vice-President.
[5] Durham University had a Fine Arts Department attached to King's College, and a similar department was formed in Reading University at the beginning of the century. They became the only universities to offer a degree in fine art, and they have been in the forefront of art school training ever since. An art department has similarly been established in Leeds University.

sity and were taking its art course—denied the right to a university degree at the end of it?

It was recognized that an undergraduate might change his course of studies during his university career, without necessarily jeopardizing his expectation of a degree, but this could not be done in art. A letter to *The Times* from Sydney Carline, then Ruskin Master at Oxford, laid this issue before a wider public. "It is scarcely to be expected", the letter ran, "that schools will raise the standard of art education so long as it is not recognized as a form of education in the universities, as with the sister arts of literature and music."

The Times responded by giving the subject considerable prominence under the challenging title: "Art and the Nation—a plea for University Recognition". Support came from many sources, but hopes were dashed when *The Times* itself, in a leading article, came out in support of the orthodox academic attitude. Agreeing that university recognition "would indeed produce a reaction throughout the schools of the country", the editor apprehended that its force could only be "proportionate to the esteem in which the new artistic degree was held at the universities themselves".

> An Honours School of Painting, Sculpture and Design [the article proceeded] would be subject to special limitations. It would be concerned with an art, knowing full well that it could teach no man to be an artist. A degree has never been an important landmark in the career of a creator, and it might not benefit the cause of artistic creation so directly as Mr. Carline anticipates.[1]

This was dodging the real issue, for education was the problem at stake, not the creation of an artist. It might have been claimed with equal force that degrees in music could not create a composer. The opponents of degrees usually fell back upon the romantic, but wholly false, conception of the artist as a remote, impractical figure buried in dreams in his garret, ignorant of the realities and competitions of the modern world. The artist could no longer live in isolation, if he had ever done so. Full qualifications in art were now needed in many walks of life, far removed from the artist's garret. This controversy helped to disclose, if it achieved nothing else, that in university circles, there was still the tendency to regard art as slightly dangerous and likely to introduce Bohemian ways.

The Art Teachers' Guild was optimistic of progress. University opposition, it felt, was being broken down. "We need not doubt", ran the Guild's report for 1923, "but that art will win its proper place in examinations and that the universities will institute a degree in art."[2]

News of a partial victory came the following year, when John Lea was able to announce that the London Senate would recognize "Art (Drawing)", to-

[1] *The Times*, 5th July 1922. Contributors to the discussion had included, Selwyn Image, former Slade Professor; Arthur Keen, Honorary Secretary, R.I.B.A.; A. Shuttleworth, National Society of Art Masters; Miss Sharp, Vice-President, the Art Teachers' Guild; A. M. Hind, Slade Professor at Oxford.

[2] *The Record*, March 1923.

gether with Music and Domestic Science, as "alternative subjects, only one of which may be offered, for the purpose of exemption from the Matriculation Examination in virtue of a General School Examination Certificate".[1] This was followed by similar steps taken by the Northern Universities' Board. In Scotland, the School Leaving Certificate had for some years past provided exemption from the university entrance examinations under certain circumstances, as it had in Australia. Bristol was to follow suit in 1929.[2] The Guild now bent its efforts towards securing the acceptance of art as a main subject in the Higher School Certificate. No move was made at Oxford or Cambridge, and this was as far as success ever went.

The struggle for a degree course in the universities now met a natural death to await resurrection under new circumstances.[3] Meanwhile, boys and girls continued to pass through school and university with very little opportunity for developing their visual perceptions or for acquiring an artistic understanding, and this lack would inevitably be handed on to the generation that followed.

[1] Minutes of the Senate, 19th December, 1923.

[2] In 1957 the examining functions of Bristol University were merged in the Southern Universities' Joint Board for School Examinations. This included the universities of Bristol, Exeter, Reading and Southampton. Durham University Examination Board withdrew from examining in 1962.

[3] The situation remains much the same today as regards most of the universities, but the position has been radically changed by the formation of the National Council for Diplomas in Art and Design in 1961. Certain colleges and schools of art have been given the equivalent of university status to devise art courses, approximate in quality and standard to a university course. Thus the specialist in art can obtain, if successful, the Diploma in Art and Design (replacing the N.D.D.), but this is not quite the same as obtaining a degree at Oxford, Cambridge or other universities, where a wide variety of studies can be pursued. But there are exceptions. The Universities of Reading, Durham and Leeds possess art departments with courses leading to a B.A. degree (Fine Art). Some of the new universities recently established, are reported to be considering the introduction of art courses—East Anglia, Sussex and Nottingham, for example— but confined to the history of art, perhaps in conjunction with some other subject. Lack of studios and equipment present obstacles to the practical study of art in these institutions.

13

Child Art and Primitive Art

THE new interest in the pictorial work of children, during the first decade of this century, arose entirely out of the enthusiasm of a few artists and art teachers. The educational authorities of the time were for the most part thoroughly hostile towards placing a value—which they assumed to be completely inflated—on children's work.[1] Thus new methods in art teaching could never have gained a foothold had it not been for the insistent voices that were raised from below.

Those concerned with general education, both in secondary schools and in universities, were unreceptive to new developments in art, and an understanding of the problems underlying its creation was seldom to be found among orthodox schoolmasters or mistresses. Works of art which were not ordinary or conventional in character usually aroused scorn or laughter, and this had its effect on any experimental efforts in the art class. Art has to be carried out in conditions of freedom or in a spirit of enjoyment, and this was bound to arouse the suspicions of the Edwardian schoolmaster.

If the drawing class was regarded by the staff with a kindly contempt, it was scarcely to be expected that the pupils would treat it with any higher degree of respect. This was particularly apparent in boys' schools, where art, flowers and needlework were regarded as the concern of their sisters. Any evidence of taste or love of beauty was frowned upon as "effeminate", and the story is recorded that when a horticultural enthusiast at one of our public schools ventured to cultivate a pot of hyacinths in his study, the house captain, catching sight of it, swept it to the ground with the warning: "There is no room for this rotten effeminate stuff here."[2]

Those few that now voiced their enthusiasm for "child art" were usually pioneers of the "new movement" in art. Of these, no one proved so effective, not only in England but throughout the world, as Franz Cizek, whose

[1] "Latterly, a kind of pedagogic futurism and cubism has arisen", wrote a leading authority on education at the period we are discussing, "which would have us allow children to draw unrecognizable daubs without correction, as a means of encouraging 'self-expression'. We might as well encourage unintelligible and ungrammatical English with the same object. It is impossible to believe that this craze will hold the field for long, though it is obviously popular with the lazy teacher."

[2] R. St. C. Talboys, *A Victorian School—The story of Wellington College*, 1943.

IIa. Winifred Baglow, pupil of Marion Richardson, *The Russian Ballet,* 1919

b. S. R. Rakshit, Delhi Juvenile Art Centre; *Courtyard in India,* 1945

work was almost exclusively confined to his native Vienna. Yet in his views and methods he was by no means ahead of his time. Indeed, some of his doctrines had been put forward in England by earlier teachers like Cooke and Ablett, though he was presumably unaware of this. Many of his pronouncements, moreover, seemed to conflict with the artistic revolution that ensued. How, then, are we to account for the undoubted spell that has carried the name of Cizek far afield, where pioneers like Cooke and Ablett have been barely heard of?

In his own creative work Cizek was not pre-eminent—he had studied at the Fine Arts Academy in Vienna in 1885 and was a member of the impressionist group in Austria known as the "Secession"—but found his true medium of expression through the work of his pupils. In this sphere he was a source of inspiration rather than a teacher. In fact, it has been asserted that he never drew for his pupils, nor worked on their pictures. Nevertheless, he managed to identify their visual expression with himself. Everything we read about him conveys his complete dedication to his task—the discovery and revelation of the art of the child.[1]

Cizek was chiefly interested in the work of younger children. He and his disciples claimed that it was different in kind from that which was produced by older children. Thus the cult of "child art" began to develop, associated mainly with the primary school and ignored at the secondary level. Art was derived in Cizek's view, from innocence and humility:

> After fourteen, they become dull very often [was his icy comment]. They see too much; they grow sophisticated; I seldom keep them after fifteen.[2]

Such statements indicate that he was more concerned with producing examples of "child art" than with promoting education throughout school life.

Francesca Wilson, the Birmingham teacher and devoted admirer of Professor Cizek's work, records the case of a particularly brilliant pupil of rich parentage. The professor was subsequently asked about this pupil's progress and he replied most uncharitably: "He produces nothing now at all—he is so rich", intimating that those who enjoy riches cannot be expected to enter the artist's heaven.[1] He was equally uncharitable regarding another pupil, from the working class, who had left him to continue his studies at the Academy. In this case Cizek complained that he was being turned out to pattern and had completely lost his individuality.[3] Here we have the weakness of his teaching. Being mainly concerned with the unconscious aspects of the child's work, he failed to provide his

[1] Our knowledge of the work of Franz Cizek is largely derived from his former pupils, Dr. Wilhelm Viola, who has written the main authoritative studies of the master (*Child Art and Franz Cizek*, 1936 and *Child Art*, 1942) and is now lecturer and examiner for the Royal Drawing Society, and Miss Francesca Wilson, who published three booklets, based on Cizek's lectures, in aid of the exhibition fund for the "Save the Children Appeal" in 1921.

[2] Francesca Wilson, *The Child as Artist*, publication of the Children's Art Exhibition Fund, 1921.

[3] Francesca Wilson, *A Lecture by Professor Cizek*, publication of the Children's Art Exhibition Fund, 1921.

pupils, as they grew older, with any protective armament against the incursions of bad taste and mistaken ideas, which they were bound to encounter.[1]

Cizek seemed to live, together with his pupils, in the small world of early childhood, and he resented them growing beyond it. He was not the discoverer of this child's world of visual expression, but he made it known to the rest of the world.

"The age he loved most was from one to seven", writes Miss Wilson, who visited him in Vienna after the First World War, anxious to raise funds to enable his classes to be carried on.

> This is the age of purest art [she quotes from the professor]. A child draws a great deal in this period, not because, as grown-ups make out, he wants to communicate something, but because he wants to formulate his own ideas—express what is in him.[2]

Both Ebenezer Cooke and Ablett had said very much the same thing thirty years earlier, but such views were then scarcely listened to.[3] Concern with the child's visual self-expression became general as a result of Cizek's work.

Henceforward the child was to be accepted as an artist in his own right—a complete reversal of the earlier assumption that the child could not do better than imitate his elders. Cizek sought to define this child art in a lecture:

> People make a great mistake in thinking of child-art merely as a step to adult-art. It is a thing in itself, quite shut off and isolated, following its own laws and not the laws of grown-up people. Once its blossoming time is over it will never come again.[2]

The further statement that "child-art is an art which only the child can produce",[4] neatly summarizes the essence of this new attitude. Children, in his view, have their own mode of expression which is different from that of adults. They have no need of teaching. They merely require encouragement to follow their own path and avoid snares by the wayside.

Cizek constantly emphasized this aspect. He explained in the course of a lecture, that his aim was "to teach children art by the simple method of not teaching at all in the accepted sense, but of letting the children teach themselves". Then he added:

> The teacher ought to learn to hover like an invisible spirit over his pupil, always ready to encourage, but never to press or force.[2]

[1] Few of Cizek's pupils seem to have made any mark as artists. In fact, Dr. Viola assures me that very few even continued to practise art after ceasing to attend the classes.

[2] Francesca Wilson, *A Lecture by Professor Cizek*, 1921.

[3] In 1884 Cooke wrote: "The child delights . . . to draw as a means of expression, to use its imagination and to invent." At the same time Ablett described how "children seek, some time or other, a means of pictorial expression which will satisfy their wants." (E. Cooke, *Our Teaching and Child Nature.*)

[4] W. Viola, *Child Art*, 1942.

But did the pupils really teach themselves, as he claimed? Did he actually exert no influence, hovering like an invisible spirit?

Looking at these Viennese children's pictures after the lapse of forty or fifty years, one finds them singularly dated, reflecting the taste and fashion of the period—"Art Nouveau". However much the professor may have considered himself as a figure in the background—a source of encouragement only—all who have had experience in art teaching know that this is difficult to achieve, and doubly so when the teacher is a strong personality. Children are quick to note the teacher's reactions, observing what he praises or dislikes, and their work reflects his influence accordingly.

The character of "Art Nouveau", familiar in the work of Aubrey Beardsley, Klimt, Walter Crane or Mucha, with its flamboyant decoration, shines through the work of these Viennese pupils, so that we could never mistake it for that of children today. Could we thus identify their work, if the children had been expressing their own view of the world, unaware of their professor's artistic prejudices or of the prevailing style or taste (plate 16b)?

Francesca Wilson records one of the professor's classes in 1921, when the children were set the subject of "Autumn" and were told to depict it by means of a human figure. They were to make the head touch the top of the sheet of paper with the feet at the bottom edge, and this was emphasized to ensure that all the pupils understood:

> The figure must exactly fill the whole sheet [the children were told]. You must sketch it out very lightly . . . before spending time on detail.[1]

With such explicit directions, it was inevitable that all the children interpreted the theme in a similar manner, each making a large figure, as in a Greek bas-relief, against a flat background. When the children were asked in turn how they intended to interpret the subject, the answers were as follows:

> Hans [we are told] would have an old man with a basket full of apples. Franz—someone blowing very hard at the trees so that the leaves blew off; Elizabeth—an old man with pots of paint, painting the leaves bright colours.[1]

The completed pictures were then pinned against the wall for criticism. Naturally the children influenced one another and there grew an obvious similarity between their work.

A striking change, for which we are chiefly indebted to Cizek, was in the manner of conducting a class. For the first time it was assumed that the pupils would enjoy their work and that such enjoyment was essential if the work was to prove of value. Cizek dated his own enthusiasm for child art from the moment that he discovered that the drawings children made to please themselves were entirely different from those that they did for the teacher. This was for him a form of spiritual enlightenment. He has recorded how this discovery occurred. He noticed that the street boys often made drawings in chalk on the wooden

[1] Francesca Wilson, *A Class at Professor Cizek's*, 1921.

fence opposite the house in Vienna where he lodged. Sometimes there were fights as to who should have the right to draw on the fence. They all made their drawings in a similar manner, but this was quite different from how they were taught at school.

Cizek turned to the children in the family where he lived, and urged them to draw in their own way. His observations led him finally to launch a class, which met at the week-end or on school holidays. Here the children were supplied with paper, paints and brushes and were encouraged to use them as they liked, treating their work as if it were a game and the paper as their wooden fence.

The children joined the class of their own free will. As soon as the door was opened they charged in like mad things, according to an account given me by an artist who visited the school in the 1920s.[1] They were soon totally absorbed with their paints and brushes, each child at its own wooden desk, paying not the least regard to anyone else. The youngest ones occupied the larger of the two rooms, which had a blackboard used for demonstrations, while the older children worked in the smaller room adjoining.

The children came from all parts of the town and all classes—rich or poor, intellectual or semi-literate alike. Some arrived with hats, some without; some girls wore aprons; others came in overalls. There were no rules or conventions in such matters. One small boy arrived in a velvet suit with lace collar, which soon got smudged with paint, but no one paid attention to such mundane matters. For the first time in their lives they found drawing and painting was fun.

Each child knew exactly what he or she was to do. They did not ask, although the professor—a tall spare man—moved constantly up and down the lines of desks, glancing here and there as the work proceeded. He gave the impression of watching in a dream, with his cold, remote eyes and far-off, unsmiling expression, while his assistant—a thoroughly capable, younger woman—would cope with visitors, of which there were many, explaining points and showing examples of the work. The pictures were retained at the school, as the children were not permitted to take them away.

The children drew and painted only from imagination, and this constituted another drastic change from earlier methods. Cizek considered drawing from sight as "the greatest mistake of the old-fashioned art teaching".[2] He allowed object drawing only at an age, as he explained, "when the creative faculty has vanished". A characteristic statement by Cizek is quoted by Dr. Viola: "A young child produces what he knows, not what he sees."[3]

[1] Ruth Munro visited Professor Cizek's class in Vienna when she was an art student at the Edinburgh School of Art.
[2] Cizek told Miss Marion Richardson in 1926, that he did not consider the work shown in England by Miss Wilson, as mentioned later, was characteristic. It was selected "for export", he explained. Some of the work seemed almost abstract, but Dr. Viola tells me that Cizek did not encourage abstract painting in the children's class, though he taught on those lines at the Academy.
[3] W. Viola, *Child Art*, 1942.

For somewhat comparable reasons, Cizek did not approve of memory draw-ing, so often practised at this period. In his view, "everything memorized is worthless".[1] He was not referring to things actually seen in daily life and stored in the memory; this on the contrary he encouraged. His disapproval was re-served for the process of memorizing an object in isolation from its surround-ings, an effort which had little connection with true visual impression.

Cizek's friends in the Viennese art group, the "Secession", viewed these experiments among children with enthusiasm. The members had broken away from the Academika in Vienna in 1896, in sympathy with the progressive aims of Bocklin, Corinth, Max Liebermann and the other impressionist painters of the Munich "Secession". They did not go to the extreme lengths of experiment in colour and abstract design which characterized the subsequent groups known as "Die Brücke" and "Der Blaue Reiter", from which the revolutionary work of Kandinsky, Paul Klee and Nolde sprang.

Cizek viewed the work of his children from the point of view of Gauguin. Civilization, to both of them, was the enemy of art, but Cizek applied this doctrine primarily to the child. He spoke of our "terrible civilization", and regretted when the older children began to acquire sophistication. "He has become civilized too soon", was a characteristic comment.[1] Francesca Wilson heard him complain of the work the children were doing in 1921: "They see and hear too much—they are taken to Cinemas and Theatres", he bewailed.[2]

Cizek was chiefly concerned with preserving the simplicity and innocence of childhood. He did not expect the adult artist to seek these qualities. In this respect he had little in common with the group of young painters emerging in Paris, who sought to emulate the work of children. Matisse frankly confessed that he wished to recapture in his own work the *naïveté* and innocence of the child.

Meanwhile, the paintings of children were exerting a profound effect on the work of the younger impressionist painters in Paris and Munich, who found in children the same liberation of spirit, the same freedom from restraint and con-vention that they aimed for. Their frank distortion of form and use of rich, violent colour earned them the name "Les Fauves", reflecting the wild abandon with which their vision was expressed. "What I pursue above all is expression," Matisse declared, and this also became the accepted aim of the German "Ex-pressionists".

The qualities to be admired in "child art" were equally manifest in the work of people living in a primitive form of society—the "savages", as they were then harshly termed, of the South Seas, of Africa of the past, or aboriginal America. The work of "primitives", like that of children, depended on feeling, rather than on reason or intellect. Such work was a repudiation of academic study. The young painters—Picasso, Braque, Derain, Modigliani, André L'Hote, as well as Matisse—rejected the old academic type of training for themselves and equally

[1] W. Viola, *Child Art*, 1942.
[2] Francesca Wilson, *A Lecture by Professor Cizek*, 1921.

for children. The masks and fetish figures of West Africa and the South Seas became their models.

Cizek was tentatively pursuing the same course, in advocating that art depends solely on the expression of the feelings, as revealed in the work of children:

> Everything great has originated from the sub-conscious. Art more and more dries up, because it is supplanted by the intellect.[1]

But Cizek never managed to achieve this aim in the work of his pupils. The "Fauves"—painters and sculptors—revealed to a far greater extent how the feelings rather than the intellect can inspire art.

Picasso and Braque, in their "Cubist" experiments between 1906 and 1908, were seeking to reduce plastic form to its basic elements, eliminating all superfluous detail. In this they were directly inspired by the sculpture and designs of "primitive" tribes. The face might become an oval mask, while the arms or the body might be seen as columns. Such simplification is equally natural to the work of children. Frank Rutter has recorded a conversation with Derain on these lines in Paris about 1911:

> We had been to some exhibition together, and after we came away, the talk fell on African savage art. Suddenly Derain stopped and pulled a pencil from his pocket. "Look," said he, "the human body is a cylinder. This pencil is also a cylinder. It is perfectly legitimate to present a pencil as a symbol of a human body."[2]

It was the work of "Les Fauves" that made people look afresh at the paintings of children. Those who responded to the vital experiments in form, design and colour by Matisse and his friends—and there were few to do so in these early days—immediately recognized that the work possessed the same qualities that were found, though in an immature form, in the work of children, and that these qualities were equally inherent in the childhood of the human race.

The work of Franz Cizek's Viennese children was not shown in Great Britain until 1921, when Francesca Wilson brought over an exhibition of paintings and woodcuts to raise money for his Juvenile Art Class. The exhibition, shown first in London, then in Edinburgh and various provincial cities, made an immediate impact on the general public, which was amazed at the fresh spontaneity of the paintings and the childish pleasure shown in creating something for its own sake. Enthusiastic adherents were soon procured among the broad general public, which had already acquired some familiarity with the strange experimental work of the new movement in art. The same public had been bewildered and often angry with these revolutionary groups—the Cubists, the Vorticists and the Futurists. The vision of the Viennese children proved mild in comparison.

The work of the experimental painters and sculptors of Paris had been first introduced to the British public in 1910, when Roger Fry held the ex-

[1] W. Viola, *Child Art*, 1942.
[2] Frank Rutter, *Evolutions in Modern Art*, 1926.

hibition, for which he coined the name "Post-Impressionist", at the Grafton Galleries. The majority of critics abused the work shown—Cézanne, Gauguin, Matisse, Picasso, etc.—as childish, clumsy and lacking skill. One critic wrote:

> The drawing is on the level of that of an untaught child of seven or eight years old. Apart from the frames, the whole collection should not be worth five pounds.[1]

This estimate, creditable only for being so singularly wide of the mark, reveals the prevailing assumption that the terms "childish" and "bad" were commensurate.

The criticism angered Fry sufficiently to determine him to return to the attack with a second exhibition at the same galleries two years later. On this occasion, there was, in addition to the French paintings, a selection of work by young British artists, including Wyndham Lewis, Duncan Grant, Stanley Spencer, Henry Lamb, Bernard Adeney and Fry himself, selected by Clive Bell, and a Russian section chosen by Boris von Anrep.[2] Roger Fry took the precaution of disarming the critics in his preface to the catalogue, with arguments which were to transform art teaching in the future. The critics had shot their darts wide of the target he claimed,

> since it was not the object of these artists to exhibit their skill
> or proclaim their knowledge.
> [Their aim was] to express by pictorial and plastic form certain spiritual experiences; and in conveying these, ostentation of skill is likely to be even more fatal than downright incapacity.[1]

Fry was at pains to prove to the public that the very purpose and aim, as well as the methods, of pictorial and plastic art were thus undergoing reconsideration.

Through the second Post-Impressionist Exhibition the British public was introduced for the first time to the work of Henri Rousseau, "Le Douanier", whose "Scène de Forêt", a fantasy of the Mexican jungle, was on show. Here was an artist who did not pretend to any academic training, and who painted only in his spare time—a "Sunday painter". To the average visitor this splendid picture seemed frankly reminiscent of what a child might do, and its inclusion in the exhibition imposed a severe shock on the public, far exceeding previous ones. Fry conceded that want of skill might be fairly levelled against the work of Rousseau, but argued that "scarcely anyone, now, would deny the authentic quality of his inspiration or the certainty of his imaginative conviction".[3]

Contact with the work of Rousseau and, subsequently, other "primitives", brought the question of art education once again to the fore. No one could pretend that Rousseau's genius would have survived subjection to the academic training of the period. Was academic training, therefore, quite unnecessary for

[1] Quoted by Virginia Woolf in her *Roger Fry, a Biography*, 1940.
[2] Leonard Woolf acted as secretary to the exhibition.
[3] Preface to the catalogue of the second Post-Impressionist Exhibition.

the production of a masterpiece? Was technical skill superfluous? Fry was cautious in committing himself:

> Want of skill and knowledge do not completely obscure, though they may mar, expression.[1]

He might have added that contrary to popular belief technical skill was not the main objective in art teaching.

Clive Bell was prepared to go even farther than Fry in revolt against the academies:

> Happily, there is no need to be defensive [he declared]. The battle is won. We all agree, now, that any form in which an artist can express himself is legitimate.[2]

At the time it was written this was an obvious overstatement. Nevertheless, these two exhibitions launched the new movement in England, and tuned peoples' minds to the ultimate acceptance of a new approach to art teaching.

The protagonists of child art were inevitably linked with those who promoted the new revolutionary art. For the average person, both spelt the approach of decadence. The explosive, richly coloured abstractions devised by Kandinsky and the sombre, angular distortions of Cubism were interpreted by the lay public as the first threats of anarchy to break up the established order and end in Armageddon.

With society in this perplexed state over artistic values, Clive Bell produced his *Art*—the first attempt to supply a reasoned exposition of the aesthetic issues that underlay the new approach to art—a few months before the outbreak of war in 1914. "Significant Form" was the doctrine that Clive Bell offered. He defined it as:

> lines and colours combined in a particular way, certain forms and relations of forms [which] stir our emotions.

This quality, he claimed, "distinguishes works of art from all other classes of objects . . . without which a work of art cannot exist".

Certain critics were quick to point out that a work of art cannot be defined as a "class of object" and that "significant form" must be found in the mind of the person, not in the picture.[3]

Bell's aesthetic theory exposed a confusion of cause and effect. His critics proved that "the common quality", which he named "significant form", and the "emotion it provoked" were one and the same, so that the author was compelling us to chase our tails. Nevertheless, despite its weakness, this book was a valuable step in the right direction. As Fry explained, it was "an attempt

[1] Preface to the catalogue of the second Post-Impressionist Exhibition.

[2] Preface to the British section in the above.

[3] Dr. I. A. Richards, C. K. Ogden and James Wood, *The Foundations of Aesthetics*, 1922.

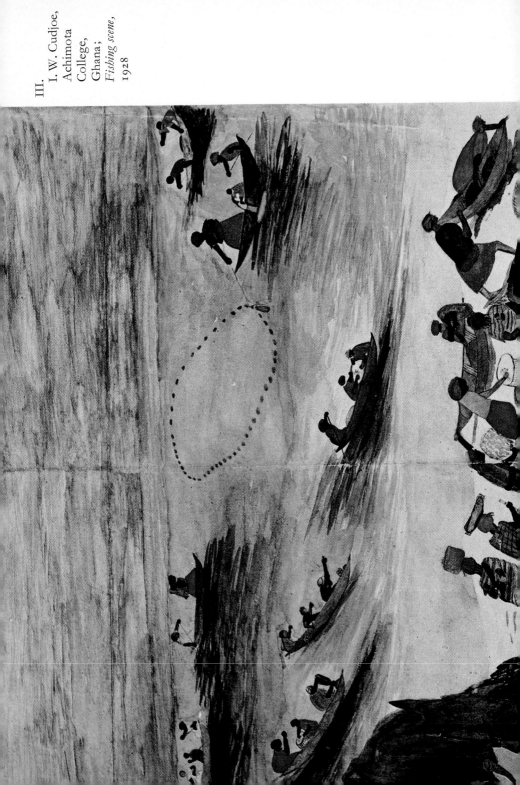

III. I. W. Cudjoe, Achimota College, Ghana; *Fishing scene*, 1928

to isolate the purely aesthetic feeling from the whole complex of feelings".[1] Bell had administered a wholesome shock to those who had closed their minds to any new approach, and encouraged those who were seeking new methods in art teaching.

Roger Fry never attempted, himself, to teach art, either to children or adults. His main concern lay with its appreciation and criticism. He was the arbiter and propagandist of the new movement in art. His own practice of painting, in which he sometimes achieved results which were by no means mediocre, was prompted by his anxiety to understand the creative problems through personal experience. Like Ruskin before him, he was not willing to criticize on the basis of theory only. His attitude to fellow artists was that of a fanatic, intensely warm when he approved and devastatingly cold otherwise.

Fry's concern with the art of children was purely incidental to his broader interest in all manifestations of art, and his tireless enthusiasm drove him to search out artistic merit in the least likely places. It was inevitable that sooner or later Fry would chance upon some child's painting which would excite him and he would realize that a new sphere for artistic investigation was before him.

Fry's first recorded contact with child art occurred as early as 1903, when he gave his daughter, Pamela, some paints and brushes, eager to see the result. He noted that the artistic merit of her work did not depend on any teaching he could offer her. With some enthusiasm, he wrote to his mother in Hampstead:

What an astonishing natural gift for art children have before teaching has ruined them.[2]

Thenceforward, he was determined that his daughter's artistic inclinations should not be hampered by conventional instruction.

Fry did not again pursue the subject of "child art" for some years, partly owing to lack of opportunity. In July 1913, shortly after the second Post-Impressionist Exhibition, he opened his Omega Workshop in Fitzroy Square, London. He conceived it as a communal centre where artists—those whose work he admired—should design objects for domestic use or interior decoration. There was room for periodic exhibitions, and in 1917 Fry decided on the novel idea of holding a show of children's paintings. This was some years before the Cizek exhibition had come to England, and it was the first attempt to stage a display of children's paintings as real works of art in their own right, entirely different in concept from the exhibitions of the Royal Drawing Society, which showed how near children could get to adult work.

Fry was convinced of the futility of approaching schools, since any work they might lend would be unlikely to contain the aesthetic merits he admired. He

[1] Roger Fry, *Vision and Design*, 1920.
Clive Bell had stated that the representation of nature was irrelevant in a picture. Fry disputed this. "The suggestion of third dimension in a picture" he argued, "must be due to some element of representation."
[2] Virginia Woolf, *Roger Fry, a Biography*, 1940.

decided, therefore, to ask artist friends to lend the work of their children, believing that they would have been allowed to paint more freely than at school.

This exhibition acquired significance not only as the beginning of a much wider interest in child art—an interest which can almost be said to have developed later into a cult. It also brought Miss Marion Richardson into contact with Roger Fry, launching a friendship which greatly influenced her career as an art teacher.

Miss Richardson was teaching at the Dudley Girls' High School near Wolverhampton and was on a visit to London in search of a new post. Fry described this meeting with "a school-mistress in the Black-country" in a letter, which reveals the immediate impact that her pupils' work made upon him:

> She'd been up in town [he wrote] to get a post in London and brought her class
> drawings: She'd been refused without a word, and I didn't wonder when I saw
> what she'd been at. . . . She has invented methods of making the children put
> down their own visualizations—drawings with eyes shut etc. I assure you they're
> simply marvellous. Many of them are a kind of cross between early miniatures
> and Seurat, but all are absolutely individual and original. Everyone who's seen
> them is amazed. John (Augustus John) was in and said quite truly it makes
> one feel horribly jealous. . . . Anyhow here's an inexhaustible supply of real
> primitive art and real vision, which the Government suppresses at a cost of
> hundreds of thousands of pounds. If the world weren't the most crazily topsy-
> turvy place one would never believe it possible.[1]

Marion Richardson was equally impressed by what she saw on the walls of the Omega Workshop—"wonderful work by the children of artists", as she described it.[2] This experience confirmed her in the determination to continue teaching on lines which hitherto she had considered as no more than an experiment. Her conversation with Roger Fry had convinced her that she was working on the right lines. She saw the connection between her pupils' response to visual stimulus and the experiments in form and colour she had seen at the Grafton Gallery exhibition some years earlier. She concluded that there must be "a common denominator" between the work of the modern masters and her pupils' "infinitely humble intimations of artistic experience".[2] This conviction determined her in the wish "to give the children complete confidence in their inner vision as the seeing eye".

This vision of the "black country"! Marion Richardson saw aesthetic meaning in its grey repetitious rooves, rectangular patterns of yellow-lit windows, uniform street-lamps, circuitous tramcars and silent people, her pupils imbibing her descriptions through their mind's eye and producing vivid, formal patterns of tone and colour (plate 16a). "This flashed into my mind's eye as I sat last night", a girl writes on her picture; "This is what I saw and I cannot see another", writes a younger girl.

The work of very young children presented, in Fry's opinion, no real problem

1 Virginia Woolf, *Roger Fry, a Biography*, 1940.
2 Marion Richardson, *Art and the Child*, 1948.

They were equipped by nature with the means to express this inner vision, as long as they were permitted to do so. It was what happened to the older children that really mattered. Here Fry would have clashed swords with Cizek, had the two been in contact with one another. Cizek was primarily concerned with conserving the artistic powers of the young child from destruction. He held out no hopes for their future. Fry wanted to see these same inherent qualities preserved as they grew older. He asked Marion Richardson to show him the work of her older children, but in this he was disappointed.[1]

Marion Richardson had the good fortune to possess an unusual and enlightened headmistress who appreciated her experiments in teaching art and felt complete confidence in her judgment, as long as she did not "turn out a wholly incomprehensible futurist".[2] Favourable conditions for drawing and painting were rarely considered in schools and often the minimum facilities were provided. An old public-school boy recalls that the headmaster was showing a new block of classrooms at Winchester to a visitor. "Why," exclaimed the latter, "it looks like a workhouse!" "Exactly," replied the head, "A school is a workhouse."[3]

At the Dresden International Conference of Art Teachers in 1912, it had been emphasized that art teaching was handicapped by being treated with insufficient respect by the school staff. The conference made the following recommendation:

> It is desirable that other members of the staff have some understanding and appreciation of art in one or other of its branches.

This, alas, was not often the case. To return to the point with which we commenced this chapter, schoolmasters or mistresses, generally, at the beginning of this century had seldom received artistic training, and examples of the new movement in art especially aroused their hostility.

When teaching art at Rossall School in 1914, Sydney Carline had made a collection of reproductions of modern art, ranging from Cézanne to Kandinsky's early abstracts and including primitive sculpture and African masks, planning it as a permanent exhibition to stimulate the boys' aesthetic reactions and develop their capacity for taste and judgment. The project, however, was not a success, due, not so much to lack of interest on the boys' part, but to the ridicule and scorn of his colleagues on the staff, for whom art of this advanced kind was more of a closed book than it was to the boys.

Art teaching had clearly reached the parting of the ways. It was either to go

[1] The same point was raised by James Wood in the *Cambridge Magazine* of May 1919 in commenting on Miss Richardson's exhibition at Fry's Omega Workshop: "When the brink of adolescence is reached, it is to be feared that the boat may sink, owing to an unhealthy tendency to introspection." It seems to have been assumed that these naïve works must necessarily be by young children, but they were adolescent, ranging in age between thirteen and fifteen.

[2] Quoted by Marion Richardson (in a letter to Sydney W. Carline, March 7th, 1916).

[3] R. St. C. Talboys, *A Victorian School—The story of Wellington College*, 1943.

forward with new ideas behind it or sink into oblivion. The old conditions were caustically dismissed by Roger Fry:

> It is evident that the ordinary method of teaching art does two things: first it prevents the children from producing anything of the slightest value while they are young, and secondly, it does nothing to enable them to express themselves when they are grown up.[1]

Marion Richardson's methods appealed to Fry precisely because she refused to give direct instruction and allowed the aesthetic sensibilities and imagination of the pupils to guide them. Fry recalled that those who sent their children's work to his Omega Workshop exhibition in 1917 were asked to say whether the children had been taught, and the enquiry elicited the following information:

> Most of those children who had had the ordinary drawing lessons were inhibited from any power of expression whatever. They had not acquired the professional standard of representation and they had not confidence in their own vision of the world. On the other hand, it was found that almost all children who had not been taught had got something interesting and personal to say about the world.[2]

Miss Richardson's experiments with her pupils at Dudley had the firm backing of Roger Fry as the publicist of the new approach to art teaching. The battle was kept alive by frequent discussion in the columns of the *Nation*, the *New Statesman* and the *Burlington Magazine*. Meanwhile exhibitions of her pupils' work from "The Black Country" were held at the Omega Workshop in 1919 and again in 1923 at the Independent Gallery in London.

Fry lost no opportunity of attacking the old order in art education. In a series of three articles in the *Nation*, he cynically suggested that artistic progress might be "more rapid were the whole of this teaching abandoned". If, as he was prepared to concede, "training in accurate observation" might have "some educational value quite apart from art", he begged that "any child who showed special artistic aptitude" might be spared this training. Fry was at pains to convince those concerned with education that art teaching as practised hitherto was of no artistic benefit to the child.

> There can be no doubt in any case [he writes] that the average child has extra-ordinary inventiveness in design and the average adult none whatever, and that in between these two states there occurs the process known as art teaching.[3]

A practising art teacher of this period has recorded how he first became

[1] Preface to the exhibition of the work of pupils of Miss M. Richardson of the Dudley High School at the Omega Workshop, Fitzroy Square, February 1919.

[2] Preface to the Omega Workshop Exhibition (op. cit.), 1919.
It would have been interesting to learn in which categories Fry placed the various exhibitors work, (including my own), but I recall that a snake in a tree by David John (son of Augustus John) aroused great admiration.

[3] Roger Fry, "Art and the State", in the *Nation*, 23 February, 1 and 22 March, 1924 and reprinted in *Transformations*, 1926.

convinced of the futility of teaching art in accordance with established methods. Among his pupils was one

> peculiarly obnoxious boy . . . His drawing was as irritating as his other characteristics. He went his own way with complete unconcern. He drew exactly what he liked and how he liked. . . . Everyone agreed that this pestiferous young nuisance was wasting his whole time. So I dealt with him in a way that stamped me as the perfect schoolmaster. "Now then," I said, "you may sit in a corner. . . . You may do as you please. But I will not help you. But at the end of the course you will take the same leaving examination as the others. Then we shall see", etc. . . . The examination day arrived and the result filled me with outward amazement and inward rage! For in spite of the fact that he had never been known to draw a leaf or flower or to show the slightest interest in the way he held his pencil, his drawing was immeasurably superior to any of the others—a grasp of form, a sense of construction, an appreciation of charm which was utterly beyond my powers.[1]

With the First World War over a new school of thought in art teaching was thus becoming firmly entrenched, though its influence was by no means extensive. Sensibility was the essential quality to be encouraged; technical competence was of minor consideration. But the essence of the new method was to draw upon the child's inner experience, as Marion Richardson explained in the catalogue of her exhibition in 1923. She sought to

> encourage the girls to concentrate upon and give expression to mental images founded upon their own observations. . . . The most positive part of my work [she proceeds] is to present suitable subjects to the child's mind, though often the children succeed in inventing their own subject.[2]

Roger Fry elaborated the new attitude to children's work:

> It does seem rather futile to teach a child how to draw, when one considers that what it has to discover is how it alone of all created beings can draw. The thing to be taught is a thing that does not exist, but has to be discovered.[2]

The discovery of these exciting possibilities in the visual expression of children, when encouraged by sympathetic teaching, was fully reinforced by the investigations of psychology. Dr. Cyril Burt's *Mental and Scholastic Tests*, first published in 1921, attempted a much more thorough analysis of the successive stages through which children's work passes, from the scribbles of infancy to the work of adolescence, than had been attempted by earlier scholars like Professor James Sully. Dr. Burt pointed out that drawing opens avenues to strange places in the childish mind, provinces otherwise untouched and unexplored. A series of pictures made by a single child between infancy and adolescence may provide a valuable self-history of his manual, mental and imaginative development. There is no sudden transition or break. One phase glides imperceptibly

[1] J. Littlejohns, *Art in Schools,* 1928.
[2] Exhibition of Drawings by the girls of the Dudley High School: Independent Gallery, London, 1923.

into the next as dawn passes into morning. Yet these phases may include a wealth of visual expression at one period, with a paucity at others.

Analysis showed that it was very common for children of about the age of thirteen to experience a period of artistic repression. Progress is laborious and slow. The child has lost some of his early confidence and keenness and readily becomes disillusioned and discouraged. But this may be followed by artistic revival.

Such studies in the artistic development of the child have done much to reinforce the methods intuitively adopted by many art teachers.

> We have to do with an activity of burning interest to the young child [writes Dr. Burt]. We must beware, therefore, of cooling or dimming that ardour, or allowing it to become extinguished before its full progress is achieved. . . .
> The child should be allowed to draw what he knows he wants to draw, not what we think he ought to draw.[1]

It is clear that there can be no real separation in kind between the art of the child and of the adolescent. They constitute phases in a continuous development, sometimes rich in production, sometimes spasmodic, sometimes self-conscious, but nevertheless passing from one into the other almost imperceptibly.

With the 1930s a sympathetic understanding of the problems involved in the artistic education of the child was steadily gaining ground among teachers. Miss Richardson had extended her teaching activity and had been lecturing to student-teachers since 1925 at the London Day Training College, which subsequently became the Institute of Education of London University. The course, which was seldom taken by more than eight to ten student-teachers at a time, led to the grant of the Art Teacher's Diploma. Many who have since become prominent in art teaching—Nan Youngman, Clifford Ellis, subsequently head of the Bath Academy at Corsham, Clarence Waite, who succeeded her as art lecturer at the Institute of Education, to mention only a random few—attended the lectures she gave, usually once or twice a week, and have frequently testified to the admiration of her work in furthering art education.

In 1930, Marion Richardson was appointed to the London inspectorate, through the influence of the Senior Inspector of Art for the London County Council, R. R. Tomlinson, a friend and an admirer of her work.[2] There she was able to help pave the way for an enlightened policy towards art education in the primary and secondary schools under the Council's control.

[1] Cyril Burt (subsequently Sir Cyril), *Mental and Scholastic Tests,* 1921, revised 1946.

[2] R. R. Tomlinson has recorded that he first met Marion Richardson at the exhibition of her pupils' work at the Grafton Gallery in 1920, when he himself was teaching at a provincial art school: "I can vividly recall to this day", he writes, "how profoundly moved I was, not only by the vital drawings in the exhibition, but by the keenness of Miss Richardson to explain to visitors what, at the time, were considered her revolutionary methods of teaching. The exhibition did not meet with general approval, but, like the true pioneer, she was undaunted by adverse criticism." R. R. Tomlinson, *Picture Making by Children,* 1934, revised 1950.

The old methods of art teaching were rapidly giving way in face of the new understanding of children's need to express their own ideas in their own way. This was revealed beyond dispute in the impressive exhibition of Drawings by London Children, at County Hall in 1938, in which Marion Richardson was the guiding spirit.

14

a New Approach to
Art Teaching Overseas

THE growing interest in the work of children which was inspired by the "new movement" in art in Europe was slow in penetrating British territories overseas. Having its roots among the younger artists of the Western world, the "new movement" made no immediate impact on the artists of the Far East, and there was no organized body of artists in Africa on whom such an impact could be made.

Yet this was a movement which set out to expand the artistic horizon and evaluate works of art from a more liberal point of view, embracing styles which had hitherto been ignored. There could be no aesthetic barriers to divide the traditional arts of the Orient and Africa from the adherents of the "new movement" in the West.

How, therefore, were these revolutionary ideas in art to be brought to bear on education overseas? They could expect no welcome in official educational circles, and many prejudices would have to be overcome before one could hope to penetrate the schools.

One of the first to respond to the new outlook in art was E. B. Havell, principal of the Government School of Art, Calcutta, whose writings on Indian art, already mentioned, had aroused enthusiasm in England. Havell launched a crusade for greater recognition of the importance of Indian art and craftsmanship in the cultural life of India, but a complete reversal of official policy in Indian education was required if the traditions of Indian art were to be saved.

In an outspoken essay of 1910, after his retirement from Government service, Havell made some devastating criticisms. Claiming that in India "the aesthetic sense of the people, in spite of all that British philistinism has done to suppress it, strongly influences their everyday life", he declared that "whatever the cause may be, since our rule has been established the old art of India has been almost killed".[1]

There were only four schools of art, set up by Government, throughout the British domains in Asia, and these were in India, i.e. Bombay, Madras, Calcutta

[1] E. B. Havell, *Indian Art, Industry and Education*, Calcutta, 1910.

and Delhi; moreover, art was entirely excluded from the courses offered by the Indian universities. The artistic traditions of the people in India could only be maintained if an informed taste and aesthetic appreciation were to be developed through schools of art linked with institutions of general education which could insist on support for these traditions.

> The new movement in art has taught us [Havell wrote] that art is not a curiosity for museums, but a beneficent influence in public and private life.[1]

When local governments in India issued a series of reproductions of Indian art and architecture Havell urged that they should be issued to schools in order to line the classroom walls and corridors; thus boys and girls might acquire some respect for their own traditions in art.

With the growing recognition in art-teaching circles in Great Britain that children could express themselves far better in their own fashion than by trying to imitate the work of adults, it soon emerged that this must apply even more forcibly overseas, where the type of art being imitated was an alien one. Some of the younger artists in England drew analogies between the vivid pattern-making of the European child and the uninhibited inventions in art and craft, not only in the Orient, but equally in Africa, when unspoilt by Western teaching. Had not children overseas artistic potentialities which only awaited a determined teacher to bring them to the surface? Old-established methods would have to be cast on one side, if educational authorities and principals of schools could be persuaded to agree.

An opportunity came with the decision in 1924 to establish a residential college at Achimota near Accra on the Gold Coast. The Governor, Sir Gordon Guggisberg, was determined that it should be progressive in character, free from some of the prejudices of the past. The Reverend A. G. Fraser, who was chosen as principal, with Dr. Aggrey, an African scholar, as vice-principal, proposed to include art in the curriculum. Thus George Stevens, who had been studying art at the Ruskin Drawing School, found himself in Accra—apparently the first professional artist to have the opportunity of teaching in equatorial Africa. With the college not yet built, teaching began at the Government Training College, which had been founded in 1909.[2]

One of Stevens' first problems was to persuade his pupils to respect their own artistic traditions. He found it generally assumed among them that everything British in education was necessarily good and anything indigenous was to be discarded. African pupils tended to reject native traditions, because they associated them with the "primitive bush". On the other hand, the "high seriousness and reverence", as Stevens has termed it,[3] that underlay the old

[1] E. B. Havell, *Indian Art, Industry and Education*, Calcutta, 1910.

[2] Fraser told Sydney Carline, Stevens' teacher at Oxford, that he found in Stevens a singular sympathy with Africans and an understanding of their problems (recorded in a letter).

[3] G. A. Stevens, *The Future of African Art*, a paper read at Achimota College, March 1928, published in *Africa*, Vol. III, No. 2.

African art was inspired by the primitive religion of the tribes. How could the one be respected and developed without the other? An African art informed by contemporary thought would somehow have to be built on the traditions and methods evolved by these artists of the "primitive bush".

At this period the old Education Code of 1887 was still functioning in the Gold Coast Colony. Drawing was provided under the dubious heading "hand and eye training", so familiar in India as in Victorian England. Those who had drawn up this code as a guide to teachers were obviously unaware that there was anything worth preserving in the native arts and traditions. The "hand and eye" concept of training for industry had been transported overseas unquestioningly, on the assumption that it constituted the only kind of drawing that could or should be taught.

Education, far from preventing the decline of the arts and crafts in Africa, had helped hitherto to promote this decline through widening the inevitable gulf that had been formed between the village craftsman and the new Western-educated urban population. It had served to increase the contrast between the hand-work of the former and the so-called "brain-work" of the latter. In a paper read at Achimota in 1928 Stevens emphasized the absence of any "real provision for a proper relation between the academic art subjects of the schools and the indigenous village arts and crafts, which must form the basis of any vital African culture".[1]

The immediate problem at Achimota was how to switch from European methods, that were naturally alien to the people, to those that naturally belonged to them, from a Western visual concept to the native one. In attempting to bring this about Stevens had not anticipated that the strongest opposition would come from his African pupils. He recounted the problem in a recent broadcast:

> These students knew that wood sculpture was connected with primitive religion and what they called "the worship of idols", and they had turned their backs on that when they left the bush. Pottery also smacked of the bush. It was dirty, and women's work anyway. Weaving? All right for villagers, but "we are now civilized" and either wore European clothes or bought our cloths ready made from Manchester. . . .
> My difficulties seemed insurmountable because art is fundamentally not a book subject. Its grass roots lay out there in the bush, among the weavers, the wood-carvers and the potters.[2]

To the students of Achimota, as in other secondary schools, drawing meant in their view the usual "hand and eye" nonsense; they wanted to draw vases with a central line bisecting them, with the two sides measured to match one another, or boxes in perspective in true South Kensington manner. It seemed that there was no alternative for the teacher but to ignore the native crafts and accept the fact that the European process of drawing was established in Africa; somehow or other the special African characteristics might ultimately emerge. Meanwhile,

[1] G. A. Stevens, *The Future of African Art*.
[2] *The Listener*, 22 February, 1962.

was there not some means of persuading these African students to look at real life, as the first step towards drawing it? A chance occurrence gave Stevens the required solution:

> In the privacy of their dormitories [he writes] they were in the habit of pinning up rather crude and scurrilous cartoons, some of them in colour, which they had drawn in their spare time. These dealt with everyday subjects, such as "Mensah falling downstairs with a pail". . . . Life had found a way of bursting through this rigid scholastic framework. The next step was to bring this work right in to the classroom. I asked the students if I might include a selection of these pictures as part of the annual exhibition. It was a gesture which worked.
> Once they had got started, ideas came tumbling out of them thick and fast. They drew the daily life of the College, their villages and homes; they dealt with weddings, funeral customs, and with subjects from the Bible and folk-lore, but always in terms of contemporary life. I soon encouraged them to work out of doors, first of all with trees, plants and buildings, then further afield. . . . In the classroom we concentrated on the human figure, its structure and movement. . . .
> But, throughout, picture-making or composition remained the all-important end.[1]

The students were soon won over completely to the expression of their ideas or their recollections of contemporary life, conveying them with sensitive drawing and vivid colour and pattern.[2] Perspective, so difficult for the African to incorporate pictorially, was ignored. The vases and boxes of South Kensington soon became things of the forgotten past.

This endeavour to resuscitate the real artistic sensibility of Africans received enthusiastic support from Roger Fry, though he was sceptical as to its prospects of success. He feared that artistic degeneration had sunk too deeply for the true qualities in African art to be regained. Fry discussed the problems in a letter to Stevens in 1925:

> The whole question [he writes] is whether one can start a passion for creating in people who have sunk into lethargy. If once it gets started it is propagated by mere imitation and rivalry, but one must know the people very well to know how you can get at them. Their great sensibility is the thing to appeal to—if it only became a conscious instead of a vague unconscious quality.
> Why has there been this degeneration in African art? We trace the degeneration of our handicrafts to all sorts of external causes (machinery etc), but none of them apply to Africa, until quite recently, and yet a similar spiritual exhaustion seems to have been taking place.[3]

[1] G. A. Stevens, *The Listener*, op. cit.

[2] One of Stevens's former students wrote to him in 1951, recalling the art classes at Achimota: "We spent a lot of time drawing pictures outside the College compound . . . the castle, the cows in the market etc; (these) are all memories I still love and cherish like a child" (Mr. Philip Gbeho).

[3] 19 December, 1925 (hitherto unpublished).
Fry had accepted Paul Guillaume's claims of great antiquity for the finer pieces of African sculpture, for which there was no real justification. Degeneration in art came with Western education and influence.

Fry thought an attempt to establish African history would help to revive a sense of identity with the masterpieces of the past: "If only some kind of historic continuity could be made apparent to them." Despairing of the artistic future of his own race, he founded great hopes on the artistic sensibilities he saw in African work. His letter concluded with the following forecast of the future:

> I conceive the possibility of a great African civilization in which sensibility would play a far larger and finer part than it has in Europe. With us the dose of sensibility is too small in relation to creative energy and capacity.

Stevens had consulted Fry on how a museum of African art might best be created in Accra, so that pupils and teachers could study the techniques and designs of the past and form a respect for them, but Fry was dubious as to how the money and the material were to be obtained. The idea was subsequently taken up with success by K. C. Murray in Nigeria, and its museum was founded in Lagos ten years later.

Murray went to Nigeria in 1927 before Stevens had resigned from Achimota, and taught both in Ibadan and Umuahia Government schools (plates 18a and 19b). He found the same deadening influences awaiting him as Stevens had experienced on the Gold Coast—the same ruler-work, copying and perspective, of which, he wrote in 1933, "accuracy has been the highest aim, but not accuracy of observation".[1]

Murray recognized that African art could not be revived in its old form. He regretted having to resort in his teaching to the modern technique of drawing and painting, since these were unknown in Africa until Europeans came there. He could find no satisfactory solution to this dilemma "except in the general outlook of the lessons".[2] The Africans themselves were abandoning their own forms of art in favour of alien forms which seemed to exert upon them an unnatural fascination.

The essential quality common to all great art lies in the creative imagination, and the introduction of European techniques might not matter, as long as this imaginative quality could be maintained. With this in mind, Stevens brought to England a collection of drawings and water-colour paintings by his pupils at Achimota for exhibition at the Imperial Institute in 1929 (plate 19a and colour plate III). While arousing much interest in art circles, it was disappointing to find

[1] K. C. Murray, "The Condition of Arts and Crafts in West Africa", *Oversea Education*, July 1933.

J. D. Clarke records in *Omo—An African Experiment in Education*, 1937, that when the school was founded in 1931, the boys drew with pencil on small drawing books and "the results were deplorable". When Murray arrived two years later, he "set the boys on to free-arm drawing with charcoal and to painting on generously large sheets of paper . . . providing opportunities to look at people doing things and to draw them from memory" and getting "the picture clear in their mind's eye" before beginning to draw.

[2] In 1935 Murray was teaching at Uyo Elementary Training Centre, but subsequently confining himself to the crafts. A few years later, he abandoned teaching, disappointed with the absence of official support.

very little impact made on those who exercised the main authority in education.

Eight years later Murray similarly brought over an exhibition of his pupils' work from Nigeria, chiefly sculpture, which was shown at the Zwemmer Gallery in London. Murray summarized his problem as follows:

> I want to convince the educated Africans that they have an art that is worth noticing, the teachers that the "free" method of teaching produces results, the government that Nigerian art deserves encouragement. . . . I want art to be part of the lives of the people as in the past, [and] oppose the vulgarity that may so easily appear when the traditional forms are left and European articles accepted without discrimination.[1]

By this time officialdom had ceased to hold back. On the contrary, considerable efforts were now made at a higher level to encourage African appreciation of the indigenous arts. Much credit for this was due to Sir Michael Sadler, then master of University College, Oxford, whose long educational experience in India and enthusiasm for the arts, especially those of Africa, gave his voice the required influence. Sir William Rothenstein, principal of the Royal College of Art, lent his valuable aid.

Writing in the first issue of *Oversea Education*, issued by the Colonial Office, in 1929, Rothenstein had pushed home the lessons of British failure in art education overseas, already emphasized by Havell:

> Knowing about things is held in higher esteem than ability to make things. Hence in our colonial and imperial responsibilities we have failed too often to value the active culture which shows its presence through creative power. Worse still, we contrived, at one time, to inculcate methods which the West had long since scrapped. The books formerly provided for the teaching of drawing in Eastern and African schools were an outrage on common intelligence.[2]

When the Colonial Office set up its Advisory Committee on Education in the Colonies, Sadler and Rothenstein were the first to be consulted concerning the teaching of art. This issue came before the committee's notice, when Edgar Ainsworth resigned his post as art superintendent for the Taiping and Perak regions of Malaya, to which he had recently been appointed. Concerned to find such a marked decline in the practice of the crafts, Ainsworth had tried to promote interest in the craft of pottery, making kilns of leaves and mud before an admiring audience of Malay boys and girls. The discouraging conditions and the absence of support from officials in the Federation prompted him to resign by way of protest.

Ainsworth's report on his Malayan experiences in teaching art stimulated the formation of a sub-committee for art education with Sir Michael Sadler as

[1] From a letter to the author, 1 May, 1937.

[2] W. Rothenstein, "The Development of Indigenous Art", *Oversea Education*, Vol. I, No. 1, October 1929.

chairman.[1] The committee turned, first, to Africa and set itself the immediate task of preparing a list of books on African art for the use of oversea departments of education. The discovery of the astonishing lack of such books prompted the committee's decision to make special surveys in selected areas beginning with West Africa.[2]

The committee had hoped to extend its surveys to other regions of the colonial empire, but this was not achieved. Meanwhile the gap was filled by the efforts of individual art teachers. In East Africa, Mrs. Trowell was the pioneer. The artist wife of a medical officer in Nairobi, she began studying the local crafts which seemed in imminent danger of dying out, and set herself the task of forming a class of native girls to practise these crafts. It was generally assumed that the East African tribes possessed no artistic traditions or natural aptitude for art, because of the absence of sculpture, such as the masks and figures of the West Coast. But the pottery and basketry of tribes such as the Bunyoro and Kikuyu are exquisite in form and quality, fully revealing the high degree of artistic sensibility to be found in the eastern regions as much as in the west of the continent.

Painting was indeed unknown in Africa when European education was introduced,[3] and Vernon Brelsford, a district officer in Northern Rhodesia (now Zambia), found that the Bemba language possessed no terms for colours other than white, black and red. Other colours could only be indicated by reference to some natural object, such as a leaf for green or the sky for blue.[4] Yet this absence of any tradition in the use of colour has not prevented the successful practice of painting following its introduction in the secondary schools of Africa, and it is precisely in their feeling for colour that African students have shown such distinction.[5]

[1] Sir Hans Visscher and Arthur Mayhew were the joint secretaries of the Advisory Committee.

[2] The first of these surveys appeared in 1935 as *The Arts of West Africa*, published with the aid of the International Institute of African Languages and Cultures; edited by Sir Michael Sadler, with articles by G. A. Stevens and others, and with its plates and Catalogue Raisonnée by Richard Carline.

It was meant to assist schools in promoting a serious study of West African art, its dating, provenance and stylistic comparisons within the different tribal areas. The illustrations of African sculpture (photographed by the Empire Marketing Board's Film Unit) were presented as if seen in Africa rather than as collectors' pieces.

Coinciding with publication, an exhibition (assembled by the author) of British and African work provided a co-operative link between the artists of Africa and England.

[3] The rock paintings of Tanganyika (now Tanzania) and Rhodesia belonged to a much earlier time, of which the traditions had been largely forgotten.

[4] V. Brelsford, "The Teaching of Art in N.E. Rhodesia", *Oversea Education*, July 1935.

[5] Murray taught his Nigerian pupils to make their own colours from the juices of leaves, petals, roots or from earths ground to a powder in water, which was then allowed to evaporate. The resulting powders or liquids might then be mixed with a weak gum. (J. D. Clarke, *Omu*, 1937).

Marion Richardson records that her pupils at Dudley High School gained respect

If art teaching was to acquire a firm basis, however, it had to take as its starting-point that aspect which was most in evidence in local tradition. The one quality which the indigenous arts of Africa had most in common with the new methods of the West lay in design or pattern. The immediate appeal of design with its use of texture could be used as the stepping-stone from which drawing or painting could be understood.

With these considerations in mind, Margaret Trowell collected traditional patterns produced by the tribes as the basis for her initial teaching. The practice of crafts being so familiar in Kenya, she was able to use them as the first stage leading to pictorial work. "A golden opportunity", she had complained in 1935, "of teaching design through their own crafts is being missed in the schools."[1]

Transferred to Uganda in 1935, she found art teaching as neglected there as it had been in Kenya, and was writing home with a sense of deep despondency:

Much has been said, though little has been done, about the spiritual value of conserving and developing the art of a people along its own lines. Unless this is more generally realized, one whole side of the life of the African people will, at the best, be submerged under western materialism for several generations; at the most it may even go altogether.[2]

Miss Geraldine Fisher was one of the very few artists then teaching art in Uganda, and Mrs. Trowell found in her an enthusiastic collaborator.[3] Opportunities came their way when Makerere College was founded in Kampala, and an art class was established for students of the college. With Miss Fisher's help, the African Art Society was formed, and its first exhibition was held in Kampala the following year. This exhibition, with the support of the Governor, was brought to England for showing at the Imperial Institute in April 1939.

Under Margaret Trowell's guidance, Makerere became a centre of art teaching attracting students from all parts of East Africa.[4] It was the first art school for training art teachers throughout that vast region, and her achievements were justly recognized, when she retired from teaching, by the school being named after her.

It was in Southern Rhodesia that Canon Patterson tried experiments in 1939 along somewhat different lines. He held the unusual view that the arts of other

for their paints as a result of experimenting with natural colours such as beetroot juice or curry powder. (*Art and the Child*, 1948). One of her pupils, aged fourteen has written on her picture: "Sky—flower petals and berries; mountains—blacking mixed with pipe-clay" etc.

[1] M. Trowell, Notes in *Oversea Education*, July 1934.
[2] M. Trowell, "Suggestions for the Treatment of Handwork in the Training of Teachers for work in Africa", *Oversea Education*, January 1936.
[3] Miss Fisher was art teacher at the C.M.S. School for Girls at Gayaza, Uganda, the pupils being of Indian extraction.
[4] Technical colleges with art departments followed later in Nairobi and Khartoum. In Nigeria, art departments have been formed at the universities of Ahmadu Bello at Zaria in the North and at Nsukka in the Eastern Region.

races or of past periods in history should be excluded from African schools in the hope of obtaining thereby a purely African mode of expression. To this end he made art compulsory throughout his primary school for Africans at Cyrene, at that time the only school in the Rhodesias which provided any art teaching for Africans.

A selection of the students' work at Cyrene was sent to London for exhibition with the aid of the S.P.G., and visitors were surprised at finding such an extraordinary gift among Africans who had not seen other pictures. The range of colour was limited, often confined to blues and earth colours. The detailed drawing was based on observation of local activities and environment, giving scope for intricate design. Observers could not fail to note, however, a marked similarity throughout the work. Whether this was indeed the natural African style, or the result of unforeseen influence at Cyrene, the future alone will indicate.

During the period following the close of the Second World War the battle for a more enlightened approach to art teaching appeared to be clearly won. Many artists, graduating from art schools in Great Britain, began teaching in the secondary schools and technical colleges overseas—in Sudan, Malaya, Singapore, the West Indies, and in East and West Africa. Graduates from art schools in India and Ceylon or from Makerere and Achimota joined them.

From a mere handful of schools teaching art throughout Africa the number has grown considerably. Uganda, alone, had by 1960 a dozen or more secondary schools for Africans or Indians, in which art formed a regular part of the curriculum, to be taught in well-equipped studios. For vigour and originality of design, luminosity and richness of colour and particularly for a vivid and highly distinctive imagination, the work from these schools has established a standard which the best work from British schools can barely equal.

A growing freedom in art teaching has emerged in many of the secondary schools of India and Ceylon, having more in common with the decoratively assertive Bengal folk art, fostered by Jaminy Roy, or the Buddhist frescos than with the highly refined Hindu miniatures, which had led latterly to a degenerate effeminacy in Indian art. The broad use of powder colour has replaced the little pans of water-colour from which faint washes could only with difficulty be extracted, bringing with it greater strength and freedom, but losing some of the sensitive refinement found in the best Indian and African work. The small, neat drawing books of old have given way to generous sheets of paper.[1]

[1] Referring to the art teaching in the Cathedral and John Connon Girls' School, Bombay, Mr. Nix-James writes:
"Lady Temple made her appearance in, I think, 1951, and immediately set free the art of the school. . . . Instead of sitting stiffly in rows at classroom desks, the girls spread their paper on drawing boards, using easels, donkeys, or if they felt so inclined, sprawled comfortably on the floor. . . . Indian designs for textiles and book-jackets, and still-life came to life. Children evolved their own individual styles instead of copying from books, blackboards or photographs." (Letter of December 1964 previously quoted.)

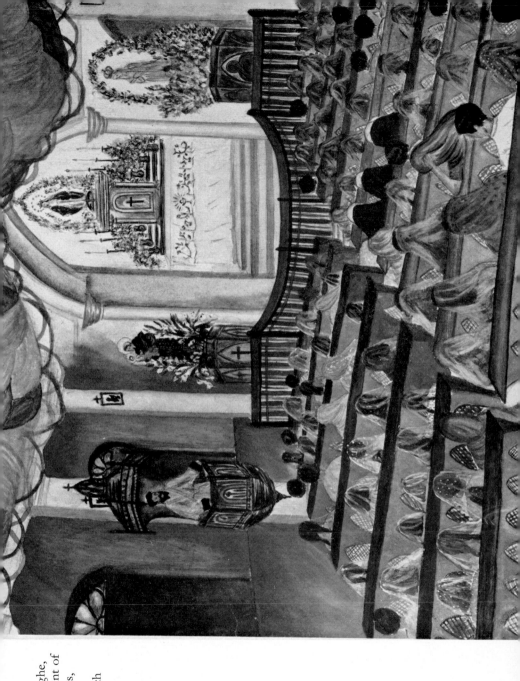

17. Winifred
Ediriweerasinghe,
age 18: Convent of
the Child Jesus,
Ratnaputra,
Ceylon: Church
Service

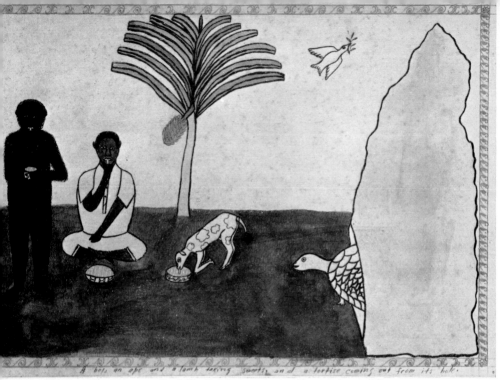

A boy, an ape and a lamb taking sweets, and a tortise coming out from its hole.

18. *a.* Uthman Ibrahim, pupil of K. C. Murray, 1930: Boy and animals
b. Harbhazan Singh, age 11, pupil of Niren Ghosh, India, 1946: Monkey land

Harbhazan Singh

"Spontaneity of expression is a child's main asset, something throbbing with more and more life—not a dead image but a living, immortal object."[1] This is the vision of the new art teachers of India.

But is it all too late? Has the commercialism of the East and the West, so readily absorbed overseas, already sunk too deeply for the artistic sensibility of the people to maintain itself?

[1] In a letter from Mr. Rathin Mitra, art master, the Doon School, Dehra Dun, India, 1964.

A. Adeshoye, pen and ink, Eko school, Mushin, Nigeria, 1958

from School Certificate to G.C.E.
—1930 to 1950

THE whole future of art teaching in secondary schools was at stake when the system of examining was reconsidered during the 1930s. Art was purely incidental to these discussions, and more often than not ignored altogether, but its fate in the local examinations and, consequently, its place in general education, was dependent on their outcome. Art was not, as it should have been, the subject of a separate enquiry by specialists in this field.

Discussions reached a climax in 1932, when the Secondary Schools Examination Council appointed a panel of investigators to study the working of the examinations, which had been, since 1917, subject to the approval of the Board of Education. The panel included among its recommendations a certain relaxation in the choice and number of subjects required for a certificate; it demanded that subjects receive varying priority. This recommendation, subsequently adopted, greatly concerned the teaching of art, since it was not proposed to re-classify "Drawing" as a "main" subject but to retain it in Group IV, where it could only contribute towards, but not govern, the granting of a certificate.

The panel had recognized that there was a demand for raising the status of "Drawing", but firmly rejected it.[1] The decision to keep the subject in the lowest group necessarily left it as an "extra" on the fringe of the examinations. This negative attitude appeared the more retrogressive when, shortly after these decisions, the World Federation of Educational Associations, meeting in Oxford in 1934, called the attention of all governments to "the urgent need for securing at every stage of school life up to and including the university stage, a fuller appreciation of the cultural significance of the arts and crafts and the importance of their practice in education".[2]

Educational circles seemed nettled by such fancies, and *The Times Educational*

[1] The panel's report stated:
"There has been considerable agitation for the recognition of this last-named group (i.e. the Arts) as one of the three groups in which success qualifies for a Certificate, but the investigators do not concede this point" (H.M. Stationery Office, 1932).
[2] *Oversea Education*, January 1936.

Supplement characterized the demand for greater freedom in art teaching as "a fluffy habit of mind with little power of distinguishing between what is correct, what is incorrect, and what is approximately correct".[1] The art examinations, described as "soft options for children", laid bare a "want of technique which is not to be disguised by grotesque strainings after the unusual in composition and form".[1] Up what blind alleys were the critics leading us in the 1930s when their definition of a work of art was something "usual" and "correct"? With such views prevailing, the decision to consign art to Group IV must have been inevitable.

With this as the examination framework, the whole system was now assailed from a new angle. It had long been questioned whether external examinations constituted the best method of assessment or whether one based on internal evidence in conjunction with an indication of a candidate's school record would be the more effective. An International Commission on Examinations had been set up by the New Education Fellowship, and its English Committee, which included Sir Michael Sadler and Sir Philip Hartog, Academic Registrar of London University, was set the task of investigation. The results of their enquiries, made public in 1935, aroused widespread alarm by raising doubts as to the soundness of the examiners' judgments in a variety of academic subjects.

The investigators were concerned, as they stated in their report, with "the part played by chance in the verdicts given at different examinations on which careers depend". This element of chance was fully substantiated.

> "It is not only", the report states, "that examiners disagree with one another. They are not always able to confirm their own verdicts. Fourteen examiners who re-examined fourteen School Certificate history papers after an interval of a year gave quite different marks on the second occasion and changed their minds as to the verdict of pass, fail and credit in several cases".[2]

They noted similar differences of opinion between examiners who assigned marks in the English language papers. The results of investigation showed that of thirty-nine scripts, which would have "failed" at the hands of one set of examiners, all but three would have received "credit" if they had been marked by another group of examiners, who would also have given "distinction" to three of the scripts. The report referred to "the inevitable uncertainty as to the relative weight to be given to 'ideas', 'vocabulary' or 'punctuation'."

Summarizing the results of the enquiry, Sir Philip Hartog drew the conclusion that when an examiner gave a script "credit" after "failing" it the previous year, he had "probably altered his views on the aim of the test in the intervening period".[2] It was essential to clarify the objectives in any particular test if divergences in marking were to be reduced, and the investigators pressed for "careful and systematic experiment" so as to improve the methods of examining and reduce "the distressing uncertainties of the present system".[2]

[1] 26th October 1935.
[2] Sir P. Hartog and Dr. E. C. Rhoades, *An Examination of Examinations*, 1935.

Had drawing been one of the subjects for investigation, it is unlikely that the conclusions reached would have proved any less disquieting. The subject was excluded from the terms of reference, but the same element of chance which governed the marking of an essay must have operated equally in the assessment of a drawing. Even object drawing, in which accuracy at that time was the main consideration, allowed scope for wide differences of opinion. Examiners must have differed over the relative weight to be given one aspect of drawing, such as correctness of proportions, as against another, such as accuracy in rendering contours or straight lines, just as readily as in an essay.

I recall during the late 1930s, when the examination was on a much smaller scale, being shown two memory drawings of a chair. One had been given a high mark, while the other was to "fail". Blue crosses on the weaker drawing indicated errors in perspective which had, presumably, caused its low assessment. I could not but think at the time that another examiner might have attached less importance to these errors in perspective and allowed more credit for the expression of form or light and shade, thus bringing the two marks closer to one another. Similarly, there were two water-colour paintings from still-life, in which the relative neatness in making the washes had obviously counted in the examiner's estimation, whereas another examiner might have preferred freer washes and ignored neatness. Obviously, the only remedy was an agreed basis of evaluation.

Opinions as to what constitutes merit in art are so diverse that we can be fairly certain that much of the work that received a "pass" in the 1930s would fail if examined today, and that similarly there must have been many candidates failing, whose work we would now assess highly. It was then, and is today, quite impossible to arrive at any consistently fair appraisal in art, as in other subjects, without prior agreement as to the precise objectives of the test and the relative values to be placed on different qualities or aspects of the work.

No records have been preserved to indicate the methods of assessment in drawing in the early days of the Local Examinations. Until well into this century the numbers of candidates in the subject were few and the entries in each paper were not more than an examiner could manage single-handed. For more than thirty years, until 1895, H. A. Bowler was alone in marking all the work submitted for drawing at Cambridge, and he alone made decisions as to the qualities required for a "pass", "credit" or "distinction". Oxford and the Joint Board usually relied on two examiners, working together.

In the 1930s, the examinations had grown in scale and the principal examining boards were employing several examiners in art, some boards using a separate examiner or more for each paper. Ultimately a procedure was evolved whereby the examiners would meet in order to agree a standard of marking for typical scripts. These would be set aside by each examiner for reference during the marking, which was generally carried out at home.

The boards were always under constant pressure to issue their results promptly, so that it was imperative to complete the marking as quickly as

possible. With the expanding volume of work as a result of the ever-increasing number of candidates, the administrative problems became more pressing, and prior agreement on the qualities to be assessed became more essential, and at the same time the more difficult to achieve. Nevertheless, recent experiment has shown that given adequate time and organization, examiners in art can, and do, reach an extraordinarily close measure of agreement in their assessments. There is no means of telling whether this was equally true in art thirty years ago, when Hartog was making his enquiries.

The investigators' enquiries into the working of the examinations had inevitably posed this question: Bearing in mind the difficulties of assessment and the necessity for speed, is it justifiable to invite boys and girls to enter for examinations in which the verdict must lie to a considerable extent at the mercy of chance? Hartog had summarized his views earlier in these terms:

> It may be held . . . that culture may be killed, that it cannot be taught by examinations. Yet teachers who realise all this, who think examinations in their subject mischievous rather than helpful, implore the authorities to include it in every possible examination syllabus. Why? Because, under the present régime, a subject that is not examined is likely to disappear speedily from our teaching curricula.[1]

While the writer of this passage did not have the drawing examination in mind, he could not have been nearer the mark had this statement concerned drawing alone.

Hartog had his own solution to offer. He wished examinations to be confined to the presentation of argument, knowledge of facts and their practical application. If such limitations were to be imposed on examining in art, we would be back once more assessing correct proportions and perspective. We would still be faced with the problem of deciding which "facts" matter in art.

However critical the art teachers may have felt, they rightly preferred to accept the tests in "picture-making", despite the undoubted hazards, rather than revert to a "factual" type of examination, such as prevailed at the beginning of the century, from which imagination and invention were precluded. To confine the examination to what was considered strictly examinable in art would have been a step backwards, offering reliability of marking at the price of a yet more restrictive syllabus.

Art teachers knew that they had to cling to any improvements in the syllabus if art was to retain a place in general education. They had to accept the uncertainties of marking such imponderable qualities as taste, sensitivity, imagination, if these qualities in art were to be treated with respect at school. From their point of view, greater freedom was needed in the art syllabus rather than increased restriction and the examinations had to be retained despite their defects.

It was through the Cambridge Syndicate's oversea examination in art that further reforms emerged. The art syllabus, as we have noted, had been invariably

[1] Sir P. Hartog, *Examinations and their relation to Culture and Efficiency*, 1918.

framed with the home centres in mind, and the problems that concerned candidates living in the tropics were seldom considered. The Advisory Committee on Education at the Colonial Office now provided a forum where such issues could be raised, and the suitability of the Cambridge art syllabus for candidates in colonial territories came up for discussion in 1933 at the request of West Africa. Steps were taken, therefore, to draft a syllabus which would take into account the artistic problems in these territories and to encourage the study of the indigenous arts and crafts.[1] The final scheme received the Syndicate's approval, and the views of colonial governments had to be ascertained.[2]

The new Syllabus for Tropical and Sub-Tropical Dependencies, to give its full title, was launched in 1936—the first attempt to persuade educational authorities that art teaching should be adapted to the needs and traditions of the people.

The Tropical Art Syllabus made a complete break from any syllabus provided by the local examination boards hitherto. It was divided into four parts or papers—the candidates being allowed to choose three. Of these, three were purely "creative", while one was "objective", such as a plant or a group of household objects or a subject from memory. It was the "creative" tests that were new in character. Although the Cambridge syllabus had included some "creative" elements in its paper entitled "Illustration" since 1925, the new syllabus set a different course, placing the main emphasis on originality and imagination. Its Part One, entitled "Original Imaginative Composition", specified a number of alternatives which might arouse memories of some actual scene or personal experience, might be purely fanciful or might be derived from folklore or literature.[3]

The third and fourth parts of the syllabus also broke fresh ground in examinations. While Part Three provided for submission of work in a craft combined with a description of the craft to be written during examination time, Part Four tested the knowledge and appreciation of "one of the traditional

[1] The Advisory Committee had set up a special art sub-committee, as previously mentioned, under the chairmanship of Sir Michael Sadler, to which George Stevens, Edgar Ainsworth and the present author were co-opted. At the request of the committee a new syllabus was prepared by Stevens and the author. Their proposals were fortunate in obtaining the very sympathetic ear of the Syndicate's then General Secretary, W. Nalder Williams, and the support of members of the Syndicate.

[2] It was decided that oversea candidates would be free to choose either the old or the new syllabus, with which proviso the Secretary of State for the Colonies gave his approval. (*See Oversea Education*, January 1937, and a fuller report in the April issue, 1943.)

[3] The specimen paper contained six alternatives, of which the following are typical: "Imagine a number of objects of varying sizes set out for sale in a store. One of them appeals to you because it feels rough and prickly, another because it feels hard and shiny, another soft and smooth, another light and wavy. Make a composition to express these different feelings and textures."
"Think of an occasion when you have sat near an open door expecting something unusual to happen. Express your feelings on that occasion by using the shapes and degrees of darkness, light and colour."

fine arts of the country", which might include woodcarving, boat-building, a ceremony or drama with costumes and masks.[1]

The inclusion of the crafts in the examination was particularly welcome at Achimota on the Gold Coast (now Ghana), where Gabriel Pippet, then in charge of the art department at the college, and especially his successor, H. V. Meyerowitz, had made them the backbone of their teaching.[2] The latter made constant efforts to foster a close communal relationship by their means. He thought that the crafts should not be developed "out of step, so to speak, with all the activities of a community".[3] Craft centres were formed in different areas of the colony in the hope that people would not lose their "love of making things",[4] and he wished to combat, as he explained, "one cultural island after another being submerged in our sea of bakelite and duco, of the sardine and petrol can, the cotton print and the corrugated iron roof".[3] Alas, Meyerowitz was unable to see his hopes realized. His premature death at Achimota in 1945 in the midst of his valuable activities saved him from witnessing this total submergence he so rightly feared.

The particular significance of the Tropical Art Syllabus lay in the stimulus it gave to reform elsewhere, and curiously enough this reform arose out of its complete failure to obtain acceptance in many of the countries for which it was intended. It was used at a few schools in Nigeria and the Gold Coast, where remarkably interesting work was produced. In all other oversea territories, even after the new syllabus had been available for some years, the schools continued to adopt the old and, as it was assumed, discredited syllabus, which was still in use for home centres.

It seemed difficult to explain this lack of support for a much-needed reform, until it was realized that the oversea candidates felt that the new syllabus implied some element of racial discrimination. Was it not assumed in Cambridge, they seemed to be saying to themselves, that boys and girls overseas were so backward that they could not tackle an examination deemed good enough for British boys and girls, but had to be given a special one for "colonial" races. That this was the attitude of boys in India is confirmed in a letter from Mr. Nix-James, then teaching at the Cathedral School, Bombay:

[1] Arthur Mayhew, editor of *Oversea Education* and joint secretary of the Advisory Committee for Education in the Colonies, had been mainly responsible for securing official acceptance of the syllabus. In *Oversea Education*, April 1943, Mayhew wrote that the aim was to "encourage a closer relation between teaching and practice of art and craft", while allowing for "indigenous methods and traditions".

[2] Attempts were made to encourage the teaching of crafts in other regions also, such as the Federated States of Malaya. At the Malay Girls' School during the 1930s Malay design and stitches were studied (N. Purdom, *Oversea Education*, January 1931). Through the efforts of the Art Superintendent, Mr. Burgess, a three-year course in crafts, chiefly basketry and textiles, was begun (R. P. S. Walker, "Malayan Arts and Crafts", *Oversea Education*, October 1940).

[3] H. V. Meyerowitz, *Oversea Education*, July 1943.

[4] H. V. Meyerowitz, *The Making of Things*, with a foreword by W. M. Macmillan, 1942.

They were inclined [he writes] to choose subjects which could be interpreted in western ways, probably because it was for an English examination. They would rather describe an English farm, though they had never seen one, than the much more homely, and sometimes more picturesque, Indian one.[1]

If candidates in England chose to draw deck-chairs or coal-scuttles from memory, or make a design for a tea-cosy, then the candidates from overseas, who might never have used or even seen such things, felt impelled to do the same.

After six or seven years of trial, it became increasingly clear that the Tropical Art Syllabus, despite its progressive intentions, had failed to achieve a better standard of teaching or to encourage interest in the indigenous arts and crafts. Either the new syllabus must be withdrawn for lack of support or the home syllabus must be reformed on similar lines. Fortunately, the Cambridge Syndicate decided on the latter course, and in 1942 a new revised syllabus was prepared for the home centres at both School and Higher School levels.[2]

The new revised Syllabus in Art, which the Syndicate announced in September 1942, followed the same general principles that underlay the Tropical Art Syllabus, while incorporating a few practical changes. The "objective" section was amplified so as to form three separate papers, and a paper in the practice of design was provided in addition to a written paper on the crafts. The balance between the "objective" and the "creative" approach was preserved by allowing candidates to take not more than two of the former and making it obligatory to take at least one of the latter.[3] Memory drawing, which had been included in the Tropical Art Syllabus, was now omitted.

For the first time since local examinations began, it was agreed to drop

[1] A. Nix-James, (letter of December 1964, previously mentioned).

[2] A committee set up to consider the new syllabus included Messrs. Bellin Carter (then Chief Examiner in Art), Hesketh Hubbard, P.R.B.A., G. A. Stevens, Miss Audrey Martin (representing the Society for Education in Art), and the author, who had been asked to prepare a draft. History of art and architecture were excluded from this revision.

[3] Candidates for School Certificate were required to take three of the following papers:
Papers 1, 2, 3. Drawing and painting from Nature, i.e. 1. An object (natural or artificial) or group of objects, which may be drawn or painted in relation to the surroundings or part of the room. 2. A growing plant, spray, fruit, group of cut flowers. 3. A living model who may be engaged in an occupation, either (*a*) moving or (*b*) still, and in relation to an object or objects.
Paper 4. Original imaginative composition in colour.
Papers 5, 6. Design for applied arts and crafts, i.e. 5. A design for either (*a*) lettering; (*b*) embroidery; (*c*) printing for fabric or wall-paper; (*d*) book-production; (*e*) poster, advertisement, packaging; (*f*) stage décor, display, interior decoration. 6. A written description of a piece of craftwork in (*a*) pottery or ceramics; (*b*) weaving; (*c*) wood-carving; (*d*) beaten or pierced metalwork; (*e*) puppet- or toy-making; (*f*) working of pre-cast plastics.
Papers 7, 8. Historical.

drawing from the flat and "space-filling". But perhaps chief importance lay in giving the candidates' freedom to choose their own materials and type or size of paper,[1] and the instruction that colour must be used in at least one paper. The "objective" tests also contained changes in emphasis. In setting the subjects there was no insistence on perspective, and the objects were to be drawn or painted as a group in relation to the background rather than in isolation.[2] Paper 3 contained a new feature with the living model in either a fixed pose or moving as in some normal occupation.[3]

The subjects for Original Imaginative Composition in Colour (Paper 4) were issued a week in advance to permit time for study, and the subjects were to be worded so as to stimulate imagination and cater for different methods of approach.[4]

The value of practising craftwork in a course of art studies in Great Britain was now recognized for the first time in local examinations and the Syndicate's syllabus was the pioneer in this respect. It was considered impractical to invite candidates at School Certificate level to submit actual examples of craftwork, but they were to write a description of their chosen craft. It was decided, however, to experiment with the submission of actual specimens of craftwork in addition to the written description for the Higher School Certificate. In other respects the two syllabuses were substantially similar, the one requiring a higher standard of work than the other.

The response from schools regarding the craft papers was so encouraging that by August, 1948 the Syndicate decided to amend the syllabus to allow School Certificate candidates, as well as those for the Higher School, to submit examples of craftwork which they had carried out during the preceding school year. There soon emerged an ever-growing number of candidates sending pottery, woodcarving, puppetry, weaving and architectural models to Cambridge for examination and subsequent return.

In announcing the revised art syllabus, to take effect in 1944, the Syndicate offered it as an alternative to the old syllabus, under which papers would

[1] The instruction read:
"Any medium may be used, with the exception of oil paints, provided that it is suitable for the subject."

[2] The specimen paper offered the following as an example:
"A breakfast table laid for a child."

[3] "Time sketching from Life" had been introduced by the Oxford and Cambridge Joint Board in 1925; Durham followed, for H.S.C. only, in 1932. The model in motion was discontinued by Cambridge in the 1950s.

[4] The specimen paper, issued in 1942, offered the following:
(1) Imagine yourself watching the conclusion of a wedding, using if possible your recollection of such a scene.
(2) Any subject suggested by and including: a policeman, a statue, a dog, a wreath of flowers.
(3) "By the Waters of Babylon we sat down and wept."
(4) Imagine that a barn is on fire, endangering some animals of the adjoining farm. Express the sudden action of this scene.

continue to be set.[1] This would constitute a trial period. Although many schools must have found it difficult to change direction so as to meet the requirements of the new syllabus, more than half the candidates—there were some two thousand in art—preferred the new syllabus, rather than the old, during its first year, 1944.[2] It soon became evident that the revisions made in the syllabus reflected the views of art teachers, and within three years the old syllabus was dropped without any demand for its retention.

The other university boards also reviewed their art examinations. The London School Examinations Council had in 1939 introduced the title "Art" in place of "Drawing", and with the termination of the Second World War revised their syllabus on lines similar to those described above. Revision of the Scottish Leaving Certificate was made in 1947, introducing two sections—a figure composition in colour and a design—but in both cases the size of the work was severely limited. The Oxford Delegacy revised its syllabus in 1945, omitting drawing from the flat, memory drawing and space-filling and introducing "Imaginative Picture-making".[3]

The Oxford syllabus contained a very interesting innovation, in addition to the ordinary still-life group. This was entitled "Picture-making from objects", the objects being set out in a row, and the candidates required:

> mentally to arrange some or all of them at choice in an attractive group. . . .
> They may also imagine other objects than those exhibited and add them to the group.

Candidates were told that they might move about and make sketches during the

[1] It was stated only that drawing from the flat would be omitted from the old syllabus for School Certificate. On the other hand, for Higher School Certificate the existing syllabus was to be finally withdrawn in 1943, and the revised syllabus only would be offered from July 1944.

[2] The revised syllabus was also available for oversea candidates in place of the Tropical Art Syllabus which was now withdrawn. The welcome with which it was received in India is indicated by Mr. Nix-James (in the letter quoted previously):
"It was the beginning of a new life and meaning to art, for it initiated the idea of a child expressing himself with some freedom and ease, though even here it was not easy for children to shed their old shackles."
For a few years a special "Alternative Syllabus for Oversea Centres" was made available, to provide for the submission of craftwork, which was not at first included in the Syllabus for Home Centres. When this anomaly was withdrawn a few years later there was no further need for the retention of the "Alternative Syllabus for Oversea Centres", although a special written paper with questions on the appreciation of indigenous art was available overseas, though with very few entries, until 1960.

[3] Some stimulus to reform may have been forthcoming with the publication of *The Visual Arts* in 1946, the results of the survey made by the Arts Enquiry on behalf of Dartington Hall Trustees (with Dr. Julian Huxley (now Sir Julian) as Chairman and the late Christopher Martin as Director). Art examining was characterized as follows:
"Most of the papers tend to demand only accuracy of representation or factual knowledge, and teachers complain that the syllabus kills imagination and freedom. The only syllabus revised to meet such criticism is that of Cambridge University, which came into operation in 1944".

first fifteen minutes. Its value lay in the creative approach to the painting of still-life, though perhaps hampered by the question papers offering "suggestions for a suitable imaginary background". A somewhat similar paper was also set by the Southern Universities' Joint Board.

These developments in the character of the art examinations went far to meet the criticisms which had been levelled by the Art Teachers' Guild in the 1930s. This society had, meanwhile, been transformed. After the formation of the New Society of Art Teachers in 1938, which represented for men what the Art Teachers' Guild was for women, proposals for joint discussions led to the affiliation of the two societies in March 1940. A year later, in January 1941, they amalgamated to form the Society for Education in Art with Miss Welch as its first President.[1]

One of the Society's first steps was to form a committee for examinations under Miss Nan Youngman, who subsequently succeeded Miss Welch as Chairman and has been a force in art teaching circles ever since. The Committee co-operated with the university boards and offered its advice in forming an art syllabus. Concerned over the need to reduce examination pressure, the committee urged that the tests be reduced to two, namely one main paper catering for "creative" ability and a subsidiary paper, carrying a lower proportion of marks, concerned with "objective" drawing or art appreciation. These two tests were to be reinforced by the submission of a portfolio of work chosen by the candidate. This principle of submitting a portfolio was to some extent resisted by the examining boards on the grounds of impracticability where thousands of candidates were involved, but it was adopted by London, by some of the smaller examining boards and by Cambridge for Advanced level tests.

Durham offered a new syllabus in art which closely resembled that of Cambridge, but omitted still-life. As in Bristol's revised syllabus, not more than two papers were required, as recommended by the S.E.A. Both boards included the crafts, but with the limitation that the work had to be carried out in the examination room. The Welsh Joint Education Committee, replacing the Central Welsh Board in 1949, introduced its revised syllabus in art for School Certificate the same year, but deferred the Higher level until 1954.

The Oxford and Cambridge Joint Board announced a revision of its art syllabus in 1947, having made only slight revisions since 1926, when life and imaginative drawing were introduced. The new syllabus contained four papers, one of which—the history of art—was obligatory.[2] Candidates were required to

[1] The Guild's journal *The Record* now became *Athene*. The Society subsequently changed its name to "Society for Education through Art".

[2] History of art was obligatory at the Higher level both at Oxford and Durham. Bristol's paper on art appreciation, which concerned the candidate's personal experience of works of art in his own environment was also obligatory. Cambridge, on the other hand, did not make any papers compulsory, and has always resisted pressure to make its history of art papers obligatory, on the grounds that not all candidates in art can express themselves equally well in words.

To assist in syllabus revision, much valuable advice was offered by the Ministry of

take two of the remaining three papers, objective drawing, life drawing and imaginative drawing. This scheme was open to the criticism that a candidate could take the examination without having to tackle the one "creative" test, and it was overweighted with written work. Moreover, the Joint Board failed to allow the same degree of liberty in choice of media that other boards allowed, and restricted the size of paper that might be used.[1]

The Royal Drawing Society was now the only independent institution offering art examinations for schools. Its Primary, Full and Higher Drawing Certificates had no connection with the School Certificate recognized by the Ministry of Education. Many schools both at home and overseas, which did not feel sufficiently advanced in art for their pupils to enter for the School Certificate of the university boards, nevertheless found a valuable substitute in the examinations of the Royal Drawing Society. Moreover, progress could be tested throughout the school course, since these examinations were designed to suit different age groups ranging from seven to nineteen and over.

The Royal Drawing Society always sought to encourage imagination and freedom of expression, so that in this respect it could safely ignore the reforms instituted by the university examining boards. It could frame its examinations much more loosely than the universities dared to do. In fact, the Society went so far as to permit the art teachers to supply their own subjects for their candidates in pictorial composition, instead of itself setting the subjects in advance. Such a degree of licence, however desirable in theory, might be so open to abuse and so dependent on the good sense and imagination of each individual art teacher that it would never have been permitted in examinations for School Certificate.

The Society's examinations were, and still are, set twice yearly in June and October, and their widespread popularity was shown by the schools for which they catered having risen in number to 1,400, with as many as 80,000 works submitted annually. The Society always considered that its examinations did not compete with those of the university boards, but on the contrary constituted a valuable preparation for taking School Certificate.

Schools continued to benefit by the Society's annual exhibition of children's work, and in this field it must be honoured as the pioneer. During this century there have been not only other exhibitions of children's work, but a great increase in reproductions both in books and periodicals. Art teaching has been greatly encouraged and supported since the Second World War by the annual

Education in 1950, in view of the impending introduction of the G.C.E., through its then Art Inspector, Mr. E. M. O'R. Dickey.

[1] With the subsequent introduction of the G.C.E., the Joint Board introduced, in addition to Drawing from Life, a further paper entitled "Detail Drawing from Life", i.e. hand, foot or folds of dress, candidates being required to take three papers in addition to art history. At A. level, candidates had the same choice in practical work, but two papers in European Painting and Architecture were obligatory; thus forty per cent of their work was written.

exhibitions sponsored by the *Sunday Pictorial*.[1] The work for display was selected by a committee from many thousands of drawings and paintings submitted both by schools and by individuals at various age groups, for which prizes were awarded. The exhibitions are now sponsored in a similar manner by the *Sunday Mirror*. Through travelling exhibitions, the work of British children has been made familiar in many regions of the world.

The need to reinforce art teaching by showing children good examples of work, not only by the old masters but also by contemporary artists, has long been recognized. The circulation of reproductions ranging from early Chinese to contemporary European Art was undertaken during the 1940s by School Prints Ltd. One of the first projects of the Society for Education through Art sought to provide schools with original pictures by contemporary artists. The scheme, initiated by Nan Youngman and Barclay Russell, had to be postponed until after the Second World War when the S.E.A.'s exhibition of "Pictures for Schools" was held at the Victoria and Albert Museum in 1947. With Miss Youngman as their chief organizer, these exhibitions have been held regularly in provincial centres as well as in London, enabling schools and educational authorities to buy contemporary work. During the first ten years over £17,000 has been spent on such purchases.

Within a few years of the close of the World War the scope for art teaching in schools had been transformed, not only through exhibitions and facilities for seeing original work but through the improvements in the local examinations. Children were now being offered fuller opportunities for self-expression and freedom in choice of medium and materials in which to work. But were these enhanced facilities to be held back by apathy in the administrative machinery?

Hitherto, the system of grouping examination subjects in varying grades of priority had proved the main hindrance to progress in art teaching. Changes had been demanded as far back as 1938, when the four associations of head-masters, headmistresses and assistant masters and mistresses of secondary schools set up a joint committee to study the subject. The committee recommended in particular that the certificate should not only indicate the subjects in which the candidate had satisfied the examiners, but also whether the grade was "pass", "credit" or "very good". The Board of Education treated these proposals with some reserve, leaving it to the Secondary Schools Examination Council to persuade the examining bodies to accept them.

Three years later, with the World War in progress, the Board of Education set up a committee of the Secondary Schools Examination Council, under its Chairman, Sir Cyril Norwood, to reconsider the relationship between the examinations and the secondary-school curriculum. To bring the group system to an end was again proposed, and, in fact, an entirely new type of certificate—the General Certificate of Education—was to emerge.

The Norwood Committee's Report, issued in 1943, contained some valuable

[1] A somewhat analagous scheme of exhibitions of children's work with the award of prizes has been organized in India by *Shankar's Weekly*.

comments on the place of art in education. It emphasized the value of art appreciation, to an extent which had not been shown hitherto, when urging that "all should have the opportunity of seeing the place of art in the spiritual, social and economic life of the present and the past". Equality of status between the different subjects for examination was clearly demanded in the following passage:

> If through literature or languages or mathematics or whatever it may be, a boy is learning to appreciate form and design and structure and composition, he will lose much if he does not go on to appreciate them also in painting, sculpture, music and the crafts.

The expression of such views aroused high hopes for the future of art education, though for various reasons these hopes were not fully realized. They were offset by proposals which were disadvantageous in practice. It was proposed to treat art and handicraft, meaning woodwork, needlework, etc., as a single subject, thus ignoring their separate history, their distinct departmental inspectorates and, to some extent, their divergent aims. In the average school, handicrafts tended to be taught on a lower plane. Closer co-ordination in teaching and examining art and handicrafts was highly desirable, as we will discuss later, but until this could be achieved, their fusion in examination would have tended only to lower rather than raise the general standing of the art class, just as the alloy may prove an adulteration of the original ingredients.

No immediate action could be taken on the Norwood recommendations, since the Committee had proposed an interval of seven years, during which period the examinations would continue as hitherto. This was to allow time in which to decide the basic issue, whether a system of internal examinations conducted by the schools themselves should replace the present external examinations. After some initial enthusiasm in secondary-school circles for the principle of an "internal" examination, misgivings emerged. Ultimately, in 1950, when the issue was to be decided, the Ministry determined on the continuance of the "external" system.

The Norwood Committee had made the bold recommendation that the group system should be brought to an end by granting the certificate in each subject separately. This was the main development arising out of these long-drawn-out deliberations. The Ministry accepted the Norwood Committee's recommendations and allowed candidates a free choice of subjects for examination, in each of which a certificate would be obtainable. This was the General Certificate of Education, to be taken first at Ordinary level and then at Advanced level two years later, replacing the School and Higher School Certificates.[1]

[1] In 1949, the Scottish Education Department announced (Circular 145) that its Leaving Certificate, which may include art, would henceforward be awarded on a subject, instead of a group, basis.

While the Scottish Universities Entrance Board does not include art in its preliminary examinations, it has, since 1927, recognized a pass granted in Art at Advanced

At first glance this appeared to place such lowly subjects as art on a higher pedestal. The age-old demand of art teachers that art should be granted a status equal to other subjects in the examinations seemed to have been fully met. The candidate who was talented in art might take the examination in this subject and in no other if he wished. This was the position in theory, but how did it work in practice?

In the event, it turned out that a choice of subjects continued very much as before. The average school expected its candidates to seek a certificate in six, seven or even eight subjects, the choice being largely governed by vocational intentions. Although subjects were not listed in orders of priority, such priorities continued to govern the choice. Wherever evidence of general education was the main consideration—and this is the purpose of the examinations in the eyes of most institutions of further education and employers—success in art did not in the past, and still does not, even now, carry a weight equal to that of other subjects, which are given greater precedence in the normal school curriculum.[1]

It was still considered that art was of little value in general education except for the specialist who might proceed to an art school or take up architecture, and it is ironic to find that even in these institutions of advanced technical studies certificates in the main school subjects are usually of greater value in securing a place than success in the secondary-school art class.[2]

An art training has its contribution to make in all forms of employment and in all walks of life. For art to be granted its proper place in a balanced education, there still remained the battle for prestige. The lowly status of art in the average secondary or public school remained much the same under the G.C.E. as it had in the past under the School Certificate.

level in the Scottish Certificate of Education, by the Ministry of Education of Northern Ireland or by one of the other recognized examining boards, as one of six qualifying subjects.

The Northern Ireland Secondary School Senior Certificate awarded by the Ministry of Education of Northern Ireland, which was originally entitled "Intermediate Examination, Senior Grade," had included the subject "Drawing" among its alternative subjects (normally six) since its inception in 1922. In 1940, the subject was described as "Art". It was not until 1952 that Ordinary and Advanced levels were introduced, equivalent in standard to the corresponding examinations in England.

[1] It is common enough in many schools today for boys to attend the art class only when they do not want to attend "games".

[2] The Ministry of Education's National Council for Diplomas in Art and Design lays down the requirement that a student wishing to enter this course must have obtained a General Certificate of Education in at least five subjects at Ordinary level, and at least three of these must be in academic subjects and at least one of them in the use of English. A certificate in art is not demanded (National Council for Diplomas in Art and Design Memorandum No. 1, December 1964).

Drawing from Objects or Still-life

O F the various branches of art usually practised at school, the drawing of objects, or still-life as we now prefer to describe them, has alone survived the changes that the examinations have undergone. It has had various designations, such as drawing from "solids" or "models", to denote the cones, cubes, boxes, chairs and tables, which were normally specified, together with casts. Different types of object are now suggested and the point of view in teaching still-life, as in setting it for examination, has undergone a fundamental change since last century.[1]

Object drawing has in the past constituted the essential groundwork of the art class in the average secondary school, just as life drawing from the human figure fulfilled a similar role in the adult art school. Unhappily, object drawing acquired the sort of reputation for dullness that used to be associated with Latin grammar. When the art teacher had to tell his class that object drawing was due the pupils would be seized with dismay. The problem for the teacher, and equally for the examiner, was, and still is to some extent, how to divest the subject of its dismal reminder of boxes, jam-jars and deck-chairs. There is a value in teaching still-life, but efforts must be made to attract the interest of the average boy or girl. A very different approach from that of the past has to be tried.

Beginners tend to see all lines as horizontal or vertical. They tend to draw the human figure as invariably upright like a lamp post or lying prone. They must be able to recognize oblique directions from one point to another. In the past this was achieved by the pupils constantly practising vertical and horizontal lines, then progressing to diagonal lines, as in cubes, and finally to curved ones as in a cone or vase. Such exercises may have proved useful for accuracy of representation, but could they advance the pupil's imagination or his interest in the subject?

Many teachers have rightly insisted that there is no value whatever in

[1] Discussion under the chapter headings—"Objects or Still-life" and "Nature"— is not intended to emphasize any fundamental difference in working from natural or from artificial objects, but to denote the separate examination tests for treating objects grouped together, some being artificial, as distinct from the analytical study of an object, which is usually natural, or of the human figure.

19. *a.* J. E. Korsah, pupil of George Stevens, Achinota College: 1928
b. Benjamin Joseph, pupil of K. C. Murray, Nigeria: *c.* 1932

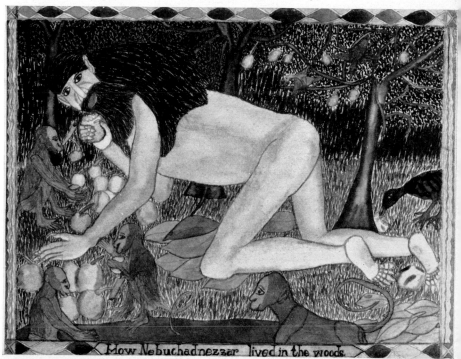

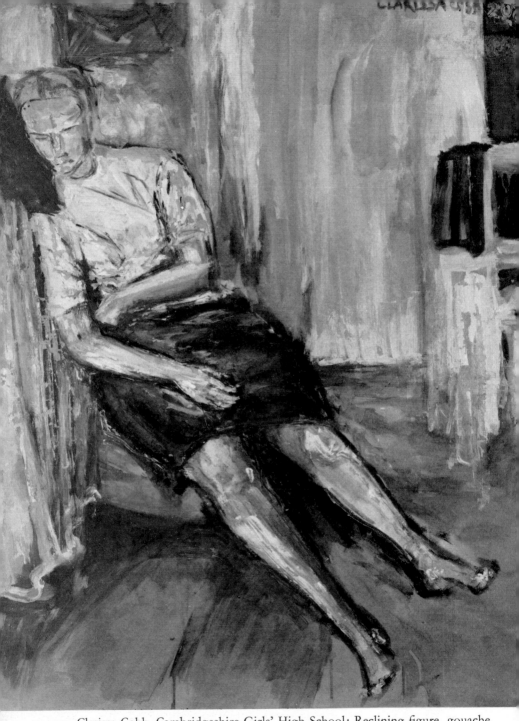

20. Clarissa Cobb, Cambridgeshire Girls' High School: Reclining figure, gouache, (G.C.E. A level, 1965)

providing pupils with exercises that they find uninteresting. The real test of good training in art is whether the pupils enjoy it. It was on these grounds that Marion Richardson rejected object drawing as understood in schools in her day. She wrote of the School Certificate examination in 1912, when she was teaching at Dudley High School:

> I could not bear that this should mean a reversal of all that we hold most dear. . . . I had, therefore, to find a way of teaching such things as Object Drawing as a part of picture-making.

She submitted her pupils' work to Oxford, surprising the examiners by its freedom in the use of colour and sense of composition, qualities seldom found in examination work at that time.

Object drawing retained its place in the examinations after the First World War in the teeth of much criticism. The attitude of the rebellious teacher during the 1920s at a typical boys' grammar school has been vividly conveyed by J. Littlejohns:

> Sometimes I am tempted to take up an oratorical attitude and say "Away with all objects, and likewise all groups! Clear the cupboard of the mouldy pots and pans, and 'art vases'! No more copying! Give the children a chance to draw *with* an object not *from* an object!"[1]

In his sense of discontent Littlejohns was tempted to place the blame quite unwarrantably on the "mouldy pots and pans", but they should not be the target for criticism. It was the method that was at fault. "Mouldy pots" can be as aesthetically interesting as any other objects; the problem is how to communicate this interest to the pupil.

Symmetry used to be the main objective and for this reason the pupil was set to draw manufactured articles of a symmetrical shape rather than natural objects. Vases were drawn by making a vertical line down the centre and measuring the distance between this and the contour on either side so that the two halves corresponded exactly. It was only after precision had been attained that the pupil progressed to natural objects.

Today we would never dream of mentioning symmetry in the art class, except as something to avoid. In fact, distortion may well prove desirable as a means of conveying the character of an object or expressing formal relationship. We should encourage the child to observe the shape rather than the lines or contours.

The very designation "object or model" drawing betrays the intention to draw an object unrelated to its surroundings or to other objects. It was assumed that the beginner must learn to draw an object in isolation so as to become thoroughly familiar with its shape, before attempting to combine it with other objects. In recent years, however, examining boards have abandoned the title, "object drawing", precisely because it laid emphasis on the individual object instead of a group.

[1] J. Littlejohns, *Art in Schools*, 1928.

We try to approach the subject today entirely differently. We seek from the child, each time he sits down to draw, an entirely fresh point of view towards the objects, as if they were being seen for the first time. To draw objects with a fixed concept of their appearance is of little value. It is the freshness of vision that counts.

To enable the child to see familiar objects in a fresh and personal manner, the teacher may point to unfamiliar shapes, revealed by the light and shade cast upon them or caused by one object partially concealing another, thus creating irregularity. But chiefly, the child learns to see them in relation to their surroundings or background. His attention may be called to the spaces formed between one object and another or to the shape of the surrounding space. If the child should choose to draw only the shapes of the background or the spaces between the pots etc. or, even, the areas of shadow, ignoring the objects themselves, which might thus appear distorted, this would prove an interesting and valid way of approaching the subject.

This sort of problem came my way when visiting a boys' school in the Himalayas of north-west India. The art master had invited me to criticize the work of the art class, where the boys were drawing a vase placed in front of a curtain hanging in folds. They were preoccupied with rendering the contour of the vase with a hard, precise outline. I thought the best help I could give would be to suggest other ways of seeing the group, and I began drawing the folds of the curtain where the edge of the vase impinged. This meant indicating the shapes of light and shade. There was a chorus of complaint. "This is light and shade," they protested. "We have not started that; we are still doing outline only."

We had to go back to the beginning. What is an outline? Has the vase an outline? This was betraying their art teacher's whole system. In the face of some scepticism, I suggested that they should forget the outline and use their pencil as if it were the means of carving forms in space. They might imagine their sheet of paper to be like a cavern in which they were to place the objects they were drawing, with their pencil moving forwards or backwards as the form dictated. Whether these suggestions proved helpful or whether they returned to "outline" as soon as I had departed, I was not able to discover.

Rather than give the child familiar objects to draw, it may be preferable to provide strange objects or, perhaps, familiar ones in an unexpected setting. The older boy who is an engine enthusiast will draw aeroplanes, steamers or trains as he knows them rather than as he has seen them, and when he makes them the subject of a picture, he tends to make them stand out unrelated to their surroundings. In the course of time the child must learn to ignore his knowledge of how objects look in order to react to the instantaneous impression they make upon him. He must try to see them as if they had never been seen before.

When teaching a class of young children it often made for success if there was some mystery attached to the group of objects they were to draw. I sometimes placed the group behind a curtain and when all the children were duly

providing pupils with exercises that they find uninteresting. The real test of good training in art is whether the pupils enjoy it. It was on these grounds that Marion Richardson rejected object drawing as understood in schools in her day. She wrote of the School Certificate examination in 1912, when she was teaching at Dudley High School:

> I could not bear that this should mean a reversal of all that we hold most dear. . . . I had, therefore, to find a way of teaching such things as Object Drawing as a part of picture-making.

She submitted her pupils' work to Oxford, surprising the examiners by its freedom in the use of colour and sense of composition, qualities seldom found in examination work at that time.

Object drawing retained its place in the examinations after the First World War in the teeth of much criticism. The attitude of the rebellious teacher during the 1920s at a typical boys' grammar school has been vividly conveyed by J. Littlejohns:

> Sometimes I am tempted to take up an oratorical attitude and say "Away with all objects, and likewise all groups! Clear the cupboard of the mouldy pots and pans, and 'art vases'! No more copying! Give the children a chance to draw *with* an object not *from* an object!"[1]

In his sense of discontent Littlejohns was tempted to place the blame quite unwarrantably on the "mouldy pots and pans", but they should not be the target for criticism. It was the method that was at fault. "Mouldy pots" can be as aesthetically interesting as any other objects; the problem is how to communicate this interest to the pupil.

Symmetry used to be the main objective and for this reason the pupil was set to draw manufactured articles of a symmetrical shape rather than natural objects. Vases were drawn by making a vertical line down the centre and measuring the distance between this and the contour on either side so that the two halves corresponded exactly. It was only after precision had been attained that the pupil progressed to natural objects.

Today we would never dream of mentioning symmetry in the art class, except as something to avoid. In fact, distortion may well prove desirable as a means of conveying the character of an object or expressing formal relationship. We should encourage the child to observe the shape rather than the lines or contours.

The very designation "object or model" drawing betrays the intention to draw an object unrelated to its surroundings or to other objects. It was assumed that the beginner must learn to draw an object in isolation so as to become thoroughly familiar with its shape, before attempting to combine it with other objects. In recent years, however, examining boards have abandoned the title, "object drawing", precisely because it laid emphasis on the individual object instead of a group.

[1] J. Littlejohns, *Art in Schools*, 1928.

We try to approach the subject today entirely differently. We seek from the child, each time he sits down to draw, an entirely fresh point of view towards the objects, as if they were being seen for the first time. To draw objects with a fixed concept of their appearance is of little value. It is the freshness of vision that counts.

To enable the child to see familiar objects in a fresh and personal manner, the teacher may point to unfamiliar shapes, revealed by the light and shade cast upon them or caused by one object partially concealing another, thus creating irregularity. But chiefly, the child learns to see them in relation to their surroundings or background. His attention may be called to the spaces formed between one object and another or to the shape of the surrounding space. If the child should choose to draw only the shapes of the background or the spaces between the pots etc. or, even, the areas of shadow, ignoring the objects themselves, which might thus appear distorted, this would prove an interesting and valid way of approaching the subject.

This sort of problem came my way when visiting a boys' school in the Himalayas of north-west India. The art master had invited me to criticize the work of the art class, where the boys were drawing a vase placed in front of a curtain hanging in folds. They were preoccupied with rendering the contour of the vase with a hard, precise outline. I thought the best help I could give would be to suggest other ways of seeing the group, and I began drawing the folds of the curtain where the edge of the vase impinged. This meant indicating the shapes of light and shade. There was a chorus of complaint. "This is light and shade," they protested. "We have not started that; we are still doing outline only."

We had to go back to the beginning. What is an outline? Has the vase an outline? This was betraying their art teacher's whole system. In the face of some scepticism, I suggested that they should forget the outline and use their pencil as if it were the means of carving forms in space. They might imagine their sheet of paper to be like a cavern in which they were to place the objects they were drawing, with their pencil moving forwards or backwards as the form dictated. Whether these suggestions proved helpful or whether they returned to "outline" as soon as I had departed, I was not able to discover.

Rather than give the child familiar objects to draw, it may be preferable to provide strange objects or, perhaps, familiar ones in an unexpected setting. The older boy who is an engine enthusiast will draw aeroplanes, steamers or trains as he knows them rather than as he has seen them, and when he makes them the subject of a picture, he tends to make them stand out unrelated to their surroundings. In the course of time the child must learn to ignore his knowledge of how objects look in order to react to the instantaneous impression they make upon him. He must try to see them as if they had never been seen before.

When teaching a class of young children it often made for success if there was some mystery attached to the group of objects they were to draw. I sometimes placed the group behind a curtain and when all the children were duly

expectant would suddenly draw it back, as if they were looking at a model theatre. The childrens' eyes would be aglow with excitement. Such play-acting would endow quite ordinary objects—dolls, toy animals, pottery figures—with a sense of drama as, doubtless, many art teachers have experienced.

I had occasion to stay some few years ago at a school in the independent state of Sikkim on the border between India and Tibet, where the girls, aged about ten or twelve, were of various races and religions—Buddhists, Hindus and Christians from Burma, Nepal, India and Tibet. The headmistress surprised me one afternoon by asking me to take the drawing class. "They have drawing books and pencils," she said; "and though they don't understand much English you can correct their drawings for them."

The language difficulty prevented any discussion of what the girls should draw, so I placed two or three pots of geraniums on a table. The children came running in eagerly and to my surprise seated themselves on the floor, so that those in the front rows could only see the underneath of the table with the tops of the plants barely visible. When I saw, however, the excitement with which they drew the geraniums peering over the edge of the table like a "jack-in-the-box", I recognized that this was much more interesting than the ordinary view I had in mind.

The very title "still life" suggests that the artist's function is to endow inanimate objects with a feeling of life. It is his task to convey this sense of life to the same extent as in a landscape or a portrait—a quality so apparent in Chardin's loaves and dishes or Cezanne's clocks with piles of apples. Children cannot be expected to infuse life into their drawings of inanimate objects unless they feel some sense of adventure. They must find varied forms and textures to explore—perhaps a contrast in the character of the objects or in their proportions. Perhaps there is the squat, heavy bowl contrasting with a slender, elegant vase, or there is the shaft of light enveloping the objects with mystery. They may need some encouragement from the teacher if they are to become aware of the unexpected aspects of the group.

The classroom often assigned for art in the average secondary school seldom facilitates the teaching. It is very hard to evoke the interest of children in objects placed on a table or desk against the blackboard at the far end of the room. The children stare at this distant group, so unrelated to anything else in sight. The room is probably full, the children at desks placed in rows and craning their heads so as to see round the shoulders of the pupils in front. Under such circumstances, the teacher may well feel that drawing from objects is best avoided until such time as more congenial surroundings can be made available.[1]

[1] Of some hundred and fifty schools in India, Malaysia and other countries of the British Commonwealth in the Far East, where art was being taught and candidates prepared for the Cambridge School Certificate, I found during my visit several years ago that all but some two dozen had no special art room, and the subject was taught in the ordinary classrooms.

The provision of a studio or workshop for art, where objects and materials can be

Such congenial circumstances would be provided by a room specially devoted to the study of art, sympathetic in character and sufficiently large to enable the pupils to move around and handle the objects they are drawing, when they wish, and to seat themselves where they can obtain a view that appeals to them.

The teacher proceeds to arrange the group. But is this really necessary? However much he or she may try to make the group look natural, it will inevitably acquire a self-conscious appearance as if informing the pupils: "This is art! Not like the rest of the room." It is hard to avoid placing the larger vessel behind with the smaller one in front, the knife and fork at a suitable diagonal, and an appropriate tablecloth with a curtain at the back. This is the teacher's creation.

If the dustbin or the waste-paper basket were to be emptied, the resulting haphazard arrangement of the contents would prove much more interesting for drawing. But if a group must be arranged, it would be preferable to let the children themselves arrange it as they wish, and if this cannot be done it would be best to say to the class: "Look around you and draw any part of the room that contains some pots or other objects or perhaps the pile of old paint-rags in the corner." We have to assume that the school cleaners have not been allowed to tidy everything away, and that pots of paint with brushes are allowed to remain on shelves or tables, in a haphazard way. Any chance combination of objects in a room may be more suitable than a group that is specially arranged. The pupils will then try to relate the objects in their own minds, thus producing order out of chaos.

In setting subjects for still-life in the G.C.E. or the Oversea School Certificate, the examiners are faced with the unequal conditions that usually prevail in schools. The lighting and the environment may be excellent in a school that is equipped with a studio, and they may be quite unsuitable in the school where art is taught in the normal classroom, with surroundings that are uninspiring, the colours of the walls overpowering and the blackboard as background.

It has been felt necessary, when setting the papers, to describe the group in precise terms in order to ensure that the candidates cannot submit drawings of a group from which they have been regularly practising. Until some twenty years ago a sketch showing its arrangement was provided for the sole use of the supervisor, and this is still provided by some boards. In 1944 the Cambridge Syndicate tried setting a subject or title instead of specifying the objects. It was hoped that a title indicating the character of the group would allow greater latitude in the arrangement. Titles such as "On the kitchen table" and "A landworker's lunch-hour"—it was wartime—were set. In 1945 there was

stored and work displayed, is just as important as the provision of an art teacher. In Nigeria, with a population equal to that of England, there are barely a dozen schools today that provide a special room for art. At one of the principal schools in Lagos, the art teacher complained to me that he had been deprived of his art room in favour of the woodwork class, while another teacher in the Eastern region found his art room used for storage in an emergency and he never obtained the use of it again.

"Early morning", requiring a milk bottle with a pair of shoes to be placed on "a door mat of rough fibre" on which the supervisor was "to scatter three or four letters of various sizes and colours, as if they had just been delivered by the postman".

It was not the intention to provoke an illustration to a story, but to give the supervisor some purpose in arranging the groups and cause the candidates to feel some reason for the choice of objects. With these intentions a "still-life" was set for Cambridge in 1955 as follows:

> The candidates should imagine that an old countryman has had a friend visiting him for the evening and has gone to bed leaving the table as it was.
> It is covered with a dark red or green tablecloth, and on it are a beer bottle with empty glasses and a few articles such as a draught-board, an untidy pack of cards or a box of dominoes, a pipe and tobacco pouch or jar, and an oil lamp or candlestick.

It may be justly argued, however, that in the absence of any explanation from the teacher, this type of question might lead the candidates to treat the relationship between these objects in a descriptive rather than a visual and formal manner. The Oxford and Cambridge Joint Board, in a recent paper, tried to combine the motive for assembling the objects with a strong visual impression as follows:

> A young painter has hurriedly tidied a portion of the studio to welcome a prospective client. This oasis in surrounding chaos comprises an old armchair, on which in lieu of a cushion lie a palette and brushes. Opposite the chair stands an easel against the foot of which lean canvases. On the easel is a picture in a frame. There is a stool by the chair, upon which a drawing board and paint-rag act convincingly as a tray and highly coloured tablecloth for a motley collection of tea things. These, by an oversight, include a bottle of turpentine. There is an oil or electric heater in the foreground on which there is a kettle.

It might be claimed that these objects could equally well be assembled and their plastic relationships conveyed without any mention of the "old countryman" or "the young painter". But could the supervisor be expected to arrange them intelligently without being given some reason for doing so?

Some examining boards have proceeded on quite opposite lines by placing no reliance on the discretion of the supervisor, who is merely given a list of objects and is told precisely where each is to be placed. By this over-rigid method of setting the subject it is likely that the arrangement will prove formal and uninspiring.

In setting groups for oversea schools the Cambridge Syndicate has had the problem of choosing objects which would be available in a wide variety of countries and climate. In past years this was often ignored, but more recently objects of native manufacture and visually interesting, such as fish-traps or dance-masks, have been set. A recent subject for overseas required the assembling of "objects such as might be found on a natural history ramble", including an

animal's skull, shells, a large stone, seed-pod, etc., but the supervisor was allowed to use discretion in substituting other objects, where necessary, as long as they were consistent with the general idea. The results showed that most candidates found such variety stimulating. On another occasion a plate of fish was set with equal success and obviously aroused much more genuine interest in drawing or painting than was possible with the deckchairs or wheelbarrows of twenty-five or fifty years ago.

What are the qualities or faults to be looked for in drawings or paintings from still-life? A quarter of a century ago, inaccuracy in representing objects, mistakes in perspective and untidiness generally were almost the only, and certainly the main, grounds for criticism. More recently, examiners' reports have emphasized that a personal interpretation of the group is much more important than accuracy of representation. The Oxford report for 1958 goes further, in reminding schools that "good candidates show that they have been excited by some aspect of the form, the pattern or the colour". To make a mere record of what is before one is manifestly insufficient. It is always possible in any group, however dull it may seem at first sight, to pick out some particular aspect, some combination of forms, some element of contrast, which strikes one with interest and may provide the groundwork for one's drawing.

There is the powerful school of thought today that recommends the pupil to free himself as much as possible from dependence on literal representation. He is exhorted to study the group of objects only until he has formed a clear visual image and then proceed to draw or paint this image freely with little or no further reference to the actual objects. In whatever way the pupil may choose to work, he must try to extract from the group some source of emotion, perhaps some sense of weight or delicacy, power or lightness. He may discover some relationship between the objects that reminds him of actors on the stage—this one proud or pompous, this nervous and hesitant, this upright like a soldier on parade. It may be the tonal or colour relationship that gives some sense of vibrancy or rhythm to the group, transforming it with effects of light or depth. Such reactions may not be discovered at once; they may emerge only after the drawing or painting is begun and thus compel the course of the work to be changed.

It is the beginner who is usually most concerned with the proportions being drawn correctly or whether the perspective is accurate. Instead of studying the rules of perspective, as the pupil was expected to do in past years, it is only important to observe. He must note the direction of receding lines or the shape of the ellipse formed by the base or the top of a bottle or a bowl when seen in perspective. If the pupil draws the basin or the clock excessively large in comparison with the knife and fork or makes the distant objects too large and the nearer ones too small, he may be merely inobservant; on the other hand, he may equally be expressing his sense of the relative importance or weight on the one hand or insignificance on the other. Such exaggeration may be perfectly justified. It is chiefly essential that the boy or girl is made aware of such contrasts.

It is particularly in schools overseas that we find all rules of perspective and correct proportions successfully defied. The top of the table or other receding surface may be presented as if tilted vertically instead of lying horizontally, and objects in the foreground may be rendered exaggeratedly small, while those in the distance are made dominatingly large instead of the reverse. Such work ignores accuracy precisely because it is intended to express a personal vision.

I recall with delight some paintings of an antelope's skull by boys of secondary schools in Uganda. Not one was alike. Each boy had seen something peculiarly individual in the large gaping eye-sockets, the spiral horns piercing the surrounding space, the flanks of the cranium and the jaws, like the ramparts of a castle, protected by the formidable and jagged rows of teeth. In some of these paintings it was almost impossible to recognize a skull as the source of inspiration. It merely provided the motive for a vivid creation of shapes and patterns intertwined in a dramatic manner. These boys were probably quite unable to represent with accuracy what was in front of them, even supposing they wished to do so. Fortunately, their teacher had never suggested to them that this was the purpose, and the resulting works of art were much more valuable than any accurate record would have been (colour plate VIa).

Such works of art can be produced only if the teacher is able to recognize their merit. How often does it happen that the inexperienced tutor stifles imagination and personal expression by misguidedly correcting the pupil's drawing? It is easier to question the pupil: Is this or that the shape you see? If he is not convinced, he may think again and re-draw it with renewed conviction.

Perhaps the greatest harm is done when schools which do not have a trained art teacher allow the pupils complete freedom in using ruler or compass or permit them to rule lines with the edge of the paper. I have seen this happen in very large classes because the teacher was unable to prevent it. Form in three dimensions cannot be expressed with a ruled line. The draftsman uses lines to denote the contours of forms which can be conveyed effectively only if he has the complete form in mind. He looks, when drawing, at the middle of the pot, box, book or whatever else may be the subject, not at the edges or contour. When children find it difficult to draw the wheels of a cart, bicycle or motor-car they often ask the teacher's permission to use a coin and the resulting circle mechanically drawn appears unrelated to the other forms in the picture, attracting one's attention like a target on a rifle range.

The examining boards—especially the Cambridge Syndicate and the Oxford Delegacy—rigorously forbid the use of a ruler or other mechanical means of drawing from still-life or from nature.[1] It is generally easy for the examiner to recognize work in which this instruction has been evaded because of its mechanical appearance, in which the true expression of form is missing.

Beginners often think it necessary to commence with drawing the contour

[1] Most examining boards allow the use of rulers in design, and they are also allowed in questions set for "abstract" composition, which is quite different in purpose from representational work.

and only when that is finished to proceed to apply shading. Yet it is by means of light and shade that we observe form, and this can be expressed both in line and in shading. Thus the pupil has to learn how both may be combined. Having a feeling for the form, the pupil can use pencil, chalk or charcoal so that lines vary in strength or delicacy, sometimes firm or deliberate, at other times merging into shadow.

In the Oxford examiners' report of 1958 we read of the need for "creating a feeling of the group as a whole and as existing in space". This reminder of the need for composition has been equally stressed in the Cambridge Syndicate's report of 1957, which notes "very little understanding of the placing of the group on paper, and little evidence of appreciation of the compositional value of one object of the group in relation to another".

Composition seldom needs to be taught. Children usually reveal a natural sense of balance and rhythm. Their sense of composition is impaired, however, when they work on paper that is too large or too small for them. They must be made aware of the limits of the space to be occupied by their picture. The hesitant beginner so often starts the drawing much too small, unrelated to the size of the sheet of paper, and when unable to fill the surrounding space tries to ignore it, so that the objects appear floating in mid-air. Any sense of three-dimensional form that the drawing might convey is overwhelmed by the empty area of blank paper. It is with these considerations in mind that attention has been called in the examination papers to the need for considering the background. By this means, the candidate is reminded of the importance of composition.

There has usually been the tendency, hitherto, to regard still-life as consisting of man-made objects, and it has been assumed that these were more suitable for drawing, whereas painting was reserved for the plant group. This distinction between natural and artificial objects is quite unjustified, and the Cambridge Syndicate has recently combined drawing or painting from a plant with still-life, which may thus include plant forms as well as man-made objects.

Although colour may seem more essential for depicting flowers than other objects, the decision whether to draw or paint should be that of the pupil. Any subject may be suitable for painting, and it does not merely depend on the colours being bright. The browns or greys of glass or china can provide just as much scope for painting as the brilliant colour of leaves and flowers. The pupil has to decide whether he is more at ease with pen, pencil or chalk or with brush and paint, but chiefly he must consider what the group suggests to him. Does he feel chiefly interested in the combination of shapes and contours which the pen or pencil can best achieve? Or does he react mainly to contrasts in tones, richness or neutrality of colour, or to warmth or cold, qualities which require the use of paint? The pupil must be made aware of these problems.

Working from Nature and from Life

UNTIL this century the teaching of drawing or painting from living forms was very limited in scope. To work directly from natural objects or from landscape was considered much too advanced for beginners, and the drawing of a spray of plant, some fruit or a feather, was confined originally to the Senior examination and excluded altogether at the Junior level. The Oxford and Cambridge Joint Board did not include any nature study in its examination until 1907, when it introduced the drawing of a spray in pencil or pen and ink.

If nature study was considered difficult, drawing or painting from a living person was regarded as altogether beyond the range of children or adolescents, unless they were destined for an art school, and it was not included in most Senior or Junior examinations until well after the First World War. London was alone among examining boards when it set life drawing for the first time in 1913. Yet modern experience with children and adolescents shows that they do not find life drawing difficult. Boys or girls entering for the G.C.E. at Ordinary level will often attain a higher standard in this subject, if it interests them, than in the more prosaic still-life.

Most of the examining boards now include tests both in drawing or painting from plant life and from the human figure. The living model, with limbs exposed, is required to take the pose specified, either for drawing the complete figure or in some cases the head and shoulders only. For plant life the drawing of a spray has usually been set, but the Cambridge Syndicate has offered, since 1944, a plant group with flowers or fruit for painting only, as an alternative.[1]

In present-day art school training the traditional discipline of life drawing is being questioned and this naturally has its effect in secondary education. Is it

[1] The Syndicate modified its syllabus in 1964 by withdrawing this alternative (painting from a flower group) from Paper II and including it in Paper I, which is now entitled "Drawing or Painting from Still-life—both natural and man-made objects" as mentioned in the previous chapter. Paper ii is now confined to the making of studies from natural objects.

really desirable for art teaching to be based on the representation of nature? But art in general education, on the one hand, and the specialized training of the artist, on the other hand, present two quite distinct problems, requiring separate consideration. For the moment, it suffices to state that the value, from the point of view of general education, in practising drawing or painting from living forms lies in observing and learning to convey the visual characteristics of life, its manner of growth, structure, flexibility and power to move. Living objects preclude the drawing of straight lines, circles or other geometrical shapes, so that the pupil is compelled to observe the form closely.

Drawing from plant life belongs to an old tradition, and many masterpieces are to be found in the Herbals published in past centuries, which may serve as admirable examples for the pupils of today. It provides the advantage, as Ruskin was at pains to point out, of combining nature study with drawing. The value in training children to observe nature prompted Ruskin to demand that such drawing should be included in the curriculum of every school. By such means, the child who shows no great talent in art may benefit from the art class by acquiring an interest in nature study. By drawing a spray with leaves, a shell or a fossil, the child is bound to gain some knowledge of natural growth and structure, and thus develop an interest in the external world even though he may never produce a work of art.

Far too many schools in the past, and even today overseas, have encouraged pupils to practise drawing from the spray as a mere exercise in accuracy. This has led them to adopt a very unsatisfactory procedure in teaching, which functions somewhat as follows. You select three subjects in art and no more, because this is the minimum number of papers required if your pupils are to obtain the G.C.E. or School Certificate. The subjects chosen will be those which you feel that the pupils can learn by rule of thumb, as it were, and they usually include the drawing of the spray, the other two favourite subjects being the drawing from still-life and a test that involves lettering. A colour wash can be applied to the latter, if necessary, in order to meet any examination requirement that candidates must reveal their sense of colour.

Such practise in drawing a spray merely to pass an examination and to make the candidate word perfect as it were, defeats the object of both art teaching and art examining. In many schools in the East, where there is a limited choice of sprays available, one may find all the pupils, some thirty or more, busily engaged in drawing the canna or the spider orchid in readiness for the examination. The results are inevitably mechanical and uninspired.

The drawing of natural objects should form part of a balanced course of study in art. Such study should extend to as many branches of art as possible to enable the pupil himself to choose which subjects he wishes ultimately to attempt in the examinations. It is a mistake to imagine that the pupil may, thus, be wasting his time. Practice in one branch of art may help towards success in another. The attempt to convey the flexibility and rhythmic forms of a spray or a feather, for example, may assist the pupil to draw still-life less rigidly. Equally,

still-life can give the pupil a sense of proportion and three-dimensional form which will free his spray from appearing glued to the paper.

Drawing or painting from nature may embrace a wide variety of objects, such as insects, roots, bones, as well as sprays. In the examination papers the choice is necessarily limited to what is likely to be available at a particular time of the year in various districts or even countries and in sufficient quantities to provide, if so required, one specimen for each candidate. In many oversea schools more than a hundred candidates may sit for the examination and I recall a headmaster complaining that his flower garden was ruined by the loss of a hundred blooms. Moreover, if a plant is specified it must be such as will not fade and will occupy the candidates for a couple of hours. But the uniformity inevitable in this examination procedure is not the ideal method of teaching nature study in art at school.

From an educational point of view, the pupils should be encouraged to go out and gather the specimens they wish to draw. Let them collect, for example, shells from the riverbank or the sea-shore, and make a series of studies showing their variety in form. Let them obtain butterflies, moths, beetles or other insects, either alive in a bottle or dead, and record, with their pencils, the pattern on wings or wing cases, the anatomical structure, and convey their power of rapid movements. Let them find roots, vegetables, skulls, prawns, birds' eggs, curiously patterned stones or fossils, or indeed any objects which may interest them to draw.[1] Such a variety of objective studies will help the pupil to reveal greater understanding of the form and structure of a spray, if this is set for examination, and thus avoid making it rigid and lifeless as is so often the case.

A pupil will learn much by handling the specimen he intends to draw, perhaps dissecting it and making a number of separate studies of sections or details. Some examining boards, Oxford for example, insist on each candidate being furnished with a separate specimen. Cambridge has recently adopted the same rule, whereas previously, one spray with flowers or fruit might be shared between two or three candidates. This sometimes provoked difficulties, as when an oversea candidate complained that he had been unable to complete his study of the fruit, because his companion had eaten it.

In order to encourage the study of natural forms in their normal environment out of doors and free from the inhibiting atmosphere of the classroom, the Syndicate has in recent years introduced, as an alternative, the drawing or painting of trees in landscape, such as looking down an avenue of trees seen in combination with buildings or sky.

In all such studies of nature, whether of trees or plants, the pupil seeks to observe the gradual diminution of trunk or stem, their flexibility enabling the structure to sway under the pressure of wind, the joints of leaves and boughs, the grouping of leaves in masses with their reflection of the light, and the growth

[1] In its revised Syllabus for Advanced Art, 1965, the Joint Matriculation Board of the Northern Universities has announced that candidates may select the specimens (plant, driftwood, geological specimen) from which to make the study or studies.

of fruit, buds or flowers. In shells or bones there is similarly the firm structure, the shiny surface, the brittle texture.

Beginners in drawing often make the mistake of applying shading in a mechanical manner throughout, as if every object, indeed every leaf, must have the same degree of shadow on one side and light on the other. They often do not notice sufficiently how light falls collectively, revealing certain leaves while casting others into shadow. As Ruskin urged a century ago, the draughtsman must tackle shading and contour together.

The plant group was set by the Syndicate until 1963 as an alternative for those who wished to paint rather than depend mainly on drawing. For many pupils it is the infinite variety of colour, the contrasts in colour and tone, the clash and harmony found in flowers and leaves that particularly appeals to them, rather than the careful study of form and structure. The Cambridge syllabus stated that the object of this test was "to treat plant life as the subject of a picture". It was, in fact, a still-life of natural objects.

Until comparatively recently painting was always regarded as the final stage in the art course, and not to be attempted by beginners, who were expected to concentrate only on drawing. Nowadays, children are encouraged to use colour from the beginning. It is the main avenue down which the average child is led towards an interest in picture-making. Sometimes the teacher, rather than the pupil, is afraid of colour, and it is the teacher who communicates this fear to the pupil. We see the result in faint washes of colour applied with nervous timidity lest the brush might go over the edge. Such use of colour merely serves, as in map-making, to separate one area from another. It is quite the wrong way to begin painting.

The use of the brush in drawing, so strongly advocated by Ablett half a century or more ago, helps to bridge the gap between drawing and painting. It avoids the self-consciousness with which the beginner tends to add colour to a pencil drawing. If the pupil tries drawing with a brush, using any colour, it will be easy for him to gradually introduce other colours, and thus achieve painting. There should be no real distinction between drawing and painting. Both provide the means of conveying a sense of form as revealed by the light.

The art mistress at one of the principal boys' public schools in Uganda told me, during the course of a visit, that some of her pupils attending the art class for the first time, at the age of fifteen to seventeen, had never previously used a pencil or brush for drawing or painting. They would look at the materials in front of them without knowing how to proceed. On one occasion she told a new boy: "Look out of the window! What do you see?" "I see boys playing," he replied. "Then come back and show what they look like on this paper," she demanded. To her surprise, he no longer hesitated but seized a large brush, dipping it in a pot of paint, and drew, almost life-size, the shapes that he remembered. Although it was scarcely possible to recognize the human form, the vigorous lines suggested an astonishing sense of action and movement, and the boy proved in course of time to be one of her best pupils.

The Cambridge Syndicate, with its revised syllabus in 1944, became, as we have seen, the first of the examining boards to encourage the use of colour and to insist on its use in one of his three papers, a rule dropped in 1950. Previously most of the candidates would have confined their work to pencil or pen and ink, whereas nowadays the majority use colour whenever possible. Moreover, many of them go farther and submit paintings in the full sense of the term in still-life, nature or in studies of the living person, as well as in imaginative composition. It is indeed sometimes complained that candidates neglect drawing, with the careful study it implies, in favour of painting exclusively.

There are always some candidates who prefer drawing and are hesitant in the use of colour. Some seek to evade it by making a few faint washes of colour, merely to comply with the syllabus. This scarcely helps them in the eyes of the conscientious examiner, since it was intended that the candidate should reveal his feeling for colour and understanding of its use.

It used to be said by teachers half a century ago or longer that colour could not be taught. A boy or girl who is colour-blind cannot, perhaps, be given a sense of colour relationship. Such pupils, who are by no means rare, usually invert green and red, but they do not necessarily lack a sense of tone. Children with a normal colour sense are by no means frightened of it, yet often tend to use all the colours in their box just as they find them, without attempting either to mix or to lighten or darken them, which they must be shown how to do.

To mix colours so as to obtain dark or light tones must be the pupil's first aim. He can then learn to recognize when a colour has reached its most brilliant or saturated point, and reduce this brilliance until it has reached neutral grey. He can discover the difference between warm and cold colours and try fusing the one into the other. But it is often wisest to let the beginner experiment in any way he wishes.

Many children, especially those in India, Ceylon, Africa and the West Indies, have a natural feeling for colour and need no instruction as to its use. It is often through colour that their originality of vision is revealed to a degree that adults can seldom emulate. It is these candidates who have chiefly benefited by choosing the group containing plant life.

At a boys' school in Malacca I recall being shown a splendid display of flower paintings which depended entirely on a sense of colour. The boys had painted them with little or no help from their teacher, who told me he merely gave them the materials and let them proceed. When he showed me his own very conventional and inadequate sketches in water-colour I fully appreciated that he could not possibly have taught his pupils how to use colour, as he did not know himself, but fortunately he allowed them to use it in their own way.

If pupils are to make any advance, they must have some criticism and advice. It is for this reason that the examining boards issue reports from time to time for the benefit of the schools. In the Cambridge Syndicate's report of 1957 on the work submitted by oversea candidates we are told that "they often fail to observe the change of colour in the shadows and paint them black or in a darker

tone of the same colour that they have used for the light areas". This was pro-
bably written with the work of candidates in Malaysia and Singapore chiefly in
mind. The report also complained that "the background of the group is often
represented quite flat". Here we have a problem in composition as much as
colour.

In setting a flower group the teacher is faced with the problem of avoiding
pitfalls in composition. The ordinary and obvious arrangement is a bowl of
flowers on a table against a wall or curtain. The unwary pupil is tempted to
place the bowl in the middle of the paper with the flowers at the top, drawing a
horizontal line across the middle to separate table from background. He then
became the target of the examiners' report, which told him:

> The weaker candidates do not sufficiently consider the size or placing of the
> group on their paper and . . . the front and back edges of the table are often
> drawn as horizontal lines across the paper.

To give more scope for composition the Syndicate has usually avoided
setting a bowl of flowers. Typical examples have been as follows:

> A wicker bicycle basket overflowing with sprays of rhododendron, azalea or
> other flowering shrub [set for G.C.E. Home Centres, 1955].
> On a crumpled piece of sacking stand several garden or wild plants, their
> roots encased in a ball of earth as if newly dug for potting; place two empty
> flower-pots behind them, one standing and one lying on its side [G.C.E. Home
> Centres, 1954].

The Cambridge Report of 1957 observed that the majority of candidates in
the nature paper continued to choose the drawing of a spray, but that there was
an ever-increasing number choosing the group for painting "in spite of the fact
that it is the more difficult subject to do really well, and makes more demands on
creative energy and enterprise".[1] Here we have the kernel of the problem. Those
who tackle any branch of art creatively tend to do much better than those who
are content merely to reproduce what is before them. Such candidates, in the
words of the report, "try to convey the freshness and brilliance of colour in
the flowers, perhaps contrasting with the cool greys, greens or browns of the
leaves rather than make a detailed study, for which the Spray offers more
scope". At the hands of the better pupils the painting of plant life gives scope
for creative designs that may be almost abstract in conception and which are
certainly nearest in character to pure picture-making.

In drawing from the human model, the child has to face problems which do
not recur in other branches of work. Individual character in the model has to
be considered, something which is not apparent in the lower forms of life.
Moreover, the pose may express the model's mood or feeling, and there is
action, whether of repose or incipient movement, to be conveyed.

In the Cambridge Syndicate's revised syllabus of 1944 was tried the experi-

[1] This and previous comments were made before the plant group was withdrawn
from the Nature paper and included with Still-life; (see footnote page 207).

ment, as already mentioned, of specifying a continuous movement, which the model would take for ten minutes at a time. A female model was to adopt the motion of making pastry and pouring liquid into a bowl. Two years later, in 1946, the model was to be seated while polishing a tray. The intention behind this section of the examination was to test the candidate's powers of observing and memorizing action, these being the circumstances in which people are usually seen in daily life. We do not normally see them in a still position except when asleep. Children usually draw people doing something. They will tell you: "This is Daddy taking the dog for a walk", or "This is Mummy out shopping". The child tries to seize upon the essential features and to put them down quickly, expressing the action by the rhythm of shape and accent. Unfortunately, the examination results proved unsatisfactory; the few candidates choosing this alternative did not seem to justify its retention, and within a few years it was discontinued in favour of the fixed pose alone.

Although the drawing of the human figure or a head has been growing in popularity in schools since the Second World War, it is the Cinderella of art subjects. A decade or so ago, barely ten per cent of the examination candidates in England chose it. Overseas the proportion was even smaller. Teachers to

Beneath are sketches of the poses.

In all drawings the eye-level must be indicated.

An Examiner's illustration from the Art Paper, Durham University, 1932

whom I spoke in India, Malaysia and elsewhere would protest that it was too difficult. They would argue that they could not draw the human figure sufficiently well to trust themselves to teach it. At a girls' school in Malacca, the sister in charge of art told me frankly: "I do not encourage my girls to draw the human figure, because I have never studied it myself and I would not be able to demonstrate or correct their mistakes." I pointed out to her that she had only to encourage and direct. Her pupils would soon teach themselves. The drawings of children overseas often reveal a close familiarity with birds and animals, and this might prove a welcome alternative in the art curriculum.

In the girls' school at Gantock, capital of Sikkim in the Himalayas, I made each pair of girls turn their chairs so as to face one another. They were soon absorbed in their efforts to draw the girl in front of them. Afterwards, we mixed the pictures and placed them round the room; I asked them to try to recognize which drawing was of which girl, in order to call attention to their individual characteristics. It was astonishing how they were able to recognize one another: "This is so-and-so, because her nose is long, or because her hair is parted on the right", and so forth. Later, they decided which was the best—it was by a little Burmese girl of her Tibetan friend—and they presented it to me as if they were offering their photograph.

Within the last few years drawing and painting from the living person has been increasingly recognized as one of the most valuable branches of art teaching in secondary education. This is indicated by the growing number of candidates in the subject. In England, it is now one of the most widely chosen of the subjects in art examinations, and even overseas it is taken by some fifteen per cent of the candidates, a very great advance from the position a few years ago. In some countries, difficulties are experienced in obtaining models willing to pose. A superstitious fear of being drawn restrains them.

Schoolchildren usually fall into two categories: those who flatter themselves that they are good at drawing, or have been told so by fond parents or friends, and those who frankly claim that they cannot draw or paint. The latter category is often much more promising than the former. This distinction is particularly revealed in drawing from the living model, especially the head. Those who think themselves good at drawing often fail to observe the character of the model or the nature of the pose, but are content to draw a typical figure which they have often practised, the features summarized in a facile manner, picked up from posters or magazines. They concern themselves too readily with "make-up" or hair styles. Those who find drawing difficult, on the other hand, make more effort to observe characteristics and struggle to convey the form, in which they often succeed to a much greater extent than they anticipate.

In setting this paper examiners generally indicate a particular pose, such as a seated model turning the head as if surprised, or with a musical instrument across the lap, as if pausing from playing. The better candidates try to convey this action, perhaps the side-view of the head combined with front-view of the shoulders and seek to express the idea that has prompted the pose. They will try

b. Valerie E. Steward, Hatfield Girls' Grammar School;
Revelation, 6, 12-15, 1965

IVa. G. Footman, Victoria Boys' School, Kurseong, India;
Caravan from Tibet, 1950

to grasp the personality of the model and convey it in formal terms—perhaps a character which is small, strong and wiry, tall and thin, or old and bent.

Some schools make the mistake of choosing pretty or attractive models as if they are more suitable for drawing or painting. On the contrary, old men or women or models of distinctive character offer much more suitable material for study.

Those who paint the model are expected to include the background. There is no value in painting the model in isolation from its surroundings. Even if the background is not indicated, as in a drawing, one must try to study the whole scene, model and background together. I recall an occasion when I was drawing a woman poling her boat down the broad River Li in the Far East. The vari-coloured patches on the seat of her trousers made a curious pattern in relation to the clouds and precipitous mountains. When I returned to my bungalow I learnt that I was in trouble with the local authorities. "Not seemly to make a picture of woman's backside," I was told. Caught by surprise, I tried to argue my way out of it. "Not just backside of woman only," I explained, "but back-side of mountain also."

In many schools there are pupils who show remarkable ability in drawing or painting the living model, having a clear grasp of the pose, some understanding of human anatomy to infuse their observation of the structure of head or body, and an ability to convey the individual character of the model. Even less sophisti-cated pupils, and especially some at schools overseas, who lack a command of proportions and have little knowledge of the construction of a human figure, may produce vivid work which is expressive of life and character. Such work, even though it may bear little resemblance to the model, is much to be preferred to a facile drawing of a figure executed without character and culled from constant copying of fashion drawings in magazines.

J. A. Odutayo, pen and ink, Eko school, Mushin, Nigeria, 1958

Imaginative Composition

IT is only within the past two decades that the creative aspect of producing a picture has secured full consideration in the art examinations, and, consequently, in general education. The subject has been presented by the different examining bodies under varying titles such as "Original Imaginative Composition", "Pictorial Design" or "Picture Making", but each has catered for the creative aspect, reflecting the child's need for the means of self-expression in purely imaginative terms.

It is the emphasis on imagination and creation that is comparatively new—the belated response to the constant demand for creative outlets in the art class, voiced for half a century or more. The opportunity to compose pictorially by making an illustration is by no means new in the examinations. As we have already noted, the Oxford Delegacy included it as long ago as 1860, but it was merely one of three alternatives in the production of a design, and fulfilled such a minor role in the art syllabus that there was little compunction shown in omitting it a few years later. The subject did not again appear in any examination for over half a century, when the Oxford and Cambridge Joint Board introduced "Imaginative Drawing" for the first time in 1926. This, however, was no more than an illustration, since it was confined to "some well-known incident in history". The title "Illustration", with all the limitations it confers, was adopted in the 1930s by London, for its General and Higher School Examinations, Wales and Cambridge.[1] It was assumed that a picture must have a title, and "Home"," An Author in his Study" or "A-Hunting We Will Go", etc., were set.

It was the generally accepted view that the illustration of an incident was within the capacity of children, while the creation of a picture was beyond their reach. A picture was envisaged in oils, which only an adult was expected to practise, while an illustration was necessarily on a small scale appropriate to water-colour. Limitations on the size of work and in the materials to be used in the examinations continued until the 1940s, and are still imposed by some

[1] This formed part of Section II, which was designated "Creative"; previously, in 1925, the Syndicate had been more restrictive, describing it as "Figure Composition"; the type of subject set—"The Labourers", "Spring Cleaning", "A Fairy Tale"—remained much the same after the revision of the 1930s.

boards.[1] The fear that children would make a "mess" if allowed the free use of paint had retarded art teaching for years, until sugar paper used with powder paint or body colour, which could be handled freely like oils and on a large scale, became popular in the late 1930s. I have heard teachers say that art in schools owes its transformation to the free use of powder colour on sugar paper.[2]

The old concept of "illustration" still impedes art teaching, especially overseas, and many candidates label their work in this way, unaware of the limitation it implies. Neat, meticulous drawing without life or vigour, tinted with a faint wash, still persists—the legacy from the questions set by the examination boards in the 1930s. Typical titles such as "School", "The Lonely Road", "Surrender" or "The Cricket Match" gave no help towards visualizing a composition in form or colour. "Surrender" with its hint of the Indian Mutiny or the Boer War could be treated only as an illustration. Nor could the "loneliness" of a road or "school" be visualized simply in terms of form and colour. They are primarily labels for the finished work. "Cricket" is especially hampering in this respect. It is difficult to see the scattered players as a compositional unit. The boy or girl, who has perhaps sat all day in the school pavilion, sees the batsman very small in the remote distance, the wicket-keeper, with pads and gloves, crouching, then, across the paper, the bowler has to be put in, with trees for the background. Then comes the application of colour, with the inevitable disappointment when the green paint smudges the white figures. The subject is disheartening from the start.

Three main principles underlay the Cambridge Syndicate's revised syllabus in imaginative composition of 1944: The candidates should receive the question paper well in advance of the examination so as to have time to choose the subject and think about it; they should be entirely free in their choice of size or type of paper and other materials, but the work had to be in colour; the wording of the questions should be framed so as to stimulate the visual imagination while allowing for different ways of working.[3]

[1] At the time of writing, most boards allow paper not exceeding half imperial size (15 in. × 22 in.) with any medium other than oil; the Joint Board instructs candidates that they may use water-colour or wash, but "in conjunction with a firm basis of drawing". The Scottish Education Department, the Syndicate, the Southern Universities and the Associated Board either allow a much larger size at ordinary as well as higher level or offer no limitations in size, as well as freedom as to media.

[2] The use of acryllic paints or synthetic resins are becoming increasingly popular in schools, since these have the advantage of drying hard much quicker than oil-bound paints. Moreover, they can be used impasto, revealing the texture of the brush strokes, or can be thinned in the manner of water-colour. Many schools make the mistake of allowing too much use of the gloss media, which gives the work a false effect of shininess to resemble varnish. For examination purposes, acryllic paints, although drying quicker than oils, still require some hours to dry and should not be packed immediately like work in watercolour or powder colour.

[3] The Oxford and Cambridge Joint Board had previously made a step forward in 1940, with the instruction that candidates: "exercise their personal experiences and powers of imagination and observation"; There was no apparent change, however, in the type of subject set.

The emphasis placed on the imagination, use of personal experience and freedom in treatment had a welcome response in schools. This has been evident in the increasing popularity of the subject among candidates. Whereas twenty or thirty years ago the paper "Illustration" was taken by barely a quarter of the candidates in art, numbering no more than a few hundred, today many thousands choose "Imaginative Composition"—the most popular choice of all the art papers. This contrast has been even more evident overseas, where scarcely any schools attempted imaginative painting until after the Second World War; it is now taken nearly as extensively as in home centres.

Imaginative composition presupposes the expression of an idea in terms of form and colour. Whether or not the work is to be realistic—a composition need not necessarily represent nature—a visual idea must be established, perhaps only in embryonic form, before painting begins, then growing, evolving and changing as the work proceeds. How to spark this idea in the child's mind is a question of frequent debate among teachers and examiners. Various methods have been or can be adopted.

Marion Richardson's success with her pupils at Dudley High School before the First World War arose from her recognizing her pupils' need for external stimulus. They could not paint successfully otherwise. She has recounted how, following her visits to London to attend the Russian Ballet—a memorable and inspiring experience—she would describe her impressions to the girls. Few of them had ever visited London and none had attended the ballet, and they would listen keenly to her description of the stage, its lights and colour, the curtain, and then the climax with Nijinsky and Karsavina. They would conjure up the scene with its colour and design from her vivid description, producing watercolour designs of unmistakable charm, on small sheets of paper, forcibly reminding us of the miniatures of the medieval missals.[1]

It is not easy to visualize a scene which you have never witnessed. Marion Richardson was, in effect, providing her pupils with a glimpse into the recesses of her own mind, but this could only have meaning for them in terms of their own personal experiences. Even an escape into the realms of fantasy must have some basis in the recollection of natural forms. The images in a nightmare usually assume legs, tails, eyes or other attributes of nature, and it is for the teacher to stimulate the child's vague recollections so that they can be used pictorially. Even supposing that it results in an abstract design, its origin may lie in the grouping of colours and shapes seen in the heart of a clump of bushes or the depths of a pond or in the scratches or mouldy patches on a wall.

Evelyn Gibbs, in referring to her teaching experiences, describes the "robust

[1] Diaghilev's Russian Ballet held Marion Richardson, like so many of her artist contemporaries, spell-bound, and it was not surprising that she shared this enthusiasm with her pupils. There are at least fifty of their pictorial improvizations. The ballet of *The Midnight Sun* was the favourite choice, with its barbaric row of suns across the stage, the red glow and the tiny scale of dancers and orchestra (colour plate IIa).

memories of everyday life" as "the real stimulus to imagination".[1] Visual
memories are not easily evoked by subjects that are too broad in character as,
for example, "Summer" or "Home". Offered such titles, which are mere
generalizations, the child finds difficulty in pinning down his recollections to
any particular aspect or occasion. His imagination wanders vaguely over sun
and fields, house or garden, and he may be tempted to begin work before a
definite visual idea has taken shape. He is helped to concentrate his thoughts and
invoke his visual memories if the subject is closely linked with some personal
experience as when "Home" becomes "Returning Home Tired" or "Summer"
becomes "Falling Asleep on a Hot Summer Day".

One may even go farther and claim that if the child is to use his personal
experience in producing a picture, rather than imitating the work of others, he
should be specifically reminded of a particular occasion or event. If "A Rainy
Day" happened to be the subject set, the child might begin without having
recalled any distinct impression of his own. A man with an umbrella would come
instantly to mind with diagonal lines for the rain, and the drawing would soon
be finished. "What do I do next?" is the immediate question. In order to relate
the work to his memories, you ask, when it is almost too late: "How did you see
him? Was it through the window?"—and square window panes may be added.
"Was there nothing else to be seen?" you ask in some desperation, but by now
the child has lost interest and the picture can no longer be changed. More
might have been obtained if the child had been asked: Do you remember the
occasion when it was too late to go out and we sat by the window watching the
people hurrying by with their umbrellas? The shapes of umbrellas through the
window panes would be recalled and the material for a composition created.

Children often paint a scene as if it was noon on a cloudless day. They remem-
ber the incidents, but forget the circumstances. They need to be reminded of the
weather, the season or the time of day, whether it was dark or misty, light or
clear. Such reminders may help to establish the mood of their picture: They may
recall the circumstances: "Oh! It was wet and cold" or "It was getting dark",
and convey them in tone and colour.

Education is served when the child's powers of observation and visual
recollection are developed. The pupils may be shown a number of objects,
perhaps told to walk round them and handle them, and then make a composition
based on what they have observed. They may be told to walk out of doors for a
few moments to watch people, birds or animals and then come back and make a
picture. Or a number of familiar objects can be mentioned, perhaps varying in
size and texture, which they can look at and then combine together as the basis
for a picture. There are many ways of uniting observation with visual imagina-
tion. I had long been familiar with the imaginative and unsophisticated paintings
from a certain school in Eastern Nigeria, always vividly descriptive of native
life and surroundings. In visiting the school recently, I expected to meet an
experienced art teacher in a well appointed studio and was astonished to meet

[1] E. Gibbs, *The Teaching of Art in Schools*, 1934.

one who had no professional training himself nor studio in which to teach, who relied entirely on describing subjects related to daily life, making the boys go out and observe places or people, then working from memory.

To recall impressions or experiences does not mean that pure representation in an academic sense must result. It is only when the child is asked to illustrate some incident that he feels impelled to represent nature literally. It is precisely such vague subjects as "Summer" or "Home" that tend to produce the literal illustration of the cat by the fireside or the sunshade on the beach. The effort to recall something more specific prompts the child to remember what he actually felt as well as what he saw. He may recall that it was dark and associate it with fear, and the effort to express this emotion eliminates the temptation to be purely imitative. When encouraged to think back, he may recall impressions of movement or contrasts in dark and light, or perhaps the interlacing vegetable forms, and he may express these in visual, or even abstract, terms. Children are not always aware that their own work is divorced from nature, though very much concerned with natural resemblance in other peoples' pictures.

There are, of course, art teachers who dispute the child's need to resort to nature. There is the inner world of sensation which can be projected in terms of colour, form and design,[1] and some children may find satisfaction in expressing these inner sensations. Others, probably the majority, may never be aware of them. Whether the average child, who is not exceptionally talented in this respect, benefits by such introspection is questionable. For some types of child it may be positively harmful and lead to introversion. Such tendencies must not be confused with the non-representational treatment of subjects drawn from the physical world.

Some art teachers refrain from setting specific subjects on the grounds that children should be allowed complete freedom to draw or paint any subject they choose. While full freedom of expression is essential, the question to be faced is whether children may work better when certain limitations on their freedom are prescribed. The child who is told: "This is the art class and you may do whatever you like in any manner you like", may feel as if in a ship on the broad ocean without a rudder.[2] Is it not better to be specific as regards the subject or the function of the work while allowing complete freedom in the manner of carrying it out?

Boys or girls, when told to draw or paint what they like, often choose unwisely, mistakenly selecting what they think is easiest. In a class of, say, twenty

[1] Herbert Read in *Education through Art*, 1945, has recorded experiments at a girls' secondary school. Told to close their eyes and relax, as Marion Richardson taught her pupils in 1920, the girls would then paint what they saw in their mind's eye. Their purely abstract patterns were described by their art teacher, as "Mind-pictures"—the term used by Marion Richardson. Read discusses this under the heading—"Haptic sensibility."

[2] Hartog castigated this approach in setting essays as "the write anything about something for anybody" method: Sir P. Hartog, *English Composition at the School Certificate Examination*, 1936.

boys, it is a fair guess that half of them, if allowed to choose, will depict rockets, aeroplanes, ships, trains, buses or cars. Their choice is not impelled by an aesthetic urge, but is prompted by an expert knowledge of one or other of these vehicles, and for this reason they assume that they can draw them more easily.[1] Life under the sea, with goldfish and seaweed, constitutes a frequent choice of subject among children. They find it easy to produce an effective and decorative composition, but this, like the pictures of rockets, prove to be superficial, having no basis in genuine observation.

For the child to invent a scene that he has never observed is perfectly legitimate and delightful work may be based on pure fantasy. But is the fantasy his own? How often is it inspired by the film cartoons of Walt Disney? The subject "Minding the Baby" was set on one occasion, as being within the experience of most children. It was surprising how many resorted, instead, to the picture language of the animal film cartoon, with mother and baby elephants or deer.

Children are only too anxious to adopt a ready-made formula derived from picture books or film cartoons, or they pick up simple pictorial tricks such as a disc with radiating lines for the sun, or the letter *v* for birds on the wing. "Can I draw a rabbit?" the child may ask, and reproduces the picture-book formula of two circles one above the other for head and body, with tuft for the tail and floppy ears. Such clichés are particularly common in drawings that are intended to be funny, with patches on trousers or red noses. When children attempt humourous drawings the results are usually disastrous, judged purely from the aesthetic standpoint.

If children could always be relied upon to choose their subjects sensibly, complete freedom of choice would be welcome. But this is too much for the teacher to expect. A child merely wastes time and defeats the purposes of education when he reproduces the observations of others, in the mistaken belief that this will prove better than his own unaided impression. When visiting a school at Kurseong in the Himalayas, I noticed one of the boys hard at work on a picture of mountain scenery. I looked out of the window with its magnificent panorama of snow-capped peaks with the valley down below and the villages clinging to the slopes, and asked which was the view he was drawing. "Oh! This is not around here," he replied. "My picture is of the Rocky Mountains", and in proof of this, he produced from his desk an American magazine containing a colour reproduction, which he had been copying. I could scarcely conceal my disappointment at such wasted effort, and I felt the teacher was to blame for not directing his interest towards the real scenery with which he was so fortunately surrounded.

It may be thought by some teachers that the school surroundings are too drab

[1] In 1911 Dr. P. B. Ballard, after inspection of some 20,000 drawings by children, noted that between the ages of five and eleven ships were the boys' favourite subject, while girls preferred flowers, first, and houses, second. Girls drew human beings more often than boys before the age of nine, but less often later. Landscape was seldom chosen by either boys or girls until a much later stage was reached.

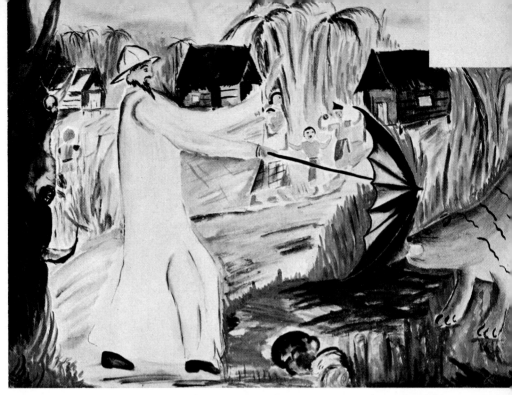

Va. Joyce Marina Boyle, Penang Girls' School, Malaysia; *Priest meets Tiger, 1955*
 b. Godson Nwabuwa, Washington School, Onitsha, Nigeria; *The family asleep, 1963*

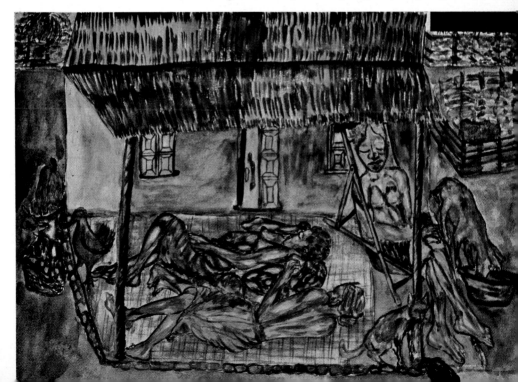

for children to find congenial subjects therein, and for this reason it is better to draw upon the world of "make-believe". But are children normally concerned with what "grown-ups" think is picturesque? If asked, on the other hand, to paint an impression of the school yard, which may be as dreary as a prison, the child will readily see the substance of an exciting composition. It is the task of the teacher to make the child observant of his surroundings, whatever they may be, and persuade him to record his impression in form and colour.

Children may be surrounded by the most magnificent material for painting and be completely unaware of it in the absence of any direction from the teacher. This struck me forcibly when I was staying in a Dyak village in the jungles of Sarawak, where everything was a perpetual source of pictorial inspiration. The children used to crowd round in order to watch me painting their "long houses" built up on bamboo stakes over the swamps. A small boy murmured into my ear: "We do drawing at school." I was curious to see this art class in such a glorious, if primitive, environment. The school with its thatched roof was at some distance from the village, so detached as to suggest a fear of contagion. They proudly showed me their drawing books and I was dismayed to find no drawings of the villagers, their animals and houses, the magnificent forest trees, the mud, the water and the crops, but only aeroplanes, ships and city gentlemen in their motor-cars. Few of these children could ever have seen such subjects, or only on very rare occasions. I was led to conclude that they were told to draw what they liked, and instead of responding to the real wonders that surrounded them they preferred the wonders of which they had heard, or they had seen in magazines, and longed to see in their reality.

The issue with which we are concerned is essentially this: The purpose in teaching art in schools is to educate, and only rarely to produce an incipient artist. From the point of view of education, the child can learn very little by trying to depict an ambition to wear fashionable clothes, possess a racing motor-car or fly an aeroplane, but he can benefit a great deal by learning to observe his surroundings, and then to select, memorize and record what he has seen.

Much research has been made and much written about the creative urge in children and the motives that inspire them to paint. Such psychological investigations, begun by James Sully and taken further by Sir Cyril Burt,[1] have been discussed even more thoroughly in recent years. No name stands out more prominently in this field than that of Sir Herbert Read[2] who has sought to clarify what the child is ready to acquire in art rather than what he can be made to acquire.

As the advocate of education through art—a doctrine universally associated with him—Sir Herbert Read has made it abundantly clear that art should be regarded as the means of education rather than as a branch of education, providing as it does a means of communication within the realm of feeling. "It is", he has written, "properly speaking a contagion, and passes like fire from

[1] Sir Cyril Burt, *Mental and Scholastic Tests*, 1921.
[2] Sir Herbert Read, *Education through Art*, 1945.

spirit to spirit."[1] We are, nevertheless, still very far from teaching through art, and we may well doubt whether any appreciable advance has been made by schools, in general, towards such a goal. In the great majority of schools, art is still taught largely as a hobby.

The average art teacher may justly feel in something of a dilemma when held back by the scepticism of those in authority and urged to advance by critics such as Burt and Read. When challenged to reveal the benefits of his teaching, the art teacher must act the part of a diplomat. He has to persuade the school staff that his teaching is of value, although in point of fact he does not really teach at all. His task is to encourage, without disturbing the natural drift of his pupils' imagination. The child's participation in the art class must be voluntary, for he must not be allowed to feel that the teacher insists on or even requests his presence. The child must feel that he is free to create what he wishes in the art class. When offering his suggestions, the teacher must be able to convince the child that these suggestions are precisely what the child, himself, had in mind.

In seeking to promote creative or imaginative work, the role played by the examinations with their set papers, precise subjects and fixed regulations must seem dubious at first sight. "Why," it is sometimes asked, "must the art papers be set in this restrictive form? Why cannot the candidates submit whatever they wish without being confined to a series of specific subjects"?

The boards might answer, if they wished, in various ways. They are concerned, in the first place, with adolescents at a particular age and not during development preceding examination. Secondly, they are concerned with the results of teaching rather than with teaching methods, which must be as little in evidence as possible. But the teacher's influence is often paramount. When the pupils of one teacher obtain exceptionally good results, while those of another teacher as frequently fail, it is often argued that it is the teacher rather than the pupil that is being examined. Often the real talent of a candidate is buried beneath the mannerisms imposed by the teaching. Thus, if candidates were to submit whatever work they wished, without set papers but choosing their subjects freely, the influence of the teacher, for good or for bad, would be even more in evidence than it is at present.

There are yet other considerations that govern the formation of a syllabus. By setting specific papers, of which the character is known in advance, a greater degree of fairness to all candidates is ensured, irrespective of their teaching. Their work is detached from the influences, favourable or otherwise, of the school environment. Thus the work is judged against a uniform background as it were. Furthermore, it can be argued that if no subjects were to be set, could the examining boards be sure that the candidates had not submitted copies of pictures instead of their own unaided work? Perhaps this fear is not as substantial as it used to be, but there have been occasions when candidates smuggled ready-

[1] Sir Herbert Read, an article entitled "Education through Art" in *Education and Art, a Symposium*, published by U.N.E.S.C.O., 1953.

made pictures into the examination room, seeking to pass them off as their own work.

For examination purposes there must be some element of comparability between the work of the candidates if it is to be fairly assessed, and this is to be achieved only by setting prescribed tests. It is equally necessary to bring out the best from the ill-taught candidate, without hampering those who have had the benefit of excellent teaching. Equality in opportunity must be the aim, a subject to be discussed more fully later.

Fairness requires that the choice of subject in imaginative composition, as in the other papers, should be governed to some extent by the range of experience of the different types of boy or girl. There must be subjects that cater for those living in urban surroundings equally with those who live in the country or by the sea. Children in rural areas may be accustomed to drawing animals, but there are city children who may never have seen a horse or a cow. There are some who have rarely, if ever, seen the sea.

Rivalry between the sexes must be taken into account in setting subjects, since boys may resent subjects which they consider are meant mainly for girls. There can be no absolute rule, but subjects involving trains or other vehicles with speed or violent action are usually favoured by the boys. Girls are not afraid to tackle crowds of people. Boys, less venturesome, tend to confine their work to a few isolated figures. The girls depict a world populated mainly by females, while neither boys nor girls can convey old age, but present their grandparents as if in their teens.

In setting subjects for the countries overseas, other considerations have to be taken into account. The religious beliefs, for example, of Moslem and Hindu exclude certain subjects. Some domestic animals are sacred according to one creed and unclean to another. There are schools in the East where religious belief requires the girls to remain in seclusion, with their impressions of the world inevitably limited.

Many candidates live in countries where snow is unknown, and subjects connected with winter as we know it cannot be set. Mountains and jungle, so familiar to some, may be unknown to others. At a boys' school in Kenya, I found the art class drawing yachts at sea. Most of the boys drew them with no understanding of their construction and I asked how many had ever visited the coast. I was surprised to find only one put up his hand. I recall, on another occasion, at Kalimpong in the Himalayas, the headmaster complaining of the subject "Supper on the Train". "It may surprise you," he explained, "but we have boys here who have never seen a railway train except in pictures."

The better candidates in the examinations try to enter into the spirit of the subject set. They do not shirk the problem, but try to realize its possibilities for the expression of form, colour and design. There are always some, on the other hand, who do badly through seeking to evade the subject. The Oxford Examiners' Reports refer to a "total disregard of the subject set" both at

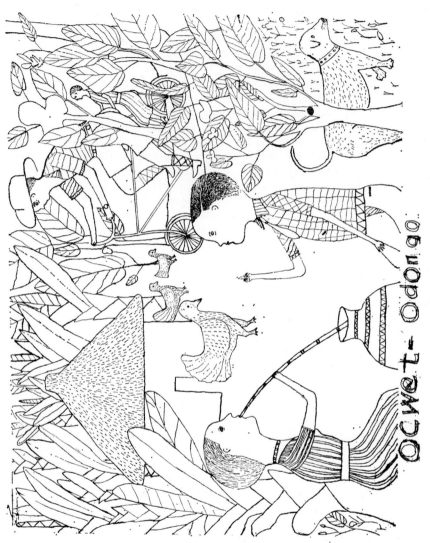

Ocwet-Odongo, Namilyango College, Uganda, Village Scene, pen and ink, c. 1958

Ordinary and Advanced level. "Some candidates", we are told, "reproduce a picture obviously learnt and practised which has only by chance a connexion with the subjects set. . . ."[1]

Children often think it clever to seek the easiest solution. When the "Return of the Fishing Fleet" was set a good many years ago some depicted a broad expanse of sea, with the fishing-boats hull-down over the horizon, so that only their funnels and smoke were visible, in the mistaken belief that this made it easier to draw. Many candidates use black paper for night subjects, as if the colours at night-time are necessarily black. Some years ago one of the subjects set by Cambridge was entitled "Hiding from One's Enemy", and most candidates tried to convey the action and tension. A candidate from Jamaica, however, who obviously hoped to get the better of the examiner, confined her drawing to the silhouette of distant mountains with a solitary tree in the foreground. Underneath was written: "My enemy is behind the mountains and I am hiding behind the tree."

Some art teachers have found that the reading of passages from literature evokes a response in their pupils. Their success has depended on presenting passages with a strong pictorial appeal. Both Oxford and Cambridge, in common with other examining boards, have usually included at least one subject from literature or from the Bible. Such subjects—perhaps a descriptive passage from Dickens, such as the jostling of umbrellas amidst the fog in the gas-lit streets by the river in *Bleak House* or Tolstoy's *Reminiscences of Childhood*—are usually taken by a minority of the candidates, but it is often apparent that they are the better ones. Passages from the Old Testament, and equally from *Under Milk Wood*, have inspired candidates to produce far more than a mere illustration. They have succeeded in conveying feeling and atmosphere. In setting such subjects, the Cambridge Syndicate has drawn the candidates' attention to the following instruction:

> Quality of composition, feeling and originality, rather than a literary
> approach, are the main objects of this Paper.

Subjects for examination are usually set so as to give as wide a scope as possible in composition, expression of form and use of colour. They may prescribe human figures or animals, with potentiality for movement, to be drawn or painted in relation to their static surroundings. But the need to consider compositions in human terms has sometimes aroused criticism. For the more talented children, the subject set is of little importance. They may produce compositions which are deeply moving and the inclusion or omission of people or animals is governed entirely by the visual idea and the feeling to be conveyed. It is the weaker candidates—the great majority—who often seek any opportunity to avoid the inclusion of human beings which they consider difficult to draw. They think it easier to produce a landscape than a figure composition, but

[1] Oxford Local Examinations G.C.E. Examiners' Reports, 1958.

this is a mistaken view, and their work suffers accordingly from the absence of movement, scale or action.[1]

The Cambridge Syndicate made a notable experiment in 1962 with the introduction of additional questions catering for abstract or non-representational work. This was intended primarily for Advanced level candidates, Home and Overseas, but was also tried at Ordinary level in G.C.E.[2] It was felt to be unsuitable for the School Certificate candidates overseas, since the abstract approach was not at that time generally studied there, and without such study it is valueless.

In announcing this step in the syllabus of 1962, the Syndicate warned candidates as follows:

These new subjects are being set as an experiment for a limited period. Candidates should be warned not to attempt them unless they have had considerable experience as well as instruction in this type of work.

Typical questions set have been as follows:

A composition in related colour: transitions, modulations, textures etc, developed and brought together.
A painting for which the title "Movements on a Fluid Surface" is suggested.
Dynamic tensions in a Composition on a Plane Surface.

It was further explained that they were "intended only for candidates who have studied composition of a non-figurative type. Painting which is figurative or representational in intention must not be submitted for these questions."[3]

After three years of this experiment, it appears that relatively few candidates wish to avail themselves of the opportunity to present abstract work—barely one per cent at Ordinary level, but a larger proportion at Advanced level. Apart from the pupils of a few schools where this approach to art is taught and excellent work produced, many of the candidates reveal their lack of teaching and show a misunderstanding of the objectives. Such candidates find in these questions the opportunity to make a decorative pattern and avoid exposing their inability to compose or draw. The best candidates, on the other hand, reveal considerable intellectual grasp and sensibility to form, colour and texture.

[1] The Northern Joint Matriculation Board has included "Industrial Landscape" among subjects for its "Pictorial or Graphic Aspects of Art" at Advanced level, but this does not specifically exclude figures.

[2] The Cambridge Syndicate has announced its withdrawal in 1966 at Ordinary level.

[3] Several of the examination boards have recently announced the acceptance of abstract work as alternatives in imaginative composition. The Welsh Committee has included it at Ordinary level, but not at Advanced level, though one would expect this procedure to be reversed. The Northern Board, announcing its revision of its art syllabus for Advanced level, in May 1963, included the following alternative:
"A non-figurative or an abstract composition on a single set theme."
Candidates would be informed twenty-one days in advance as to the subjects and would be required to bring their preliminary sketches, of which two would be handed in with their examination work.

Many children find a romantic appeal in "modern art" and make the mistake of thinking it quite easy. They are not fully aware of the disciplines involved and are glad to evade the equal difficulties in the observation of nature. Both types of approach have their place and value in general education. There are always some candidates who have neither observed nature nor studied abstract problems. For them the term "non-figurative" means animal life instead of human, and the abstract questions result in pictures of rabbits and squirrels.

Teaching Design

THE need for good design in the service of industry during the last century had an inevitable impact on teaching, and the subject acquired an over-riding importance in schools as well as in the examinations, when these were launched over a century ago. But this concern with design was of short duration and within a few years we find it virtually ignored. Was this, perhaps, due to what we would now regard as mistaken methods in tackling design during the Victorian era?

During the 1850s and 1860s the teaching of design demanded the making of a sketch on paper of any object intended for subsequent manufacture. This was altogether the wrong approach. Today, we recognize that the making of household or industrial objects, if three-dimensional, as in pottery, or textural, as in textiles, can best be planned in their actual material, and that designing on paper should be confined to those branches of art—the poster being typical—which are conceived and completed on paper.

The successive steps taken by the examining boards during the past century are illuminating as to the evolution of contemporary ideas on design. As we have already noted, the first syllabus in art, issued by the Oxford Delegacy in 1858, included a practical test in design to be carried out in pen and ink and in colour. The reader will recall that ten different subjects were offered, with no time-limit imposed, and candidates were, apparently, to attempt any of the subjects, or even all if they wished. The subjects included an ornamental border for a book and the making of designs for other specified objects in embroidery, porcelain, woodcarving, glass, ironwork, weaving, etc.[1]

With such a wide variety of crafts, few candidates could have revealed a practical working knowledge of more than one of these, if any, and this may have prompted, very sensibly, the additional instruction that appeared in the syllabus the following year:

> In each case, the candidate is expected to consider the materials in which the designs are to be executed and the use to which they are put, and he is at liberty to explain in writing his reasons for the forms he may adopt.

It must have been difficult for a boy at school to obtain an adequate knowledge

[1] Given more fully in footnote on page 103.

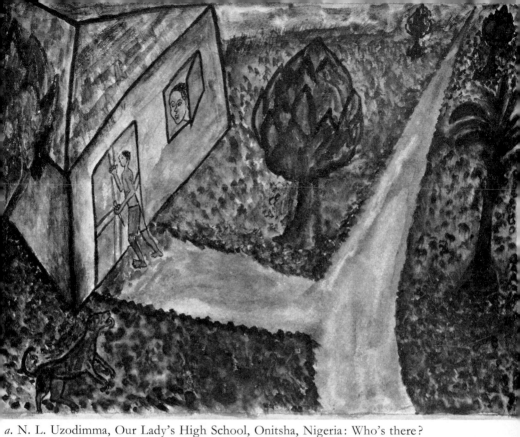

a. N. L. Uzodimma, Our Lady's High School, Onitsha, Nigeria: Who's there?
It's late for a visitor! (School Certificate, 1956)

b. Juliet Watson, Sidcot School, Somerset: Wing of a humming bird, (G.C.E. O level, 1965)

of these various materials and functions, and it is scarcely surprising that this highly involved and complex paper was dropped thereafter in favour of a simpler test, containing only three questions—"an ornament" which might be for a chair or a cornice, "a pattern" as for an altar-cloth or a mosaic pavement, and an "illustration". But this modified scheme was dropped in 1880. The Cambridge Syndicate set a similar paper for a few years, but ceased doing so early in the sixties.

It is indeed curious that at the very period when William Morris and his friends of the Arts and Crafts movement[1] were seeking to promote the public appreciation of good design and craftsmanship in wall-papers, chintzes, metal-work, etc., the teaching of design in schools and its encouragement through the university examinations should have ceased. When reintroduced around the turn of the century the subject was confined to a mere mechanical pattern-making.

The Oxford and Cambridge Joint Board was the first to reintroduce a test in design in 1889, requiring an "ornamental arrangement of floral details to fill a given space". Cambridge adopted a similar paper eleven years later, to be "flat coloured in not more than four colours". This was the period of "Art Nouveau", when design was identified with surface pattern based on plant forms. The Oxford Delegacy did not follow suit until 1904, when both Seniors and Juniors were given the instruction:

> A copy of some portion of a plant will be supplied and a design based on it
> must be executed in flat washes of colour so as to fill a given space.

Thus was launched the meaningless exercise of "space-filling" which has persisted in schools until recent years, especially overseas, and has largely closed the door on any practical approach to design. I have seen classes of some twenty-five boys and girls, not so long ago, busily engaged making segments and circles with compasses and rulers, and filling in the spaces with colours. "Space-filling" was sufficiently popular with schools in this country, however distasteful it may have been with the pupils, to justify its retention by the examining boards for many years. According to the Cambridge report of 1905, some fifteen per cent of the Senior candidates in art and ten per cent of the Juniors included this test in their choice of papers.

During the early years of this century enlightened teachers were pressing for a greater recognition by schools and universities of the practical function of design, but the response was slow. Some improvement was obtained, however, in the revision of the Cambridge syllabus in 1925, when the title was changed to "Design and Decorative Composition". Although "space-filling" was retained, the paper included a test in script writing and lettering, together with designing for stencilling, leatherwork and pottery. Junior candidates were given the useful instruction:

[1] Messrs. Morris, Marshall, Faulkner & Co. was set up in Red Lion Square, London, in 1862, to undertake various branches of craftwork and designing.

In any writing that appears, credit will be given for good lettering.

It was not until the Syndicate made its revision of the syllabus in 1944, that the injurious "space-filling" was finally omitted and the questions confined to those branches of design which are suitable for carrying out on paper, with a separate test for the crafts. The Oxford and Cambridge Joint Board and the Joint Matriculation Board of the Northern Universities subsequently adopted a similar syllabus for design. The other examining boards also omitted "space-filling", though they included designing on paper for craftwork.

It will thus be noted that lettering, the essential feature of a design to be carried out on paper, was not included among the crafts catered for in the early design papers until Cambridge mentioned it for the first time in 1925, with London introducing it the following year for Higher School Certificate, other boards being even later.[1]

The efforts made by William Morris, Walter Crane and their associates during the later years of the nineteenth century, to promote public taste and an appreciation for the "layout" of the printed page would have been helped very greatly had schools made some effort to encourage the drawing of letter forms and the planning of their arrangement within a given space. With the emergence of the poster, which began to make an immense impact when Millais' "Bubbles" appeared on the hoardings in the 1870s—Cheret's posters had appeared in Paris some years earlier—the general public acquired a new familiarity with pictorial and lettered design. By this means aesthetic taste was influenced to an extent that had never been possible hitherto, but it was not informed by any experience in lettering while at school.

Schools took little or no part in thus forming public taste during the half century when the art of the poster, with its use of lettering, was in process of development. Indeed, the promotion of taste through such exercises as the planning of letter forms and spaces was ignored both by schools and examining boards until it was wellnigh too late to exercise any beneficial influence. The worst forms of commercial advertising were thus left unchallenged by an aesthetically uninformed public.

The Syndicate's syllabus of 1944 placed emphasis for the first time on the various branches of design involving the use of drawn letters. Questions were set for designing a notice, such as "Cross if the road is clear", a design for a package advertising its contents, a trade-mark or a page of a book. The paper also provided for the designing of printed fabrics or papers, stage setting and costume, interior planning or shop-window display, etc., but these, with the exception of patterned papers, have been subsequently dropped or transferred to the separate paper on crafts. These changes were inspired by the wish to familiarize boys and girls with the problems of design that face them most frequently in daily life. It was hoped that schools would seek to develop their pupils' powers of criticism, thus enabling them to appreciate or condemn. A

[1] The Oxford and Cambridge Joint Board did not introduce this branch of design until 1947.

somewhat similar syllabus in design was also introduced by the other examining boards.

Artists and art teachers were beginning to recognize that it was useless to merely turn their backs on the commercial use of art, as if it were an infectious disease. New forms of advertisement had sprung into existence, and were not only there to stay, but would inevitably prove to be one of the main avenues by which art, whether good or bad, would reach the mass of the people. The Society of Industrial Artists had been formed in 1930 to promote and maintain standards in design, and the Syndicate together with the other examining boards have pursued a similar course in general education.

It has been steadily realized, however, that the designing of notices, packaging or posters intended for commercial printing can be harmful as well as advantageous in schools. While it was hoped that boys and girls would thus learn to think critically of these branches of design, which most often affect their daily life, the examination work has often revealed results which were the opposite of what was intended. Where good teaching was lacking pupils would absorb and enjoy the worst, rather than the best, types of commercial advertising.

Design is best taught in relation to the actual needs of the pupils in their school, home or club. The type of subject suitable for a poster might be the school concert, play or sports event, rather than the allurements of travel. A design for book production might be concerned with school hobbies or a personal diary. Stage design might be confined to a production on the school stage, rather than the professional theatre which lies beyond the reach of most pupils. Although a familiarity with the industrial use of design is obviously desirable, since it affects our lives so deeply, it can do harm unless adequately taught, and this depends on more time being allowed for it in the average school curriculum. At present many schools are fortunate if they can allow one or two periods for design during an entire term.

In recent years some schools have ventured to provide a printing press as part of the art-school equipment. Instead of the work being confined to whatever can be produced and completed by hand, the pupils can study design in relation to printing. They can plan their letters in terms of printing type and their colour schemes in printer's ink. This is, however, an advanced stage, and the preliminary step must consist in drawing and planning the "layout" of a notice, a poster, an emblem or the page of a book which can be completed by hand alone.

In any branch of design involving lettering the study of letter forms is the first essential step, and this constitutes a valuable exercise in taste. Fitness and refinement in form can be conveyed by this means more readily, perhaps, than by any other. Such an exercise in taste is obstructed, however, when alphabets of debased character are used. The examinations have revealed that a considerable number of schools tend to allow their pupils to choose commercial types of alphabet, with no beauty of letter form, rather than true Roman, as shown in the classic examples on the Trajan Column, or a good "sans serif".

A type of alphabet persistent in the work of some schools, and very injurious to the development of a sense of good design, consists of curved and straight-sided letters, built from tiny ruled squares. This is a purely mechanical method of forming letters, allowing no exercise of judgment or play in their final shaping and spacing. Lettering is too often practised mechanically instead of as an artistic exercise. Not only are the letters formed with ruler and compass, but the spaces between each letter are measured equally instead of judged by the eye. This produces a wider gap between the round letters than the eye would allow and deprives the work of any rhythm in the spacial relationship between one letter and another. When an instrument of measurement, like a ruler or a set-square, is interposed between eye and page, the latter ceases to possess life or unity.

If letter forms are ill understood or badly executed, it is yet possible for a pupil to learn something of good proportion by judging the forms of his letters in relation to the spaces surrounding them or their size and position in relation to the area of paper. An appreciation of the shape of the letters may follow later. Unlike in the painting of a picture, where knowledge of technique is of minor importance compared with realizing the idea that has inspired it, a good design cannot be attained without a basic knowledge of letter forms. But this is not to affirm that familiarity with them constitutes the sole object in studying this branch of design.

On the other hand, to be content with the teaching of lettering by itself is to ignore its purpose. There can be no real value in letters by themselves. They depend on being read, and this in turn involves a consideration of their back-ground. Where the letters are seen is just as important as their formation. The design must, therefore, be planned in advance, necessitating the production of a preliminary sketch in which the rough shape and placing of the letters is estab-lished in relation to the background and surrounding space. Without this careful preparation no organic unity, comprising the right proportions of lines and letter forms can be achieved. Only by this means can the design be endowed with rhythm and vitality.

A design of any kind, be it a notice or a poster, must be planned so as to be effective for its purpose generally. Unless this is fulfilled it cannot be aesthetically satisfying. Legibility is, perhaps, the first objective, but scarcely less essential is the suitability of the design. Does it suggest the idea or the theme which it is meant to convey? There must be emphasis on certain letters or words, with variations in proportion and greater or less prominence in position.

Whereas the painter of pictures escapes into his personal world, where he concerns himself with the expression of his ideas or feelings in plastic terms, the use of lettering constitutes an applied art, in which vision, taste or skill has to be harnessed to the solution of a practical problem. This requires constructive ability, almost of abstract thought, analagous to the problems facing the archi-tect in his use of forms and space.

The examination tests involving drawn letters have proved to be the most

popular of design questions among candidates taking the G.C.E. or the School Certificate Overseas. This popularity is in itself an indication, to some extent, of a wrong approach to the teaching of design. The use of lettering is a specialized branch of art, although so important in daily life. Its educational value depends on its occupying no more than an appropriate place in the framework of a general art course, and the latter must be planned to develop the visual faculties in general. Too much time spent practising lettering leaves insufficient time for the other branches of art, on which a balanced training in art equally depends.

The practice of lettering to the exclusion of other aspects of art leads towards the production of neat but mechanically drawn letters, while the work as a whole lacks a sense of life, enterprise or adventure. Fundamentally it is the artistic capacity of the pupil that has to be tested. The production of drawn letters alone, uninspired by any artistic feeling, is of little value.

In painting a picture it is often found that the average boy or girl produces a good composition unconsciously. Their best work is produced when their thoughts are concentrated first on the subject and then on the vision that it inspires. Good design in a poster or a notice is not so easily left to the subconscious department of the mind. The practical problems of unity, cohesion, legibility and function demand conscious planning, and the type of pupil who excels in such aspects of design may well find that similar planning applied to the other branches of his work, such as imaginative composition or work from nature, makes it lack spontaneity and the exploitation of happy accident. While design requires conscious preparation, pictorial composition depends on the development of the senses.

Those who reveal a natural inclination for painting pictures are not necessarily suited for designing posters or book-jackets merely because these may have some pictorial content. Boys or girls who are familiar with the problem of painting a picture will not necessarily appreciate how to combine the pictorial element with the lettered message. They tend, unless taught otherwise, to paint the picture first and then fit in the title or message wherever there is space, or, worse still, write it across the picture without regard for its legibility. Sometimes the picture and the lettering are incongruous in style or treatment, due to the mistaken belief that painting for a poster should be in a conventional or stilted style. Some go even further and assume that flat colours are essential for printing and, therefore, appropriate for a poster, whereas modern methods of printing allow the artist complete freedom.

The difference between painting and design is particularly evident in the use of colour. A good sense of colour is developed rather than taught, and it is in colour, perhaps more than in the expression of form, that feeling can be conveyed. There is no particular merit in being able to make an even wash of colour in a painting. On the contrary, colour should be applied so as to reflect one's feeling and perception of form. But such varied application of colour in a design may render the letters illegible. A design requires a careful choice of colour and tone, which will render the notice or the poster readable at a distance.

Drawn or painted lettering used in design, with its need for careful and deliberate planning, is a branch of art which appeals to boys more often than girls. The latter usually prefer the use of script writing, with its possibilities for rhythmic flow of line, although the examinations reveal it to be less popular with candidates on the whole.

It is no less essential to consider the function of a piece of script writing than in any other branch of design. Careful planning is, in fact, all the more important because the work has to be carried out with continuous action and a freshness of touch which can only be compared with the handling of watercolour painting.

Many of the considerations that apply to the teaching of drawn lettering within the framework of a general art course apply equally forcibly to the teaching of script writing as a branch of design. Here we are concerned with its use as an art form, as a means of self-expression and creative effort in the use of the pen. The overall unity and beauty of the design, as a whole, are our objectives. Unless the pupil has acquired a familiarity with the natural stroke of the pen, he or she can scarcely expect to obtain a good foundational hand, with the broad pen held at a constant angle to the paper.

Script writing by no means lacks good classic examples going back to the fifteenth and sixteenth centuries or even earlier, when the perfection of writing was more widely appreciated than it is today. It has always been closely associated with the teaching of drawing, as we have noted earlier, and emphasis was always made on the careful preparation of the work. We cannot elevate it, however, to the heights it occupied during many centuries in China, where calligraphy was one of the six most esteemed branches of art, a degree of exclusiveness to which neither sculpture nor architecture were admitted.

In China today calligraphy is respected and appreciated among all classes of society to an extent that would be astonishing in any other country. We can learn much from a Chinese calligrapher. To watch the master at work, as I have done in China, can be a revelation; he ponders over the subtle meaning of the text, absorbs its mood, senses the feeling, then contemplates silently the sheet of absorbent paper spread upon the table so as to visualize the task before him. With sleeve pulled back, he fills his brush with the right proportion of ink and water. Then with brush poised aloft like a torch, so that no drop will inadvertently fall, he pauses a moment to concentrate his thoughts, before swooping suddenly upon the paper, with lightning stabs and darts, alternating with softer, lingering caresses. The words of the Tang Dynasty Master, Sun Kuo-t'ing, provide an eloquent description of this, his favourite, art:

> Here, a drop of crystal dew hangs its ear on the tip of a needle; there, the rumbling of thunder hails down a shower of stones. . . . Some strokes seem as heavy as the falling banks of clouds, others as light as the wings of a cicada.
> A little conducting and a fountain bubbles forth, a little halting and a mountain settles down in peace. Tenderly, a new moon beams on the horizon; or, as the style becomes solemn, a river of stars, luminous and large, descends upon the

solitary expanse of night. . . . The brush never touches the paper but with a purpose.[1]

The technique of writing by means of the brush, with its flexibility and variation of tone, is fundamentally different from that produced by the pen, but the point of view with which the two processes are approached need not differ. The Italian script permits variation in the thickness of upward and downward strokes with an element of shading which provides depth or lightness. The special qualities of the pen, like the brush, must be appreciated and exploited. In former days, the pupils were taught to cut their feathers or reeds themselves, and it is equally encouraged in some schools today; in Africa the use of home-made pens and brushes is often unavoidable on grounds of expense.

It is important for the child to choose the type of script that appeals to him. This is particularly the case overseas. In the hope that candidates for School Certificate would be encouraged to practise the script traditional to their own country, the Cambridge Syndicate has stipulated that the sentences given in the question may be translated into any language. Alas, examiners have seldom seen this option utilized. Chinese boys and girls from Singapore or Malaysia, rather than use the flexible Chinese brush, as they have ample opportunity of doing at home or in the shops, mostly prefer to write their script with the pen in a hybrid style or draw their letters in some debased commercial alphabet. I have seen elegant and distinguished work in schools in Malaysia that was based on the Arabic script so often displayed on the tiles or the walls of the mosques, but it would seem that overseas candidates wrongly assume that English examiners or teachers are prejudiced against any non-European alphabet or script.[2]

The handling of the pen is insufficient by itself. It is the "mise-en-page" that counts. In the planning of an invitation or a notice, the proportions of lines to spaces must be calculated so as to provide a rhythmic unity, as with drawn letters. The provision of border patterns, elaborated capitals or contrasts in colour are no less permissible. If the "layout" is well considered in advance, there should follow a balance between the marginal spaces surrounding the text and the intervals between the lines.

While the use of decoration or pattern is not essential to good design, it may help the pupil to appreciate good spacing and proportions. It may prompt him to respond to the text and enable him to convey something of this in the boldness and depth or the lightness and delicacy of the design. The elaboration of an enlarged capital so that it may spread around the body of the writing may become a source of delight rather than a laboured disfigurement in form or in colour.

Letters [writes A. J. Fairbank] may be considered as abstract forms used for the building up of word-patterns; words as the units for building lines; lines as the units for building the textual column or page.[3]

[1] Translation by Sun Ta-yu, *T'ien Hsia Monthly*, September, 1935, quoted by L. Carrington Goodrich, *A short History of the Chinese People*, 1948.
[2] Recently, there has been a welcome increase in the use of Asiatic scripts.
[3] Alfred J. Fairbank, *A Handwriting Manual*, Dryad Press Ltd., 1932.

Of the various types of design in which letter forms can be used, none have proved more successful in art education and examining than the trade-mark or emblem. Although examination results have shown that this type of question is chosen by relatively few candidates, these are usually among the more advanced designers. Typical among questions set in recent years by the Cambridge Syndicate are a monogram of three initials to occupy a circle of six inches in diameter. Another typical question reads as follows:

> Your county is holding a pageant for which you are to design a simple emblem to be used on handbills, omnibus windows and car windscreens.

The question requires the design to be "contained within a circle of nine inches so as to include a quarter-inch plain coloured border; not more than two colours are to be used on a tinted background". Designs produced on such a theme have proved stimulating, vigorous and appropriate.

There are, of course, types of design, intended to be on paper for which neither drawn nor pen-made letters are required. These may be the end-papers or the covers of a book or wrapping-paper, for which repeat designs would be needed. All the examining boards include questions of this kind in their design papers. Some, like the Cambridge Syndicate, allow the candidates to cut and print their design during the examination. Others, like London and the Southern Universities' Joint Board, require the final work to be submitted separately. Approximately half the candidates taking design tend to choose this type of question.

Children cannot expect to design satisfactorily if they have had no experience of the practical working of the repeat nor the effect of printing. Furthermore, it is only by making the actual article, be it for a book, for a paper handkerchief or for use in wrapping, that the full effect of the design can be appreciated or its degree of suitability recognized. Those who lack this practical experience—and they are only too numerous in schools—tend to treat their task as merely pattern-making, often producing a design of rigid, tiny motifs, stiff, timid and lifeless, the spaces between each repeating pattern ignored, so that the whole lacks the necessary flow of lines from one unit of pattern to another. The subject should be tackled, rather, with courage and enterprise.

The whole problem of how design should be taught has long been a matter of debate and this is clearly shown by the many changes that have appeared in its examination procedure. It is gradually being recognized that all types of design, even those destined to be on paper, are in reality crafts, in which design is merely the preparation for the final carrying out rather than the end-product. Work in the examination-room is best confined to preparatory studies, with the final product to be completed at leisure. Some of the examining boards now ask for this completed work to be submitted separately as evidence of work done during the school year, although this may involve many practical difficulties. The essential aim is to discourage the practising of design purely for examination purposes.

the Crafts

THE teaching of crafts has acquired a certain stigma from its association with the revival of medievalism, which was instigated by the Arts and Crafts movement towards the end of last century. Its pioneers—William Morris, Walter Crane, C. R. Ashbee and their friends and followers—in their efforts to re-create the artist's joy in true craftsmanship with the hands alone, have been charged with seeking to direct civilization backwards, instead of making peace with the new world of machinery.

The form that art is to take in the present world, in which so much is controlled by the machine, is, of course, a problem that the artist of today has to tackle. It is equally the concern of the art teacher. But can a work of art be produced by means of a machine? Morris was uncompromising in his view that a work of art can only be made by hand and, arguing that civilization cannot exist without art, he condemned "production by machinery" as "altogether an evil".[1] Artists, in his view, were to see their true function as craftsmen, designing and creating objects of daily use with their hands rather than remaining aloof in the rarefied air of pure painting and sculpture.

These views were loyally upheld by Walter Crane, who proclaimed, at the opening of the Arts and Crafts Society's first exhibition in London in 1888, that "the true basis of all art lies in the handicrafts". Other societies devoted to the encouragement of crafts were established in the 1880s, such as the Art Workers' Guild and C. R. Ashbee's Guild and School of Handicraft, which began in London and was later transferred to the Cotswolds.

The movement was, surely, fully justified in rejecting any distinction drawn between "crafts" and "fine art", meaning painting and sculpture, a distinction still maintained, as we shall note later. "Crafts", because they are useful, were placed lower than "art", which was assumed to be ornamental. But such grading is purely artificial, since, until comparatively recent years, all forms of art had a useful function. In the art of the past—that of Egypt, Greece, India, Renaissance Italy—there could be no distinction, with any relevance to art, between objects such as a spoon, or a water-jug, which we would regard as craft, and a tomb-painting or a painted altar-piece or, again, a funerary monument, which is sculpture. All of these may be works of art, differing only in their degrees

[1] William Morris, *Collected Works,* ed. by May Morris, published 1910/15.

of importance and all have a function. Before Europeans arrived in Africa a woodcarver might make both a stool, an umbrella-top, a mask and a fetish figure. According to our popular definitions, the two latter objects would be elevated to the status of sculpture, but it is by no means certain that the African carver would not have placed his stool and umbrella carvings in the higher category, simply because they were associated with a high social rank.

The article made by machinery for mass production, which has eliminated the work of handicraft in many parts of the world and is in rapid process of doing so in less highly developed countries, seldom possesses any artistic value whatever. If a work of art must necessarily reflect the thought and feeling of its maker from beginning to end, and this was Morris' view, the use of machinery can only hinder this process. The machine product may reproduce an artist's design, but cost of production and price competition tend to reduce the artist's contribution. In the end the article, say a gas or electric fire or a child's toy, can scarcely do more than please, if it does not repel, whereas the object on which the artist has worked throughout may inspire aesthetic emotion. Nevertheless, we cannot escape the machine; we must seek the means to make it reflect artistic feeling as with any other tool.

The manufacture of mass-produced goods, launched on the world with the ever-increasing speed of a prairie fire, has had a devastating effect on public taste. In less developed countries their introduction has been disastrous from the standpoint of art education, by their competing with, and ultimately replacing, the traditional crafts such as pottery, textiles and dress. Some of the crafts had reached, over the centuries, a very high level in art and technique. The Berber potters of North Africa, for example, who have inherited their technique practically unchanged from Pre-Dynastic Egypt, cannot compete with the uncontrolled importation of cheap European machine-made pottery, enamel and plastic goods. Nor can the Arab weavers compete with cheap machine-woven cloth and ready-made suits. Thus art is gradually being excluded from daily life, leaving only a small part of the world's population any longer able to see or handle objects of artistic merit. But there is the one avenue of escape—the schools—through which some familiarity with art can still be provided.

In designing any object one must understand its construction; for this purpose a knowledge of hand-produced crafts constitutes the essential basis of study, leading to those advanced forms which must depend on the use of machinery. In Great Britain efforts have been made to preserve this basic knowledge and to re-establish some of the indigenous crafts in rural community life. Some schools have greatly contributed towards this survival of craft knowledge.

Are adequate efforts being made in countries overseas—in Africa and Asia—to prevent the extinction of the crafts, so essential to the survival of artistic traditions, before it is too late? Crafts such as pottery, basketry, the dyeing and weaving of cloth, still flourish in many village communities in Africa, India, Malaysia and other non-European parts of the world. Such crafts constitute the only contact which many people can have with the creative process in art. Is this

contact to disappear as it has been allowed to do in the greater part of Europe and America? It is in this that the schools overseas can play their part by spreading an appreciation of the crafts and revealing their value in daily life.

In the process of transition by which the machine must inevitably supplant the hand, it is for the artist, and therefore the art teacher, to seek a positive role, perhaps designing in textures and materials suitable for the machine to exploit. A highly successful pioneer effort is to be seen at Chipping Camden, where C. R. Ashbee's Guild and School of Handicraft has been converted to the manufacture of well-designed articles in stainless steel, under its artist director, Robert Welch. The artist may gain in the future a greater voice in the manufacture of household utensils, and the machine may ultimately reflect his ideas to a closer extent than is possible at present. We may even have to envisage the time when the hand-painted picture might become obsolete, with manufacturers devising a machine to produce paintings or sculpture, if economically worth while.

The art teacher must not be content merely to follow behind these trends. Of all branches of art, the crafts, meaning the production of household utensils, bear the closest on daily life, and an understanding of their design and production is particularly valuable for the education of the community. If we begin with the making of objects solely by hand, such as pottery, basketry, hand-block printing or embroidery, as the fundamental training, there follows the use of such basic forms of machinery as the potter's wheel, hand-loom and printing press. Experimentation with new materials must follow, to be combined with designing for production by machinery. Co-operation between factory and school may permit a more widespread practical teaching in this field. The use of these media may help to develop the creative sense, as an alternative to painting or sculpture, some pupils proving more receptive to the use of clay, metal or textile than to paint, pencil or stone.

Despite the impetus given to craft teaching by the Arts and Crafts movement in England during the latter part of the nineteenth century, few secondary schools, if any, at that time ventured to include the crafts as a branch of art in their curriculum. This was mainly owing to the thoroughly false concept prevalent in official and scholastic circles that the preparation of a design and its carrying out are two quite separate functions. Before Morris' time it was assumed that the artist designed on paper, while the artisan carried out the actual work. As we have seen in discussing design, the early Oxford papers in Drawing provided tests for the different crafts—pottery, textiles, woodcarving, glassware and metalwork—but they were confined to designing on paper. The candidates were not expected to make any of these specified articles, and it is safe to assume that the results showed very little working knowledge of the crafts, and the value of the work must have been negligible. After these tests in design had been dropped, not surprisingly, it needed more than the urging of Morris and his friends to bring the crafts back into the examinations. In fact, this did not occur until the period of the Second World War.

The Board of Education gave a certain impetus in 1938 to the integration of

the crafts with art teaching through the publication of its handbook for teachers.[1] This contained a section on art and craft with the recommendation that both should be treated as "part and parcel of one important branch of teaching". In the subsequent pamphlet (No. 6), entitled *Art Education*, 1946, the Ministry, as it had now become, emphasized the value of craft teaching yet further. For the lower forms, a special course was recommended. This should

> lead to the merging of the pictorial work with the craft work. . . . Some may gain more by concentrating on the crafts which specially appeal to them for their practical value, while others, who have a taste for drawing and painting, may spend a larger proportion of their time on work of a pictorial kind.

The pamphlet laid stress on the value of "teaching boys to use tools" or the use of "a small handpress" or other equipment for printing; Thus

> the art and craft course will have established itself most fully as a means of relating work done in school to practical activities in the outside world.[2]

Reading such welcome statements from official sources on the unity of the arts and crafts makes it the more difficult to credit their continued separation, which still subsists in many schools, especially those under direct state control. George Stevens, who spent much of his teaching career in furthering the synthesis between studio and workshop, bitterly complained in an article written in 1947, that the two branches of art were still by no means treated equally.

> In most schools of general education [he writes] workshop and studio are kept separate, under separate teachers with quite different backgrounds. The art teacher has often "graduate status", but the handicraft teacher, until recently, was often called an "instructor in manual work" and for various reasons not quite accepted as a regular member of a school staff.[3]

While art and craft teaching is more fully integrated at the nursery and elementary-school level for the simple reason that their technology is at such a primitive stage, the cleavage becomes more pronounced as technical teaching advances. This cleavage, as Stevens has asserted, "runs through the whole of our educational system between art and technical education", with the Ministry of Education conducting two separate inspectorates and two separate types of institution—technical schools and art schools—to which pupils may be destined.[4]

[1] Board of Education, *Handbook of Suggestions for the Consideration of Teachers,* London, 1938.

[2] Strong support for teaching of crafts was also given by the Society for Education through Art, which has organized since 1946 holiday working conferences for teachers in the basic crafts.

[3] G. A. Stevens, a paper (apparently not published, but privately circulated) entitled *Values in Craft Teaching*, June 1947.

[4] Stevens pointed out that in the world of adult education the crafts, such as woodwork and metalwork, were regarded as "vocational", covered by the Further Education Regulations, whereas the more "academic" aspects of art teaching came

The separate treatment of these two branches of art in secondary schools was encouraged, even enforced, by the examining boards' provision of quite distinct examinations in art, handicrafts, technical drawing and needlework. These separate compartments are still maintained today. Handicraft is generally understood to mean woodwork and metalwork, but the degree to which their examination impinges on that of art is shown in the Oxford and Cambridge Joint Board's syllabus in Handicraft; this requires candidates to make working designs on paper with sketches in freehand, and a written paper revealing a "study of fine craft work from the seventeenth century to the present day", tests which ought to rely on a general study of art.

It may be of value to compare the separate tests: the Oxford papers in Woodwork, for instance, at both Advanced and Ordinary level for 1959 required designs sketched on paper with written answers, such as the following from the Advanced level paper:

> Sketch a clock case which is suitable for a veneer finish and then carefully explain the various stages in making it.
> Make neat drawings of a typical dining-table which might be found in a middle-class household in the years 1759, 1859 and 1959 respectively.
> The headmistress of an infants' school has asked you to make a wooden horse on wheels for use in her reception class. Make a sketch design of such a toy showing clearly how you propose it should be made.

In the Needlework paper at Advanced level for the same year we read:

> The pale yellow linen curtains and cushion covers of the school rest room are to be decorated with embroidery. Draw suitable designs, illustrating the colours and stitches to be used.

Other questions in the same paper concern designing and illustrating articles of dress. Yet in all these subjects we find precisely similar types of question set in the Art syllabus for the same year. Under the heading "Fabric Printing" in its Design paper for Art at Advanced level, we read:

> Sketch some designs for a patterned fabric to be used for a full-skirted summer party dress.
> Sketch some designs for a patterned fabric to be used for curtains, etc.

The Design paper in Art also includes a section on dress, with questions such as "Design a shirt-waister dress for afternoon wear", which thus repeats questions set in the Needlework examination. Each may encourage an entirely different approach to the craft, especially since they are assessed by separate teams of examiners, who may have no contact with one another.

It is obvious that these separate examinations encroach on one another and

under Adult Education Regulations, employing a different kind of teacher with a different scale of fees. When crafts were introduced into a W.E.A. class in art appreciation its grant was withdrawn. (*Values in Craft Teaching*, 1947.)

that their independent existence arises from catering for two distinct compart-ments—the studio and the workshop. The policy has come about in response to the centuries-old concept of the artist as distinct from the artisan, a concept which is now congealed through the examinations. Since most of the examining boards provide a separate syllabus for handicrafts, such as Woodwork, Metal-work and Needlework as well as other crafts, schools have to decide whether to take them merely as one of several sections in the art paper, or to take handi-craft or needlework as separate examinations, divorced from art, to which they properly belong.

I have often found that schools catering for handicraft or needlework tend to abandon art altogether. This is especially the case overseas, where the separation of craft from art has no validity whatever in native tradition. I visited schools in Zanzibar, where I was told of the difficulty in combining art with these other branches of work. There was no time, I was assured, for both. The same circum-stances prevailed at Kitwe in Northern Rhodesia (now Zambia), where classes were provided in technical drawing, woodwork and metalwork, but not in art. I noted that the sense of design and the ability to sketch the appearance of the completed article was very elementary, because no time was available for the proper study of freehand drawing or design.

As long as the examining boards continue to provide separate examinations in certain branches of craftwork without any obligation on schools to combine this with a basic study of art, the "split" nature of our civilization, which Sir Herbert Read has so cogently condemned, will continue to flourish.[1]

These separate compartments in the examinations and in the school curricu-lum not only trespass on one another's sphere of activity but tend to defeat their respective aims. For example, in art the pupil is generally discouraged from using instruments in order to place the utmost reliance on the use of the eye. But this rule is reversed in the workshop. Sir Herbert Read has rightly commented on this. The two activities must meet "in the sphere of formal values":

> The boy who is making a bookcase or a tray, or the girl who is making a dress, will only reach that region if what they make by measurement is, in the process of making, determined by a sense of design, [he proceeds.] Nothing will inhibit that instinctive sense so quickly as the premature use of instruments of precision. The senses must first be educated. . . .[2]

[1] The passage referred to occurs in Sir Herbert Read's *Education through Art*. In discussing the separation of art and handicrafts, he writes:
"They should both be treated as merely different media for the expression of the same aesthetic activity. But in many schools especially public schools for boys, the studio and the workshop are offered as alternatives, and there is a bias, all the stronger for not being openly expressed, in favour of the workshop. . . . The distinction merely reflects the 'split' nature of our civilization, a civilization which can complacently tolerate that divorce between form and function, work and leisure, art and industry, which is basically the divorce between mind and matter. . . ."
[2] *Education through Art*, 1945.

George Stevens equally condemns "this pathetic reliance on instruments . . . this split between design and making, between visualization and geometrical construction, between intuition and logic, almost endlessly from craft to craft".

> The besetting danger with the crafts [he writes] is for the mechanical to drive out the aesthetic, as bad money drives the good out of circulation altogether, and the danger is all the greater, the more numerous and the more elaborate are the processes—the technology.[1]

The crafts should provide the means for studying art, so that the whole subject constitutes a balanced course. This is not possible when crafts are taught and examined in isolation from other branches of art.

When Sudhir Khastgir took over the art teaching at the Doon School, India, on its foundation in 1935, he introduced a wide range of arts and crafts. He obtained the assistance of a stone-carver from Jaipur, a bookbinder and a local potter: "The potter visited the school on Sundays only", writes the present art master.[2] Boys could practise any of the following:

> painting in oil or water-colour, engraving on wood or lino, embossing leather, modelling clay, relief-work in cement-concrete, stone- and woodcarving, pottery and bookbinding.

The school has recently added a further range of crafts, such as batik on cloth by means of bees-wax and dipped into coloured water, or on leather with the help of glue. "Ceramics will be introduced", Mr. Mitra explains, "in addition to the pottery and terracottas. We have a mind to introduce stained-glass painting and welding sculpture".[3] Thus the art department has become, as it should be, a workshop.

The Cambridge Syndicate was the first, as we have noted previously, to include the submission of actual craftwork in its Tropical Art Syllabus for Overseas in 1937 and again for the Higher School Certificate taken by home centres in 1944. For Art in School Certificate, however, a written description of craftwork sufficed until 1948, when it was withdrawn and candidates at both levels were permitted to submit pieces of craftwork together with notes and drawings. The Syndicate was thus the only examining board to have renounced designing on paper for three-dimensional craftwork in its Art syllabus, but other examining bodies now allow the submission in Craftwork in their Art papers.[4]

[1] G. A. Stevens, *Values in Craft teaching*, 1947.
[2] Mr. Rathin Mitra, art master of the Doon School, Dehra Dun, India, in a letter to the author.
[3] Many candidates from India and Malaysia submit splendid designs, pictorial as well as abstract, in batik by painting the cloth with the wax resist. The "tie and dye" method in textile design is also used with great success by candidates for the Syndicate's craft examination.
[4] London allows the submission of an actual piece of craftwork, at both levels, made within the previous two years, combined with designing for the same craft in the examination-room. It has recently introduced a separate syllabus for crafts. The

The inclusion of craftwork in the Art examination has given enormous encouragement to the practice of crafts as a branch of art. Candidates taking this subject for Cambridge alone now number several thousand, having increased annually by as much as twenty-five per cent since the termination of the Second World War. At Advanced level today, as many as one-third of the candidates in art include the crafts in their choice of papers.

There has been the same spectacular increase in the popularity of the crafts in oversea schools. From very small beginnings fifteen years ago some four thousand oversea candidates, or nearly fifteen per cent of those taking art, now enter crafts as one of their papers at Ordinary level, and the Syndicate has to make special arrangements for the reception and assessment of this huge consignment of craftwork.

It has sometimes been remarked that if only one kind of material was available for craft education preference should be given to clay. Basically, this material does not depend on the use of tools, since the fingers and the palm of the hand may suffice, so that children can begin using it at an early age. The wheel is by no means essential for the making of pots, as the masterpieces of pre-dynastic Egypt or of pre-Columbian America fully testify, and many regions of the world today enjoy strong local traditions in the making of pots by the coil or building methods without the use of the wheel.

When visiting a teachers' training college in East Africa I found that the teacher who was from England had assumed, very naturally, that the acquisition of a potter's wheel, was necessary, and his male pupils were busy, though perhaps reluctantly, learning to make pots by this means. I could not help commenting on this procedure, firstly because pottery in Africa is a woman's craft, and secondly because in this particular part of Africa they have from ancient times made superb pottery without using the wheel, and must know far more about the craft than we do. The girls at this college, who came mostly from neigh-

Southern Universities' Joint Board requires a design for a craft to be made during three hours in the examination-room, as Stage 1, followed by the actual execution of the same craft during five hours under the same conditions, as Stage 2. The test applies equally at both levels.

Both the Associated Board (as will be mentioned later) and the Welsh Committee offer separate examinations in various crafts which can be taken without combining them with other aspects of art. Moreover, the Welsh Committee does not accept practical craftwork as an alternative in its art syllabus, whereas the Associated Board offers an alternative syllabus, Art and Crafts, which does combine the two branches of art.

Until recently the Oxford Delegacy and the Oxford and Cambridge Joint Board were alone in expecting no submission of craftwork. The latter still does not include the crafts in the Art syllabus, and the former required only a design for a craft to be made in the examination-room, but there had to be evidence that candidates had previously practised the same craft. Since 1964, however, the Delegacy has accepted certain categories of craftwork, executed during the previous year, in support of the candidate's script in Design at Ordinary level. A special syllabus for pottery may be introduced in 1967. Northern Ireland sets a paper, only, on "Design for a Craft".

23. Drawings submitted for G.C.E. A level, 1965:
a. (*left*) D. J. Dahl b. (*above*) Wendy Morane-Griffiths c. (*below*) A. Robinson

24. Work submitted for Cambridge G.C.E. Examinations (Paper 6, Craftwork) *a*. Ghana *b*. Rhodesia *c.*, *d*. London

bouring Bunyoro villages, were not attending the pottery class. Otherwise they might have demonstrated how their mothers chose and prepared the clay, moulding it in the hands to form superb water-vessels and cooking-pots with thin, but strong, even walls, which would be fired in earth kilns. I felt that these girls were probably laughing at the efforts of their brothers, who must have been embarrassed at thus doing women's work. An electric kiln had been imported at considerable expense, but the girls could have shown how earth kilns had been constructed in the villages for generations past.[1]

The teaching of pottery is hampered in some regions by the difficulty of obtaining clay of good texture, unless the school happens to be situated near suitable clay deposits. This craft is, nevertheless, one of the most popular in schools, more so than the comparatively small number of candidates in the G.C.E. indicates; the submission of pottery for examination presents obvious practical difficulties in its transport.

The practice of pottery demands a very severe test of the pupil's ability and imagination. To master its technique requires a great deal of patience, and many secondary schools are unable to offer sufficient time for it. It is not surprising, therefore, that the general standard is less high than in some of the other crafts. It is often found that candidates for the G.C.E. submit pots which are very mechanical and uninteresting in form, with a misunderstanding of the function of decoration or the suitability of glazes. Sometimes pots almost identical in shape will be submitted by several candidates from the same school as if they were working from a set pattern, instead of treating pottery as a means of self expression and using their imagination in the creation of form. On the other hand, there are schools where splendid pots of individual character, fine decoration and glazing are produced.

The beauty of clay lies in its endless possibilities. So much can be done with it. The handling of clay may thus lead to sculpture, though this is perhaps one of the most difficult branches of art to be taught in schools. The firing of terracotta presents technical problems which are difficult to master without long experience. Building on to an armature presents equal difficulties in securing the required strength. The pupil may well be rewarded, however, with achieving a sense of balance and tension between the solid masses and intervening spaces, which he would not otherwise obtain.

Sometimes there are gifted pupils who can tackle sculpture in wood, if sufficient time can be allowed for it, but the problems involved are entirely different from those of modelling. It is chiefly from overseas, and especially West Africa, that fine woodcarving is submitted for examination. Schools in

[1] The wasteful introduction into Africa of alien methods was also demonstrated in the teaching of basketry. I saw African pupils learning to make wastepaper baskets with flat wooden bases, as used in England, although so many of the pupils came from homes with the uneven floors characteristic of many African villages. Their own superbly designed baskets usually have round bases suitable for suspending from the shoulders or from the wall.

England can scarcely expect to rival that of West African schools, where many boys have been familiar with the adze from childhood. They can apply this dangerous-looking tool with unerring aim and dexterity in carving from a block of wood held securely between the knees; they would have previously prepared the wood from a section of tree-trunk carefully selected in the forest.

This ease in handling tools, sometimes ambidextrously, according to convenience, is not always directed at the right result. In earlier times custom and beliefs decreed the types of object that might be carved. Deprived of such guidance, the problem that faces the African boy today is what to carve rather than how to do so. Gabriel Pippet, who was teaching art at Achimota on the Gold Coast in 1931, in recounting his impressions of the woodcarving class, found the boys chiefly anxious to tackle quite unsuitable tasks, such as carving a model of a motor-car or a bicycle.[1] Visiting a primary school on the slopes of Mount Kilimanjaro in Tanganyika in 1959, I watched the boys occupied in woodcarving. Some showed me spoons, which I assumed at first were the typical wooden ladles used in African villages. A closer look revealed that they were carved imitations of an English metal spoon, and one boy proudly produced one of these as evidence that he had copied it.

In Sarawak, I found the boys at the Secondary School in Kuching carving frames for photographs. When my face fell, as it were, at seeing such misdirected effort, the master asked what else they might tackle, and I suggested the boys should study the splendid Malay and Dyak carved puppets, roof terminals, chests, etc. in the Kuching museum, in order to observe how good designs are always appropriate for their purpose. Woodcarving was equally misdirected in England in past times. Our grandmothers used to make tables unusable by carving floral decorations on the table top.

If crafts in wood or clay are more nearly related to drawing, textiles are more closely related to painting, with their dependence on colour and texture. It would be ideal for an art class to practise both textiles and a craft in three dimensions, but schools can seldom provide a kiln and potter's wheel as well as looms. Weaving is not a popular craft in schools in this country, because of its practical difficulties, and comparatively little weaving is submitted in the examinations. There are a few schools, however, at which this craft is brought to the very highest level, with the pupils trained to spin their yarn by hand and experiment with vegetable dyes.

For the child who is not a specialist in weaving it is the originality of the design with its scope for combining colour and textures (assuming that yarn of good quality is available) that matters chiefly. There is not much educational value in merely weaving a length of cloth with a thoroughly conventional pattern, unless there is evidence of personal taste or experiment.

In schools overseas weaving is taught in those areas where it has been traditionally practised. In East Africa, where the loom was unknown in pre-colonial times, I seldom found it practised in the schools. But this is not a satisfactory

[1] *The Arts of West Africa*, ed. by M. E. Sadler, 1935.

Batik cloth, pupil of Dow Hill School, West Bengal, 1960

reason for its neglect in education today. In fact in Nairobi in 1934, Mrs. Trowell and her class of girls experimented with weaving rugs of sisal or coconut fibre for the first time. In India, where weaving has long-established traditions, relatively few schools, when I visited them in 1952, provided looms. Where looms were provided, as at the Scindia School in Gwalior, splendid cloth was produced, rich in colour and pattern, with an even quality throughout.

Perhaps nowhere has weaving such a hold in communal life as in West Africa, where looms were introduced from the Arab North and from India some centuries ago; this has been reflected in the work of the schools. Meyerowitz founded a textile department at Achimota College in 1942 with spinning, dyeing and weaving of local fibres, and this was extended to the local crafts centres which he established in various parts of the country.

With this living tradition to draw upon, it is only to be expected that the woven fabrics from Nigeria, Ghana and Sierra Leone, submitted for the Cambridge Examinations, have aroused the examiners' admiration, whether they are cotton cloths in white, brown or natural indigo from Nigeria or *Kente* cloths from Ghana with their elaborate, mosaic-like, patterns of brilliant colour. The Syndicate's report issued in 1957 contained a comment as follows:

> The work submitted has shown very little of the deterioration which so often sets in wherever commercial values are substituted for aesthetic or social ones. The work from these centres has usually revealed its practical use, related to the normal requirements of the community, and it is fortunate that schools have developed their craftwork on the methods practised locally, rather than introducing alien crafts or methods which have no relation to the needs of the community.[1]

Judging by the examination entries, embroidery is much the most popular of crafts practised at schools, and the number of candidates submitting it, both from home and oversea centres, far exceeds that of any other craft. This is presumably because it does not require any expensive equipment and the materials, silk or wool, are easily obtained. Pupils can experience delight in texture—the contrast of silk on muslin, of rough textures against smooth. They can build their design out of varied materials juxtaposed—wools, silks, velvets, tweeds—producing a mosaic of rough, smooth or glossy surfaces, the whole underlined by the stitching.

Although embroidery has a long tradition in this country, schools in England cannot compete in technical mastery with those in the East, especially Singapore, Hong Kong and Malaysia. The Syndicate's report of 1957 remarks on this as follows:

> In almost ninety per cent of the work submitted (i.e. from the Far East) there is a great perfection of stitchery beyond anything produced in schools in the United Kingdom..
> Although there is, unfortunately, some impact of alien western ideas of design,

[1] The work is now examined in Accra and Lagos by the West African Examinations Council.

on the whole the high tradition of technical excellence and quality of design
handed down in the Far East is still revealed in most of the candidates' work.

It is often difficult to unite technical ability with suitability of use. How often
do we find that inventive stitching, bold and rich in colour, with charm of
detail, are applied to decorative panels intended for hanging on the wall in
frames, so that the flexibility and texture of the cloth cannot be fully appreciated?
Such panels merely compete with painting, which is a more suitable medium
for the expression of pictorial ideas. The embroidery of scenes in cities or jungles
of the East, however interesting, can scarcely improve on a painting; the em-
broidery of legendary stories is more satisfying. But when the embroidered panel
is merely copied from a popular painting or, worse still, from an illustration in
a magazine, or perhaps from the photograph of some familiar personality or
sports hero, one can only regret the debased purposes to which this ancient craft
has been assigned.

But such copying of paintings in embroidery is no more to be deplored than
the use of motifs drawn from children's picture books. The Oxford examiners'
report, published in 1958, puts this issue:

> It is difficult to understand why subjects such as bunnies, pussy-cats, and fairies
> should be so popular with candidates [who should] remember that the pattern
> qualities of the subject in embroidery, as in other crafts, are more important
> than their sentimental associations.

The reason is, of course, that it is easier to draw these elementary pictorial
symbols than to invent an original design. Pupils are taught the bare technique
of embroidery without having had any practice in design. When visiting a school
in northern India, I was shown table-mats and handkerchiefs embroidered with
kittens and rabbits. I criticized the girls for such a puerile choice of subject, but
the teacher rose to the defence, retorting that the girls did not choose their
subjects—she did.

A sense of pattern is one of the gifts peculiar to childhood. How often is this
lost, or at least diminished, in the process of imparting a knowledge of technique.
The design for a textile, whether woven, embroidered or printed, can become a
mere exercise. It is only when the child thinks in terms of the material and its
use that the imagination is brought into play with lively and original results.

A feeling for design and function may find an outlet in making puppets,
which the Ministry of Education's handbook of 1946 recommends for children
as "an outlet for their sense of character and appropriateness in devising and in
dressing".[1] Puppetry has found its niche in schools, because children can learn
to use their puppets and can themselves observe and criticize their success or
failure in representing the characters of the play. Freedom of movement is an
essential quality in the puppet, and the making of its costume may appeal to
the pupil's sense of colour.

[1] *Art Education*, pamphlet No. 6.

When children design and create objects which they can themselves use they may experience a sense of adventure and excitement and appreciate their success or failure, and this is the essence of art education. Ideally, children should be taught to make, when possible, the things they need to use and equally to use the things they have learnt to make.

S. J. Urquhart, West Buckland School. Display card for a careers exhibition, 1965

Art Appreciation and History

THE value in studying the history of art has been consistently recognized since the eighteenth century and to some extent even earlier. In his *Discourses to the Students of the Royal Academy*, Sir Joshua Reynolds, like Fuseli and Barry who followed him, concentrated on an analysis of the work of the Old Masters, as the supreme model on which students should base their style. At the same time, Winckelmann's researches in Rome were arousing an intense public interest in the art of the ancient world. The history of art has never ceased to be a subject for constant study ever since. Yet in general education it occupied, and still occupies, a very modest place.

Oxford and Cambridge duly recognized the importance of the subject when they launched their respective examinations in 1858. Both universities included a paper on the history and principles of the arts of design, as it was then described, covering both the antique and Italian art. Yet within a few years we find the subject dropped from the examinations and not reintroduced until well into the present century.[1]

The subject was not dropped because of any indifference on the part of the examiners. On the contrary, Dyce, Ruskin and Redgrave, as we noted earlier, made a point of strongly emphasizing its importance in art education. It could only have been omitted because the standard of achievement was disappointingly low and there was insufficient demand for it from schools. When London in 1915 introduced the history of architecture in its art syllabus—the first of the examining boards to do so in this present century—it was announced that the paper would be set only if schools applied for it. The same rule was made when the history of painting was included in the syllabus a little later. There can have been few candidates, since the papers were seldom set.

By 1924 there were no more than fifty candidates in both papers out of a total of 3,677 candidates for the London General School examination in art, and they were confined to only three schools. Even in recent years, the number of candidates in the history of art at Ordinary level has barely numbered two to three per cent of the total candidates in art with scarcely any overseas. How are

[1] The Oxford Delegacy, as previously noted, included the history of architecture in its syllabus for 1897, with the papers to be set only if demanded. The demand was obviously insufficient, since the paper was soon afterwards withdrawn.

we to account for this neglect of the subject in general education? The answer must lie in the difficulty that schools experience in teaching the subject.

In the past many schools may well have hesitated to enter candidates because the papers covered such a wide range. This was evident when the Cambridge Syndicate introduced its "History of Art and Architecture" in 1925, the questions ranging over European painting and sculpture from the thirteenth century to the present day and the architectural questions covering both the ancient and modern world.

The Oxford and Cambridge Joint Board set a paper on the history of art for the first time in 1926. This was available in the Higher School Certificate only and was divided into three sections dealing with architecture, the arts and crafts of daily life and the chief schools of painting, the work to be illustrated with sketches. The paper was optional and only one candidate attempted it. Six years later there was again only one candidate. In this same year a similar paper was offered at School Certificate level, including "Greek Art".[1]

It must have been very difficult to prepare candidates adequately when the area of study was so vast.[2] Candidates could make only a very cursory survey of the subject, hoping to find questions they could answer, and it is not surprising that the Joint Board's examiners considered the results "vague and inaccurate".[3] In recent years, some of the boards have made efforts to reduce the area of study and, as the Syndicate suggests in its syllabus, "encourage candidates to study shorter periods rather than make a superficial study of the whole". While this may produce better examination results the wisdom of this solution from the point of view of art education is debatable. Reducing the range so as to provide specific periods announced in advance, and accompanied by an appropriate list of books, does not solve the real difficulties in teaching art history, which hinge on the allowance of time.

The study of the history of art has always tended to fall between two stools. The school history stream ignores the subject because it belongs to the art course, and the art class cannot allow sufficient time for it when preference must be given to the practice of art. Candidates who might like to include the subject in their choice of papers for the G.C.E. at Ordinary level know that most of their time must be given up to the practice of drawing or design in which their other two papers must be taken. Only the exceptional candidate can hope to

[1] The Joint Board now offers at Ordinary level a choice of papers—either British Painting to 1890 or Architecture based on *The Parish Churches of England* by J. C. Cox and E. B. Ford, one being obligatory. At Advanced level, papers on European Painting and European Architecture are both obligatory.

[2] The University of Adelaide's examination for the Australian School Leaving Certificate offers an extreme example. In 1956/7 the paper catered for the results of a three-year school course, with questions covering the arts of Egypt, Assyria, Greece, Rome, Byzantium, down to the early twentieth century, though "only in outline", including "the pictorial effects of the Post Impressionists". Surely this is far too wide a range for any boy or girl to tackle with the limited time allowed for it at school?

[3] Examiners' Report for 1926.

reach a sufficiently high standard in art history if most of his available time has to be absorbed in practical work.

At the average public school or grammar school the boys and, even, girls seldom have more than two periods a week for art, and this is often voluntary. Sometimes they attend the art class only as an alternative to carpentry or some other handicraft. Circumstances may have improved compared with a century ago, but they remain such that the study of art can only be treated seriously by the few who are specially interested and are not particularly good at any other subject. All boys and girls ought to learn about art and the great figures that mark its history. It should not be confined to those who are interested in any case and will learn about it on their own.

At Advanced level, the circumstances are often very different. The examination caters for candidates who plan a career in which art may be useful, and are likely to be granted extra time at school for preparation. It is not surprising, therefore, if many more candidates choose the subject at Advanced level compared with Ordinary level. Even so, wherever the subject is optional it is the least popular of the art papers, although taken by some thirty per cent of the Advanced level candidates in art. This is very different, however, from the small proportion taking the subject at Ordinary level.

The Oxford and Cambridge Joint Board is alone among the examining bodies since 1947 in making the history of art, which includes architecture and painting, compulsory at both Advanced and Ordinary levels.[1] To what extent this has served art teaching is hard to say. It has been approved in some quarters on the grounds that a knowledge of art history is more important for the lay public than the ability to practise drawing or painting. It has also been urged by the Art Panel of the Secondary Schools Examination Council in view of art history forming one of the requirements of art students seeking the new Diploma in Art and Design.

On the other hand, the element of compulsion on candidates to include art history in their choice of papers has equally been the target of criticism. Art teachers often claim that candidates who have a talent for drawing and painting fail because they are weak in expressing themselves in words. Do these various views take into account the circumstances? With so little time for art in the curriculum, the obligation to include its history in the choice of papers must prove a deterrent to many who would otherwise enter for art. This factor may well account for the relatively small proportion of candidates choosing art in the Joint Board's examinations compared with other boards.

The difficulty that teachers experience in combining art history with practice in the limited time allowed them is altogether unsatisfactory from an educational point of view. The two branches of study ought to go hand in hand. The practice of drawing or painting alone does not enable the pupil to

[1] Some Boards, such as Oxford, Wales and Durham, have made the history of art obligatory only at Advanced level. Others, like Cambridge, have made the subject optional at both levels.

understand works of art or recognize artistic merit, but neither can this be achieved solely by studying the work of the Masters. It must depend on combining creative work with a study of the masterpieces of art. This is the main issue: Time ought to be found for both.

It is not easy to draw a line between general history and the history of art. In fact, they ought not to be in separate compartments. If one seeks to understand the work of Goya, one must have some familiarity with the social struggles that followed the Napoleonic invasion of Spain, and if one is to enjoy Hogarth, one must know something of urban life in eighteenth-century England. It is equally true that a knowledge of art may contribute to one's study of history, with domestic life and customs so often laid bare in the paintings and sculpture of the past.

Art history may sometimes be included in the general history course, and some examining boards, notably Cambridge, are now allowing art history to contribute towards the G.C.E. in history, though very few history candidates avail themselves of this concession.[1] Ideally there ought to be an art historian on the staff of every secondary school. We may justly claim that it is just as important to know something about Michelangelo, Giotto or Rembrandt as to know about figures in political life, but most boys and girls leave school well acquainted with the kings and queens of England, but barely knowing the names of the greatest figures in art.[2]

The study of the history of art or architecture has not greatly changed in character over the years. In fact, comparison of the examination papers set today with those of a century ago reveals much less change than in the practical branches of art study. If Dyce or Ruskin were alive today, we might readily ask them to set our question papers in art history, knowing that they would not prove divergent from those set by our contemporary colleagues. The main differences would be found in the emphasis, with much greater attention paid, for example, to the classical and ancient world, and much less specialization in a narrow field.

There have been inevitable changes in taste. The Victorian favourites—Guido Reni, Salvator Rosa, Murillo, Corregio, to name a few—have been relegated to a back seat in our time. One of the great treasures of the National Gallery, as it was considered to be half a century ago, Rosa Bonheur's "Horse

[1] Courses in art history are now allowed to contribute towards a history degree at many of our universities.

[2] Mr. Nix-James (in the letter quoted previously) deplores the absence of art history in Anglo-Indian schools:

"I have seen such names as Leonardo da Vinci, Galileo, Beethoven etc., inscribed on walls and surrounded by laurel wreaths, but doubt if one boy in a hundred would have been able to say which was a musician or painter."

The standard of art appreciation is indicated by a candidate writing as follows:

"Mona Liza was painted by a man who was equally as great as the original Mona Liza. And so this might be one of the reasons why Leonardo spent most of his precious time in painting this portrait."

Fair", reproductions of which were to be found in every home or schoolroom, has been consigned to the Gallery's cellars for many years past, in company with C. L. Dyckmann's "Blind Beggar", so greatly esteemed formerly and now unknown to connoisseur or general public.[1]

If there has been no great change in the history of art papers themselves, there has been no such consistency as regards the purpose or policy in setting the paper. We have already noted that Dyce and Ruskin differed in 1857, with Dyce pressing for "general information about art" rather than an expression of views.[2] Ruskin, on the other hand, condemned what he described as "received opinions" and urged the need for "critical power" so that a candidate could "form and express judgments of his own."

This same conflict of view, whether to demand aesthetic criticism or factual information, persists today. Most examining boards have sought a little of both. Very few candidates, especially at Ordinary level, are able to offer original criticism of any merit. On the other hand, is there any value in retailing information, derived from reading books about artists or works of art, if unaccompanied by any personal reaction? The candidate who wrote that Rembrandt "cut off his own ear", having read a life of Van Gogh, would not have shown any more aesthetic understanding had he not got the names mixed.

Pupils are often tempted, on the other hand, to offer their own opinions as a means of concealing a total ignorance of the facts, as, for example, the one who suggested that Venus de Milo "has never been put together, because her arms were never found. Some" we are told, "say that the block of stone was not big enough to include the arms, and that the sculptor, rather than give up his work, continued making her armless." One may enjoy the candidate's fanciful, if inaccurate, description of the "Parthenon in Rome with its famous sculptures of David and Goliath"! Is it really desirable, however, to invite candidates to write about works of art which they have never seen and who derive their information merely from misreading?

There are those who claim that boys and girls can only gain an understanding of art through direct contact and by exploring their own environment. This was the basis of the paper on art appreciation, obligatory to candidates at Ordinary level, which was introduced by Bristol in the revised syllabus of 1948. Candidates were to be tested in their knowledge of their own town or village and of pictures, sculpture or craftwork which they had actually seen. The aim was to test the candidate's taste.

Whether boys and girls, especially those at Ordinary level, are capable of aesthetic taste is a matter for debate. They are seldom able to discriminate between works of art in the way adults can. Children's taste is usually the product

[1] The popularity of Dyckmann's "Blind Beggar" is revealed by Raphael Tuck having made it his first choice for reproduction in photogravure for the first series of postcards of "Masterpieces of the National Gallery" in 1901—the earliest attempt to popularize the National Gallery in this way (Richard Carline, *Pictures in the Post*, 1959).
[2] Sir T. D. Acland, *Middle Class Education*, 1857.

of their home environment or it may merely echo that of the teacher. It is surely sufficiently welcome, if pupils can observe, draw and describe the works of art or architecture they have seen and which interest them, perhaps giving their reasons for being interested, without attempting the self-analysis involved in determining their personal taste. They may well be asked to indicate preferences in an indirect manner, and when their work reveals good taste or bad taste, the reason can be explained to them.

The essential aim is to promote the powers of enjoying and appreciating works of art, and this was the real function of the Bristol scheme. It lead pupils to reveal their personal reactions, and thus convey some element of criticism, though this may have had little merit in itself. Children gain nothing by trying to dispute the greatness of a master, like Leonardo or Titian, as Ruskin was at pains to point out, and we might equally add Cézanne or Picasso. But there is value in their learning the reasons for such greatness. Direct contact with actual works of art in public galleries or with masterpieces of architecture probably provides the only sure way of learning to distinguish artistic merit.

It is because a serious study of the history of art and architecture is beyond the reach of most pupils taking the G.C.E. at Ordinary level that the Cambridge Syndicate introduced some years ago its paper entitled "Study of Buildings" as an alternative to the "History of Painting". It was hoped that the new paper would encourage the observation of actual buildings. As explained in the syllabus for art at Ordinary level, candidates were

> to explore their own locality, to interest themselves in the social and historical background as revealed by its buildings, and to examine intelligently places of architectural interest further afield.

The opportunities for carrying out such a programme were to be found, according to the Cambridge syllabus, by studying any of the following:

> country houses and cottages (old and new), village churches, farmhouses, ancient inns and almshouses [as well as] cathedrals, town halls, blocks of flats, factories, and power stations of larger towns.

The Cambridge candidates were asked to provide sketches and, perhaps, draw the plan and elevation of a building they had studied, or discuss building materials, such as iron, steel, wood or glass. Oxford's paper on "The History of Architecture", alternative to the "History of Painting", is similarly confined to buildings in England, which the candidate might have seen, though placing more reliance on technical knowledge. Candidates at Advanced level are told: "Whenever possible, make use of examples to be found in your own locality."

If we agree that the main object of teaching art at Ordinary level is to encourage an intelligent interest in the visual world, develop observation and memory and exercise the power of aesthetic judgment and discrimination, such questions dealing with a pupil's environment provide the most admirable corollary to the practice of drawing and painting. Such study can be undertaken

without undue dependence on reading, if the pupil is pressed for time. Much can be learnt by visits to buildings or public galleries, helped by attentive observation and discussion.

Obviously, some technical or historical knowledge is desirable if the maximum value is to be obtained by direct study of works of art or buildings. But is it wise at Ordinary level to insist too heavily on such specialized knowledge? For instance, the Oxford examiners' report on the results at Ordinary level for 1957 emphasizes that "a grasp of the main constructional principles of the Norman and Gothic Church" is essential to success. Candidates must also have some "rudimentary idea of the concentration of thrusts". However desirable such elementary technical knowledge may be, should success be conditioned by it? If a pupil is told that he cannot hope to acquire an appreciation of art or of buildings without some degree of technical knowledge, he is likely to be deterred from the outset. Is it not chiefly important that he develops his powers of careful observation of forms and structure, detail and mass, reveals his interest and reactions, and displays some aesthetic judgment?

The examining boards have often included questions of a general nature which may test a candidate's power to think out problems concerning art, as in the following example from an Oxford paper at Ordinary level:

> How has the introduction of new materials influenced the design of modern buildings?

While some technical knowledge is desirable for answering such a question, an interesting answer can be based on intelligent observation. Such general questions may be set in relation to painting, as in the following example set for the Cambridge oversea candidates:

> Explain what you think the human eye and hand can give you which the camera cannot; in other words, the difference in function between painting and photography.

Or again the following from the Cambridge "History of Painting" at Ordinary level:

> Cézanne is reported to have said of Monet "only an eye, but my God what an eye". What did he mean by this remark?

The Oxford and Cambridge Joint Board has made a point of confining its papers on the history of art and of architecture to questions which are based, in the main, on prescribed books, obligatory at Ordinary and Advanced levels. Thus the Board bases its examination on the evidence of knowledge wholly derived from reading, preferring a sound if derivative knowledge and excluding the expression of personal opinions or observations. When visiting Rhodesia several headmasters mentioned to me that an examination on art history of a factual character would be of value for its incentive to read books which the boys would otherwise ignore. Some teachers, on the other hand, argue that a pupil's interest in art is likely to be inhibited by too much emphasis on textbook

questions, and support the guidance offered by the Cambridge Syndicate as follows:

> Coherent recollection of works, clear descriptions and imaginative grasp of relevant ideas will receive more credit than mere catalogues of facts and recorded opinions.

At Ordinary level it may well be questioned whether a general survey of art history, sufficient to develop the pupil's interest in the subject, is not more valuable than a study in depth in a narrow field. As the Secondary School Examinations Council has been at pains to emphasize, the purpose and aim should be to foster appreciation over a reasonably wide range rather than one narrow period. Surely the tendency for "cramming" to emerge in art is to be avoided? Factual information is necessary only to feed the full enjoyment of works of art. It must not provide the main aim by itself. At Advanced level the problem is often very different, and the more specialized knowledge both of historical facts and technical issues may prove essential for candidates who wish to prepare for the art school or other college of further education.

The Council for the Indian School Certificate, while using the Cambridge syllabus in art, the papers being set and the work examined in England, provides a special section on Indian art for inclusion in the art history paper. This is set and examined in India, and is rightly added to the Cambridge paper.[1] Candidates are required to answer two questions from this section on Indian art. Thus a valuable step has been taken towards the encouragement of an appreciation of art in the Orient and it might be similarly tried in Africa and Malaysia.

Recently, the Cambridge Syndicate withdrew its two papers at Ordinary level, "The Study of Buildings" and "The History of Painting", and combined them to form a single paper entitled "The Study of Art", which also includes a third section of general questions, some of which can only be answered by reference to the illustrations provided with the paper. While this paper is designed for candidates at Ordinary level, it is also available as a separate subject on its own for sixth-form candidates, without the obligation to take any of the other art papers. Such candidates are required to answer five questions in the "Study of Art" paper instead of four and are expected to attain a higher standard than candidates who take it as one of their papers in art.

This scheme may well lead to an increase in the number of candidates, but is it right thus to separate the theoretical study of art from the practice of art, although there is so little time for both? The paper permits the inclusion of drawings, diagrams or plans, stipulating that these must be "clear, careful of proportions, economical of means and to the point". Should not some evidence of an ability in drawing be demanded of candidates who enter for this "Study of Art", even though specializing in art appreciation? If it is desirable that those

[1] This is the paper entitled "Historical and Critical" which is set for Advanced level candidates in England, but is taken at Ordinary level in India. Section A is entitled "Indian Art", with sub-sections on architecture, painting and sculpture.

who draw and paint should show, also, some appreciation of works of art or architecture, it might be argued with equal force that those who tackle the theoretical study of art should have practised it.

Perhaps we may summarize the position as follows: It is important for boys and girls to exercise their powers of appreciation of works of art as well as to acquire some knowledge of its history. This necessitates combining some practice of drawing and painting with exercises or discussion in the field of art appreciation and in the understanding of the basic problems underlying the production of a work of art. Such understanding can only be acquired by actual observation of buildings or study of good reproductions of paintings and drawings when originals are not available. This broad educational programme is, alas, seldom available.

Abstract Teaching

MOST teachers in secondary schools today must be familiar with the request: "Please may I do modern art?" Children see examples of abstract art of one kind or another constantly. They constitute a normal part of the contemporary environment. As a result of their visits to museums or art galleries or seeing illustrated books on art or magazines, children have come to realize that in the modern world painting falls into two categories, that which represents nature and that which does not. They jump to the mistaken conclusion that because they find the former difficult the latter must be easy.

Artists generally agree that expression in abstract terms must be preceded by a study of form and colour in nature. While such studies constitute one avenue for developing visual sensibility, and perhaps the more valuable as regards children, they do not form by any means the only way. In fact, any study of natural forms and visual effects can be greatly helped by the study of form and colour in the abstract. The child who begs to "do modern art" may well be encouraged in his wish, as long as it is made clear that it must be done seriously or not at all and that it involves a great deal of concentrated effort.

The natural place for any foundational study is the secondary-school art class. Such studies may lead to abstract expression in art but this may be quite irrespective of whether more advanced visual studies are to be envisaged later. The objective in any form of art training is the power to use information acquired through the eyes, and the art teacher rightfully employs any means of developing this power in his pupils.

Contemporary art, in reflecting the characteristics of our modern environment, inevitably rejects any concern with the "picturesque", in so far as it still survives, as the favoured subject-matter of the artist. In fact, there is a strong reaction in the opposite direction. The typical environment of today has become the product of the engineer and technician, with its abundance of neon lighting, steel and concrete construction, conveyor-belt goods and aluminium tubing.

For many a city dweller, assuming he has any artistic interests at all, abstract painting—not necessarily examples of great merit but nevertheless reflecting the mechanized contemporary scene—has an undoubted appeal, strengthened perhaps by the growing opportunities for hearing good music through the radio. This appeal may be due to its obvious suitability, which is less evident in

traditional art, for decorating the walls of the modern mass-produced flat or office. It does not impose the severe intellectual challenge of the great master-pieces of the past, an appreciation of which demands considerable knowledge. This immediate appeal of abstract art manifestly attracts many adolescent boys and girls in the secondary schools.

These are not the considerations that prompted the pioneers in non-figurative work in the past—Kandinsky made his first experiments as far back as 1910—since their work was by no means appreciated or understood. Nor do they concern the serious artists of today, who are involved in the deeper problems of visual research. But the need to reflect this mechanical age certainly inspired the artists of a generation or more ago as it does at present.

It is not easy to separate form and colour from nature since it is normal to identify them with recognizable objects. To seek pure relationship between form and colour, freed from any external associations and released from imprisonment in nature, was Kandinsky's aim and that of Klee, Miro, Mondrian and other pioneers in this field, at a time when other artists had not considered it a pos-sibility. This aim is equally one that can be placed before children. But most of them embark on abstract work without adequately understanding its aims or problems. It needs serious study just as much as any other aspect of art.

According to general popular belief, abstract art is purely a contemporary creation without roots in the past. Few are aware of its background. Alexander Cozens' abstract experiments of nearly two centuries ago, although the pro-duction of a landscape was the ultimate objective, first indicated the possibility of composing without the direct help of nature. The researches in the early part of the nineteenth century on the part of the optical scientists—Thomas Young, M. E. Chevreul, Hermann von Helmholtz and others—with their classification of colours and construction of a chromatic chart, made subsequent abstract experiments possible. Helmholtz's investigations in musical tone did much to inspire the belief in an analogy between musical and colour scales, which Tudor-Hart brought to fruition at the beginning of this century. This, in turn, gave rise to the many experiments of fifty years ago by Sheringham, Klein and others in composing sequences of pure colour unrelated to nature, to be presented by means of slides for projection on a screen as in the cinema.[1]

The ideas and the methods of today concerning the teaching of abstract art stem in varying degrees from the pedagogic systems evolved in the Bauhaus. This experimental school was originally established in 1918 as a department of the Saxon Academy at Weimar, with Walter Gropius as its founder and first

[1] P. Tudor-Hart, "The Analogy of Sound and Colour" in the *Cambridge Magazine*, 2nd March 1918. (This embodies a short summary of the artist's theories, which he demonstrated before his art classes.) Chevreul's work, published in 1839, was translated into English by John Spanton in 1857 as *The Laws of the Contrast of Colours*. Meanwhile, George Field, a chemist, had published in 1845 his *Chromatics; or the Analogy, Harmony and Philosophy of Colours*, which demonstrated his theories, long in advance of anyone else, as to the equation of colour with musical notes.

director. Subsequently, new buildings were designed by Gropius for its reception at Dessau, whither the Bauhaus removed in 1925. It was able to function there for only a further nine years until its final closure under Hitler's orders in 1934.

The Bauhaus aim was to provide the practical training necessary for craftsmen, who were to work together in the atmosphere of a community; but this was not the William Morris conception of the crafts, but rather design adapted to the needs of the new industrialized society. "The artist is an exalted craftsman" was the definition given in the school's first proclamation. Painting did not form part of the original curriculum, which was confined to instruction in the crafts together with design, described as "form problems".

These "form problems" constituted the preliminary course, and Gropius persuaded Johannes Itten, whom he had met in Vienna, where the latter was conducting his own school, to take charge of it. It was the essence of this course that nature provided the essential material for study, but a new attitude governed the way that nature was used in teaching. Whereas in the past it had always been assumed that the artist was concerned only with natural effects which could be perceived with the eye, the Bauhaus course adopted a more all-embracing view, assuming that any aspect of nature, by whatever means it might be perceived, could be conveyed visually. This concerned such aspects as potentiality for movement, texture and even the inner, unseen, structure. According to Bauhaus theory, the senses are the means by which we acquire information which needs to be then sorted out before it can be used aesthetically.

> Every new student [wrote Gropius subsequently] arrives encumbered with a mass of accumulated information which he must abandon before he can achieve perception and knowledge that are really his own.[1]

When Itten resigned in 1923, Moholy Nagy took over the preliminary course, while Josef Albers, who had himself studied at the Bauhaus, conducted the studies in materials. These constituted the essential beginning. Their use was first studied on the typical handicraft basis, wood, metal, etc., but this soon led on to the fundamental properties in various materials; every kind of experiment in their use was constantly encouraged. Thus students became accustomed to think of creative work in terms of the materials they proposed using rather than leaving this to the artist's colourman, as was formerly the general practice.

For example, the students would study the use of paper as one of the commonest materials. Albers wrote of these experiments as follows:

> We try paper standing upright or even as a building material. We reinforce it by complicated folding; we use both sides; we emphasize the edge. Paper is usually pasted; instead of pasting it we try to fix it, to pin it, to sew it, to rivet it. In other words, we fasten it in a multitude of different ways.[1]

[1] *The Theory and Organisation of the Bauhaus*, by Walter Gropius, 1923, included in *The Bauhaus, 1919–1928*, edited by Herbert Bayer, W. Gropius, Ise Gropius; Museum of Modern Art Publication, U.S.A., 1952.

The students were taught to perceive the "flexibility and rigidity" of paper as an essay in "constructive thinking", as Albers explained.[1] Exercises of this kind, which develop the powers of invention, can be practised in any school, and their suitability for those who may not reveal any special talent in painting should recommend them in general education.

The development of a tactile sensibility was the main objective of the preliminary course, and the painter, John Duguid, one of the few British students studying at the Bauhaus during its latter years, has graphically described some of these exercises in letters he wrote from Dessau at the time:

> We had barbed wire given us the other day, and after feeling it and getting pricked by it, we had to sit down and give an idea of the feeling.[2]

Given a briquette of coal to draw, Duguid described the lesson as follows:

> Herr Albers found that my first bricket was too sweet, and the matt surface too much like granite. My second bricket I broke in half. For the broken bit, I painted black ink on top of thick paste in low relief; for the matt surface, black ink scraped with a knife, and for the shiny surface, black oil paint put on with a palette knife.[2]

How to combine wire with celluloid, which are fundamentally different types of material, presented another task, of which Duguid wrote:

> The characteristic of wire is that it can be bent about, and is capable of the most unexpected feats of balance. Celluloid rolls itself into a cylinder which expands until it is restrained by something such as wire.[2]

Although such exercises were devised for professional artists and designers, they are equally practicable for adolescents at school. A series of exercises might be formulated as follows: Identify as many different types of texture as you can and describe them. Gather together as many different objects as you can, each of which has a distinctly different texture and record the contrasting sensations you perceive when handling them, noting those which are most opposed and those which seem nearest to one another. Given a number of different materials when blindfold, try to identify them. Try to grade textures from one extreme to another, say from hardness to softness and then from smoothness to roughness, rather as one might learn a scale on the piano.

The use of line as the means of enclosing two-dimensional space took a prominent place in Bauhaus studies, and especially the sense of movement that the line may convey. Paul Klee spoke of its "inner movement", and Moholy Nagy set out to develop the student's sensitivity to the flow of interweaving lines

[1] *The Bauhaus, 1919–1928* (op cit).

[2] 12th January, 1932; this and subsequent quotations are from letters addressed to the author, and quoted in the monograph *John Duguid, 1906–1961*, a short biography by Richard Carline with an appreciation of the artist's work by Max Chapman; (privately printed under the supervision of Edmund Swinglehurst), 1962.

and forms. Emphasis was not placed so much on the quality of the line, its cadence, softness or accentuation, as had preoccupied earlier teachers, but on its precise position and direction together with the shapes it may enclose. The Bauhaus students were taught to be accurate in their observations and exact in rendering them on paper.

In a letter dated 28th January 1932, John Duguid recounted an exercise in precise delineation:

> This morning Herr Albers produced from a bag about a hundred stiff butterfly collars. We picked a couple each, and the whole morning was spent drawing one collar on a large piece of uncrumpled paper six times exactly the same. When the collar lies before you on the desk, the exercise is to draw it as neatly and exactly as possible. That these six butterfly collars look, when drawn, like a flight of doves moving upwards is chance and in no way to be counted.

The point here is to learn how to record forms detached from their surroundings as readily as in relation to their surroundings. Duguid found these exercises in objective observation of inestimable advantage to him in later years when concentrating on the problems of drawing from the human model or from landscape.

When Kandinsky joined the Bauhaus staff at Gropius's request in 1922, he concentrated on exercises which imposed a severe mental discipline. These had their effect on his own painting, resulting in his series of works, which embraced geometrical forms in place of the looser abstract expressionism of his earlier days. Thus Kandinsky's teaching at the Bauhaus was directed towards the construction of a composition. John Duguid records being set by Kandinsky to "balance a maximum space which is empty by a minimum space occupied by elementary forms, such as rectangles, circles, triangles, etc."[1]

Kandinsky gave weekly lectures on composition and colour. He also conducted his "free painting class", to which the students brought work for criticism. Duguid had described in an earlier letter in autumn 1931 how the students had to "put [their work] on easels or pin them on the walls. The room," he proceeds, "hot and rather small, is very crowded. Kandinsky enters and is ill at ease at the sight of so many strange works, most of them shockingly bad, starts to smoke and talks about music. He then invites students to say something about a special work."[2]

The link between painting and music preoccupied Kandinsky during this middle period. The analogy between colour, contained within specific shapes, and musical notes had interested many artists previously and Kandinsky thought to take it farther, though without attempting to place this analogy on any scientific footing. He would often set the students a visual theme and then ask them to develop it compositionally as one might develop a musical theme. Tension was the quality to be looked for.

[1] Letter dated 25th April 1932.
[2] Letter dated November 1931.

The watchword of the Bauhaus was *Raum und Raümlichkeit*, which Duguid described as form and third dimension in the sense of "things standing in a room".[1] Discussing one of his own essays in abstraction which he had submitted to Kandinsky for criticism, Duguid explained in his first letter on returning to the school after the Christmas vacation:

> One of Kandinsky's notions is looking through something on to something else, by which a feeling of '*raümlichkeit*' is obtained. Thus I am using shapes in the picture as three transparent screens set at an angle into the picture plane. Then I will try to invent abstract forms, some outside the screen, some half way through, some behind.[2]

The distribution of weight was an important consideration in Kandinsky's teaching, and Duguid tackled an arrangement of transparent squares one over the other with the weight at the top. Weight, when loosed from gravity, can be disposed in any part of the picture, but when Duguid submitted his work for criticism, Kandinsky commented that he had accentuated the top, but had left the weight in the middle.

Working from still-life groups, the students would be set to reduce the whole composition to a few simple forms to be rendered in line only. This would lead them to the discovery of where lay the points of tension, their direction and interaction, and colour might be used as a means of accentuating or arresting the movement between these points.

Hitler's Germany soon took steps to discard the Bauhaus. Gropius and Klee had already left, the latter for Dusseldorf. Under Mies van de Rohe, as Director, the Bauhaus staff vainly sought to ward off the conflict that threatened the school's existence. By the spring of 1932 it was apparent that it could not long survive, with the local government now threatened by the Nazis, who had already announced their intention to close this cradle of "Jewish-Jazz culture", as they derisively termed the Bauhaus. The students were constantly in revolt, not only against the Nazis but sometimes in opposition to the director's attempts at compromise.

On one occasion the director had removed a picture from exhibition because of local complaints that it was indecent. The incident prompted John Duguid to describe the setting in which Bauhaus teaching was conducted, in a letter of November 1931:

> At 1.15 we collected in the canteen to discuss the matter. I had gone up to collect my second course of hash and potatoes, but when I returned found my seat occupied by a big nut and the meeting already started. So I had to eat my lunch on the window sill over hot pipes while we lost our tempers with the 'fascists', the bourgeoisie who had complained and the Director, and tried to formulate a protest. It was 2.45 before we had finished.

Efforts to re-establish the Bauhaus in Berlin failed, and most of the teachers

[1] Letter dated November 1931.
[2] 11th January 1932.

and many of the students left Germany. Some—Gropius, Moholy Nagy, Albers among them—went ultimately to the U.S.A., where they were able to continue teaching in various colleges, but the initial verve and community spirit of the Bauhaus was lacking.[1] It is only within the past ten or fifteen years that the ideas which originated mainly in the Bauhaus have obtained a firm foothold in Great Britain, rapidly permeating art teaching like a river in flood.

One of the chief advocates of these methods, Victor Pasmore, although he would not claim to be among the pioneers in the field of abstract art, has in recent years thrown himself wholeheartedly into the promotion of its teaching in this country. He has sought to emphasize in particular the essential unity of two-dimensional and three-dimensional expression in a true synthesis of painting, sculpture and architecture.

At a two-week course for secondary-school teachers, held at Scarborough at the invitation of the North Riding Education Committee, Pasmore urged that the division of art into these three separate departments had no longer any real validity in teaching:

> An exercise in the partitioning of space [he writes] begins in the division of two-dimensional area (drawing) and develops into actual three-dimensional structure (architecture). Similarly a project in shape making and shape relationship begins in two dimensions (drawing or painting) and ends in three dimensions (sculpture or construction).[2]

The essential unity of the arts was Pasmore's aim, or, as he put it, bringing together "in spirit, where it is not possible in actual practice, all branches of the visual arts which are necessarily separated through technological, social and economic differences".[2]

Here we have the echoes of the original Bauhaus doctrine to "coordinate all creative effort" and "to achieve the unification of all training in art and design".[3] The ultimate goal was to be the collective work of art—the building. Thus first-year students at the Bauhaus were given geometric shapes indicated in plan. They were to construct them three-dimensionally in paper, by cutting out the shapes and fixing them so as to stand upright. In another exercise two sheets of glass were placed upright at an angle to one another like a half-open book. Given an irregular-shaped label the students would be asked to visualize and draw its appearance when folded round the edges of the two pieces of glass.

[1] Gropius was in England for some while after leaving Germany and I recall joining Norman Dawson, the surrealist painter, and other artist friends in discussions with Gropius, hoping that it might be possible to re-establish the Bauhaus in London, but, alas, the project never had much prospect, owing to the lack of funds, and, more important, the absence of support in the art circles of London at that time.

[2] *The Developing Process,* published by King's College, Durham University, to coincide with an exhibition at the Institute of Contemporary Arts, London, 1959.

[3] *The Bauhaus 1919–1928* (op. cit.).

Such constructive exercises are a practicable possibility in the secondary school art class, and some institutions have made experiments on these lines.[1] Elementary courses have included constructions in cardboard or wire, with the cardboard attached to a central armature so as to indicate planes in space, or with wire bent to correspond with lines indicated on paper.[2]

It may be asked whether such exercises have any real value for pupils who are not specializing in art. It can be answered that it is precisely such pupils who would most benefit by developing their perception of how forms are related in space, removed from any direct representation of nature. Such exercises cannot fail to prove of value irrespective of whether the pupil is ultimately interested in portraying the external world of nature or expressing his inner concepts in abstract terms. It is chiefly important, from the educational point of view, that they are attempted in all seriousness and do not degenerate into the mere imitation of some trick or artifice such as often attract attention in contemporary art exhibitions.

The essential aim is to infuse in boys and girls an element of personal enquiry and discovery, to induce them to analyze their emotional reactions and record such discoveries. This can have a valuable psychological effect. But it is difficult to make analytical discoveries when fully aware that the forms being studied are human, animal or vegetable. Such formal relationships are best discovered when studying parts of an object, or observing the spaces separating objects.

Elementary exercises can be devised which bridge the gap between natural form and abstraction. Pupils can observe a row of chairs and table legs as seen from floor level and indicate on paper the intervals between them, or the fanlike intervals between a row of paint brushes standing in a bowl. Curvilinear forms may be found and studied in natural objects—stones, roots, shells, etc.— and the analysis of crumpled paper or sheets of tin may reveal a combination of curvilinear with rectilinear shapes. Boys and girls can be urged to devise their own visual exercises. Maurice de Sausmarez, principal of the Byam Shaw School and a leading art educationalist, has described basic design as "an attitude of mind, not a method", providing the "means of making the individual more acutely aware of the expressive resources at his command".[3]

There are various exercises based on elementary visual phenomena, which can be compared with practising scales in music and have been tried out in schools. Exercises in the use of line necessarily start with a point or spot which does no more than indicate location. The decision has to be made where to place

[1] Basic design courses were established in the late 1950s at King's College, Department of Fine Art, University of Durham, and at Leeds College of Art, under the direction of Victor Pasmore, Harry Thubron, Richard Hamilton, Tom Hudson and others.

[2] A course for secondary schools has been formulated on these lines by James Bradley, art master at Sidcot School, where remarkably successful results have been produced by boys and girls (plate 21).

[3] M. de Sausmarez, *Basic Design—the Dynamics of Visual Form*, 1964.

it on the sheet of paper. When it is not placed in the centre of a square the element of composition must immediately ensue. When a succession of points or spots are added a line is created; then its length must be decided, to be followed by a series of such lines of varying length.

The direction of lines may be considered, varying from the vertical to the horizontal. In the average room there are edges, otherwise lines, following every variety of direction or diagonal, and these may be observed and recorded. There follows the relationship of lines, varying in length, perhaps parallel and at equal intervals, and then unequal and, finally, intersecting.

An exercise sometimes practised at the Bauhaus involved cutting out lines of newsprint and rearranging them in any direction, like the contents of a matchbox spilled on the floor, or they could be bent like caterpillars on a leaf. When the sheet of paper is covered with a series of intersecting lines, a number of unequal and, perhaps, overlapping areas are formed, thus constituting a rectilinear composition.

With the use of curved lines a rhythmic movement may be created, as in the cadence of a dance. Paul Klee described his linear essays as "the line going for a walk".[1] Such rhythmic use of the line was exploited by the early calligraphers, like Bales and Cocker, but as a means of decoration rather than formal expression. Curved lines, moreover, produce irregular shapes, which can be seen as forms in space, and their interrelationship can be conveyed.

When the sheet of paper is partitioned to form unequal areas, some of these may be shaded, thus changing the compositional balance. For example, a very small area, shaded very dark on a white ground, may counterbalance a much larger area which is shaded faintly. Various experiments in the balance of a composition in this manner may be made; either the areas appropriate for a combination of three tones may be chosen or, reversing the process, one may choose the appropriate tones for particular areas, so as to preserve a sense of balance, and the work may be done on a grey or black ground as well as white.

To recognize balance in a composition is not always easy. The child can direct his gaze at the paper in such a way that all the four corners are brought within his focus. He can then draw or shade an area, while the whole sheet of paper is within his view. In this way he may become aware of the spaces as well as the concrete forms, with their mutual interaction and movement.

The development of a sense of tone has to precede that of colour, because the latter must include the former. Tone, on the other hand, may be considered without colour in terms of black and white with the varying degrees of grey intervening. A scale of such neutral tones may be made from black to white, and colours then mixed to match the same tones.[2]

[1] Paul Klee, *Pedagogical Sketch-book*, English edition with Introduction and translation by Sibyl Moholy Nagy, 1953.
[2] Both tonal and chromatic scales were evolved scientifically by P. Tudor-Hart, showing how they varied psychologically and physiologically, and were used by him in his art teaching during the early years of the century.

Children will readily play with colour unrelated to any recognizable drawing, and this is often tried in schools, but should be supplemented by exercises which extend the experience in mixing colours and tones. They may cover their paper with a checkered pattern of small rectangular shapes, filling them with different tones of grey or of colour to form a progression from dark to light. They may try to make a tonal scale in one colour only. Here they face the problem of identifying a colour, and they have to be shown a colour rose or chart, so as to recognize colours with their complementaries on the opposite side of the rose.

To find the complementary of any given colour is an essential beginning, and the pupil does this by mixing them together and noting whether they produce a neutral grey. Once the complementary colour has been fixed, the darker and lighter tones may be discovered by the same test, and a scale produced from dark to light. A similar progression may be made from maximum coldness in colour to maximum warmth, or developing one particular colour from neutrality to full saturation. Such exercises may develop a sense of colour and tonal relationship, and give scope for composition in which forms are conceived in terms of colour and tone.

Among contemporary exponents of abstract art are those who reject any such analytical procedure, relying instead on creating the right state of mind. Before starting to paint, the student is recommended to relax. A degree of mental relaxation is necessary in order to eliminate any particular idea. In fact, he must try to discard the use of the reason, so that the result will be completely free, quite illogical and purposeless, with no specific end in view. Alan Davie, who has taught on these lines, has described it as "a philosophy of the irrational" which functions as "an activity motivated by a faith in the actuality of existence which is outside and beyond knowing".[1]

It may be questioned whether this approach to painting, which requires something like a state of trance with its undertones of Eastern mysticism, could be applied with any benefit to general education. Davie's teaching experience has revealed the following:

> Strangely enough, the student finds that to work without thought requires a great deal of mental discipline, and it is some time before he can achieve an image without the intermediary of reasoning.[1]

This process is designed to produce a particular kind of painting rather than education. It is primarily a technique and as such can scarcely contribute much in general education at secondary school level.

In direct opposition to this method, popularly known as "action painting", there are those other painters and teachers, belonging to the same general circle, who advocate quite the reverse. The student is urged to allow reason, rather than any aesthetic motive, to dictate his work. It is claimed that some internal

[1] Alan Davie, "Notes on Teaching" in *The Developing Process* (op. cit.).

process of logical compulsion must direct what are described as "diagrams of thought processes".[1] The aim is to produce "a reasoned result" rejecting any "free expression or aesthetic decision".

There are the contemporary movements derived from "Dadaism", which began in Germany before and after the First World War, allowing any form of expression which aesthetic feeling may prompt.[2] The collecting of odd scraps of paper, natural objects or other material for assembling in a composition can provide a valuable aesthetic exercise in schools.

The many conflicting art movements of today, with divergent views and rapid changes backwards and forwards, are indicative of the state of uncertainty and instability of purpose that assails many contemporary artists, reflecting the similar struggles in the social, political and economic fields. The earlier art movements, from which they have derived so much of their inspiration, were animated by a common revolutionary aim to free artistic expression from its state of torpor and academic shackles during the first quarter of the century and to join in the general battle against artistic reaction. But no such revolutionary endeavour can quicken contemporary art movements, since they already suffer from general popular approval.

Until some greater stability in aim can be envisaged as the future pattern for art, we must excuse art teachers and secondary schools in general if they cannot keep abreast of current developments. If they are to lean first on the one side and then on the other, their ship is bound to capsize. In other subjects, such as science, teachers do not necessarily adopt, though they may take note of, every fleeting experiment, and there is no reason why every experiment in art, perhaps equally fugitive, should be instantly adopted in schools.

But art is not like other branches of study in that it must reflect the changing pattern of life. Art teaching must not become moribund and academic as if governed by inflexible rules. It must pursue a progressive course. We may perhaps envisage different kinds of art, that of schools combining free experiment with objective discipline, which might be quite different from the type of art presented by the art galleries and dealers.

It is quite possible that representational art, as it has been understood in the past, may disappear altogether from the professional art schools and contemporary galleries. On the other hand, its educational value in training observation and a visual interest in natural phenomena makes it essential in schools for general education. Representational art may, in fact, be confined to children and acquire at their hands a fresh and vital existence. It may be taught in secondary schools in the same way that dead languages—Latin, Greek, Sanscrit or the laws and literature of the Ancients retain their place at school—sometimes a pre-

[1] Richard Hamilton, "Diagrammar" in *The Developing Process* (op. cit.).

[2] The "Dada" movement emerged in various cities at much the same time between 1912 and 1920, with George Gross and John Heartfield (who used photo-montage for the first time) in Berlin, Kurt Schwitters in Hanover, Max Ernst in Munich, and others in Paris and Zürich.

eminent place—only to become largely forgotten in later years when school is left behind.

Visual art is a primitive activity in which people who lie at the threshold of civilization excel. Thus the work of children may far excel what is produced by their elders. Such representational art may go hand in hand with visual experiments by boys and girls, perhaps abstract, "Dadaist", or of some other character, by which they may forge new paths for their elders to follow.

23

Present Trends
in Art Examining

EXAMINATIONS in Art, as in other subjects, are thoroughly impersonal, with no contact or individual relationship possible between the examiner and those examined. The results are achieved in the automatic and businesslike manner with which goods are produced by machinery and conveyor-belt. This may be perfectly proper if we are to consider only the basic function of an examination, which is an independent and detached assessment of work submitted. But if we consider it as part of the whole process of teaching, this detachment is far from desirable.

The cold and impersonal character of an examination has nothing in common with the production of a work of art. To tell a boy or girl—Come here on Monday morning; sit still in a bleak hall under the eye of a supervisor for two and a half hours, and convey your visual emotions in line and colour—is a ludicrous proceeding if a work of art is to ensue. The astonishing aspect is that so many boys and girls are able to take an art examination in their stride and produce thoroughly free and highly imaginative work under these conditions. Many produce the masterpiece of their career. But this is by no means true of all candidates; how many can never be ascertained.

Oversea candidates are a prey to nervous strain even more than those in the home country, with their examination results claiming altogether too great a say in future careers or employment. In March, when the results are expected, one finds the principal cities in a ferment with the local newspapers issuing special editions and the Education Department's offices virtually besieged by the anxious candidates.

No student in art can be expected to work satisfactorily with one eye on the clock, and with the limitations on his freedom of movement which examination conditions normally impose. But chiefly it is the state of nervous apprehension that hampers so many candidates. It is characteristic of this tension that so many of them, more especially overseas, waste valuable time in writing futile appeals to the good nature of the unknown examiner or pathetic apologies for some trifling error, as when an anxious pupil writes on the back of his picture:

"I was so nervous seeing this is my first exam paper. I don't mean to dis-
obey your instructions. Please forgive me. I know you are very angry with
me, but please . . ." and so on in the same vein. But then comes the afterthought;
perhaps he should end on a less aggrieved note, so there follows: "Thank you!
Merry Christmas and happy new year to you."

Obviously, the local centre cannot make special provision for candidates in
art as distinct from other subjects unless these have been agreed in advance. Nor
can the supervisor neglect his functions in order to soothe their nerves.
Nevertheless, the presence of this awesome figure in command is bound to
deprive some candidates of that sense of freedom so desirable in art. This is
revealed when a Malaysian boy writes: "The Chief Supervisor is wearing the
university uniform and it looks very strange to me as I have never seen such
uniform before. I wish I could be able to use it one day, yours faithfully the
candidate." The boy's imagination was at work, but not where it should be in his
picture.

A common source of anxiety concerns the materials to be used. Most of the
boards allow reasonable freedom in this respect, although providing white
cartridge paper if required.[1] It is when the work seems to be going astray that it
is tempting to blame the tools, as when a boy writes: "Dear Sir, this paper is very
bad. If I use better paper I can do much better than this, but I have no money to
buy good paper", etc. It is the weak candidates who are chiefly concerned over
the quality of their materials, which seldom prevents good work from revealing
itself.

The fact that so many real or supposed anxieties arise in examinations
naturally prompts the question: Are set examinations in art at fixed hours under
strict supervision really necessary or desirable? Many teachers question this,
but is there any satisfactory alternative? Ought we to be content with certificates
in art issued by the schools? It is doubtful whether such certificates would carry
sufficient weight.

In conducting an external examination in art, as in the G.C.E., the examining
boards are faced with various unavoidable problems. However much examining
boards might like, or local centres be willing, to establish more sympathetic
conditions which might help to relax the rigidity of the art examinations, they
are hampered at the outset by the enormous numbers of candidates. The fifteen
years since the establishment of the G.C.E. has seen a phenomenal increase in
their number at home as well as overseas, as in other subjects. The number
taking art in England each year in the G.C.E. at Ordinary level has quadrupled,
and must now approach 100,000, with about half as many again taking it from
overseas.[2] It is about eighth in order of preference among all subjects, being
taken by nearly 20 per cent of all candidates. On the other hand, there are regions,

[1] Some restriction on the size of paper is still imposed by certain boards.
[2] In addition there are some 10,000 candidates in art at Advanced level. These rough
estimates do not, of course, include candidates in the new Certificate of Secondary
Education, nor those taking the Royal Drawing Society's examinations.

such as West Africa, where barely 5 per cent of the candidates include art in their choice of papers. This is due to the subject being neglected by the schools.

Examining boards no longer seek schools to examine. It is quite the other way and schools have to persuade a particular board to accept them. It is possible, in theory, for a school to choose the examining board whose art syllabus it finds most suitable, but in practice most boards are unwilling to accept a school in art alone; they expect it to take a full range of subjects. Thus art has to fit into the general administrative pattern of examination as a whole.

If there were merely two or three candidates in art at any one centre, the problem of providing more congenial arrangements for the examination—a favourable environment with supervision less in evidence—might prove within the bounds of possibility. But the numbers of candidates at one school or centre often exceeds fifty, so that the arrangements to be made constitute a distinct problem for the school and are inevitably austere. Overseas the numbers present even greater difficulties. In some territories more than half the centres submit some fifty or more candidates in art and there are some which enter more than five times that number.[1]

The art examiners usually find that the standard of work produced at these large centres is lower than at those which enter only a few candidates. Such mass production in art seems to have a harmful effect, producing work that is uniform in character and seldom distinctive. One may sympathize with the candidate who finds himself unable to assert his personality nor produce work of individual distinction when lost in such a crowd.

This leads one to ask again: Is the holding of examinations in art too heavy a price to pay for the sake of a certificate? If certificates are essential—and it is generally agreed that without them art teaching might cease in many schools—can they not be granted by some more sympathetic system? The possibility of detaching the art examinations from their present academic environment might be considered.

The G.C.E. as a whole is mainly an academic test of intellect. Although in theory art can be taken as a separate subject, as can music or the handicrafts, it is normally attempted as one of a series of academic subjects representative of education as a whole. When the moment of crisis approaches the candidate in art is already overwhelmed with anxiety, brought to the boil with last-minute coaching in languages, mathematics or science.

Although thus taken among a group of subjects and by a very large number of candidates, it is usually treated as little more than a make-weight and is scarcely ever the main objective in tackling the G.C.E. In fact, it is often admitted that art is recommended for candidates to attempt when they are particularly weak in some other subject. Art, as we have already noted, is not even considered essential for those who seek entrance to an art school, unless the question of a grant from the local authority arises.

[1] In 1964, approximately 10 per cent of the Singapore centres entered more than 200 candidates in art at any one centre.

Academic subjects—languages, mathematics, science, history, etc.—do not make congenial bed-fellows for art. There is very little in common between their methods of teaching. In fact, many art teachers today seek divorce from the normal classroom environment in favour of greater individual freedom and more stimulating surroundings. The pupils in the art class at school are no longer expected to sit at rows of desks and remain silent. They move around at will and discuss their work freely. Cannot this approach be similarly reflected in examining? Some examining boards already permit a certain measure of freedom in the art examinations, allowing candidates to handle objects to be drawn and to work from different positions in the room, which was by no means possible formerly. Strict discipline in art examinations is mainly necessary to ensure that candidates do not interfere with one another. But do such liberal measures suffice?

The ideal circumstances for an art examination would permit candidates not only to walk about at will but to carry their notebooks with them, refer to sketches, try different materials and, indeed, work for as long or as short a time as they choose, within reasonable limits. But still more important, the art examinations, ideally, should be taken at a completely different time from other subjects, when intellectual concentration is not imposing an unnatural strain on the visual sensibilities. If such were the conditions, the grounds for frequent criticism might be removed and the examinations prove more acceptable.

It has always been assumed in the past that the School Certificate, and its successor, the G.C.E., should cater primarily for those who intend taking up one of the professions, in which academic qualifications are essential and may be subsequently pursued, perhaps, at a university. Since the Second World War, however, the needs of the secondary modern and technical institutions have been urged. It is with this in mind that the City and Guilds of London Institute set up a new examining body entitled the Associated Examining Board in 1953, thus becoming the ninth board catering for the G.C.E. to be recognized by the Ministry of Education.

Being concerned mainly with schools which train boys or girls for commercial and technological careers has led the Associated Board to place a stronger emphasis on the arts and crafts, and it is to be noted that a larger proportion of its candidates choose these subjects compared with most of the other examining bodies.

The Associated Board's emphasis on the creative arts is shown by its offering as many as four different alternatives at both ordinary and advanced levels, in each of which a certificate may be obtained. Candidates may tackle the subject "Art and Crafts", which offers a general survey, selecting three papers from either drawing and painting, pictorial composition, art history or design and practice of a craft, the syllabus being "designed", as it states, "to test creative talent, skill and craftsmanship, together with the proper use of materials, within the field of general education". On the other hand, candidates who prefer to specialize may take either of the subjects "Art" (excluding the crafts), "Art

History", or "Crafts".[1] The system differs from that of other boards in that a specialist in art history or in crafts can obtain certificates in those subjects without combining them with drawing or painting.[2]

With the art examinations for the G.C.E. offering wider scope, teaching has greatly benefited. Art classes have been introduced in a broad range of schools which formerly neglected the subject altogether. In many secondary modern and comprehensive schools the general standard in art has been raised much above that of the older institutions. These newer schools have been to the forefront in seeking changes in the examination system, changes that concern art as much as other subjects.

Methods of assessment in the G.C.E., even more than the character of the syllabus, have been challenged.[3] This was made evident as regards art in the criticisms offered by the Art Panel of the Secondary School Examinations Council of the Ministry of Education in 1963. These concerned only the Ad-

[1] The regulations contain a number of significant provisions: In the subject "Art", for example, the choice of three papers must include pictorial composition in which the questions set are circulated to the candidates in advance, as with Cambridge. Work done during the school course may be required for inspection at Ordinary level and must be submitted at Advanced level. Art history, apart from the special subject, is obligatory only at Advanced level in the subject "Art and Crafts".
 Mr. E. M. O'R. Dickey, formerly Art Inspector at the Ministry of Education, became the Board's Chief Art Examiner with Mr. D. E. Milner as Chairman of its Art Committee.

[2] London has recently introduced its Syllabus B, both at Advanced and Ordinary levels, which mainly caters for craftwork, fifteen hours being allowed, but candidates are rightly required to take in addition one test in painting.

[3] Computers are used in the U.S.A. as the only practical means of assessing examination results in view of the enormous number of prospective candidates throughout the country, and the merits of the system have been seriously studied in this country. The College Boards Examination, introduced in the U.S.A. only in recent years, sets multiple questions in a wide variety of subjects. At the same time the candidate is offered a series of possible answers from which he must pick the correct one, to be indicated by a mark in the space alongside. No writing is required and the computer assesses the number of correct answers given by the candidate in each subject.
 The examination provides, therefore, a reliable and uniform test in factual knowledge only. Its results guide the colleges in accepting or rejecting admissions. Since the computer cannot assess imagination or powers of expression, any ability in art as distinct from art history, cannot be taken into consideration by the American universities and art would have to be dropped if the computer system was adopted in this country. Nevertheless, most of the larger universities throughout the U.S.A. contain a flourishing art faculty. A student who will have entered the university of his choice on the basis of his satisfactory factual knowledge may subsequently switch over to art during his university career.
 Art teaching is still far from being generally included in the curriculum of the elementary and high schools of the U.S.A., and in those schools where it is taught it is usually treated as an extra, but there are, of course, many exceptions. Nevertheless, there is a growing public interest in creative, visual work, as in other countries. Young American men and women no longer regard art as effeminate or to be avoided, as their elders did, as I recall, in mid-western and southern cities in the years before the Second World War.

VIa. Sylivestri Kiwanuka, St Mary's College, Kisubi, Uganda; *Still-life with Skull,* 196(
 b. Harry Ssengonze, Namilyango College, Uganda; *Washing the Baby,* 1959

vanced level in art, but might equally apply to the Ordinary level. With some boards a script is seen by only one examiner, and it was questioned whether one examiner can adequately assess a number of scripts in various aspects of creative work.

Such criticisms and the many others that have emerged have naturally brought to the fore the whole issue of whether an external examination in art constitutes the best or only way of conducting it.[1] The principle of granting certificates in art on the basis of an assessment initially made by the art teachers of each school and externally checked, has, in fact, been accepted to some extent, as we will mention later. It has not been attempted for the G.C.E., with its very large number of candidates. But can such internal assessment produce any greater reliability in marking? The qualifications of art teachers vary enormously; there are still some schools, especially overseas, which depend on teachers with very little training in art. Moreover, methods of teaching vary in accordance with the concepts of individual teachers, who can scarcely avoid some prejudice in favour of their own style of work.

Opportunity is given in the G.C.E. examinations for teachers to submit their own assessments of their candidates, though examiners are under no obligation to accept them. While these assessments sometimes correspond to the examiner's judgment, it is extraordinary how much they vary. The teacher naturally tends to pursue the middle of the road, assuming that some pupils should pass while others should fail with a sprinkling of very good and very weak, but this is not the characteristic pattern that examinations reveal. Schools are often extreme, either in excellence of the work submitted or in weakness. In some schools the majority of the candidates may deserve a very high grade, while in others few may deserve to pass and most must fail. With such schools—perhaps the majority —the teacher's standards must differ enormously.

With a team of independent examiners working together, it is possible in principle to achieve a standard of assessment which cannot fail to be much fairer to the candidates than any internal one. That this external system has been criticized at all is perhaps the fault of the examining teams. They are free to adopt their own methods and these naturally vary. But they were devised years ago when the number of candidates were counted in hundreds not thousands, as they are today. Their ever-increasing number has overtaken the examiners, like a tidal wave, leaving them quite unprepared.

Successful co-operation as a team with prior agreement over standards of marking was quite a different matter when the examination in art could be

[1] The Wyndham Committee to survey secondary education in New South Wales, Australia, considered this problem in 1957 and firmly recommended the maintenance of external examinations, not only because "the public is not yet ready to accept" any other system, but there is "almost no other way in which standards may be safe-guarded". The Committee, however, did not propose the inclusion of art or music in its examination scheme.

In Canada, where the States are autonomous in education, Ontario has recently introduced external examinations in art for senior secondary schools.

managed by no more than ten or twelve examiners, but there are today over 300 art examiners employed by the eight boards in the G.C.E.[1] together with the Scottish Board and the Ministry of Education of Northern Ireland. It may even be questioned whether this number suffices.[2]

The boards have adopted varying systems of examining in art, based on their experience or traditions. The Northern Board, for example, allocates each of the candidate's three papers to a different examiner, as does Oxford, Cambridge, the Welsh and Scottish boards, so that the aggregate mark is the result of separate assessments, and it is often found in practice that a generous mark from one examiner is offset by a severe one from either of the other two. London, on the other hand, allocates all the candidate's three papers to one examiner, who then submits them for checking to a second, senior, examiner, who has therefore a considerable amount of work to assess. The Associated Board has all the work assembled in a central place where the examiners can meet and adjudicate together, but most of the examining boards, especially the larger ones, have no option but to send the work to the examiners for marking at home.[3]

A final award has to be made, at which marks are converted into the grades issued to schools, but the degree of participation of the art examiners in this procedure varies. For the Associated Board, the whole process of marking, with all the work seen together by the assembled examiners, serves as a final award in itself, but this ideal procedure is only practical because the Associated Board still receives far fewer entries than the four larger boards. For the Oxford and Cambridge Joint Board, with relatively few candidates in art, an adjudication by by the chief examiners meeting together is likewise essential and presents no great difficulty. London's Advanced level marking is similarly conducted in one place, where the four examiners meet and adjudicate collectively. In its Ordinary level the three chief examiners meet to consider cases near the border-line or revealing any grounds for doubt as to the fairness of the preliminary marking which has already been checked.

For the Cambridge Syndicate, with its separate assessment of the different papers in art, considerable reliance has to be placed on the final award, which is attended by five or six examiners both at Advanced and Ordinary levels. The separate assessments of a candidate's three papers may differ greatly and need checking by inspection of all three scripts, since they have not previously been seen together. Wherever there is any reason to doubt the fairness of the original mark given, as in London's procedure, or if any candidate's assessment places

[1] The number was reduced to eight when Durham University brought its Local Examinations to an end.

[2] The Cambridge Syndicate employs the greatest number of art examiners (over a hundred for the winter examinations for oversea candidates, and over fifty for the summer examinations for home centres). The other boards employ equivalent numbers in proportion to the quantity of candidates.

[3] Craftwork is usually sent to the board's headquarters for assessment by the craft examiners.

him near the border-line, the work is reviewed and the final grade raised, lowered or confirmed.[1]

With the very great number of candidates in art from Great Britain—between 12,000 and 25,000 for each of the four larger boards—there may well be about 35,000 to 65,000 or more individual works to be seen by their examiners. If this huge volume of work could be reduced, assessment would inevitably gain in reliability. It has been suggested that the number of papers to be taken should be reduced from three as at present to two or even one. But this would only increase the hazards for the candidate, since his fate would depend on one or two assessments instead of three, and a second checking of the marking would be all the more essential.

So much of the examiners' time goes to waste over work that is far too elementary. As much as 15 or even 20 per cent of the candidates can have had scarcely any training in art, and it is a matter of surprise that schools consider that it is worth while to enter them. The explanation must lie in the uncertainty of schools regarding the standard required. Moreover, far too many schools encourage the taking of art as a "sporting chance" for candidates who have no hopes in other subjects. If this quantity of worthless work was not submitted and the total reduced, the practical difficulties in examining would be greatly relieved.

Those experienced in examining will usually agree that assessment in art, whether internal or external, can never be completely reliable.[2] It is inevitably subject to personal taste or prejudice, however much these feelings are kept at bay. Moreover, all who examine succumb on occasion to a "blind spot". Artists choosing works for exhibition are prone to speak overconfidently of accepting the best work and rejecting the worst, as if works of art can be measured accurately, but their judgments are unavoidably hazardous. Moreover, examining requires much more than the simple decision of acceptance or rejection. The precise degree of acceptance or failure must be determined. It must depend on careful thought rather than snap decision, with the work seen under varying circumstances. It is the least experienced who think they can assess artistic merit on the instant.

Various methods of assessment have been adopted for obtaining fair and just

[1] A similar procedure is adopted by Oxford, the Northern Board, the Welsh Committee and the Scottish Education Department. In the Syndicate's winter examination for overseas the checking includes grade 8 (pass in School Certificate) as well as grade 6 (G.C.E. pass). Approximately 38 per cent of oversea candidates gain grade 6 in art, compared with over 60 per cent from home centres. Notable exceptions are Uganda (over 70 per cent) and Rhodesia (over 60 per cent).

[2] Public interest in the reliability of marking was revived recently, though not in respect of art, when a headmaster reported that he had entered twenty-eight candidates in English language for two different boards. Twenty-seven passes and one failure were given by one of the boards, while the other gave only three passes and twenty-five failures. Both boards had agreed on the grade for only two of the candidates, and one candidate found himself placed in the top grade by one board and at the bottom by the other. (Presidential Report to the Association of Chief Educational officers, London, 4th February 1965.) Fortunately, no similar exposure has been forthcoming as regards art.

results in art, and these are applicable only to an external examination, such as
the G.C.E. When marking is about to begin meetings of examiners are usually
held for discussion of the relative qualities to be expected and the values to be
placed upon them. Unusual work may be produced for discussion, but the
examiners are mainly concerned with agreeing an appropriate mark for work
which is typical at the various grades. Some boards are content to rely on the
chief examiners to establish standards in marking on typical scripts which are
then sent to the assistant examiners, or each team of examiners may choose its
own standards, while other boards go somewhat further by holding meetings of
all the examiners to discuss and agree these standards in each of the papers seen
together. The examiners work, thenceforward, in teams under a senior examiner
who is responsible for maintaining co-ordination.[1]

In most examination subjects it is usual to prepare mark schemes which
provide the means for checking the accuracy of assessment. The Cambridge
examiners have adopted this system in art, alloting a proportion of the available
marks to particular aspects, such as use of colour, quality of drawing, com-
position, suitability of a design for its purpose, imagination or originality, etc.
The qualities in a work of art cannot be compressed entirely within a series of
categories, and examiners usually agree that any analysis must be combined with
an overall impression. Nevertheless the use of a mark scheme does reduce the
margin of error. Should an examiner be overimpressed by one particular aspect
or prejudiced against it, perhaps for crudity in colour or mistakes in drawing, his
tendency to mark too high or low will be confined to the limited range of marks
allowed for this aspect of the work.

Some boards have confined assessment to the chief grades, such as pass, fail,
credit or distinction, but since most work falls along the vital border-line that
divides pass from failure, a more precise assessment becomes essential when the
result depends on the aggregate of three papers which have been separately
assessed by different examiners.

Reliable marking cannot be achieved, however experienced an examiner may
be, with only one initial inspection of the work. Examiners generally agree
that the candidate's work must be seen more than once under different condi-
tions. Preliminary marks may be revised by placing the scripts in a provisional
order of merit, so that scripts seeming similar in quality can be seen to-
gether and subjected to comparison. Thus scripts which are better or weaker
than their fellows will readily emerge. Many of the scripts submitted today are
large, and these must be seen, at some stage, from a distance. Such comparisons
are equally possible when the scripts are examined collectively in a central place.

The whole question of reliability of assessment must depend to a large extent
on this possibility of comparison. Some examiners rely on comparing the scripts
to be marked with those given a standard mark, but this does not adequately

[1] A preliminary meeting of senior examiners for Cambridge is usually held in
advance of the main meeting, which is attended by all the examiners working in teams.
A general discussion of problems is usually held.

cater for exceptional or unusual work which may escape recognition. Here we have the main issue between teaching and examining. Most work submitted for examination is ordinary in quality and similar in character, presenting no great problem. It is the minority of candidates who present unusual work, perhaps original in technique or vision. These, which must especially interest the teacher, need, but sometimes defy, careful assessment. It is here that comparability is most necessary and least obtainable.

The basis of comparison need not, and should not, depend on the character or style of the work, for in these respects it is to be hoped that the work will prove as diverse as possible. Grounds for comparison must be found in the requirements of the syllabus or in the setting of the questions, as we noted earlier, when discussing imaginative compositions. There are, to take an example, innumerable ways of drawing or painting direct from the human figure, but the basis of comparison is provided by prescribing the particular pose that the model is to take. A sketch for a mural may be required to fill a given space. It may be tackled in a realistic or in an abstract manner, but its suitability for the place described provides an aspect common to all the work submitted.

It has been proposed, how seriously I do not know, that question papers should be withdrawn, allowing candidates to submit whatever they wish. Thus the examiner might be faced at one moment with a pen-and-ink illustration, then a landscape or portrait in oils and, perhaps, a collage. It may be argued in support that this is precisely what the jury faces when selecting work for an exhibition. But there the problem is confined to approval or refusal; the precise degree of its merit or defects is not assessed. If set tests were to be withdrawn, the work submitted would scarcely differ from work carried out during the school year. But a greater degree of reliance on "course work" in the examinations has long been advocated. Is this advisable, since reliability in marking is the primary aim?

Several of the boards have allowed the submission of "course work". London has been especially to the fore in this respect for more than a decade. All candidates at Advanced level have been required to submit a portfolio of their work for comparison with their examination work. There were many protests when the Board reluctantly decided to discontinue it in view of the increasing number of candidates and the heavy problem involved in handling and transporting such a large number of portfolios. The Cambridge Syndicate also introduced the submission of portfolios in Advanced level some years ago, but this was voluntary and only a small proportion of candidates complied.[1] The Associated Board has made "course work" an integral part of its examination at Advanced level, as have most of the other boards.[2] The Associated Board, alone, however, has

[1] The work submitted in the crafts and examined at Cambridge is entirely "course work".

[2] The Welsh Committee requires submission of "course work" at Advanced level, and it is also required by the Northern Board for its "Special Paper" prescribed in its recent revision of the syllabus. The Oxford and Cambridge Joint Board allows submission of one additional work executed in the candidate's own time to be available for consideration at the Award. The Southern Board stipulates that Advanced level

required candidates at Ordinary level to make "course work" available for inspection, on request, by visiting examiners.

Examiners are reluctant to place entire reliance on portfolios of "course work" unaccompanied by work carried out in the examination room, supposing such a procedure were thought practicable in the G.C.E. Their attitude may be formulated as follows: The strong-minded art teacher cannot help influencing the pupil; work done during the school year will presumably have benefited by, or perhaps suffered from, the teacher's influence and guidance; the degree of influence might be difficult to estimate, and the examination prove to be a test of the teacher's work rather than that of the candidate.[1]

It is often found that the pupils of a particular school have been working in a style common to all of them. If it happens a year later that this style is no longer evident, we may assume that there has been a change in teacher. This clearly reveals the degree of the teacher's influence. The main objective in an examination is to test the candidate's real ability, entirely free from such influence, and this is best achieved by examination work, though it may be reinforced by "course work".

The G.C.E. is by no means alone in the field of school-leaving examinations in Great Britain. The Scottish Education Department in 1962 introduced its Certificate of Education, which includes art both at the Ordinary and the Higher Grades, replacing the Leaving Certificate, which had been available since 1888.

While the Scottish Ordinary grade, for which six papers in art are set, is considered equal to the G.C.E., the standard at the Higher grade is thought to be less high than in the Advanced level. In both grades the time allowed and the maximum marks in each paper vary, so that certain papers carry more weight than others. Northern Ireland introduced its G.C.E. in Art at both levels in 1963.[2]

candidates may submit "specimens of various types of work done during the two previous years".

[1] The Secondary School Examinations Council's *Examinations Bulletin No 1*, 1963, states that enquiries made by its Curriculum Study Group revealed that marks given for course work "were almost invariably higher than examination marks", and that "teachers believed, probably correctly, that course performances were in fact 'better' than those in examinations". This is not necessarily in accordance with experience in art examining. The assessments in the G.C.E. have revealed that of those candidates who chose to submit "course work" barely 10 per cent justified raising the assessment given for the examination script, whereas there were far more cases where the effect of the "course work" was to lower the marks.

When arranging a schools exhibition for India, Pakistan and Ceylon in 1955, I approached certain schools where I knew that pupils had submitted excellent work for the G.C.E. In the majority of cases I was disappointed. Boys and girls capable of inspired work in examination submitted for this exhibition commonplace pictures of winter sports or of mermaids.

[2] Two choices are offered at Ordinary grade; candidates may take either the following four papers—composition in painting, modelling or carving, still life painting, life sketching, pattern design (there being double marks allowed in the first two papers), —or they may take three papers as follows—design and craft (carrying half the total marks), still life and plant form. (*continued on next page*)

The Royal Society of Arts has reintroduced art examinations. One of the first institutions to inaugurate local examinations over a century ago, the Society had dropped examining in art at a very early stage. In 1958, however, it re-established its School Certificate and included art. It was made clear that there was no intention to compete with the G.C.E., the new examination being intended mainly for those entering commercial or secretarial work.[1] During the six or seven years of its functioning the number of candidates in art has risen to over a thousand, but it is symptomatic of the neglect of art in commercial circles that barely one candidate in twenty-three chooses art as one of the subjects.

The Royal Society of Arts also assumed responsibility for administering the new Certificate of Secondary Education for the London County Council, for which the first examination was held in 1963.[2] The new Certificate derived its origin from the special sub-committee set up in 1958 under Mr Robert Below by the Secondary School Examinations Council of the Ministry of Education. The sub-committee's report, issued in 1960, drew attention to the constant expansion of existing examinations and recommended the Ministry to exercise some control in this respect. It stressed the need for an examination at a lower level of ability than that required for the G.C.E. and recommended that it should be organized on a regional basis.

At the Higher grade, candidates must take five papers—composition painting, design, still life, life sketching, history and appreciation of art and architecture, which carries less marks than the first three papers. The teacher's assessment in craft work may be taken into consideration.

There were 4,200 candidates in art at Ordinary grade and 1,800 at Higher grade in March 1965.

In 1963 the Northern Ireland examinations were directed by the General Certificate of Education Committee associated with The Queen's University, Belfast, and replacing the Grammar School Senior Certificate, which had been conducted by the Ministry of Education of Northern Ireland. The G.C.E. is awarded in the subjects taken, which may include "Art". Some 1,500 candidates take the subject at Ordinary level (more than two-thirds of them being girls), but only about 230 take it at Advanced level (the boys and girls being equal in number). The Senior Certificate is also awarded to those who pass in a required group of subjects, which may include art.

[1] Initially, a minimum of five subjects were required, including the English Language, but in 1964 the regulations were revised to permit single subjects to be taken alone, but the Special School Certificate was available only to those who satisfied the examiners in four subjects, which might include Art, together with English. The subject, Art, consists of two papers only: Paper 1 (a written paper) sets a number of questions requiring identification and information regarding a series of reproductions of paintings provided, while Paper 2 (practical) sets a number of alternative subjects for a pictorial composition (which are fully described) using any medium, other than oil, on sheets of paper provided (royal size), but candidates are advised "to use a limited number of colours for your colour scheme". Thus the candidate is judged on much less practical evidence than in the G.C.E.

[2] This had been tried out as a "pilot" scheme, but in 1966 it became the Certificate of Secondary Education of the Metropolitan Regional Examining Board. It is assumed that the art syllabus and method of assessment must remain substantially the same, although a reduction in the number of examiners may have to be envisaged.

In 1963 the Minister announced his approval of the new Certificate to be taken at the end of five years of secondary education by children who were not expected to take the G.C.E. The examination was planned on a regional basis, but its main principle placed the control of the examination in the hands of the teachers at schools that provide the candidates. The teachers were also to be represented on the Regional Boards, of which fourteen were announced in 1965, and the candidates' work would be assessed in the schools.

This revolutionary feature of teacher control is affirmed by the Secondary School Examinations Council thus:

> Effective teacher control of syllabus content, examination papers and examining techniques is the rock on which the C.S.E. system will stand.[1]

In thus "adapting the examination to the needs of the pupils", the Council expands the doctrine as follows:

> It will be the responsibility of the teachers themselves to ensure that what is examined is what they want to teach; they will not be obliged to teach what someone else has decided to examine.[1]

If we take the general run of schools, the standard of work sought by art teachers varies enormously, and it is difficult to envisage any consistent standard of examining if it has to be adjusted to what teachers choose to teach.

There is the implication that teachers have been ostracized in the examinations for the G.C.E., a policy to be reversed in the C.S.E. Is this implication justified? Teachers have always had a predominant voice in the art examinations from the beginning. They usually constitute the majority in the policy-making panels, and the school view usually prevails. Examining is entirely in their hands. Could it be otherwise? If we take Cambridge as an example among examining boards for the G.C.E., it may be noted that all the art examiners, about a hundred, are, or have been, practising art teachers, mostly in secondary schools or in teacher training colleges. This is equally the case with the other examining boards. In fact, examiners are required to have had art-teaching experience, and they meet together periodically for discussion of the syllabus and methods of assessment.

The new certificate envisaged the teachers examining their own pupils; in other words the principle of an internal examination, moderated externally, to which we referred earlier. The great advantage lay in flexibility and adaptation to teaching methods. But is this really valid in art? The Secondary School Examinations Council admits doubt when posing the following questions:

> Is it possible for teachers to set question papers for the very children they teach, and not be influenced by their knowledge of the tests they propose to set?

> Can teachers be relied upon to avoid prejudice in their assessment of course work or of written performance of pupils they know well?

[1] *The Certificate of Secondary Education*: Examinations Bulletin, No. 1, H.M. Stationery Office, 1963.

Is it possible for teachers to hold to a sufficiently high standard of work from their pupils when they are closely concerned about their success?

The Council confesses that "at this stage, these questions cannot be fully answered".[1] Does the system of teacher control over assessment—the rock on which it stands—offer the firm basis that has been suggested?

The examining boards for the G.C.E. have always pursued the opposite policy, strictly forbidding any examiner to examine his own pupils. They have always assumed that the public would not repose faith in an examination unless they knew that the work had been assessed by a completely impartial and disinterested teacher. A school tends to produce work which is unmistakably distinctive in style, reflecting the teacher's visual taste or feeling. It may have both merits and defects, as, for example, an emphasis on form but weakness in colour. The artist is usually blind to the characteristics of his own style, and this must be equally true of the art teacher. Is it conceivable, therefore, that the latter can avoid some prejudice in favour of his pupils' work and assess them as fairly and dispassionately as an independent examiner?

The C.S.E. examination scheme contains a number of valuable, but controversial, plans. In the London area schools have been asked to provide their candidates with facilities for displaying small exhibitions of their work, to be assessed by the examiners visiting the school. Seventy-five per cent of the total marks have been allocated for the work on display, leaving only 25 per cent for the work done during examination time. Credit is given for the quality of the display as well as for the merit of the work shown. Thus success or failure mainly depends on the course work and only to a small extent on the examination work. This is, of course, the reverse of the procedure in the G.C.E. in which "course work" may contribute towards, but never govern, the assessment.

The principle of asking the candidates to display their own "course work" at school can scarcely fail to win approval, and has often been advocated by examiners and teachers, but it is, alas, impracticable for the examining boards in the G.C.E., with thousands of schools and the considerable time that such inspection would require. In the London pilot scheme for the C.S.E. in 1964, not more than sixty to seventy schools were involved, all in the London area. Even so, some thirty to forty examiners were required, one pair of examiners visiting two schools.

The C.S.E. examination is essentially regional. This has many practical advantages and the system could not be operated otherwise. But is there not some merit in the broad national character which pertains to the G.C.E. Its standards based on a cross-section of the entire country are more reliable than local ones. Local assessments have been introduced overseas with the establishment of Examination Councils in some of the newly independent countries—there is the Sudan Examination Council established some ten years ago and that of West

[1] *The Certificate of Secondary Education*: Examinations Bulletin, No. 1, H.M. Stationery Office, 1963.

Africa formed more recently. Such a step is not so favourable for art as it may be for other subjects, since its standards must depend on seeing a wide variety of work from a great many different centres and in some territories the general level may be much above or much below the average.

The C.S.E., with its new structure for examining in art, has inevitably given rise to much discussion, both favourable and critical. Many of its features are founded upon disatisfaction with the G.C.E., and fair criticism may stimulate some valuable reforms. It is, however, too easy to assume that older institutions, like the existing examination boards, are necessarily outworn and have therefore very little to contribute.

The announcement of the C.S.E. has proved of great service to art teaching, arousing intense enthusiasm, though sometimes coupled with some scepticism in art-teaching circles. Whether examination is under the G.C.E. or the C.S.E., the essential issue is that art teaching should reach by their means an ever-growing proportion of the population. In its explanation of the C.S.E. examination system, the Secondary School Examinations Council states:

> If art teachers have freedom to form their courses, and largely to control the means of assessment, there is no reason why the new examination should not be far more stimulating than many at present in use and give the teachers a chance to make a real contribution to raising the standard of art and design throughout the country.[1]

Such encouragement from above might have been given many years ago and art teaching have benefited accordingly, through the G.C.E. just as much as through the new examination. But the fact is that art teachers have never lacked freedom in forming their courses, as many pioneers have proved, and they have long had control over the means of assessment, including the syllabus and setting of papers, for the examining boards, with few exceptions. It is the educational authorities, including the Secondary School Examinations Council, holding the reins of policy, which held back progress in art teaching over the past years.

There is scope for improvement in various directions: We may hope that the pressure of new ideas will produce close and regular contact between schools and examiners. The examining boards have sought to promote such contact through the circulation of their periodic reports on the art work, and by visits to schools whenever this has been requested. Travelling exhibitions of work submitted for examination have been circulated, notably by London, and recently by the Associated Board, which has organized such exhibitions on a considerable scale. An exhibition of craftwork submitted for the 1964 examination was arranged by the Cambridge Syndicate, followed by a general discussion between teachers, and a further exhibition of painting and graphic work has been held more recently.[2]

However much it may have been argued that the artist cannot reveal true

[1] *The Certificate of Secondary Education*: Examinations Bulletin, No. 1, H.M. Stationery Office, 1963.
[2] A successful exhibition and discussion of examination work for the London G.C.E. was recently held in the Senate House.

ability in examinations, which are in consequence an anachronism, they are probably unavoidable. In the G.C.E., the student is rehearsing for greater ordeals to follow in the art school or college of further education.[1]

Full co-operation between art teaching and examining is perhaps hampered by the system agreed between the examining boards and the Examinations Council of announcing only the grades attained in the subject as a whole. Thus a candidate who may have done extremely well, for example, in design or history of art, but failed lamentably in another paper, thus producing a mediocre grade, may never learn of his success nor where his failure lay, nor can he profit by experience should he wish to try again. It is to be hoped that in the not too distant future grades in the different papers in art may be issued to candidates in addition to the overall result. Similarly, exceptionally distinguished results do not reach the candidate, since Grade A represents little more than a "good" result, and there are a fair number of candidates who do very much better.

The syllabus in art is constantly reviewed by the different boards and efforts have been made to render it freer and more flexible. For example, it has been proposed to allow candidates to choose and arrange their own material and subject-matter for nature study or for still-life and to include their preliminary sketches with their examination work. Moreover, it has been recommended that there should be less restriction, if any, on the time allowed in the examination-room.[2]

Although the National Advisory Council on Art Education, in its third report of 1962, emphasized the importance of art in general education and urged closer co-operation between the secondary schools and colleges of further education, such co-operation remains regrettably absent in art. It would constitute a valuable step forward if the art schools gave more consideration to the needs of the art departments in the secondary schools. As long as examination results are ignored by the art schools, the courses planned by the secondary schools may prove to be leading them up a blind alley.

Of particular importance for the well-being of art in secondary education is the infusion of a more enlightened attitude towards the art examinations, whether in the G.C.E., the C.S.E. or others. They should be regarded as a challenge to creative effort, not a disagreeable hurdle to surmount. It should be possible for boys and girls to throw off the examination complex, so as to carry out their

[1] Students of university art departments—Reading, Durham, Leeds being the only ones established at present—may expect to sit an examination at the end of the first year (usually in practical work, history of art and some other subject). There may be further tests after the third and fourth years, though these may consist mainly in a display of work or a preparation for a special project together with some written work. There will be further tests if they continue as post-graduates for a fifth and sixth year.

[2] Certain changes on these lines have been introduced by Cambridge at Advanced level. The Northern Board has liberalized its syllabus in a similar manner. Reforms have also been introduced by the other boards. London has recently agreed to the inclusion of sketches and the Welsh Committee is in process of revising its Advanced level syllabus.

work in a spirit of independence, as if unaware of being examined. To achieve this, we need a much more sympathetic and flexible examination environment where art is concerned.

Far from hoping that the examinations in art may one day disappear in favour of an internal system of assessment, I foresee their growth. The competitive element has, in the past, served to stimulate the general interest in art and respect for art teaching and, subject to revision and the full collaboration of the art-teaching profession, the art examinations should promote this aim even more fully in the future. An increase in the support given must have its effect in the schools and ultimately give art teaching its rightful prestige in secondary education.

Such an objective cannot be achieved if the examinations are allowed to diminish in scale on a regional basis. There should be more schools entering candidates, but these should be more carefully selected, and there might be closer collaboration between those who conduct the art examinations of the various boards. Perhaps national touring exhibitions of the best work submitted in the examinations may be undertaken, and the inclusion of a candidate's work in such exhibitions may prove one of the rewards of success.

There is no need whatever for teaching and examining in art to conflict, and the day may even arise when prospective candidates will think affectionately of their examiner as a potential friend instead of a foe.

Notes on the Illustrations

A. The Colour Plates

I

H. S. Ahiable (age 16), Zion College, Keta, Ghana; *Ulysses and his companions escape from the Cyclops*; water-colour (15 × 11 in.); Cambridge School Certificate, December 1957 (Paper 4: Imaginative composition).

His headmaster has informed me that this pupil subsequently enrolled in the School of Hygiene.

II a

Winifred Baglow (age 13), pupil of Marion Richardson at Dudley High School for Girls; *Performance of "The Midnight Sun" by Serge Diaghileff's Russian Ballet*; water-colour (10 × 7 in.), 1919. (Collection of Miss Kathleen and Mr Donald Richardson, Oxford.)

Marion Richardson described the performance; her pupils had not themselves seen it. Vivid and imaginative compositions were produced by nearly all her pupils and she preserved about fifty of these pictures.

b

S. R. Rakshit (age 13), a Bengali boy, pupil of Niren Ghosh, Delhi Juvenile Art Centre, 1945; *A courtyard in India*; water-colour (11 × 8½ in.).

Exhibited (with IVa) in *Art from Class-rooms of the East* in The Imperial Institute, London, 1954.

III

I. W. Cudjoe, pupil of George Stevens, Achimota College, Ghana; *A Fishing Scene*; water-colour (18½ × 21½ in.), 1928; exhibited at the Imperial Institute, London, 1929.

IV a

G. Footman (age 15), pupil of Niren Ghosh, Victoria Boys' School, Kurseong, India; *A caravan from Tibet*; water-colour (11 × 8½ in.), *c.* 1950.

b

Valerie E. Steward (age 16), Girls' Grammar School, Hatfield; *Revelation* (". . . Lo, there was a great earthquake; and the Sun became black as sack-cloth of hair, and the moon became as blood; . . . And the Kings of the earth . . . hid themselves in the dens and in the rocks of the mountains"); water-colour (18 × 23 in.); Cambridge G.C.E. "O" level, July 1965 (Paper 4).

Her meadmistress informs me that since leaving school Miss Steward has been taking a course in business studies, but is planning to attend an evening class in art.

V a

Joyce Marina Boyle, Penang, Malaysia; *An unexpected meeting between the priest and a tiger*; water-colour (15 × 11 in.); Cambridge School Certificate, December 1955 (private candidate), (Paper 4).

b

Godson Nwabuwa (age 18, Owerri Province), Washington Memorial Grammar School, Onitsha, Nigeria; *The Family Sleeps on the Verandah*; water-colour (15 × 11 in.); Cambridge School Certificate, December 1963 (Paper 4).

VI a

Sylivestri Kiwanuka (age 22), St Mary's College, Kisubi, Uganda; *Still-life with the skull of an animal*; powder colour (17 × 22 in.); Cambridge School Certificate, December 1960 (Paper 1: Painting from Still-life).

The Headmaster has informed me that his pupil, since leaving school, has taken up work that is not connected with Fine Art.

b

Harry Ssengonze, Namilyango College, Uganda; *Washing the Baby*; powder colour (16 × 20 in.); Cambridge School Certificate, December 1959 (Paper 4).

Harry Ssengonze is now an Accountant.

B. *The Black and White Plates*

I a

Henry Peacham (*c.* 1576–*c.* 1643); *Travellers at a village*; pen and ink (7¾ × 11½ in.). (City Art Gallery, Birmingham.)

Very little is known about Peacham's work and it has been questioned whether this and the two other drawings are indeed his. This, and another very similar, in the Courtauld Gallery, London, belonged to W. Esdaile in the eighteenth century, and both bear his initials "WE". The two drawings subsequently passed into Thomas Bodkin's possession, before acquisition by Sir Robert Witt. Both are closely alike, showing a landscape with groups of soldiers and villagers, and are drawn with the fluency associated with the seventeenth century Dutch school.

The Courtauld drawing is signed with the monogram HP, and the name "Henry Peacham" has been written on the back, probably by Bodkin. The attribution was accepted by Sir Robert Witt for both drawings and for another very similar wash drawing bearing the monogram HP in the British Museum, and, if the attribution is acceptable, they probably date from late in his career.

The subject and style appears quite consistent with what we know of Peacham's love of rural scenes which, as he has described them, "shewed to the life a countrey village, faire or market . . . with farme houses, water-milles, pilgrimes travelling through the woods", and he adds that he had drawn "often with my Pen and Inke only upon a faire peece of paper in an houre".

b

Bernard Lens (1682–1740); Framed self-portrait between two pupils of Christ's Hospital, who display a seascape (left) and a map of an island (right); from a drawing by Lens engraved by G. Boitard; frontispiece to the *Art of Drawing*, published, 1751, after Lens's death.

2

Illustrations to Comenius' *Orbis Pictus*, translated into English by Charles Hoole; engravings on copper (approximately actual size) from the edition of 1659. (British Museum.)

a

The Master and the Boy.
In some editions, this engraving appears both at the beginning and end.

b

Ravenous Birds (Plate no. xxiii), with names listed below.

c

The Outward Parts of a Man (Plate no. xxxviii).
The anatomical features are listed below in Latin and English.

There were many English editions of this popular school-book. The artist is not recorded. In the first three English editions, the engravings are those of the original German edition, but they were re-etched in 1689. Fresh drawings were made of the same subjects in the eighteenth century with a steady decline in quality.

3 a

Wynkyn de Worde; *The Master with his Pupils*; woodcut, 1508; frontispiece to John Holt's *Lac Puerorum or Mylke for Children*. (British Museum.)

Wynkyn de Worde was Caxton's pupil and successor at his press in Westminster.

b

William Faithorne the Elder (1616–91); *Portrait of John Smith*; engraved by Peter van der Bancke from Faithorne's drawing. (Victoria and Albert Museum.)

John Smith was Writing Master at Christ's Hospital until his resignation in 1695. It was under him that William Faithorne the Younger was appointed to teach drawing. The engraving is undated, but the elder Faithorne was active in London from 1650 until his death; and it was, according to Walpole, during the last decade of his life that he took to drawing portraits in crayon or black and white. Van der Bancke came to England about 1674. The portrait was probably made, therefore, not later than 1680.

4 a

Alexander Cozens (*c.* 1717–86); *Landscape with a man driving animals along the bank of a river, Italy*; unfinished, with pen and ink over pencil, probably 1746. (British Museum.)

b

Alexander Cozens; *Landscape with rocks stream and buildings, Italy*; pen and ink ($6\frac{1}{4} \times 9$ in.); signed and dated 1746. (British Museum.)

These examples of Cozens' early style, when he was staying in Rome, reveal his method of drawing first in pencil, perhaps direct from nature, and then re-drawing over it in pen and ink. His fine parallel lines create effects of light and shade in the manner of etching. They are among the drawings dropped by Cozens

from his saddle-bag in Germany on his way to London, but recovered subsequently by his son in Florence. Cozens' method of teaching at Christ's Hospital must have conformed with this style of work.

5 a

Alexander Cozens; *Landscape with solitary tree*; brush with black ink.

b

Alexander Cozens; same as above carried out in greater detail with pen and sepia.

c

Alexander Cozens; *Composition for an imaginery woodland scene*; brush with black ink.

d

Alexander Cozens; *Imaginary landscape of a tree with distant mountains*. All are about half the actual size. (British Museum.)

These undated examples of Cozens' extemporized brush work or 'blot making' are derived from the system he described in his *New Method*, of about 1784, and are presumably of about that date. They indicate the method of teaching, based on imagination, which he used in his later years.

6 a

Robert Marsh, pupil of Christ's Hospital; *Ships with sails set*; signed and dated 15 May 1765; one of several illustrations in pen and ink for his Elements of Navigation, a hand-written book submitted for examination at Trinity House, in 1766. (Library of Christ's Hospital School, Horsham.)

b

James Slater Elly, pupil of Christ's Hospital; *Young men bathing in the river*; signed and dated 3 November 1755; one of eighteen pen and ink illustrations in his hand-written book for examination at Trinity House, 1755. (Library of Christ's Hospital School, Horsham.)

While some of Elly's drawings were copied from Bernard Lens's etchings, this may be his own composition. His use of the pen with fine line and stylized foliage clearly indicates Cozens' tuition. The latter resigned in June 1754, and was succeeded by Thomas Bisse, who was in charge of drawing until his death, twelve years later.

Boys had submitted work to Trinity House since the formation of the Mathematical School in 1674, but only gradually did the test assume the character

of an examination held twice yearly at stated times. Essays, diagrams, drawn initial letters, headings and illustrations were prepared by the candidates under the direction of the Mathematical Master.

In September, 1787, this procedure was changed when Benjamin Green, the vigorous drawing master who had enjoyed a long reign of over thirty years prior to his death in 1798, protested to the School Committee. The boys' drawings, so run the Committee Minutes, "had been selected hitherto without his knowledge or consent, by which means very indifferent performances have been exhibited to the disgrace of the boys themselves and to his reputation as master". The Committee agreed that in future the candidates' drawings should be submitted for examination in a portfolio which the Drawing Master would himself take to Trinity House. Thus began the separate assessment of Drawing, as distinct from the written work, in conformity with contemporary practice.

7 a

William Pars (1742–82); *Imaginary landscape with a farmhouse, and Roman arch*; pen and ink (7½ × 4½ in.), 1759. Pars was seventeen and received a fourth prize of two guineas. (Library of The Royal Society of Arts, London.)

The curiously naïve proportions of the human figures, animals, laundry and wooden palings suggest that this must have been drawn from imagination, unaided.

William Pars was a pupil of William Shipley, founder of the Royal Society of Arts, and he became one of the pioneers of the English water-colour school. His elder brother, Henry, taught drawing.

b

Michael Rooker, A.R.A. (1743–1801); *The Brill by the Bowling Green House, near St. Pancras*;pencil drawing (8¼ × 6 in.), 1759, for the best landscape after nature by competitors under nineteen. He was then aged 16. (Library of the Royal Society of Arts, London.)

Known as 'Michaelangelo', Rooker studied engraving under his father, and became well known for his topographical drawings.

This unconventional composition with the footpath receding on the left suggests that Rooker drew it on the spot, a proceeding that was still unusual at this time.

8 a

Richard Cosway, R.A. (1742–1821); *The cast of the Fighting Gladiator*; signed and drawn in pencil, 1758, for the competition for the best drawing of a human figure from models or casts by youths under twenty-two years old.

Cosway was 16 and received the fourth prize of two guineas.

b

John Smart (born *c*. 1742); *The cast of the Dancing fawn*; drawing in black chalk, 1757; the same competition as the preceeding for youths under eighteen.

Smart was awarded the first prize of five guineas. It is stated that he was then 14.

c

Denis Dighton (1792–1827); *Julius Caesar landing in Britain*; drawing in pen and sepia, 1807. Dighton was said to be 15 and was awarded the Greater Silver Palette.

The son of a caricaturist, Dighton became known subsequently for his paintings of battle scenes.

The drawings in plates 7, 8 and 10 were entered for the Royal Society of Arts Competitions, and are now in the Society's possession in the Adelphi, London.

9

George Dance, R.A. (1745–1825); *The Drawing Lesson*; oil on panel (7¾ × 7¼ in.), signed G. Dance, but undated. (Collection of Mr and Mrs Paul Mellon, Washington, D.C., U.S.A.)

This picture was included in the Exhibition "Painting in England" at the Royal Academy of Arts, London, 1964/65, as No. 144, and the catalogue states that no other oil paintings by him have been recorded. He was known chiefly for his architecture and portrait drawings.

The picture well portrays the procedure in a drawing lesson of the late eighteenth century. The young pupil submits his drawing of a man's profile for correction by the master and submissively watches while the master demonstrates. The lesson takes place in the master's study, his profession indicated by the palette hanging on the wall and the paint brush suspended on the extreme left.

10 a

Miss S. C. Day; *Venus and Cupid*; water-colour drawing, 1807.

b

Miss S. C. Day; *Augustus entering the appartment of Cleopatra*; pencil, 1806.

Both drawings were submitted for the competitions for girls, and the earlier drawing was awarded the Small Silver Palette. (Library of the Royal Society of Arts, Adelphi, London.)

Imaginative composition was one of the few branches of art which female competitors could practise. The weak and unsophisticated drawing of Venus reveals the lack of opportunity available to girls at this period for practising direct from the living model. The drawings have a naïve charm which is often lacking in the more sophisticated work by the boys.

11 a

Louisa Gurney; *Thatched cottage in a glade, Norfolk*; pencil drawing inscribed "Charlecomb L.G.". (From an album of drawings by the Gurney sisters in the possession of Alec M. Cotman, Esq.)

b

John Crome (1768–1821); *Group of trees overhanging a pool*; pencil drawing, inscribed (top left corner) "Old Crome J.C.". (Castle Museum, Norwich, formerly in the collection of Percy M. Turner.)

Louisa was the sixth of the seven Gurney sisters, all of whom received drawing lessons from John Crome in the summer months between 1802 and 1804, when this drawing was presumably made; Louise and Richenda showed the most promise.

Efforts to emulate Crome's style can be noted in the emphasis on points such as the fork of a tree or depth of foliage. There is considerable delicacy in this use of accents, but she was unable to achieve the unity and simplification characteristic of Crome's drawing.

12 a

Samuel Prout (1783–1852); *The Moselle at Coblence*; lithograph from his *Sketches in Flanders and Germany*, 1833. (British Museum.)

Prout published his volumes of lithographs as a means of instruction. Ruskin was a great admirer of Prout's work, from which in his youth he often made copies, and he writes in *Praetorita*, 1885:

> "I well remember going with my father into the shop where subscribers entered their names, and being referred to the specimen print, the turreted window over the Moselle, at Coblentz."

Prout was one of the first to offer the students studies of street scenes with the florid details of Gothic and baroque buildings instead of the severe landscapes and classical ruins of the earlier topographical artists. The softness of the pencil with the irregular contours and broken areas of light and shade helped to create the picturesque effect which so appealed to his pupils and patrons.

b

John Crome; *The Glade*; wash drawing, undated and unsigned; formerly in the collection of Percy M. Turner and included in the Crome Centenary Exhibition as exhibit No. 82 at Norwich, 1921. (Castle Museum, Norwich.)

The unity of sky and trees, the concentration of light and the freedom of brush work characterized the new approach to landscape painting, which Crome introduced into his teaching during the last decade of his life.

13

Dante Gabriel Rossetti (1828–82); Selection from a set of illustrations to Homer's Iliad; pen and ink ($4\frac{1}{2}$ × $3\frac{1}{2}$ in.), 1840, when the artist was 12. (Collection of Mrs Rossetti Angeli, Woodstock.)

(a) Title page.
(b) *Achilles.*
(c) *Ajax and Menelaus defending the body of Patroclus from Hector.*
(d) *Jupiter awaking sees Neptune rallying the Greeks.*

14 a

Anne Martineau, Cotman's pupil; *Fishing boats in a squall at sea*; drawing in pencil on which brush strokes in sepia have been superimposed by the master. (Castle Museum, Norwich.)

The master has tried to pull the composition together and to show the pupil how to visualize the entire scene in greater breadth rather than as a series of separate details.

b

John Sell Cotman (1782–1842); *Dun Otter Castle*; drawing in pencil, signed "Cotman J 7552 6235", and stamped "Cotman Kings College London". (Calman Collection, Castle Museum, Norwich).

There are nine pin-holes at salient angles of the buildings, into which the pupils inserted the points of their pencils, to help in copying.

15 a

S. C. Edwards, Cotman's pupil; copy from Cotman's work, below; pencil, signed "S.C. Edwards, 1835". (Castle Museum, Norwich.)

b

John Sell Cotman (1782–1842); *North Gate, Yarmouth*; drawing in pencil, signed "Cotman J no 2363". (Castle Museum, Norwich.)

Opportunities for comparing the work of master and pupil are rare. The pupil has used a sheet of paper which differs in proportions from the original and this has hindered his appreciation of the composition. His heavy handling of the pencil has resulted in hard contours and failure to express the atmosphere in light and shade so splendidly conveyed by the master. The absence of any understanding of perspective is curiously apparent.

16 a

N. Yates (age 12), pupil of Marion Richardson at Dudley High School for Girls; *Town at night*; water-colour (7 in. square), *c.* 1919. (Collection of Miss Kathleen and Mr Donald Richardson.)

b

Ilse Breit (age 14), pupil of Franz Cizek, Vienna; *The Farmyard*; pen and ink wash. (From a photograph in the possession of Dr W. Viola.)

A portion of the picture to left and right has been omitted. Dr W. Viola informs me that Ilse Breit gave up practising art after leaving Cizek's class.

17

Winifred Ediriweerasinghe (age 18), pupil at the Convent of the Child Jesus, Ratnapura, Ceylon; *A Church Service*; water-colour (15 × 13¾ in.), *c.* 1950. Exhibited (with 18b) in *Art from Class-rooms of the East*, Imperial Institute, London, 1954.

18 a

Uthman Ibrahim, pupil of K. C. Murray at Government School, Ibadan, Nigeria; *A boy, an ape, and a lamb taking sweets and a tortoise coming out from its hole*; pen and ink with water-colour wash (15 × 11 in.), 1930. (In the possession of K. C. Murray, Esq.)

A note on the back of this drawing records Roger Fry having singled it out for especial praise, when Murray showed these drawings in London in the early 1930s.

b

Harbhazan Singh (age 11), pupil of Niren Ghosh at Delhi Juvenile Art Centre,

India; *Monkey Land*, an illustration to his own story; pen and ink with water-colour (10½ × 8½ in.), 1946.

19 a

J. E. Korsah (Fanti tribe), pupil of George Stevens at Achimota College, Ghana; *A young farmer and his brother and sister*; water-colour (13 × 10½ in.), 1928. Exhibited at the Imperial Institute, London, 1929.

b

Benjamin Joseph, pupil of K. C. Murray at Government School, Ibadan, Nigeria; *Nebuchadnezzar in the woods*; water-colour (15 × 11 in.), 1932. (In the possession of K. C. Murray, Esq.)

20

Clarissa Cobb (age 17), Cambridgeshire High School for Girls; *Figure reclining*; powder colour (18 × 23 in.); submitted Cambridge G.C.E. "A" level, June 1964 (Paper 3: Painting from the living person).

She had obtained almost equally high results at "O" level and went on to study at a College of Art.

21 a

N. L. Uzodinma (age 20, Owerri Province), Our Lady's High School for Boys, Onitsha, Eastern Nigeria; *Who's there? It's late at night for an unexpected visitor*; water-colour in black with orange lights (15 × 11 in.); Cambridge, School Certificate, 1956. (Paper 4: Imaginative Composition.)

b

Juliet Watson (age 16), Sidcot School, Somerset; *Study from the Wing of a Humming-bird*; painting (22 × 15 in.); Cambridge G.C.E. "O" level, July 1965 (Paper 4: Additional abstract subjects).

Her Headmistress states that Juliet Watson based her work on studies she had made from the wing of a humming bird, the colours being mainly blue and black, and that she may take up art as a career.

22 a

Krishna Ghosal; Dow Hill Girls School, West Bengal, India; *A Nepalese girl*; black chalk (15 × 11 in.); Cambridge School Certificate, 1959 (Paper 3: Portrait Study).

b

Nathaniel Adeyemi (Nigerian, age 18), Government Secondary School, Tamale, Ghana; *Head of a man*; pencil (15 × 11 in.); Cambridge School Certificate, 1959 (Paper 3: Portrait study).

N. M. Adeyemi gave up art when taking Higher School Certificate and went on to Fourah Bay College, Sierra Leone.

23 a

Daniel J. Dahl (age 18), Grammar School (boys), Hertford; *Model turning towards the left*; pen and ink (22 × 15 in.); Cambridge G.C.E. "A" level, June 1962 (Paper 3: Drawing from the living person).

Although at school he was chiefly successful in drawing, it was painting which appealed to him at the London art school where he went on to study.

b

Wendy Morane-Griffiths (age 17), Kent College, Pembury; *Dock root*; pencil (22 × 15 in.); Cambridge G.C.E. "A" level, June 1965 (Paper 2: Study from a natural object).

Her Headmistress has informed me that she was chiefly interested in plant drawing, being not so successful in the other branches of art and is not proposing to take up art as a career.

c

Anthony Robinson (age 17), pupil of Ounsdale Comprehensive School, Wombourn, Staffordshire; *Study of the bone of an animal*; pencil (22 × 15 in.); Cambridge G.C.E. "A" level, June 1965 (Paper 2).

He went on to train as an architectural draughtsman.

24 a

Unidentified pupil of Adisadel College, Cape Coast, Ghana; *A Cockerel holding Keys in its Claw*; mahogany (10 in. high); Cambridge School Certificate, December 1953.

b

Unidentified pupil in Rhodesia; *A Night-Ape or "Pookie"*; soapstone (about 5 in. high); Cambridge School Certificate, December 1962.

Mr H. A. Baker, Master in charge of art at Plumtree School, Rhodesia, has kindly sent me the following information:

"I introduced soapstone carving in my first year here (1959). Soapstone in a great variety of colours is fairly easily obtained in this country, and is an excellent medium for school work, as it is reasonably simple to carve and most varieties polish up to a very pleasing finish."

He adds that the native name for this little animal is Npukunyoni—"the schoolboys love to have them as pets". It has not been possible to identify the carver and Mr Baker does not recall it among his pupils' work.

c

Helen Glass (age 17), Elliott School, London; *A Seated Figure*; sculpture modelled in ciment fondu (36 in. high); Cambridge G.C.E. "A" level, June 1961.

The Head of the School Art Department has informed me that Helen Glass was very successful in art and continued her art studies at the Slade School, London.

d

Christine Sexton (age 17), Copthall School, Mill Hill; *A hand-built Pot and moulded Dish* (the pot 24 in. high); Cambridge G.C.E. "A" level, June 1961. This was submitted together with a portfolio showing drawings and experiments in glazing.

Although a pupil at Copthall School, she sat the Cambridge examination as a private candidate at King Alfred School, Hampstead.

Her Art Mistress, Mrs Nomi Durell, has written me as follows:

"We decided that her talents might be more suited to craft; as I would never consider any pupil doing craft in isolation, she did fine art as well. Her craft would never have reached the creditable standard it did without the fine art. I only wish that all craft teachers would adopt this policy rather than use craft as a refuge for the less talented."

Christine Sexton subsequently studied at an art school and trained as a specialist teacher in pottery.

All the above (in Plate 24) were submitted to Cambridge for Paper 6 (Craftwork).

C. Line Blocks in the text

Illustrations to Comenius' *Orbis Pictus*, 1659 (see plate 2). (British Museum.)

Page x: *The Picture.*
Page x: *Society betwixt Parents and Children.*
Page 312: *The Soul of Man.*

Page ii: Charles Hayter; *An Introduction to Perspective, Drawing and Painting in a series of pleasing and familiar dialogues . . . carefully adapted for the instruction of females and suited equally to the simplicity of youth and to mental maturity,* 3rd edition, 1820.

"*Foreshortening*"—"Now, John, tell me how long the 12-inch rule appears to your eye, as you see it end-ways to you, where you sit? John: I think it appears twelve inches long. George: I will presently prove that it only appears about three inches long to you."

Page 8: Tail-piece to Wynkyn de Worde's edition of John Holt's *Lac Puerorum*, 1508. This exquisite use of letter forms was adopted by Wynkyn de Worde in imitation of his master, William Caxton, who used a similar device for his books in 1487. (British Museum.)

Page 15: Henry Peacham (*c.*1576–*c.*1643): Scene 2 of Shakespeare's *Titus Andronicus.* This drawing in pen and ink precedes Peacham's handwritten copy of sections of the play, signed "Henricus Peacham" and dated 1595. (Collection of the Marquess of Bath, Longleat.)

Peacham was 18 or 19 years old and was still an undergraduate at Trinity College, Cambridge, since the College records show that he took his B.A. degree that year, before he began teaching at Wymondham.

The drawing effectively corroborates Peacham's interest in drawing since his childhood. The naïve charm in the spontaneous drawing of the figures offers a welcome contrast to the oversophisticated ease shown in the much later work attributed to him (see plate 1).

The drawing was made the year after this play was produced, and it presumably displays the appearance of the actors and their costumes at their first presentation on the stage.

Page 34: Henry Peacham; Woodcuts to illustrate "Drawing the Face or Countenance of a Man" and of "beasts, birds, flowers etc." in *The Art of Drawing*, 1606; (actual size).

Page 23: Joseph Terry, pupil of Christ's Hospital School; Tail-piece in the form of a bird, from his log book, 1680; it is drawn in pen and ink with continuous line in the manner of Edward Cocker. (The Library, Christ's Hospital School, Horsham.)

Page 36: Joseph Terry; A Ship at Sea; drawn in pen and ink in the margin of his log book of a voyage to New York and the West Indies, 1680.

Page 41: Bernard Lens (1682–1740); landscape with animals and fowls near a pond; an etching ($4\frac{1}{2}$ × 7 in.) made for his pupils to copy at Christ's Hospital School, about 1720, and published subsequently in his *Art of Drawing*, 1751.

Page 47: Pupil of Christ's Hospital School; Design drawn in pen and ink for his essay on Astronomy, *c.* 1780; Trinity House Examinations. (The Library, Christ's Hospital School, Horsham.)

Page 60: Charles Hayter; *An Introduction to Perspective, etc* (see above).

(*Figure seated to left*) "Make an easy, graceful position while engaged in study . . . many have neglected this, to the injury of their health, as well as the natural beauty of their persons."

"You must have a desk or easel, which you may elevate, or lower, by placing it before you on a table, and raising the desk lid, till your eye is as near the top edge as the bottom."

(*Figure seated to right*) "You will find it very convenient to take a light portfolio, or plain board, on your lap, and rest it against the table where your copy is, till by inclining your head easily forward, not stooping, you find your eye fall nearly perpendicular to its surface."

(*Standing figure*) "I much recommend the habit of standing, both to draw and paint, as most conducive to health. . . . Indeed, it is all contrived to your hands in a frame called an 'easle' to be had at any of the colour-shops."

"Take care never to hold (your pencil) too tight, but handle it with ease and freedom, using little more of muscular exertion than is sufficient to keep it from falling from between your fingers."

Page 74: Dante Gabriel Rossetti (age 14); *La Tomba*; illustration to his poem *Lisa ed Elvis*; pen and ink ($6\frac{1}{2}$ × 4 in.), about 1843. (Collection of Mrs Rossetti Angeli.)

Page 134: Jessie McConnell (age 16), Streatham Church High School; *The Dancing Class*; drawn in pen and ink, 1901; submitted to the Exhibition of the Royal Drawing Society, and awarded the President's Prize. (From the cover of the Society's Report of its twelfth Annual Exhibition, 1901.)

Page 183: A. Adeshoye, Eko Boys' High School, Mushin, Nigeria; *Portrait*; pen and ink (15 × 11 in.); Cambridge School Certificate, 1958 (Paper 3).

Page 213: University of Durham: Higher Certificate Examination, Art, 1932. The Examiner's illustration of the pose is included in the Confidential instructions to Superintendents, which reads: "Figure Study: Two action studies. Each pose to be of 10 minutes duration, and the drawings not less than 6 inches high."

Page 216: J. A. Odutayo, Eko Boys' High School, Mushin, Nigeria; *Portrait*; pen and ink (15 × 11 in.); Cambridge School Certificate, 1958 (Paper 3).

Page 226: Ocwet-Odongo, Namilyango College, Uganda; *African Village scene near Kampala*; pen and ink (17 × 22 in.), *c*. 1958.

Page 249: Unidentified pupil of Dow Hill School for girls, West Bengal, India; *The boatmen*; blue and white design in batik; Cambridge School Certificate, 1960 (Paper 6: Craftwork).

Page 252: Simon J. Urquhart (age 16), West Buckland School, Barnstaple, Devon; Design in black and white for a display card for a Careers Exhibition (15 × 11 in.); Cambridge G.C.E. "O" level, June 1965.

"He is hoping to make a career in Architecture," writes his Headmaster, "and possibly Interior Design as well."

Books and Publications
referred to in the text

Acland, Sir T. D., *Middle Class Education, 1857*, reprinted in *Some account of the Origin and Objects of the New Oxford Examinations for the title of Associate of Arts and for the Certificates*, 1858, *f*86–*f*89, *f*94, *f*98, *f*257.

Adelaide University, *Public Examinations, 1956/57*, *f*146.

Africa, Journal of the International Institute of African Languages and Cultures, *f*175.

Anon.: *An Essay to facilitate the invention of Landskips*, attributed to Alexander Cozens, 44.

Archer, R. L., *Secondary Education in the 19th century*, Cambridge, 1921, *f*97.

Arts Enquiry, *The Visual Arts*, sponsored by Dartington Hall Trustees, Oxford Univ. Press, 1946, *f*192.

Ascham, Roger, *The Scholemaster*, 1570, 19.

Austin, A. G., *Australian Education, 1788–1900*, *f*124.

Bales, Peter, *The Writing Schoolemaster*, 1590, *f*20.

Barry, James, R.A., *Lectures delivered in the Royal Academy*, London, 1811, *f*65.

Bayer, Herbert, Walter and Ise Gropius, *The Bauhaus, 1919–1928*, published by the Museum of Modern Art, New York, 1952, *f*264.

Bell, Clive, *Art*, Chatto & Windus, 1914, 166; Preface to *Second Post-Impressionist Exhibition*, 1912, *f*166.

Bell, John, *Outline from Outline or from the Flat*, published by the Royal Society of Arts, 1852, *f*83, *f*86.

Benham, Daniel, *The School of Infancy*, London, 1858, translated from Comenius' *Schola Materni Gremii*, *f*33.

Board of Trade, *Department of Practical Art*, 1853, *f*81, *f*82, *f*84.

Bolton, Edmund, *The Cabanet Royal*, 1627, *f*29.

Brinsley, John, *Ludus Literarius*, 1612, *f*14, *f*20, *f*22.

Burgh, James, *The Dignity of Human Nature*, 1754, *f*65.

Burt, Sir Cyril, *Mental and Scholastic Tests*, 1921, 171, *f*172, *f*223.

Butcher, A. G., *Education in New Zealand since 1878*, 1930, *f*125.

Campagnac, E. T., *Richard Mulcaster's Elementarie*, edited, 1925, *f*21.

Carline, Richard, *Pictures in the Post*, Gordon Fraser, 1959, *f*257.

Carline, Richard, Max Chapman and Edmund Swinglehurst, *John Duguid, 1906–1961*, privately published, *f*265.

Clarke, J. D., *Omu—An African Experiment in Education,* 1937, *f*178, *f*180.

Cleland, James, *The Institution of a young Nobleman,* 1607, *f*19.

Cole, A. S. and H. *Fifty years of Public work by Sir Henry Cole,* 1884, *f*81, *f*82.

Collingwood, W. G., *The Life and Work of John Ruskin,* 1893, *f*94.

Comenius (J. A. Komensky), (see Benham, Hoole).

Cooke, Ebenezer, *Our Art Teaching and Child Nature—A review of the Discussion, Art Section, International Conference, Health Exhibition, 1884,* published in the Transactions of the Education Society, 1885/86; *Neglected Elements in Art Teaching,* published ditto, 1887, *f*130–*f*132, *f*136, *f*160.

Cozens, Alexander, *The Shape, Skeleton and Foliage of thirty two Species of Trees for the use of Painting and Drawing,* 1771; *Principles of Beauty relative to the Human Head,* 1778; *A New Method of assisting the invention in Drawing Original Compositions of Landscape,* reprinted by A. P. Oppe (see below), 44, 45, *f*47, *f*63.

Department of Science and Art, *Instruction in Art,* 1855, *f*83.

Department of Fine Art, King's College, Durham University, *The Developing Process,* with articles by Victor Pasmore, Alan Davie, Richard Hamilton, etc., 1959, *f*268, *f*271, *f*272.

Dick, O. L., *Aubrey's Brief Lives,* edited by, 1950, *f*12.

Digges, Leonard, *Pantometica,* 1571, *f*11.

Dury, John, *The Reformed School,* 1645, *f*31.

Dyce, W., Report to the Board of Trade on his *Enquiry into the state of Schools in Prussia, Bavaria and France,* 1840, 78.

Education, Board of, *Circular on Primary Drawing,* No. 191, H.M. Stationery Office, 1901, *f*137; *Handbook of Suggestions for the Consideration of Teachers,* 1938, *f*242.

Education, Ministry of, *Art Education,* Pamphlet No. 6, H.M. Stationery Office, 1946, 242, *f*251.

Elyot, Sir Thomas, *Boke named the Gouernour,* 1531, 17, 18.

Evelyn, John, *Scuptura,* 1662, *f*25, *f*33.

Fairbank, A. J., *A Handwriting Manual,* Dryad Press, 1932, *f*237.

Fearnshaw, *History of King's College,* London, *f*69.

Field, George, *Chromatics; or the Analogy, Harmony and Philosophy of Colours,* 1845, *f*263.

Foxley, Barbara, Translation of J. J. Rousseau's *Émile, f*62–*f*64.

Frith, W. P., R.A., *My Autobiography and Reminiscences,* 1887, *f*72, *f*79.

Fry, Roger, *Transformations,* 1926; *Vision and Design,* Chatto & Windus, 1920, *f*167, *f*170; Preface to *Second Post-Impressionist Exhibition,* 1912, *f*165, *f*166.

Gething, Richard, *The Art of Faire Writing,* 1619, *f*30.

Gibbs, Evelyn (Miss), *The Teaching of Art in Schools,* Williams & Norgate, 1934, *f*220.

Goodrich, L. Carrington, *A short history of the Chinese people,* 1935, *f*237.

Griffiths, D. C., *Documents on the Establishment of Education in N.S.W. 1879–1880, f*125.

Gropius, Walter (see Bayer).

Hartlib, Samuel, Translation of Lubinus' *The True way to learne the Latin tongue*, 1654, *f*33.

Hartog, Sir Philip, *English Composition at the School Certificate Examination*, 1936, *f*221. *Examinations and their relation to Culture and Efficiency*, 1918, *f*153, *f*187.

Hartog, Sir P. and Dr E. C. Rhoades, *An Examination of Examinations*, 1935, *f*185.

Havell, E. B., *Indian Art, Industry and Education*, 1910, *f*174, *f*175.

Hind, A. M., *Short History of Engraving and Etching*, Archibald Constable & Co, 1908, *f*24.

Hoby, Sir Thomas, *The Book of the Courtyer by Count Baldassare Castiglione done into English*, 1561, 17, 18.

Holland, L. E. and F. C. Turner, translation of Pestalozzi's *How Gertrude teaches her children*, 1894, *f*61.

Holt, John, *Lac Puerorum or Mylke for Children*, 1495, 12.

Hoole, Charles, Translation of Comenius' *Orbis Pictus*, 1658, 32.

House of Commons, Select Committee on Arts and Manufactures, Reports of the, 1835 and 1847, 76, 77, 80, 81.

Howard, Frank, *The Sketcher's Manual*, *f*69.

Hudson, Derek and Kenneth W. Luckhurst, *The Royal Society of Arts, 1754-1954*, *f*51.

Ireland, John, *Hogarth*, 1792, *f*50, *f*59.

Jones, Owen, *Propositions on Decorative Art; The Grammar of Ornament*, 1856, *f*90.

Kilham, Hannah, *Report on a recent visit to the Colony of Sierra Leone*, 1828, *f*116.

Kitson, S. D., *The Life of John Sell Cotman*, 1937, *f*66–*f*69.

Klee, Paul, *Pedagogical Sketch-book* (see Nagy).

Knox, Dr Vicessimus, *A Liberal Education*, 6th ed., 1784, *f*65.

Knox, H. M., *Two hundred and fifty years of Scottish Education, 1696-1946*, *f*142.

Lens, Bernard, *For the Curious Young Gentlemen and Ladies that study the noble and commendable art of Drawing*, 1751, *f*42.

Littlejohns, J., *Art in Schools*, Univ. of London Press, 1928, *f*171, 199.

Luard, L. D., *The Training of the Memory in Art*, Macmillan & Co, 1914, translated from Lecoq de Boisbaudran, *L'Education de la Memoire Pittoresque*, 1879, *f*136.

Lubbock, Percy, *Earlham*, 1922, *f*66.

Lubinus, Eilhardus, Preface to the *New Testament*, 1614; *f*33. (*See also* Hartlib.)

Macfall, Haldane, *A History of Painting: The British Genius*, London, 1911, *f*58.

Mackintosh, M. *Education in Scotland, yesterday and today*, 1962, *f*142.

Makin, Mrs Bathsua, *An Essay to revive the antient Education of Gentlewomen with answers to the objectors*, 1673, *f*32.

Melbourne University Schools Board, *Handbook of Public Examinations*, 1923/24, *f*146.

Meyerowitz, H. V., *The Making of things*, 1942, *f*189.

Morris, May, William Morris's *Collected Works*, edited by, 1910, *f*239.

Mortimer, Thomas, *The Rise, Progress and present State of the Society of Arts*, 1763, *f*51.

Nagy, Sibyl Moholy, translation of Paul Klee's *Pedagogical Sketch-book*, 1953, *f*270.

National Council for Diplomas in Art and Design, *Memorandum No. 1*, December 1964, *f*197.

Nelson, James, *An Essay on the Government of Children*, 1756, *f*43.

Oppe, A. P., *Alexander and John Robert Cozens*, A. & C. Black, 1952, *f*44–*f*47.

Oversea Education, published for the Secretary of State for the Colonies, Oxford Univ. Press. (See also Stevens, G. A.)

 V. Brelsford, *The Teaching of Art in N.E. Rhodesia*, July 1935, *f*180.

 A. Mayhew (Editor), *Notes*, Jan: 1936, 1937, April 1943, *f*184, *f*188, *f*189.

 K. C. Murray, *The condition of Arts and Crafts in West Africa*, July 1933, *f*178.

 Sir W. Rothenstein, *The development of Indigenous Art*, October 1929, *f*179.

 M. Trowell, *Notes*, July 1934; *Suggestions for the Treatment of Handwork in the Training of Teachers for work in Africa*, January 1936, *f*181.

 H. V. Meyerowitz, July, 1943, *f*189.

 R. P. S. Walker, *Malayan Arts and Crafts*, October 1940, *f*189.

 N. Purdom, *Malay Crafts*, January 1931, *f*189.

Peacham, Henry, *The Art of Drawing*, 1606, re-issued as *Graphice*, 1612 and included in *The Compleat Gentleman*, 1622, *f*13, *f*14, 24–26, 29, *f*67.

Petch, J. A., *Fifty years of examining*, 1953, *f*142.

Petty, Sir William, *The Advice of W.P. to Mr Samuel Hartlib*, 1648, *f*29.

Pevsner, Nicholas, *Academies of Art, past and present*, 1940, *f*50.

Phillips, C. E., *The Development of Education in Canada*, 1957, *f*126.

Prout, Samuel, *Bits for Beginners; Hints on Light and Shadow, Composition, etc.; Rudiments of landscape with progressive studies*, 1813; *Sketches in Flanders and Germany*, 1833, 71, *f*72.

Quick, the Rev. R. H., *Educational Reformers*, 1894, *f*33.

 Richard Mulcaster's *Positions*, edited by, 1888, *f*21.

Rankin, D. H., *History of the Development of Education in Victoria, 1836–1936*, *f*124.

Read, Sir Herbert, *Education through Art*, Faber & Faber, 1945; Contribution to *Education and Art, a Symposium*, edited by E. Ziegfield and published by U.N.E.S.C.O., 1953, *f*3, *f*221–*f*224, *f*244.

Record, The (see Index, Art Teachers' Guild, published by).

Recorde, Robert, *The Ground of Arts Teaching*, 1607, *f*22.

Redgrave, Richard, R.A., *Elementary Manual of Colour*, 83, 84, 89, 109.

Redgrave, F. M., *Richard Redgrave, C.B., R.A.*, 1891, *f*82.

Reeves, James, *Memoir of the Artist*, in the Cotman Exhibition Catalogue, Norwich, 1888, *f*68.

Reynolds, Sir Joshua, P.R.A. *Discourses delivered before the students of the Royal Academy*, 58, 59, *f*59, *f*63, *f*64, 253.

Richards, I. A., C. K. Ogden, James Wood, *The Foundations of Aesthetics*, Allen & Unwin, 1922, *f*166.

Richardson, Marion (Miss), *Art and the Child*, 1948, *f*148, *f*168, *f*181.

Rossetti, William, *Memoirs of Dante Gabriel Rossetti*, 1895, *f*70.

Ruskin, John, *A Joy for Ever*, *f*94; *A note by Professor Ruskin for the use of the students at the Ruskin Drawing School*, *f*129, *f*130; *Art School Notes*, 1873, *f*95; *Education in Art*, 1858, *f*84, 94–96; *Inaugural Address, Cambridge School of Art*, 1858, *f*95; *Notes by Mr Ruskin*, *f*73; *Praetorita*, 1885, *f*72–74; *The Elements of Drawing*, 1857, *f*84, 94–96, *f*97, 98, *f*106, 114, 133; *The Elements of Perspective*, *f*96; *The Stones of Venice*, 93, 96.

Rutter, Frank, *Evolutions in Modern Art*, G. G. Harrap, 1926, *f*164.

Sadler, Sir Michael, *The Arts of West Africa*, edited by, and published 1935 by the Oxford University Press for the International Institute of African Languages and Cultures, *f*180, *f*248.

Salmon, Dr William, *Polygraphice*, 1672, *f*25.

Sanderson, Sir William, *Graphice*, 1658, *f*25.

Sausmarez, Maurice de, *Basic Design—the Dynamics of Visual Form*, 1964, *f*269.

School of Design, Reports to the Board of Trade by the Council of, 1841–47, *f*78, 79.

Secondary Schools Examination Council, *The Certificate of Secondary Education, Examinations Bulletin, No 1*, H.M. Stationery Office, 1963, *f*284, *f*286–*f*288.

Seitz, J. A., *Variability of Examination Results*, 1936, *f*146.

Sherring, Herbert, *The Mayo College—"The Eton of India"*, *1875–1895*, *f*120–*f*122.

Smith, J. T., *Nollekens and his times*, 1828, *f*52, *f*54.

Smith, S. H. and G. T. Spaull, *History of Education in N.S.W. 1788–1925*, *f*124, 145.

Snell, George, *The Right Teaching of Useful Knowledge*, 1649, *f*30.

Spanton, John, translation of M. E. Chevreul's *The Laws of the Contrast of Colours*, 1857, *f*263.

Stevens, G. A., "The Future of African Art" in *Africa* iii, 2; "Education in West Africa" in *The Listener*, February 1962; "African Art—the next phase" in *Oversea Education*, July 1939; "Teaching and Examining in Art" in *Oversea Education*, October 1941, *f*175–*f*177.

Strange, Sir Robert, R.A., *Inquiry into the Rise and Establishment of the Royal Academy of Arts at London*, *f*52.

Sully, Professor James, *Studies of Childhood*, 1895, *f*132.

Talboys, R. St C., *A Victorian School—The Story of Wellington College*, 1943, *f*158, *f*169.

Thomas, F. W., *The History and Prospects of British Education in India*, 1891, *f*115.

Tomlinson, R. R., *Picture making by Children*, Studio Ltd, 1934, revised 1950, *f*172.

Tucker, Abraham, *Light of Nature pursued*, 1756, *f*11.

Tudor-Hart, Percival, "The Analogy of sound and colour" in *The Cambridge Magazine*, 2 March 1918, *f*263.

Tyrwhitt, Rev. St John, *Handbook of Pictorial Art*, 1868, *f*128, *f*129.

Viola, Dr Wilhelm, *Child Art*, 1942; *Child Art and Franz Cizek*, 1936, *f*159, *f*160, 162–*f*164.

Walpole, Horace, *Anecdotes of Painting in England*, 1762, *f*25, *f*37, *f*43, 59.

Wodderspoon, John, *John Crome and his Works*, 1858, *f*66.

Wood, Sir Henry Trueman, *The History of the Royal Society of Arts*, 1913, *f*51, 55.

Woodward, Hezekiah, *Of the Child's Portion*, 1641, *f*12.

Woolf, Virginia, *Roger Fry, a biography*, 1940, *f*165, *f*167, *f*168.

Zachariah, K., *History of Hooghly College, 1836–1936*, *f*119.

Ward, William C., *John Ruskin's letters to William Ward*, 1922, *f*94.

Watson, Professor Foster, *The English Grammar Schools to 1660*, 1908, *f*20.

Whitley, W. T., *Artists and their friends in England, 1700–1799*, 1928, *f*50, *f*57.

Wilenski, R. H., *English Painting*, 1933, *f*65; *John Ruskin*, 1933, *f*93, *f*97.

Wilson, Francesca (Miss), *Child as Artist; A Lecture by Professor Cizek; A Class at Professor Cizek's*, published by the Children's Art Exhibition Fund, 1921, *f*159–*f*163.

Wise, C. G., *A History of Education in British West Africa*, 1956, *f*116.

XLIII.

The Soul of man. *Anima hominis.*

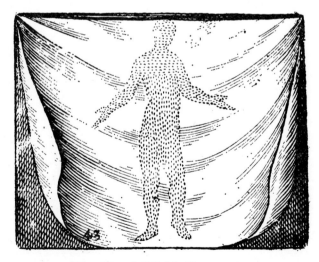

From Comenius' Orbis Pictus, *1659*

Index

Note: The letter *f* preceding a page number indicates that the subject is mentioned only in the footnote.